How to Read a Modern Painting

Understanding and Enjoying the Modern Masters

How to Read a Modern Painting

Understanding and Enjoying the Modern Masters

Jon Thompson

Abrams, New York

For Ludion:

Editing
Martine Stroo, Harriet Stroomberg, Wim Ver Elst

Copy editing
Fiona Elliot, Andrew Brown

Picture research
Andrew Webb, Wim Ver Elst

Design and typesetting
Dooreman, B-Ghent

Color separations
Die Keure, Bruges

For Abrams:

Cover design
Mark LaRiviere, Neil Egan

Production manager
Colin Hough Trapp, Anet Sirna-Bruder

Library of Congress Cataloging-in-Publication Data

Thompson, Jon.
 How to read a modern painting : lessons from the modern masters / Jon Thompson.
 p. cm.
 ISBN 978-0-8109-4944-7
 1. Painting, Modern—19th century. 2. Painting, Modern—20th century. 3. Art appreciation. I. Title.

 ND190.T52 2006
 750.1'1—dc22

 2006012018

Printed and bound in China
10 9 8 7 6 5 4 3 2

HNA
harry n. abrams, inc.
a subsidiary of La Martinière Groupe

115 West 18th Street
New York, NY 10011
www.hnabooks.com

Contents

6 Preface

8 **From Courbet to Warhol**

379 Selected bibliography

381 List of collections

391 Index

399 Acknowledgments for photographs

121405

Preface

The pleasure of a mind engrossed in an image. Michel Foucault once described sex
as bodies and pleasure. Art might be described as minds and pleasure, but it is
a pleasure sustained and developed by reflection, by thinking into the otherness
of the visual.

Art is a contested concept. It is not just that people can disagree about what is a good
or significant work of art. Even when they all admire a work, they can disagree
about why or how it should be admired. This is not a problem. Like people, works
of art are complex. It would be some kind of hell if the nature of each person's
worth was agreed by everyone. Both kitsch and academicism try to end the
debate; kitsch by fixing a work of art in sentimentality and clichés, academicism
by anatomizing it within systematic discourse.

To say that art is a contested concept is then to say that it is a discussion, a conversation
we have both with ourselves and with others. A great pleasure is to discuss
paintings with a good companion. Someone who sees things we have not noticed,
who can find vivid words to describe them or who knows things about them
we do not know. This is particularly true when looking at modern paintings,
paintings made after the rise of a plural public for art.

If you look at a book of reproductions or a gallery of paintings made prior to 1848,
say the Louvre in Paris or the National Gallery in London, most of the paintings
refer to Christian and classical literature. The work is made for a homogenous
public educated in the Bible and Ovid's *Metamorphoses* and other sources
of classical and Christian mythology.

Look through this book or imagine walking around a major collection of modern art.
It might, for example, be the Stedelijk Museum in Amsterdam, or Museum
of Modern Art in New York. Now ask yourself: what are the common texts,
the shared literature of art since 1848? There appear to be no shared texts,
no equivalents of the Bible or Ovid.

One reply to this observation is to say that there is a common text. The common text
is the absence of text; art is purely visual. It is sometimes argued that art as art,
or true art, or good art, or modern art is purely visual. There are ways of looking
at art just for a visual pleasure, the pleasure of a visual unity. In the first half
of the twentieth century the British art critic Roger Fry and in the second half
the American critic Clement Greenberg were great advocates of this. In their
way of looking the fictional three-dimensional space made by colour, tone and
shape should achieve a unity.

But if you look at the paintings in the major modern collections or those reproduced here, there are many works that do not have this unity, much of Picasso's work for instance. Further, in the work of those who do have it, the work of Matisse is the example, there is much more to be said and to be seen than visual unity.

Jon Thompson's text does not tell us how to look at modern paintings. Rather, it shows us something of how he thinks when looking at particular pictures. He indicates the kinds of texts that inform his experience. He brings a complex mixture, and not all kinds figure in all of his descriptions.

There is history, the times the artist lived through. There is biography, what we know of the artist's life, what training or experiences seem to bear upon their work. There is art history, the position of the painting within the artist's oeuvre, their work in relation to other artists and images, the reception their work received from audiences and institutions. Then there is the painting's debt to literature and ideas; are there texts by philosophers or poets or other writers or in other art forms that shaped this work or to which it refers? Thompson does not try to tell us everything that can be known about these works. We should bring our own texts to bear. The book offers a resource for developing our understandings, not conclusions.

Jon Thompson is an artist. He is also a curator of exhibitions, a critic and has been one of the most influential teachers of artists of his generation. What he offers us is a selection of modern paintings that he finds compelling. In telling us about them he tells us something of how he finds these paintings compelling. Ideally, his words will be joining a discussion we have with ourselves and with others. Jon Thompson is a good companion.

Andrew Brighton

Andrew Brighton was formerly
Senior Curator Public Programmes
at Tate Modern.

Gustave Courbet

the father of French Realism, was born in the provincial town of Ornans in 1819. Unimpressed by the traditional academic teaching at the École des Beaux-Arts in Paris, he attended private academies and studied on his own by copying the Old Masters in the Louvre. In doing so, he developed a particular passion for the work of Caravaggio and Velázquez. Courbet exhibited at the Salon for the first time in 1844. A political radical, he refused the Légion d'Honneur when it was offered to him by Napoleon III. He supported the Commune, and in 1871 he was imprisoned for complicity in the destruction of the Vendôme Column. Courbet was ordered to pay for its reconstruction and fled to Switzerland in 1873, where he lived until his death in 1877.

The Artist's Studio

1855
Oil on canvas,
361 x 598 cm
Musée d'Orsay, Paris

Courbet's studio painting is rightly said to stand at the threshold of modern art. Even though it takes the form of a classical tableau, it speaks of wholly contemporary issues: the changing relationship between town and country; the need for a new contract between the artist and the workaday world of ordinary men and women; the place of art within the broad field of political, social and cultural ideas current at the time; the effects of the new, post-revolutionary order on the stability of daily life. But it was also a deeply personal work. Courbet described the painting as 'a real allegory summing up seven years of my artistic and moral life'. The picture is forcefully presentational, intended to be read.

The Artist's Studio, 1855 (details)

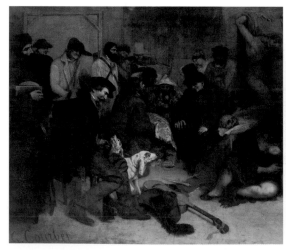

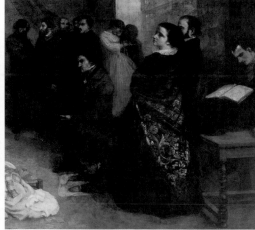

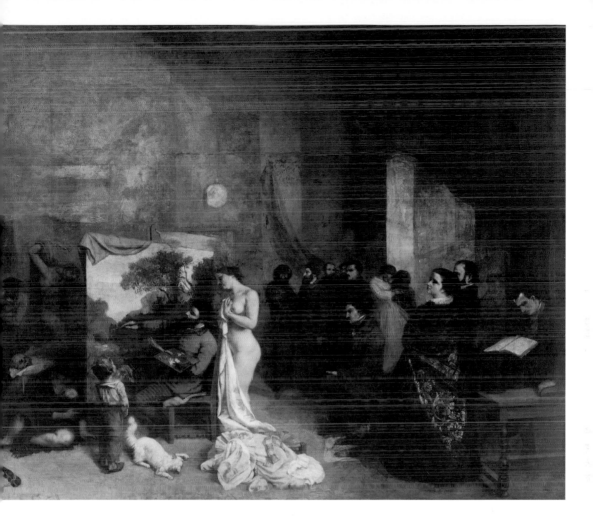

The painter, seated at his easel at work on a landscape watched by his naked model
and a child, occupies the central position in the tableau. Beyond the canvas to the left
is a group of ordinary people: a Jew, a priest, a republican veteran of 1793, a game-
keeper, a textile pedlar, an undertaker, a woman suckling a child, and so on. To the
right, in semi-darkness, behind the artist, are a number of Courbet's friends, some
of whom were important influences on his thought and work. The poet and art critic
Charles Baudelaire is perched on a table, front right; the 'Realist' novelist Jules
Champfleury is seated immediately behind Courbet; and the radical political
philosopher Pierre-Joseph Proudhon—forerunner of Karl Marx—is standing in the
background. Perhaps the most remarkable feature of *The Artist's Studio* is the way in
which Courbet has dissolved the back wall of the studio so as to merge the landscape
beyond with the interior space. As he later said, he wanted to convey the idea of the
whole world presenting itself to him to be painted.

Realism The term 'Realism' was first coined by Courbet and his circle at one of their
regular meetings at the Brasserie Andler near the artist's studio about 1846. It should
be seen in contradistinction to the term 'Naturalism'. While 'Naturalism' refers to a
way of treating the visible world, 'Realism' refers to subject-matter: the depiction of
contemporary life as it really is, no matter how brutish or disturbing that might be.

Théodore Rousseau

Théodore Rousseau was born in Paris in 1812. His early work was influenced by Dutch landscape painting. After travelling and working widely within his own country, he eventually settled in Barbizon on the edge of the Forest of Fontainebleau where he remained for the rest of his working life. With Millet, Corot, Daubigny and Diaz he became a founding member of the Barbizon school of landscape painting. Although Rousseau submitted his paintings regularly to the Paris Salon, they were mostly rejected because they departed from established academic conventions. He died in Barbizon in 1867.

The Gorges d'Apremont at Midday

1857
Oil on canvas,
64.5 x 100.5 cm
Middlebury College
Museum of Art

The celebrated writer Théophile Gautier described Rousseau as 'the Delacroix of landscape painting'. He was referring to the vibrancy of the painter's colours and the vigour of his painting method, and it is certainly true that Rousseau introduced a new range of colour harmonies and looser brushwork into French landscape painting, similar in some respects to the English landscapes of the same period, the late large-scale oil 'sketches' of John Constable in particular. But Rousseau was innovative in other respects, too. He developed a radically different approach to landscape composition that was to have an enormous influence on the Impressionists. *The Gorges d'Apremont at Midday* is a prime example of this. Here there are neither framing devices nor a central point of focus for the eye to settle on. Instead, the emphatic horizontality of the canvas—a typical Rousseauesque device—coupled with the broad, half-and-half division between earth and sky and the introduction of a secondary, false horizon between flat and rocky terrain, generates a strong feeling of a world that is endlessly scanned rather than simply looked at. This feeling is further reinforced by a parade of small pictorial incidents, moving left to right and right to left across the middle ground of the picture, where most of the sunlight is falling.

John Constable, **Old Sarum**, 1829
Oil on thin card, 14.3 x 21 cm
The Art Institute of Chicago

Narcisse Diaz de la Peña
The Hills of Jean de Paris, Forest of Fontainebleau, 1867
Oil on canvas, 84 x 106 cm
Musée d'Orsay, Paris

A Painter of Place

Like John Constable—whom the French painter is known to have admired—Rousseau saw himself very much as a local artist and his work as a product of his own locale, 'my beloved forest' as he called it. Unlike the Impressionist painters who followed only a few years later and who celebrated the idea of working outdoors directly from the motif, Rousseau worked in his studio from drawings and colour notes collected during long walks in the countryside. Contrary to appearances, then, his paintings are constructed images more than they are impressions or snippets of pictorial reportage. And like all constructed images, Théodore Rousseau's paintings are as much about memory as they are about observation. It is for this reason, too, that they have a timeless quality about them. They represent a place, a time of day, and a certain kind of weather but they are bereft of any sense of immediacy.

les-François Daubigny
set over the Oise, 1865
n canvas, 39 x 67 cm
ée d'Orsay, Paris

11

Frederic Edwin Church

studied painting with the English-born, self-taught landscape painter Thomas Cole (1801–48). Cole had single-handedly 'sublimed' the American landscape, imbuing it with an almost Ruskinian, distinctively Christian, allegorical force. Church, who inherited Cole's mantle as America's leading artist, was a flamboyant self-publicist who managed the public side of his career with considerable skill—putting on grand showings of individual works in New York and touring them to important cultural centres in Europe. Philosophically, he was a devotee of the great German naturalist Alexander von Humboldt, author of *Cosmos: Sketch of a Physical Description of the Universe*, and he shared Humboldt's passion for the Central and South Americas.

Cotopaxi

1862
Oil on canvas, 121.9 x 215.9 cm
The Detroit Institute of the Arts

Church made two journeys to South America. During the first of these (1853) he set out to test Humboldt's approach to nature. Crossing the Andes from Columbia into Equador and intent upon demonstrating Humboldt's notion of a God-given universal harmony, he logged the journey in a series of pencil-and-watercolour drawings of everything he came across, from the smallest plant to the largest mountain. This was when he first set eyes on Mount Cotopaxi, but the raw material for the painting itself was collected during Church's next journey, in 1857, when he witnessed the volcano in eruption. It was a major work in a set spanning the period of the American Civil War. In *Twilight in the Wilderness*, painted in 1860, when war was already threatening (as art historian and critic Robert Hughes has pointed out), an angry sunset seems to turn the lake into blood. *Cotopaxi*, Church's most apocalyptic vision of nature, came a year after the war began. And the airily luminous *Rainy Season in the Tropics* was completed a year after the war ended.

The allegorical power of *Cotopaxi* resembles that achieved by the English painter John Martin in works like *The Fallen Angels Entering Pandemonium* (1841), but it is doubtful whether Church had ever seen Martin's work. Both painted images of the natural order *in extremis* as a way of pointing to a world on the verge of moral collapse. In Church's painting the angry Earth is belching burning gas and ashes into the sky and threatening to blank out the sun. The sun, in its turn, seems to be turning the whole Earth into a sulphurous hell-fire in which everything is about to be consumed. It is a *tour de force* of pictorial organization. As well as confronting the powerful forces at work in nature, Humboldt taught his readers the importance of detailed observation, and in works like *Cotopaxi*, Church shows a fine balance between the grand event and the rendering of small pictorial incidents.

Alexander von Humboldt's View of Nature

Humboldt, a devout Christian as well as a scientist, saw nature in terms of unity in diversity, a unifying interior energy, manifesting itself in a multitude of different forms – the whole, animated by the breath of life.

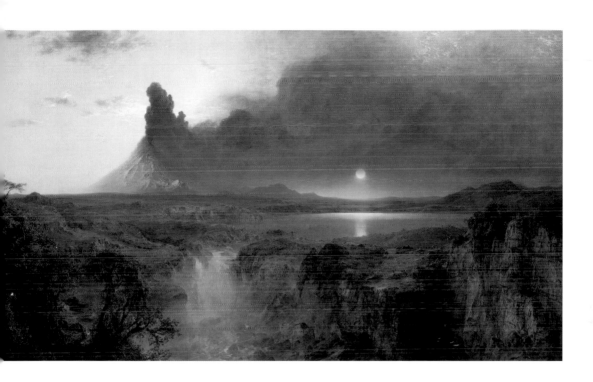

Twilight in the Wilderness, 1860
Oil on canvas, 101.5 x 162.5 cm
The Cleveland Museum of Art

John Martin, **The Fallen Angels Entering Pandemonium,**
from 'Paradise Lost', Book 1, 1841
Oil on canvas, 62 x 76.5 cm, Tate Collection, London

Edgar Degas

was born in Paris in 1834. His family supported his ambition to become a painter. He entered the studio of Louis Lamothe, a student of the great classical master Jean Auguste Dominique Ingres. He attended the École des Beaux-Arts in 1855 and 1856. Degas spent three years working in Naples, Rome and Florence. He died in 1917.

Young Spartans Exercising

c. 1860–62
Oil on canvas, 109.5 x 155 cm
The National Gallery, London

The scene is set on the high plain of Sparta. The action moves from left to right. A group of girls confronts a group of naked, posturing youths. They seem to be taunting them, perhaps about their manliness. A group of adults watches from a distance. The landscape is imaginary. Degas never visited the Greek peninsula, although he had read about the history of ancient Sparta. Placed behind the girls, in this gentle narrative of sexual confrontation, we see Degas's version of Mount Taygetos—where legend has it that male Spartan infants were exposed to the elements, even to the point of death. Despite its youthful imperfections, *Young Spartans Exercising* possesses a remarkable, highly evocative, atmospheric unity. The whole scene, from the spare, sunburned, athletic bodies in the foreground to the city of Sparta tumbling over distant foothills, is bathed in a honeyed light and the brooding heat of a summer evening.

Young Spartans Exercising was painted shortly after Degas returned from his studies in Italy: a difficult transitional moment for the young painter. He wanted to be 'modern', but he also wanted to carry forward some of the lessons of the past. This painting shows a distinctly classical approach to picture-making. At the Academy, Degas had been schooled in history painting in the manner of Jacques-Louis David. In Italy he had copied paintings by Mantegna, Botticelli and Raphael. Presented as a friezelike, neoclassical tableau, *Young Spartans Exercising* is marked by both experiences. In the event, the composition was hard-won. There are several versions, which, taken together, show Degas struggling to balance the two main groups and to situate them comfortably within the landscape.

His classical training dictated that, in order to ensure proper articulation, figures should be drawn naked before being clothed, and studied individually before being brought together in groups. Both procedures caused Degas some difficulty and signs of this are clearly evident in the finished work. The drapes that cover the young women look like an afterthought, and despite Degas's best efforts, the five youths fail to cohere as a convincing group.

While in Rome, Degas developed a particular fascination with the adolescent body. He stopped working from the heavily muscled, heroic male and fulsome female models favoured by the French academies and instead employed young people suited to his chosen themes. He undertook major pictorial projects with youthful subjects, such as *St John the Baptist and the Angel*, *The Daughter of Jephtha* and *David and Goliath*.

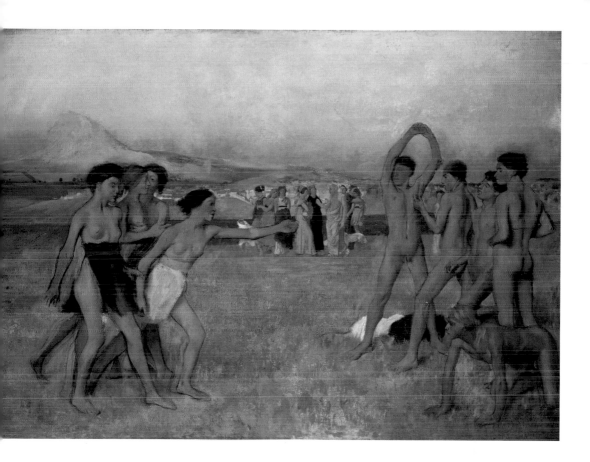

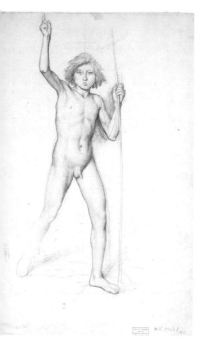

**Study for St John the Baptist
and the Angel**, *c.* 1856–58
Pencil on paper, 44.5 x 29 cm
Von der Heydt-Museum, Wuppertal

Édouard Manet

was born in 1832 into a well-to-do Parisian family.
He studied painting in the studio of the Salon painter Thomas Couture and
early on in his career was influenced by the Spanish masters Velázquez
and Ribera. During the second half of the 1860s, Manet became the leader
of the Batignolles group of painters that included Degas, Monet, Sisley
and Pissarro. He caused a sensation at the Salon des Refusés of 1863
when he exhibited *Le Déjeuner sur l'herbe*, and again, two years later,
when *Olympia* was accepted by the official Salon.

Olympia

1863
Oil on canvas, 130 x 190 cm
Musée d'Orsay, Paris

Manet is sometimes described as the first modern painter. Certainly he
provides the bridge, or conceptual link, between Realism and Impressionism:
between the studio-based painting of Jean-Baptiste Greuze and Gustave Courbet
and the *plein-air* painting of Alfred Sisley and Claude Monet. As a highly skilled
Salon painter, Manet was able to produce the schooled and elegant type of
composition beloved of the Academy while treating a thoroughly contemporary
subject. At the same time, he was also able to execute paintings in the more
relaxed manner popular with the new generation of painters. *Olympia* is a very
accomplished and technically consistent composition with none of the spatial
awkwardness of *Le Déjeuner sur l'herbe*, which was started a year earlier
and completed in the same year.

The model for *Olympia*, as in *Le Déjeuner sur l'herbe*, was the red-head
Victorine Meurent, one of the artist's favourites. She is posed very deliberately
as a courtesan. The title of the painting clearly hints at her role, since many of
the courtesans of the day worked under assumed names intended to make them
seem more exotic to prospective clients. 'Olympia', propped up on her cushions,
her legs stretched out on an expensive silk shawl, is waited on by a black serving-
woman who is presenting her with flowers — a gift, no doubt, from a grateful
gentleman. Yet while she seems to be blatantly displaying herself — making it
abundantly clear that she is available — she is also delivering a moral provocation
to the viewer with her gaze.

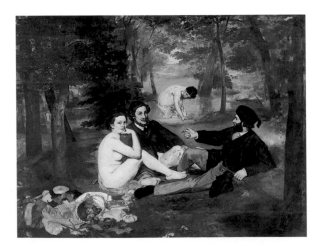

Le Déjeuner sur l'herbe
1863. Oil on canvas, 208 x 264 cm
Musée d'Orsay, Paris

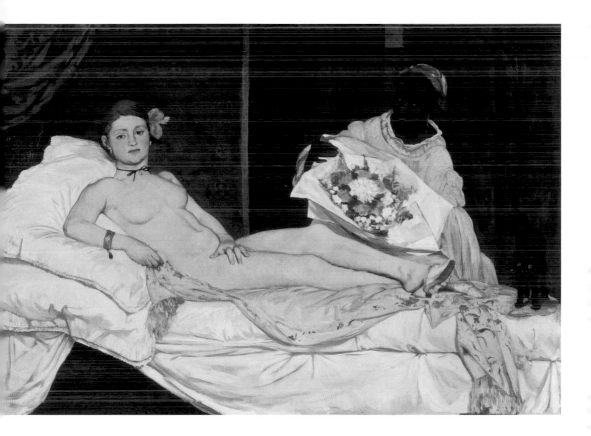

Realism and Theatricality

While Courbet's use of tableau in paintings like *The Artist's Studio* and *The Burial at Ornans* invokes a strong sense of the viewer as part of a collective — an audience, in other words — Manet's *Olympia* addresses each of us individually. Courbet's theatricality is framed and contained as if behind a proscenium arch. Manet breaches this convention and destroys the theatrical illusion in order to address us directly, in the manner of a highly personalized soliloquy.

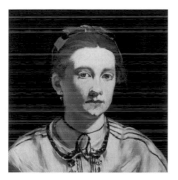

Portrait of Victorine Meurent
1862. Oil on canvas, 43 x 43 cm
Museum of Fine Arts, Boston

Gustave Moreau

was born in Paris in 1826. He studied painting at the École des Beaux-Arts. In his sixties he became a key figure in the reaction against Impressionism and the evolution of French Symbolism. He numbered amongst his admirers the writers Joris-Karl Huysmans and Marcel Proust. In 1892 he was appointed Professor at the École des Beaux-Arts, where his students included Georges Rouault and Henri Matisse. He died in Paris in 1898.

Young Girl Carrying the Head of Orpheus

1865
Oil on canvas,
154 x 99.5 cm
Musée d'Orsay, Paris

Diomedes Devoured by his Horses
1865. Oil on canvas, 138.5 x 84.5 cm
Musée des Beaux-Arts, Rouen

Moreau was in his late thirties and at the height of his powers when he painted *Young Girl Carrying the Head of Orpheus*. At the time, the painting—like its maker—was regarded as somewhat eccentric, and it was almost twenty years before cultural taste was to catch up in the guise of a new group of young Symbolist painters that included Émile Bernard, Odilon Redon and Ker-Xavier Roussel.

This painting is typical of Moreau's middle period: a luxuriously detailed, exotic mirage of a picture that hints at mysterious pagan practices and ritualized eroticism. The story of Orpheus is a familiar one. The nymph Eurydice, wife of Orpheus (a poet and musician of Thrace and son of Apollo), is bitten by a poisonous snake and dies. Orpheus is heartbroken and sets out to retrieve her from the underworld. He charms Persephone with his music and she agrees to release Eurydice as long as Orpheus resists the temptation to look at her until she is back on Earth, a condition that Orpheus fails to keep, with disastrous results. Eurydice is returned to the underworld. Enraged by his singleminded love of Eurydice, Orpheus is torn to pieces by a group of Maenads. They throw his head and lyre into the River Hebrus. All this has already taken place before the disputed episode depicted by Moreau. According to this version, Orpheus' head and lyre were carried to the island of Lesbos. The painting shows a young girl reverently recovering Orpheus' severed head and lyre.

Moreau against Impressionism

More than anything else, Moreau argued for a return to the mystical in painting. He once famously remarked, 'I believe only in what I do not see and solely in what I feel.' To make such a statement at a time when Impressionism was just gathering momentum suggests a radically different view, not just of the nature of art but of its cultural purpose too. The new Symbolist work of art was to function first and foremost as a cultural enrichment. Alongside his interest in the painters of the high Renaissance— Leonardo da Vinci in particular—Moreau was fascinated by Indian and Chinese art. Instead of the dissolution of decorative detail, so much a part of the reductive language of Impressionism, Moreau wanted to return to a type of painting that 'evoked thought through line, arabesque, and all the ornate devices available to the plastic arts'.

...metheus, 1868

...n canvas, 205 x 122 cm

...ée Gustave Moreau, Paris

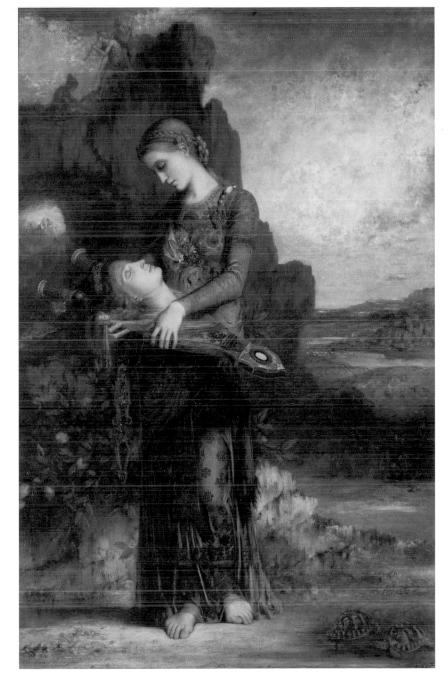

Alfred Sisley

was born in Paris in 1839 to English parents. He studied painting alongside Claude Monet, Auguste Renoir and Frédéric Bazille in the studio of the Swiss painter Charles Gleyre. He exhibited at the Salon des Refusés and was included in the first Impressionist Exhibition in 1874. He received scant recognition during his lifetime, but an exhibition of his work arranged by Monet after his death was hugely successful and established him as an important figure in Impressionism.

Avenue of Chestnut Trees at La Celle-Saint-Cloud

1865. Oil on canvas, 129.5 x 208 cm
Musée du Petit Palais, Paris

Painted when Sisley was in his mid-twenties, his *Avenue of Chestnut Trees at La Celle-Saint-Cloud* is by no means typical of his work. However, it is one of the grandest studio-painted landscapes of the period. Although he had already aligned himself with the new painting, it is not, in any obvious sense, an 'impressionistic' work and it has been suggested that it was intended as a submission to the official Salon, but was rejected in the summer of 1867. In terms of painterly language, it owes more to the Realist landscapes of Gustave Courbet and the work of the Barbizon painters than to that of his fellow Impressionists. Camille Corot and Narcisse Diaz had painted in the same area, even the same trees, in the 1830s and the layered, formalized foliage and slight exaggeration of the contrast between light and dark where sunlight falls upon rocks and trees is reminiscent of the young Corot in a work such as *The Chestnut Grove* of the early 1830s. As in Théodore Rousseau's painting of *The Gorges d'Apremont at Midday*, Sisley emphasizes the flat lie of the land by using a false horizon to divide the picture almost exactly in half, while at the same time peppering the foreground with small visual incidents that diminish as the ground recedes.

In preparation for what was clearly intended as a major work, Sisley made a number of on-the-spot oil studies of the chestnut trees at La Celle-Saint-Cloud and he returned there again in 1867 when he painted another, much more brooding, Corot-like work that bears the same title and is now in the collection of the Southampton City Art Gallery in England.

Avenue of Chestnut Trees at La Celle-Saint-Cloud, 1867
Oil on canvas, 95.5 x 122 cm. Southampton City Art Gallery

Jean-Baptiste Camille Corot, **The Chestnut Grove**, early 1830s
Oil on canvas, 34 x 49 cm
The Fitzwilliam Museum, Cambridge

Sisley and Monet
Sisley's painting style changed after the first Impressionist Exhibition in 1874. He had always been close to Monet and now, under his influence, he began to intensify his colour and extend the range of his brushwork. It was Monet's daringly vivid, almost expressionistic view of the harbour at Le Havre that he provocatively entitled *Impression, Sunrise* that had given rise to the label 'Impressionism'.

Gustave Courbet

The Origin of the World

1866
Oil on canvas, 46 x 55 cm
Musée d'Orsay, Paris

The history of Courbet's 'scandalous' painting *The Origin of the World* is one of obfuscation and concealment. Originally commissioned by Khalil Bey, a Turkish diplomat working in Paris, it was kept hidden behind a green silk veil. It then disappeared for a time before re-emerging in the Szépművészeti Múzeum in Budapest, where it was kept out of sight behind another Courbet painting, *Le Château de Blonay* (1877). In 1955 it passed into the hands of the French psychoanalytical theorist Jacques Lacan, who had it hung in his office, concealed behind a specially commissioned painting by André Masson.

Seen alongside Courbet's other major Realist works, *The Origin of the World* is an unusually small painting. The image, which shows the reclining torso of a naked woman, legs spread wide so that her genitalia are exposed and seen in close-up, is less than life size. As such, it lacks any real feeling of intimacy and bears the true stamp of Realist thinking: the idea that whatever the subject, it should be depicted directly and faithfully — dispassionately even. The exposed flesh has a rawness about it that is slightly disconcerting. The labial divide is coarsely stated and lacks sensuality or mystery, even where it loses itself in the bush of dark pubic hair. It is hard to escape the feeling that Courbet is treating the body as landscape. Not in the highly metaphorical manner of a Romantic painter, more as an objective topographical exercise. Even so, there is a feeling of the staged 'reveal' in Courbet's painting. Confronted with something that is usually kept hidden, we are being encouraged to see it as it really is. However, we are left wondering about the purpose of this act of public exposure, which in turn brings us full circle to consider the meaning of the painting's title. *The Origin of the World* does not suggest an erotic image, but a quasi-mystical one. Through the removal of the last layer of clothing, the remnants of which are still visible, framing the top edge of the painting, we are brought face-to-face with the ultimate bodily mystery, that which obtains between outside and inside: the invisible, interior space of the body, seen as the source of new life, as opposed to its exterior as the subject of the masculine gaze and object of male desire.

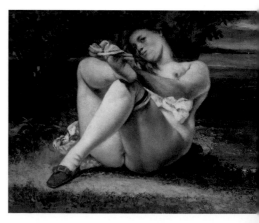

Woman with White Stockings, 1861
Oil on canvas, 65 x 81 cm. The Barnes Foundation, Merion

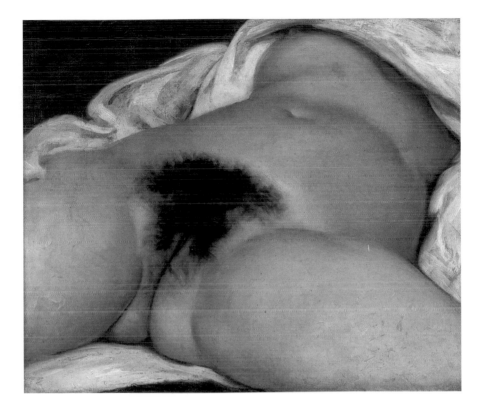

Courbet as a Forerunner of Marcel Duchamp

It has sometimes been suggested that *The Origin of the World* influenced Duchamp's thinking in *The Large Glass* (1915–23) and a number of works that followed including *Given: 1. The Waterfall, 2. The Illuminating Gas* (1946–66), and the photographic version of *Female Fig Leaf* (1966). However, evidence of a direct connection is in short supply. Courbet's painting was not on public view for most of Duchamp's working life. However, his lifelong fascination with the Realist master is beyond dispute, as the late engraving *Pastiche: Selected Details after Courbet* (1968) clearly shows. This work was based on Courbet's *Woman with White Stockings* painted in 1861. The presence of the bird in the engraving — whether it is a falcon or a parrot is a matter of some dispute — also suggests a relationship with Courbet's highly erotic *Woman with a Parrot*, which was painted in the same year as *The Origin of the World*.

Marcel Duchamp, **Pastiche: Selected Details after Courbet**, 1968
Etching from copper plate, 35 x 23.5 cm. National Gallery of Canada, Ottawa

Jean-Baptiste Camille Corot was born in Paris in 1796.

His first studio was in his father's house at Ville-d'Avray near Versailles, and he returned there to work throughout his life. He studied painting in the studio of Jean-Victor Bertin. Between 1825 and 1828 he spent much of his time travelling and working in Italy; this gave his early landscapes a distinctly Italianate, Poussinesque feel. He was awarded the 'Croix' of the Légion d'Honneur in 1846 and made an 'Officier' of the order in 1867. He died in Paris in 1875.

The Ponds at Ville-d'Avray

1868. Oil on canvas, 102 x 154.5 cm
Musée des Beaux-Arts, Rouen

In his later work, Corot began to view the region of Ville-d'Avray as Arcadia, an idealized world in which nature, man and the gods exist together in perfect harmony. This particular version of the water meadows in early morning is a fine example of landscape treated as a classical 'pastoral' and is one of two pictures that Corot showed at the 1868 Salon, the other being *Passing the Ford, Evening*. As the titles suggest, both pictures are about the time of day — Corot referred to it as the *enveloppe* — characterized by a particular light, atmosphere and mood that was all-pervasive and seemed to contain all of the natural world. *The Ponds at Ville-d'Avray* captures the dawn's blush and the pale luminosity that occurs in lowland landscapes immediately after sunrise. Everything is tinged with green-grey and ashen-violet, slightly ghosted and floating. Trees show as coral-like silhouettes or climb skywards like columns of smoke. By contrast, *Passing the Ford, Evening* is softly golden. The atmosphere is not hot but comfortably warm in a very northern European way. The ground and shrubbery are all vegetal browns and greens shaded over with aurelian yellow. Shadows solidify into darkness. Trees feather outwards, dissolved by the evening light. And always underlying Corot's vision is a picture of social life which, typically, is depicted as that of the peasant farmer: deeply rural, agrarian.

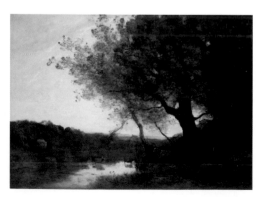

Passing the Ford, Evening, 1868
Oil on canvas, 99 x 135 cm
Musée des Beaux-Arts, Rennes

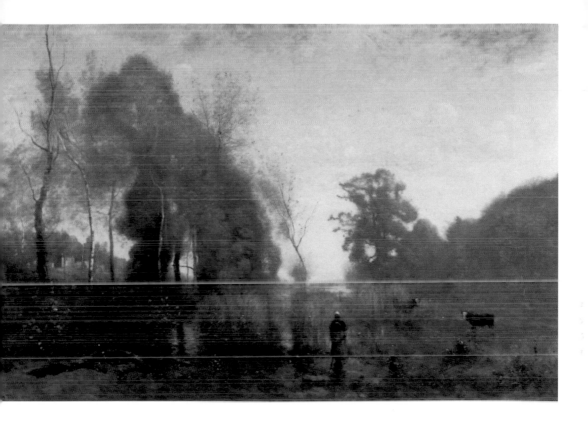

Corot's Influence and Legacy It is impossible to overstate the importance

of Corot to the evolution of modern painting in nineteenth-century France.
Picking up where the classical landscapes — the carefully manicured,
studio-crafted 'groves' — painted by Poussin and his followers left off, Corot
took landscape painting back to nature but without jettisoning its narrative
potential or its poetry. The Symbolist artist Odilon Redon described Corot
as the complete painter standing before nature as 'a poet and a thinker'
in contrast to Courbet and Manet who remained enslaved by 'observed
reality'. But it is Corot's contribution to the evolution of Impressionism, Post-
Impressionism and Cubism upon which his real importance rests. Claude Monet
painted his homage to Corot in 1897 with his celebrated series of paintings
Arm of the Seine, near Giverny; later, seeing his work hanging next to Corot's,
he famously remarked: 'There is only one person here ... we are nothing,
absolutely nothing. This is the saddest day of my life.'
And Monet was not alone in expressing his admiration.
Paul Gauguin memorably wrote that 'Corot loved to dream
and in front of his paintings I dream as well'. Renoir,
Pissarro, Picasso, Braque and Juan Gris all expressed their
indebtedness to the painter they called the 'Master of
the Ville d'Avray'.

Claude Monet, **Arm of the Seine at Giverny, Morning Mists**, 1897
Oil on canvas, 89 x 92 cm. North Carolina Museum of Art, Raleigh

James Abbott McNeill Whistler

was born in Lowell, Massachusetts, in 1834. He spent part of his childhood in Russia where his father was a railway engineer working on the St Petersburg-to-Moscow railway. He decided to become a painter during a visit to Europe in his late teens. However, his plan was thwarted by the death of his father and he was forced to return to America. In 1851 he enrolled at the West Point Military Academy only to be discharged three years later. He travelled to Paris in 1855 and joined the studio of the academic painter Charles Gleyre.

Nocturne: Blue and Silver — Chelsea

1871. Oil on panel, 50 x 61 cm Tate Collection, Lon[...]

This is the earliest of the London *Nocturnes*, and followed hard on the heels of the transitional figure composition *Variations in Flesh Colour and Green: The Balcony* (1864–70). Both works show the artist's fascination with Oriental art, particularly Japanese prints and Chinese painting. In the earlier work these influences had still not fully resolved themselves into a painting style. The composition closely resembles a wood-block print, and there is a curious stylistic divide between the flattened, printlike, highly coloured foreground and the impressionistic, almost monochromatic background. By contrast, the Orientalism of *Nocturne: Blue and Silver — Chelsea* is, stylistically speaking, integral to the image and seems to have been achieved with consummate ease. Painted on a thin hardwood panel using a medium with a good deal of oil in it, the long sweeping brushstrokes move horizontally across the surface of the painting to create an aqueous, floating world in which substance and atmosphere seem almost interchangeable. Distant lights flicker, sending sharply yellow reflections downwards into the moving water. A slightly opaque, green-blue mist ghosts everything, including the standing figure in the foreground. The connection to Japanese and Chinese painting is underscored by Whistler's use of the 'butterfly' signature in the centre of the bottom edge of the painting.

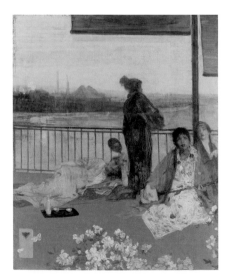

Variations in Flesh Colour and Green: The Balcony 1864–70 Oil on canvas 61.5 x 49 cm, Freer Gallery of Art, Washington

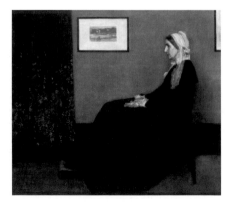

Arrangement in Grey and Black: Portrait of the Painter's Mother, 1871 Oil on canvas, 144.5 x 162.5 cm. Musée d'Orsay, Paris

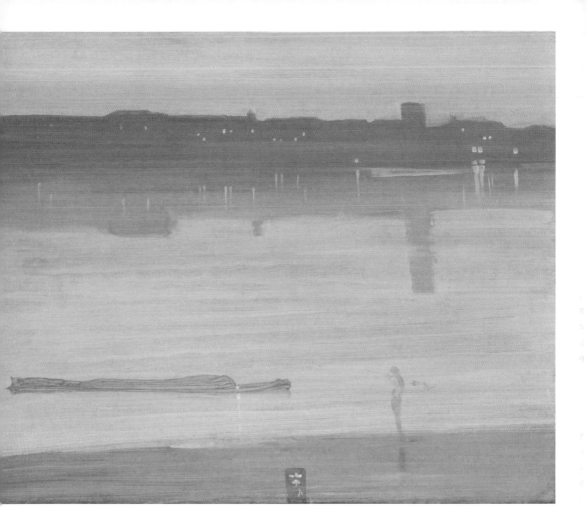

Colour-Forms and Music

Whistler's wish to separate his painterly concerns from any personal involvement with the subject first showed itself when he entitled the portrait of his mistress, Joanna Hiffernan, *Symphony in White, No. 1: The White Girl* (1862), and some nine years later when he called the famous painting of his mother *Arrangement in Grey and Black*. These were neither insensitive nor capricious acts, but were intended to make a serious point about the nature of his engagement with painting and about painting in general. Whistler was against the Victorian penchant for pictorial sermonizing and sentimental narrative. He wanted to make paintings that were 'modern', formally rigorous and 'abstract' in the manner of music. The suggestion to call the London paintings *Nocturnes* came from his friend, the composer and musicologist Francis Seymour Haden.

Jean-François Millet

was born in the village of Gruchy near La Hague, Normandy, in 1814. He received an academic training as a painter from Paul Dumouchel and Jérôme Langlois in Cherbourg. In 1838 he left for Paris to complete his training under Paul Delaroche. Under the influence of Honoré Daumier, from 1840 on he increasingly distanced himself from academic painting. In 1849 he settled in the countryside in the village of Barbizon near Fontainebleau, where he worked for the rest of his life. He died in 1875.

The Gust of Wind

1871–73. Oil on canvas, 90.5 x 117.5
National Museum of Wales, Cardiff

Although associated with the Barbizon school (the French movement towards realism in art in reaction to the more formalized romantic movement of the time), Millet is best known for his paintings of peasant life, some of which, like *The Angelus* (1857–59), were made popular through reproductions, not just as photogravure or engraved prints but also as transfer-motifs on every kind of industrially produced domestic artefact. *The Gust of Wind*, then, is not typical of Millet's output, but it was greatly admired, especially by fellow artists. It was bought by the great engineer, industrialist, collector, and friend of Degas Henri Rouart, in whose house it was seen by the English painter Walter Richard Sickert, who was profoundly moved by it: 'I doubt if any modern but Millet would ever have thought of selecting the moment when a tree has been torn out by the roots and is in the act of falling ... [a] terrifying object ... painted at the brief moment when it is silhouetted, free against the sky ... an astonishing artifice of mystery and terror.'

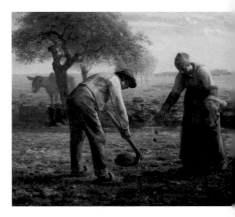

Millet was entirely familiar with the windswept landscape of the Cotentin Peninsula in Brittany, where he was born. Reminiscent of Camille Corot's *Le Coup de Vent* painted in the 1860s, there is nothing in the picture that does not play its part in the visualization of the drama. Everything is in motion from left to right. A wild, darkening sky of whipped clouds bleeds orange and red at the horizon. Scraps of foliage and broken branches scurry across the middle ground. In the extreme foreground, the edge of the water is scooped up and dashed against the land by the ferocity of the wind. The uprooted tree is being dragged inexorably across the middle of the picture, threatening the shepherd who is fighting manfully against the elements in a desperate attempt to save his flock of sheep.

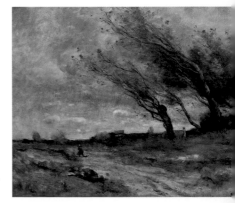

Planters
52
canvas,
110 cm
m of Fine
oston

Baptiste
e Corot
ust of Wind
5–70
canvas,
59 cm
des
-Arts, Reims

Peasant Life and Nature

The influence of Millet on Vincent van Gogh is well documented.
The Dutchman admired the artist for his faithful recording of peasant life
and representation of the ideal coexistence of man and woman joined in
marriage and through common labour. But there is another Millet present
in *The Gust of Wind*: Millet the phenomenological observer. One of the
most telling examples of this is his *Potato Planters* (1862), in which a
peasant couple are working together on the land. The man strikes at
the ground with a mattock. The woman drops the potatoes — here
arrested in mid-air — into the holes as he makes them.

Claude Monet

was born in Paris in 1840 but brought up in the Channel port of Le Havre. When he was still in his teens he met the painter Eugène Boudin, who persuaded the young Monet to work directly from the motif. After military service in Algeria, which was brought to an abrupt end when he contracted typhoid, Monet returned to Le Havre, where he renewed his friendship with Boudin. He also met the Dutch landscape painter Johan Barthold Jongkind, whom Monet later described as his 'true master' who had seen to 'the real education' of his artistic eye. He returned to Paris in 1862 to study in the studio of the academician Charles Gleyre, where he met Frédéric Bazille, Auguste Renoir and Alfred Sisley. In 1883 Monet moved to Giverny in Normandy, where he died in 1926.

Impression, Sunrise

1872–73. Oil on canvas, 46 x 63 cm. Musée Marmottan, Pari

Monet exhibited *Impression, Sunrise* at the first exhibition of the 'Société anonyme coopérative d'artistes' held in the studio of the photographer Félix Nadar in April 1874. It was following this exhibition that the terms 'Impressionism' and 'Impressionists' became common currency. The term 'Impression' was not new as

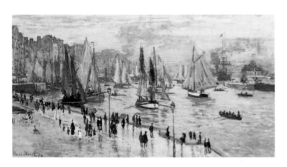

Fishing Boats
Leaving the Harbour,
Le Havre, 1874
Oil on canvas,
60 x 101 cm
Private collection

such; it was already in use to denote a sketchy, on-the-spot landscape study, normally used as an aid to the completion of a studio painting. It seems that Monet also intended to convey something of this meaning by his choice of title. *Impression, Sunrise* was exhibited alongside a larger, more topographically descriptive painting of the harbour at Le Havre, entitled *Fishing Boats Leaving the Harbour, Le Havre*, painted a year later in 1874. To judge by a letter from Monet to the critic Maurice Guillemot, it seems that he himself regarded *Impression, Sunrise* as a sketch: 'it could not pass as a view of Le Havre'. What is striking and perhaps indicative of an entirely new way of thinking about painting, is the fact that despite its brevity — it was executed in one sitting — and its unrevised directness, Monet felt able to exhibit it as a work in its own right. The painter's comment to Guillemot is significant in another way, too, in that it suggests that the painting's subject was not topographical, concerned not with the location as such but with the time of day. Monet was chasing a particular atmosphere and the attendant effects of light and their realization as an orderly array of coloured marks; in effect he was striving for a new quality of painterly abstraction. While he was in London, Monet may have seen the earliest of James Abbot McNeill Whistler's *Nocturnes*, and although he was not yet ready to embrace such a radical simplification of the image, he had understood their importance in terms of painting's evolution as an autonomous visual language in the face of the continuing advance of photography.

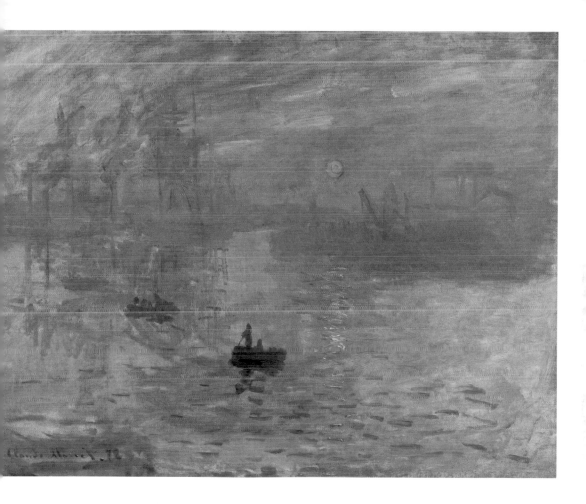

Impressionism. The term was first used by the critic Louis Leroy in a
derogatory sense. The suggestion was of something throw-away and trivial,
partial and unresolved: 'Impression ... wallpaper in its most embryonic form
is more finished.' The use of strong colour was also regarded by some as
problematic, as in an outburst by another contemporary critic, Albert Wolff,
who weighed in with, 'Trees are not violet ... the sky not the colour of fresh
butter ... and a woman's torso is not a mass of decomposing flesh with
those purplish-green stains.'

Berthe Morisot

was born in Bourges in 1841. She studied landscape painting with Camille Corot and in the studio of Achille-François Oudinot, a pupil and close friend of Corot. Later she took instruction in figure drawing and painting from Édouard Manet, who later became her brother-in-law. She showed nine paintings in the first Impressionist Exhibition in 1874 and remained a staunch member of the movement until her death in 1895.

View of Paris from the Trocadéro

c. 1871–73
Oil on canvas, 46 x 81.5 cm
Santa Barbara Museum of Art

was painted in Berthe Morisot's parental home in the rue Franklin. At the time, the house enjoyed a truly extraordinary, panoramic view, looking across the loop of the River Seine to the Champ de Mars site of the Paris International Exhibition of 1867. Although looser in its handling, this painting has much of Corot about it. The width of the picture is almost double its height, a proportion that Corot used frequently, especially when working from an elevated viewpoint. There is also something very reminiscent of Corot's work in the simplified mass of green in the foreground and the sweeping brushstrokes that Morisot uses to describe the lie of the land from the middle distance to the far horizon. Compositionally, Morisot's painting resembles Monet's *Hyde Park* (*c.* 1871), while Manet's influence is apparent in the freshness of the paint, especially in the deft, highly suggestive painting of the figures in the foreground.

Despite its verve, *View of Paris from the Trocadéro* is closely observed with the eye of a real city-dweller. Industrialization in the second half of the nineteenth century led to a rapid expansion of all the main northern European cities, including Paris, dramatically changing the way they looked. Air pollution was a major factor. It affected both visibility and air-coloration. This is very much a feature of Morisot's painting: the buildings in the distance disappear in the grey-purple haze of the smoke-laden atmosphere.

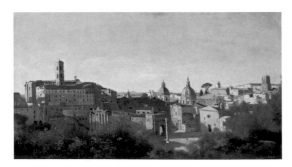

Jean-Baptiste Camille Corot
Rome, The Forum Seen from the Farnese Gardens, 1826. Oil on canvas, 28 x 50 cm
Musée du Louvre, Paris

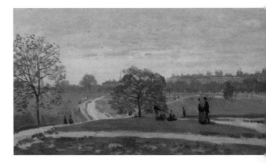

Claude Monet, **Hyde Park**, *c.* 1871
Oil on canvas, 40.5 x 74 cm
Rhode Island School of Design, Providence

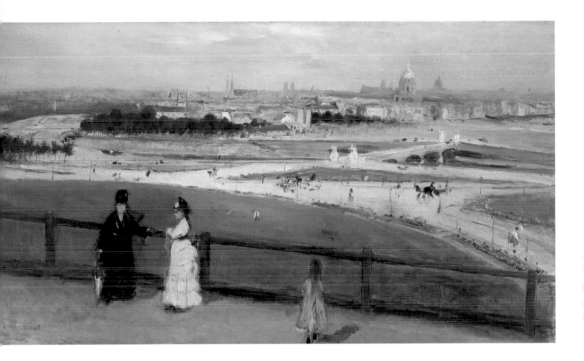

lution and Its Contribution to the New Painting

By the turn of the eighteenth century, most Parisians associated London with creeping, damp air and smoke-thickened fogs. It is not surprising, then, that pollution was first prized for its effects on light and form by J. M. W. Turner in paintings like *The Thames above Waterloo Bridge* (c. 1830–35), nor is it surprising that London should attract painters who were similarly fascinated by such effects. The most important of these included James Abbott McNeill Whistler and the Impressionists Claude Monet and Camille Pissarro. Monet made his first visit to London in the winter of 1870–71 when he painted a series of images of London parks and a number of hazy views of the Thames looking towards Westminster. And in later life he became a regular visitor for the express purpose of painting

the light effects caused by the London 'pea-soupers'. Ensconced in his room high up in the Savoy Hotel, waiting to start painting, he once wrote to his wife in Paris that when he got up he 'was terrified to see that there was no fog, not even the shadow of a fog. I was devastated and already imagined that all my canvases would be ruined. But little by little the fires were lit and the smoke and fog returned.'

Claude Monet, **Waterloo Bridge, Sun Effect with Smoke**, 1903. Oil on canvas, 65 x 100 cm
The Baltimore Museum of Art

Edgar Degas

Place de la Concorde

1875
Oil on canvas, 79 x 118 cm
State Hermitage Museum,
St Petersburg

Degas's interest in photography has been well documented. Even so, looking at his *Place de la Concorde* it is hard to believe that roll-film and the portable camera had not yet been invented and that shutter speeds were still painfully slow. In this respect, Degas's painting is entirely propositional. He has made a 'snapshot' image, long before he could possibly have seen one. Today we might call it a 'constructed' image: one that has been dreamt up, in every detail, in advance. The artist engaged the assistance of his friend Viscount Ludovic-Napoléon Lepic to pose with his two daughters and their old hunting hound. Degas positioned them and made several studies. As with all constructed images the painting raises questions about the artist's intentions. What exactly is he trying to convey and why this particular mode of address?

From the outset, the Impressionists, as a group, had concerned themselves with the representation of life in the city. One of their favourite subjects, for example, was the late afternoon 'promenade', crowded streets seen from above, as in Claude Monet's *Boulevard des Capucines* painted in 1873; another was people at leisure, enjoying public spaces, as in Édouard Manet's *Music in the Tuileries Gardens* of 1862. But *Place de la Concorde* is very different from these rather comfortable views of city life. There is a profound sense of unease in Degas's painting that arises out of the composition itself. It is a picture without frame or centre and it depicts individuals who are likewise robbed of a unifying point of view, or a common subject of address. If they are enjoying their experience of the city — and they seem more puzzled than enchanted by it — they are doing so independently of each other.

A New Way of Seeing

Degas's great invention here is the construction of a momentary glimpse — a fleeting image — as a new kind of painterly realization. In this respect, *Place de la Concorde* is as much about photography as it is about city life. Degas was demonstrating to his contemporaries in the late nineteenth century that photography had already changed the way they saw the world and that it would change it even more in the future. Degas was also convinced that painting, too, would have to change if it were to meet the challenge posed by photography.

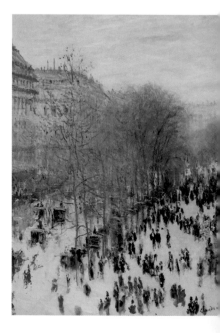

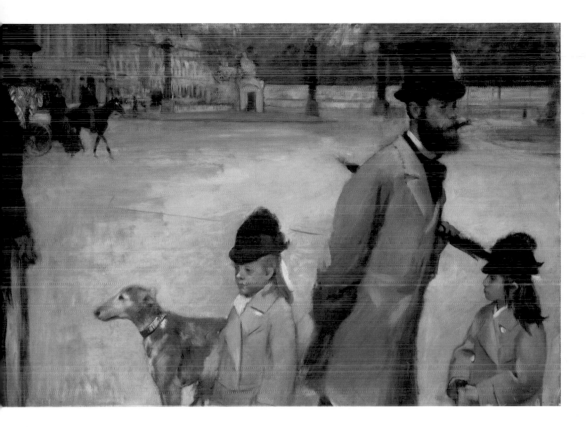

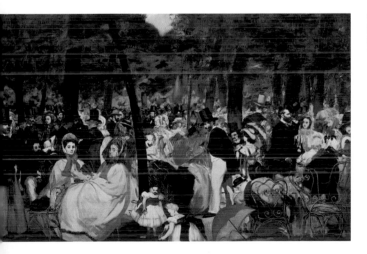

Édouard Manet
Music in the Tuileries Gardens, 1862
Oil on canvas, 76 x 118 cm
The National Gallery, London

Je Monet
Boulevard des Capucines
−74, Oil on canvas, 79.5 x 59 cm
Nelson-Atkins Museum of Art, Kansas City

Thomas Eakins

was born in Philadelphia in 1844. Apart from four years spent in Europe as a young man studying under Jean-Léon Gérôme in Paris and travelling in Spain, where he spent 'many an hour in the Prado', he stayed all his working life in his native city. His early work shows the influence of Rembrandt, Velázquez, Ribera and the great French Realist masters Courbet and Manet. He is now widely regarded as the father of American Social Realism. As well as producing a prodigious body of work, Eakins was a celebrated, if somewhat eccentric and aggressive, teacher who insisted upon the efficacy for both sexes of drawing from — and sometimes in — the nude.

The Gross Clinic

1875. Oil on canvas, 244 x 198 cm
Jefferson Medical College, Thomas Jefferson University, Philadelphia

Eakins undertook this large-scale work, *The Gross Clinic*, on his return from Europe. He wanted to make an eye-catching painting that would immediately establish his reputation as an artist; it shows him in his most Spanish of moods. It received a mixed reception. Some — a minority — declared it a masterpiece. Others — the majority — shocked by its graphic detail, condemned it for its 'morbidity' and lack of 'politesse'. It is a dramatic, tensely brooding picture, set in the surgical teaching theatre of the Jefferson Medical College, Philadelphia, where Eakins had studied anatomy before his departure for Paris. As a teenager, he had become fascinated by science and what he saw as its passionate commitment to objective truth. Now he wanted to make paintings imbued with the same passion. Viewed from this standpoint, not only does *The Gross Clinic* reflect Eakins' interest in the procedural apparatus of medical science, it also holds a mirror up to his desire to create an utterly objective mode of painting: a new 'realism' with allegorical overtones. As the operation proceeds, the celebrated surgical anatomist Dr Samuel David Gross — scalpel clasped between bloody fingers echoing Ribera's *Archimedes* in the Prado — has turned aside in order to reassure a woman (possibly the patient's mother) who cannot bear to watch. By contrast, in the background, the artist charged with making a step-by-step visual record of the surgery (perhaps he is a stand-in for Eakins himself) is entirely engrossed in his drawing, seemingly untroubled by the gruesome nature of the scene before him.
Controversial from the outset, *The Gross Clinic* had to be 'rescued' for posterity by Dr Gross himself, who arranged for it to be hung in a military hospital building as part of an exhibition concerned with the treatment of injuries acquired during the American Civil War. By now it is generally recognized as one of the half a dozen great masterpieces of nineteenth-century American art. While Frederic Edwin Church had introduced something of the poetically inflected, divinely ordained, late-Romantic view of the natural sciences into the American arena, Eakins contributed the gritty, politically sceptical approach to science that he had witnessed first hand in post-revolutionary France. He was pursuing a modern, secular vision of science and of art that, taken together, would serve 'mind' and 'body' as a common force for liberation. The figure of the great anatomist, then, represents the immense capacity of the intellect — scientific reason — to solve human problems.

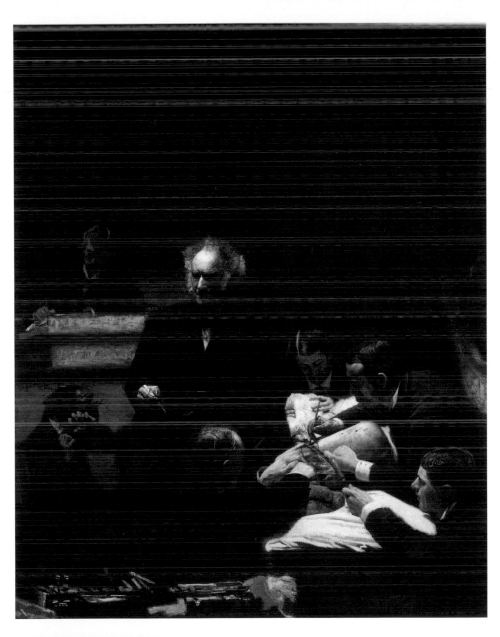

Jusepe de Ribera, **Archimedes**, 1630
Oil on canvas, 125 x 81 cm
Museo Nacional del Prado, Madrid

James Abbott McNeill Whistler

This, the last of the London *Nocturnes*, is now widely acknowledged to be the high point of Whistler's middle period. However, when it was first shown at the Grosvenor Gallery in London in 1877 it caused considerable controversy, which culminated in Whistler launching a libel action against the ageing, but still pre-eminent, writer and critic John Ruskin. Evidently disturbed and angered by Whistler's *Falling Rocket*, Ruskin accused the painter of 'flinging a pot of paint in the public's face'. Whistler, who had crossed swords with Ruskin before, felt impelled to seek redress through the courts. In the event, Whistler won his suit, but was awarded just 'one farthing' in damages. Although he had won the case Whistler lost face in the eyes of the public.

Nocturne in Black and Gold: The Falling Rocket

1875. Oil on canvas, 60.5 x 46.5 cm
The Detroit Institute of Arts

, far from being the crudely gestural painting suggested by Ruskin, is in fact a highly refined and carefully constructed image. The contradictory qualities of explosive energy and absolute stillness are beautifully combined to create a picture that compels attention. Typically, the painting deals primarily with place and time: industrial London at night, the pollution-laden, soupy green-blackness of a city park after nightfall. Fireworks light up the sky, producing a slightly livid glow in the thick air and billowing smoke. Closer examination of the technical aspects of the painting shows just how wide of the mark Ruskin was. In essence, he was accusing Whistler of pursuing cheap and easily achieved effects at the expense of 'good painting', but nothing could be further from the truth. In this work we see the skilled and technically expert Whistler at his most inventive. There is nothing more difficult than painting darkness and retaining the right degree of colour-laden luminosity. Whistler manages to do just this while pitching a soaring sense of spatial indeterminacy against a subtly suggestive structure of line and form. He manages to create a landscape that is sensed rather than seen.

Nocturne: Grey and Gold — Westminster Bridge
1871–72. Oil on canvas, 47 x 62.5 cm
Glasgow Museums, The Burrell Collection

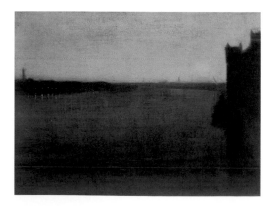

Joseph Mallord William Turner, **The Burning of the House of Lords and Commons, 16th October 1834**. 1835
Oil on canvas, 92 x 123 cm. Philadelphia Museum of Art

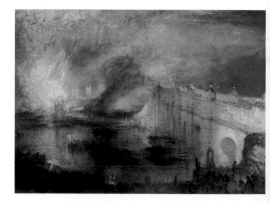

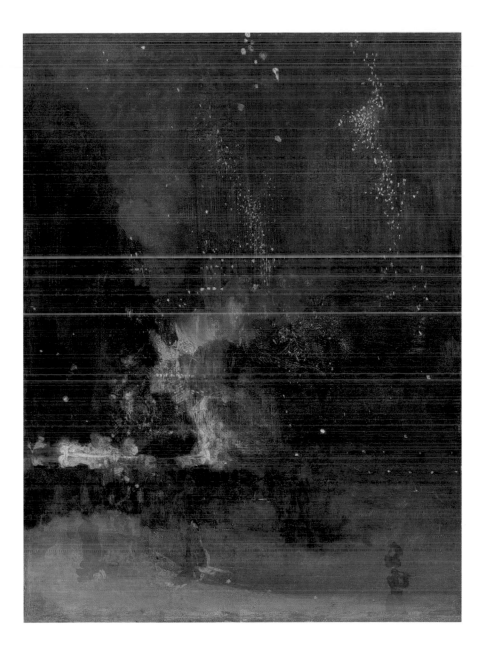

e Search for a Modern Version of the Sublime

Joseph Mallord William Turner's great history painting, the palpably sublime
Burning of the House of Lords and Commons, was displayed for sale by the art
dealer Thomas Agnew in London in 1873 and it is fairly certain that Whistler saw it
at the time. Turner's painting and the more ironic *Falling Rocket* share one important
characteristic: both portray conflagration as a spectator sport. Almost a hundred years
earlier, the philosopher Immanuel Kant had described the burning down of the Bastille
as the first example of the 'modern sublime' because of the state of 'mindless fixation'
it induced in the spectators.

Edgar Degas
In a Café (Absinthe)

1875–76
Oil on canvas, 92 x 68 cm
Musée d'Orsay, Paris

Edgar Degas was reputedly entirely at ease with women from his own class, but he was also fascinated by women from the lower social orders, by how they dressed and how they behaved towards each other in their own social milieu. This interest came very much to the fore in the paintings he made after the early 1870s, works such as *A Woman Ironing* (1873), *In a Café* (1875–76), *Laundresses Carrying Linen in Town* (1876–78), *The Dance Class* (1880) and *At the Milliner's* (1882).

In a Café is one of Degas's most celebrated depictions of everyday life. Degas persuaded two friends, the actress Ellen Andrée and his fellow painter Marcellin Desboutin, to pose for him. Andrée, the actress, looks entirely at ease, Desboutin slightly less so. Nevertheless, this is a strikingly original and entirely convincing composition and certainly not one that could have been easily invented in the studio. The way in which the slightly floaty geometry of the tables holds the woman in place, one of them pinching her across the midriff, has the stamp of observed truth about it. But the painting also has a powerful psychological dimension. The two protagonists may well be out on the town together but they are paying scant attention to each other. They are each lost in their own private world. The woman has a distracted air about her, while the man is leaning forward and looking away, but not—it seems—purposefully so. As a metaphor, 'Absinthe' seems to suggest something beyond the drink itself: a state of mind, maybe, or even a condition of being. And this more general, metaphorical level of

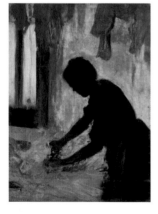

A Woman Ironing
1873. Oil on canvas,
53.5 x 39.5 cm
The Metropolitan
Museum of Art,
New York

reading is strongly underlined by the all-pervading colour mood in which different blacks are pitched against creamy whites, palish yellows and translucent greens in a slightly delirious colour extension, perhaps, of the drink from which the painting derives its title.

Degas has positioned the separate components of this compelling image with the utmost precision. We are obliged con-stantly to look past, through and

beyond things, to shift our attention backwards and forwards between the real and the reflected space. This induced restlessness becomes part and parcel of our understanding of the subject by reinforcing the woman's static inwardness. The use of the newspaper to close off the space between the two tables on the lower left-hand side of the picture increases her psychological isolation.

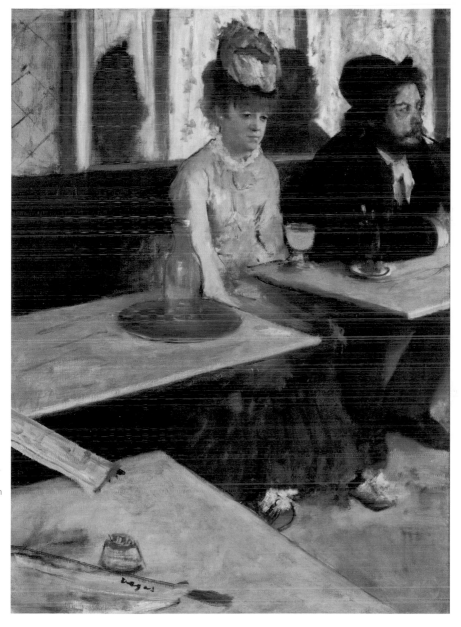

e
er's

on pale
wove paper,
85.5 cm
etropolitan
m of
ew York

Claude Monet

Saint-Lazare Station, Exterior (The Signal)

1877. Oil on canvas, 65.5 x 81.5 cm
Niedersächsisches Landesmuseum, Hannover

In the 1860s Baron Georges-Eugène Haussmann was appointed by Napoleon III to mastermind the transformation of the centre of Paris. In accordance with Haussmann's radical plans, wide boulevards replaced the existing narrow, winding streets. For the progressive painters of the period, including Édouard Manet and Claude Monet, the scheme came to represent the essence of the modern city: a symbolic realization of Modernity itself. Monet made a whole series of paintings in the Quartier de l'Europe, in and around the new Saint-Lazare Station, which was reopened with twelve new platforms in 1854.

Monet was only four years old when Joseph Mallord William Turner painted *Rain, Steam and Speed* (1844), heralding the somewhat daunting but triumphant arrival of the railway age. The first passenger service between the English towns of Stockton and Darlington had been inaugurated in 1825 and in the intervening years the railway system had expanded rapidly. Turner's painting is typically ambiguous. It celebrates the advent of steam locomotion but also shows it locked in a titanic struggle with the forces of nature. By contrast, Monet depicts it as an accepted part of normal city life. For him, Saint-Lazare Station represents a new, essentially modern, social phenomenon. It is the place where, each day, the new breed of professional city workers — the commuters — materialize anew out of clouds of steam to the clash and clamour of the steam engine. It is also a place for arrivals and departures, where Parisians meet visiting friends and relatives or gather to take trips to the country and the seaside. In Monet's paintings of the great, cathedral-like interior space of Saint-Lazare, it is the architecture and the monster engines that seem to dominate, but in this exterior view, where the railway lines gather together before diving under the great span into the station itself, Monet has discovered a new type of urban landscape: a space dedicated to a new form of transportation, shown here with its special 'furniture' and signage shrouded in billowing steam and smoke.

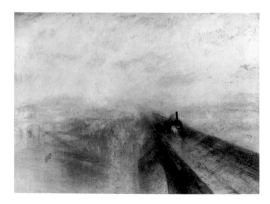

J. M. W. Turner, **Rain, Steam and Speed — the Great Western Railway**
1844. Oil on canvas, 91 x 122 cm. The National Gallery, London

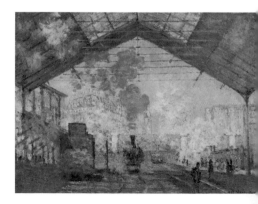

Saint-Lazare Station, 1877
Oil on canvas, 75 x 104 cm. Musée d'Orsay, Paris

ressionism and the New Leisured Class

The routine view of Impressionism is of a cheerfully colourful style of painting, entirely concerned with the perception and evocation of light effects and more-or-less oblivious to the social conditions of urban life. In fact nothing could be further from the truth. As a group, the Impressionists present a vivid picture of the day to day existence of the emergent, leisured middle class. The darker side of this picture is evident in the feigned observational indifference that a painter like Degas shows towards his subjects—the estranged, drinking couple, for example, in a painting like *In a Café* (1875–76). But above and beyond any particular examples, it is fair to say that in general the Impressionists show scant interest in anything but leisure pursuits. It is as if the world of work and working people barely exists, as if the working life of ordinary people is best viewed from a distance.

Édouard Manet

A Bar at the Folies-Bergère

1881–82
Oil on canvas, 96 x 130 cm
Courtauld Institute of
Art Gallery, London

Described as Manet's last great painting—he died in 1883, less than a year after
its completion—*A Bar at the Folies-Bergère* can be seen as his final word on
a problem that occupied him throughout his working life: the relationship,
in figurative painting, between reality and illusion. This picture has generated
a great deal of literature on this topic over the years, with most art historians trying
to find an explanation for the seeming dislocation between the barmaid and her
reflection in the mirror behind her and the curious ghosting of the customer/viewer
in the upper right-hand corner of the painting. However, very few writers have
attempted an overarching representational and allegorical reading of the painting.
This picture is made up of three super-imposed layers—or topographical regions
—of the 'real': the bar area framing the bottom edge of the picture, the working
domain of the barmaid, and the illusionary space of the mirror beyond. All three
are transitional spaces in which different types of exchange occur: material,
social and spectral. In the spectral domain of the mirror, 'real' things are brought
within the space of illusion; reality is set cheek-by-jowl with the chimerical.
Centrally placed in her own space, the barmaid addresses the viewer—customer
—slightly from above and not quite directly. Hers is not the challenging gaze of a
Victorine Meurent in Manet's *Olympia*, and her reflection in the mirror certainly
suggests that the gentleman customer has the upper hand. In fact, the painting
contains a number of pictorial conceits of this kind—small shifts of meaning—
that undermine any simple reading of the image. Manet has also created a major
fault line in the spatial coherence of the painting. The reflection in the mirror
is shown in parallax—shunted sideways—in order, it seems, to destabilize
the position of the viewing subject and render the reflected, illusionary world
more stable than the real world.

Manet set out to paint a 'modern' history painting: a picture with two distinct
levels of reading, the straightforwardly depictive and the allegorical. One allegorical
interpretation of *A Bar at the Folies-Bergère* is as an image of Paradise and the
Fall. The floor-to-ceiling mirror pictures Parisians at play—a night-time world
of gaiety and uninhibited display—while the fully clothed barmaid is the fallen,
ruefully self-reflecting Venus figure, condemned always to be an onlooker,
never a participant in the evening's pleasures.

A Bar at the Folies-Bergère, details

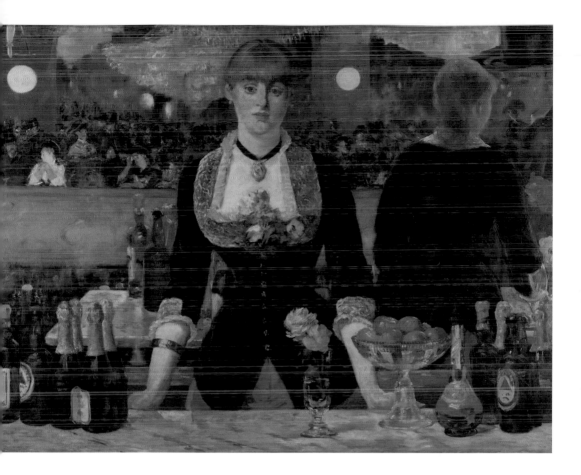

The Reluctant Impressionist

Although Manet is thought of as an important member of the Impressionist
group, it is clear that he never fully engaged with them on a theoretical level.
Closer to Degas than the others, he remained unconvinced, like Degas,
of the efficacy of working directly from the motif. As a trained Salon painter,
he respected the great tradition of French painting and wanted to stay in touch
with this at the same time as adding something new. It is highly significant
that he never exhibited with the rest of the group.

Arnold Böcklin
was born in Basel in 1827. He studied first at the Basel
School of Art and then at the Academy of Art in Düsseldorf. After his studies
he travelled extensively and formed a deep attachment to Italian Renaissance
art and the landscape of southern Europe. A Romantic Symbolist, Böcklin's
paintings are populated with antique heroes and fantastic mythological
creatures. Between 1880 and 1886 he painted five versions of *The Isle of the
Dead*, combining aspects of the island location of the cemetery of San Michele
in Venice with architectural features drawn from the English cemetery in
Florence where one of his eleven children, his daughter Maria, was buried.
Böcklin died in San Domenico near Fiesole, Italy, in 1901.

The Isle of the Dead

1883. Oil on wood, 80 x 150 cm
Alte Nationalgalerie, Berlin

The Berlin version of Arnold Böcklin's *Isle of the Dead* is the airiest, least
brooding of the five. It is the penultimate version and best expresses the artist's
wish to make a picture of 'a silent and a tranquil place'. Typically, Böcklin's
picture is an assemblage of elements — almost a kit of parts — cleverly brought
together, but never fully amalgamated into a convincing whole, but perhaps
this was the artist's intention. The image is of a single island, albeit one that
manifests itself in two quite distinct halves. Its singularity is dramatically riven
through by the vertical black strokes of the cypress trees. Their consolidated
darkness creates a central space that reaches to infinity — the still and shapeless
void that is the unknowable space of death. The blackness seems to be bleeding
from the land into the sea, interrupted only briefly by a low containing wall and
the short flight of steps that give access to the dark, inner space of the island.
In the foreground an oarsman draped in black pulls towards us across the water.
In the stern of his boat the figure of Death, shrouded in white, looks back
towards the island — a pointer to the unavoidable final journey. Clearly they
are bent upon a mission to collect a soul that is about to depart its body.

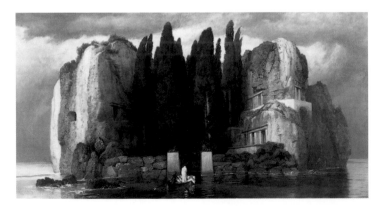

The Island of the Dead
Oil on canvas, 80 x 150
Museum der bildenden
Künste, Leipzig

From German Symbolism to Italy's 'Scuola metafisica'

Although born in Switzerland, Arnold Böcklin is commonly thought of as a German Symbolist, steeped in the northern European Romantic imagination. But he was also a highly erudite man who understood very well the importance of distancing himself from his influences. Apart from the occasional nod in the direction of Caspar David Friedrich, his work seems to plough its own rather solitary furrow. Although he was born into the same generation as artists like Max Klinger, Anselm Feuerbach and Hans von Marées, from very early on Böcklin's painting strikes a more Mediterranean note. It was probably this aspect of his work that captured the attention of Giorgio De Chirico during his

stay in Munich in 1908. Two years later, in the early days of his metaphysical phase, De Chirico quotes the shrouded figure in Böcklin's *Isle of the Dead* in a work that was to be crucial to the theoretical formulation of metaphysical painting and the foundation of the Scuola metafisica, *The Enigma of the Oracle* (1910).

Giorgio De Chirico, **The Enigma of the Oracle**, 1910
Oil on canvas, 42 x 61 cm. Private collection

47

Thomas Eakins

was fascinated by photography and bought his first camera in 1880. Unlike many of his contemporaries, he saw no conflict between photography and painting. As a 'Realist' with a strong classical bent, he treated the photograph as a means of strengthening his understanding of objective appearances. Using his students as models, he made many attempts to replicate Eadweard Muybridge's photographic experiments in the analysis of human movement.

John Laurie Wallace,
Nude, Playing Pipes, *c.* 1883
Platinum print, 17 x 10 cm
Hirshhorn Museum and
Sculpture Garden, Washington

1885
Oil on canvas, 69.5 x 92.4 cm
Amon Carter Museum, Fort Worth

Swimming (The Swimming Hole)

The Swimming Hole resulted from regular visits by Eakins and his students to a lake outside Philadelphia for nude bathing sessions, at which times he would always set up his Kodak camera. Many of the photographs have a pastoral, even idyllic, feel to them. The naked youths seem entirely at ease with each other and not at all aware of the camera. In transposing the scene to canvas, Eakins employs the pyramidal composition beloved of late Renaissance painters, with the figures posed on a rocky outcrop, warm-toned, bare flesh pitched against a clump of trees in deep shadow. As a teacher, Eakins was a great believer in drawing from plaster casts taken from Greek and Roman sculpture, and this old-style, academic discipline is in ample evidence here. The standing figure shows the tilted pelvic thrust and relaxed forward leg familiar from the 'Westmacott' athlete by Polyclitus, while the reclining figure is reminiscent of the *Dying Gaul* in the Capitoline Museum in Rome.

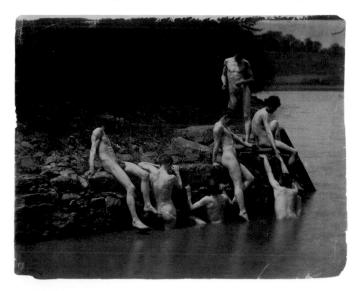

Circle of Thomas Eakins
**Thomas Eakins and Male Nudes
at the Site of 'Swimming'**, 1884
Platinum print, 21.5 x 28 cm
Pennsylvania Academy of
Fine Arts, Philadelphia

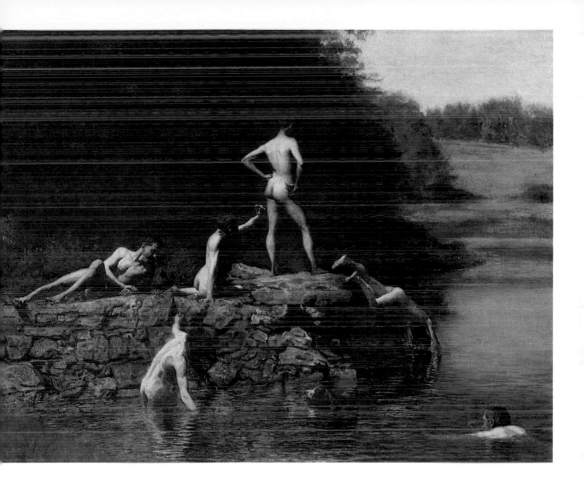

Return to Arcadia

While it is undoubtedly present, the homoerotic quality in Eakins' photographs is much more subdued than in those of the German photographers Wilhelm von Plüschow and Wilhelm von Gloeden, who worked in Italy and Sicily at the turn of the century. The boys and young men in their photographs are deliberately posed to suggest romantic and sexual liaisons, whereas Eakins' students seem uninvolved sexually: hardly conscious of each other's nakedness. Even so, Eakins, like von Gloeden, seems to have been consumed by the desire to restage Arcadia the dwelling place of the Gods—here on Earth. His models, like those of von Gloeden, are encouraged to take up classical poses and they are given Arcadian props, like flutes and pan-pipes, to carry or to play. But there is arguably a didactic purpose behind Eakins' photographs, too; a message directed at the religious zealots and moralizing bigots of middle America. In mythology, Arcadia is a place where only the law of cause and effect is in play. It is a realm—in other words—where there is no overarching system of morals and no necessity to make moral judgements, a place in which it is possible to be free.

Georges Seurat

was born in Paris in 1859. He studied at the École des Beaux-Arts and as a student was greatly taken by the drawings of Ingres and the paintings of Puvis de Chavannes. Of a serious and scientifically curious turn of mind, Seurat became interested in colour theory and set about trying to systematize the intuitive optical discoveries of the Impressionists. This resulted in the invention of 'Pointillism' and 'Divisionism'. In his last few years he turned his attention to trying to devise a rational approach to the emotional aspects of colour. He died, from a form of respiratory infection, in 1891 at the age of thirty-one, having painted several of the great masterpieces of the Neo-Impressionist period.

A Sunday on La Grande Jatte

1884–86
Oil on canvas,
207.5 x 308 cm
The Art Institute
of Chicago

The first important milestone in Seurat's quest to discover 'a formula for optical painting' came in 1884 when he completed his large composition *Bathers at Asnières*. This was the first time he had tried—with some success—to apply colour theories gleaned from his reading of Michel-Eugène Chevreul's *The Principles of Harmony and Contrast of Colors* (1839) and the more recent *Modern Chromatics* (1879) by the American physicist Ogden Rood. The painting employed a broadly Divisionist technique in the shape of additive dabs of paint that were intended—in part at least—to mingle optically when viewed from a distance. But this was still a long way from the full-blown Pointillism of *La Grande Jatte*, completed just two years later. Slightly larger, even, than *Bathers at Asnières*, the entire surface of *La Grande Jatte* comprises small 'points' of pure colour that properly cohere as an image only at the appropriate viewing distance.

This is a classical painting in Impressionist guise. Seurat's highly innovative use of colour is underpinned by a refined linearity that serves to fix, with absolute precision, the profiles of the different figures within the boundaries and space of the picture. From his practice of drawing with soft Conté crayon on a lightly knotted paper, Seurat had acquired an extraordinary ability to control complex tonal arrangements, and this is central to the intricate monumentality of the painting. It underlines the grandness of its conception and helps reveal its intimacy at the point of reception. Each of the two main tonal zones—the shadowed

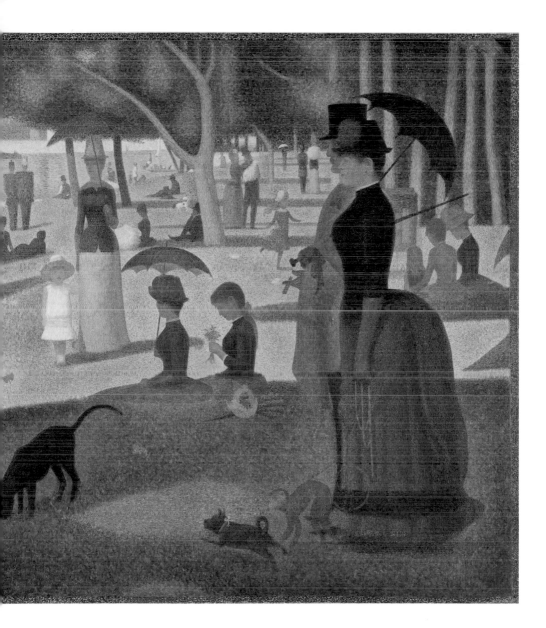

foreground and the sunlit middle-distance — work with a delicately
nuanced array of tonal changes for which Seurat has found entirely
convincing equivalents in terms of shifting colour values. The effect is
at once surprising and familiar. The figures are lit and have volume,
but without betraying the flatness and unity of the picture surface.
In 1887, Seurat and Pissarro were invited by Les XX (The Twenty),
the first genuinely international association of artists, founded in
Belgium in 1883, to take part in their annual exhibition in Brussels.
Seurat exhibited *La Grande Jatte* only for it to be met with open
hostility by the art-going public.

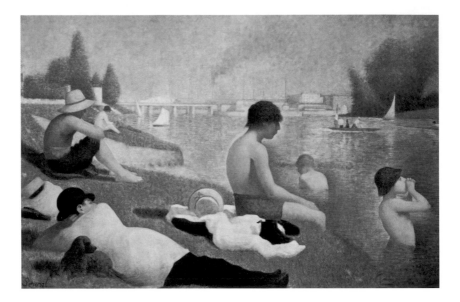

Bathers at Asnières, 1883–84. Oil on canvas,
201 x 300 cm. The National Gallery, London

The Translation of Tone into Colour: Pointillism Explained

Goethe was the first to recognize the connection between tone and colour when
he said that all colours, no matter how high in key, have a 'grey tone' value. Not
long afterwards this was interpreted by J. M. W. Turner — rather comically — to
mean that every colour, 'even a yellow, has a touch of black in it'. But it was left
to the scientific colour theorists of the nineteenth century, individuals such as
Chevreul and Rood, to provide a systematic explanation for Goethe's insight.
Chevreul devised what we today refer to as the 'colour wheel', a circular
arrangement of primary and secondary colours — yellow, orange, red, violet,
blue and green — and was the first to realize that with yellow placed at the top
of the circle and violet at the bottom, a movement either way around the circle
was a movement from light to dark. This he called 'the natural order of tone',
which quite simply means that a pure yellow is always lighter than a pure green
or a pure orange, that a pure green or a pure orange is always correspondingly
lighter than a pure blue or a pure red and that a pure violet is naturally the
darkest colour of all. Rood further extended this theory by arguing that although,
in principle, 'the natural order of tone' was correct, Chevreul's use of colour
divisions obscured the fact that the movement from yellow to violet — from light
to dark — was in fact a gradual 'chromatic' transition. Although Chevreul's

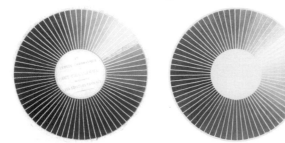

Colour wheel, from Michel-Eugène Chevreul,
**The Principles of Harmony and
Contrast of Colors**, 1839

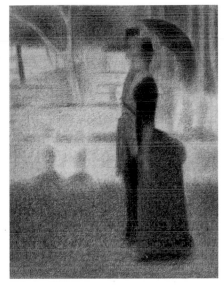

ouple
y for A Sunday
Grande Jatte)
)il on canvas,
4 cm
liam Museum,
idge

The Couple (Study for A Sunday on La Grande Jatte)
1884. Conté crayon on paper, 31 x 23.5 cm
The British Museum, London

theory is complicated by his theory
of discordant colour, which entails a
reversal of 'the natural order of tone',
it is this general theory that lies at
the heart of Seurat's Pointillism.
Broadly speaking, the 'points' of colour
in the darker areas of *La Grande Jatte*
veer towards the green/blue/violet/red
half of the 'colour wheel' and the light
areas towards the red/orange/yellow/
green half.

'Harmony is a correspondence between conflicting
and similar elements of tone, of colour
and of line, conditioned by the dominant
[colour] key and under the influence
of a particular light, in gay, calm,
or sad combinations.'
Georges Seurat

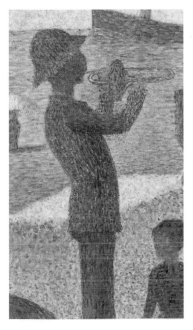

A Sunday on La Grande Jatte,
detail: hornblower at upper left

James Ensor was born in Ostend,

Belgium, in 1860. He showed an early aptitude
for art and took lessons from local artists before
enrolling as a painting student at the Académie
Royale des Beaux-Arts in Brussels in 1877.
From 1883 onwards he exhibited with Les XX,
although his relationship with the group
—which included key figures such as Fernand
Khnopff and Théo van Rysselberghe—was never
entirely comfortable. His natural disposition was
that of the 'outsider' and he became increasingly
isolated after Les XX disbanded in 1893.
He lived and worked for the rest of his life
in his native Ostend, where he died in 1949.

Christ's Entry into Brussels in 1889

1888. Oil-based lacquer
on canvas, 252.5 x 430.5 cm
The J. Paul Getty Museum,
Los Angeles

is one of Ensor's most important
paintings. An early work, made when the artist was
just twenty-eight years old, it was rolled up after
completion and was not shown publicly until 1929.
The theme was not new. Ensor had made a large,
canvas-mounted, Rembrandt-like drawing,
The Entry of Christ into Jerusalem, three years
earlier. It, too, was set in a street thronged with
people and bedecked with banners carrying quasi-
political slogans. The figure of Christ—Ensor himself—riding on a donkey, appears out
of a blinding halation of light in the centre of the drawing. There is no explosion of light
in *Christ's Entry into Brussels*, but the painter's head (towards the left edge of the
composition) is transfigured by an absurdly large, double halo. In both works, Ensor is

being deliberately provocative. Ensor was not a religious man:
on the contrary, he often declared himself to be an atheist.
His use of biblical subjects, then, was entirely metaphorical.
In this case, by casting himself as the saviour of Belgian art
and popular culture, he is also aligning himself with
progressive social and political forces. In the guise of the
Christ figure, Ensor is dispensing blessings to a carnivalesque
sea of brutishly masked faces—a garish phantasmagoria
of city dwellers—led by dignitaries from the military,
the Church and the state. The whole procession is driven
forwards by a flag bearing the words 'Fanfares Doctrinaires
Toujours Réussi' (Never-failing Fanfares of State Power).
The top edge of the picture is framed by a blood-red banner
calling very directly for social progress: 'Vive la Sociale'.

The Entry of Christ into Jerusalem, 1885
Black and brown crayon on paper, mounted on canvas, 206 x 150 cm
Museum voor Schone Kunsten, Ghent

A New Kind of Flatness
At the time that Ensor painted *Christ's Entry into Brussels* he was working in a small room converted for use as a studio in his parents' house in Ostend. A good fourteen feet wide, the canvas was too large for the room and it was impossible for Ensor to work on, or even see, the whole of the composition at once; so he was forced to paint vertical strips, rolling up the finished part as he went along. It seems fairly certain that neither he nor anyone else had a proper sight of the work until it was stretched up for an exhibition some forty years later. The visual evidence of Ensor's unusual working method shows itself in the finished work as a radical flattening of pictorial space. Though people and things are smaller as they get further away, collectively they rise up like painted flats in a theatre. The painting was made in the same year as another spatially innovative work, van Gogh's *Night Café*, although in this case the Dutch painter uses what was to become the classic expressionistic device of forced perspective, whereas Ensor folds the space inwards from the painting's edge. Nothing quite like it was seen again until the abstract painters of the late School of Paris, notably Mortensen and Riopelle.

Paul Sérusier

Born in Paris in 1864, Paul Sérusier was educated at Lycée Condorcet, where he was awarded two baccalaureates simultaneously, one in the sciences and the other in philosophy. He studied painting at the Académic Julian. In 1888, after a brief period practising as an academic painter, Sérusier travelled to Pont-Aven, where he took lessons from Paul Gauguin and where he painted *The Talisman*. He was a founder and intellectual leader of the group of artists that called themselves the 'Nabis' (the Prophets). In later life he was involved with the sacred art of the Benedictine Order at Beuron in Germany. He died at Morlaix in his beloved Brittany in 1927.

The Talisman (Landscape in the Bois d'Amour)

1888. Oil on wooden panel, 27 x 22 cm. Musée d'Orsay, Paris

Sérusier's tiny painting *The Talisman* has acquired legendary significance in the history of modern art. Painted under the tutelage of Paul Gauguin at Pont-Aven, it was Sérusier's considered answer to his mentor's demand that he should 'shed imitation and use pure colour according to its own inner logic and symbolic force'. The painting was given its somewhat portentous title not by the painter himself but by his friends. For Sérusier, his short stay in Pont-Aven had changed his way of thinking about painting and when he returned to Paris, like all converts, he wanted to pass on the fruits of his experience to others. He immediately organized a series of debates on the present condition of painting that were attended by — amongst others — Pierre Bonnard, Maurice Denis, Henri Ibels and Paul Ranson. Within months they had formed themselves into the 'Nabis' and held regular meetings to discuss art theory, occultism, theosophy, orientalism and esoteric philosophies.

In fact, as a painting, *The Talisman*, described by Denis as 'the passionate equivalent of an experienced sensation', goes further towards embracing a completely abstract pictorial language than anything attempted by Gauguin. Where 'flatness' in Gauguin is generated from the drawn line before the resulting shapes are given weight as coloured form, in the Sérusier painting it arises out of the distribution of the brushstrokes themselves, which cluster and spread out across the surface to form contrasting coloured areas and shapes. This is almost the painterly, mark-based, 'push and pull' advocated by the American abstract painter and teacher Hans Hofmann almost seventy years later. Indeed it was not fully explored as a painting method until Abstract Expressionism.

The Rule of the Nabis
According to Maurice Denis
'Remember that a picture — before
being a war-horse, a nude woman,
or some sort of anecdote — is essentially
a surface covered with colours
arranged in a certain order.'

Vincent van Gogh

was born in 1853 in Groot-Zundert, The Netherlands. At the age of sixteen he went to work for the art dealers Goupil & Cie, first of all in The Hague and afterwards in London and Paris. However, he was dismissed in 1876 and subsequently entered a long period of indecision punctuated by moments of intense religious feeling—'an anguish of the soul'. After a spell studying theology in Amsterdam, in 1878 he went as a peripatetic minister to the coal-mining area of the Borinage in Belgium. A nervous breakdown followed and after another intense period of self-examination van Gogh decided to leave the ministry and to become a painter. The year 1881 saw van Gogh back in The Hague taking art lessons from his cousin-in-law, the academic painter Anton Mauve. He moved to Paris in 1886 and attended the studio of Fernand Cormon, where he met Henri de Toulouse-Lautrec and Émile Bernard. The debate concerning Georges Seurat's invention of Pointillism was just gathering strength and van Gogh took the side of the progressives Seurat and Paul Signac. He also became friendly with Paul Gauguin and when he moved to Arles in the south of France in 1888, Gauguin followed a few months later.

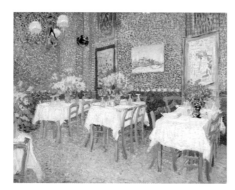

Interior of a Restaurant, 1887
Oil on canvas
54 x 64.5 cm,
Kröller-Müller
Museum, Otterlo

Paul Gauguin
Night Café in Arles
1883. Oil on canvas,
72 x 93 cm
Pushkin Museum of
Fine Arts, Moscow

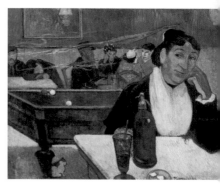

The Night Café

1888. Oil on canvas, 70 x 89 cm. Yale University Art Gallery, New Haven

During his time in Paris, van Gogh spent time with Signac trying to assimilate Pointillist theory, and he made a small number of paintings applying the Pointillist method, notably his *Interior of a Restaurant*, painted some time in 1887. However, he was quick to realize that such a methodical approach was entirely unsuited to his temperament and it was only a year later, in Arles, that he painted *The Night Café*. In most respects this is the absolute opposite of Seurat's work. Where the French painter was trying to give a new, highly controlled, theoretical architecture to the *plein-air* discoveries of the Impressionists, van Gogh's approach and method in *The Night Café* is unashamedly expressionistic. Furthermore, his use of colour seems at first sight to owe more to the Symbolism of Émile Bernard and Paul Gauguin than to anything else. As his letter to his brother Theo shows, van Gogh was beginning to see colour as a powerfully emotive aspect of painting and a source of extraordinary psychic energy. Accordingly, in van Gogh's hands the interior of the night café in Arles—with its

'I have attempted to show that the café is a place where a man might ruin himself, become mad, commit a crime ... I have tried to press the terrible human passions through the use of red and green.'
Vincent van Gogh

forced and slightly crazy perspective and the unbridled clash and clamour of raw colour—is indeed a place where a man might easily go mad. It is a wild and uncompromising painting, quite different in feeling from Gauguin's depiction of the same subject. But is it really as close to the edge of reason as it may appear? A close reading shows that far from ignoring what he had learnt from Signac and Seurat, van Gogh has not only used his knowledge of colour theory to determine the main red—green axis of the picture—in Chevreulian terms the axis of maximum colour energy—but he has also employed discordant colour throughout. Darkened sulphurous yellows and burnt oranges are flecked with whitened greens, blues and violets; olive greens are shot through with bright turquoise.

Paul Gauguin

was born in Paris in 1848 and spent some of his childhood in Lima, Peru. From 1865 to 1871 he worked as a merchant seaman, travelling mostly in the tropics. When he returned to Paris in 1872 he found a job as a stockbroker's clerk. In 1884 Gauguin took his family to live in Copenhagen where he tried to establish himself in business, but the desire to become a full-time painter proved too strong and he returned to Paris a year later, leaving his wife and children to fend for themselves in Denmark. He met Edgar Degas in Paris in 1885 and the Cloisonnist Émile Bernard at Pont-Aven in 1886, the same year that he met Vincent van Gogh. Gauguin returned to Brittany in 1888 with Paul Sérusier and Émile Bernard and together they proclaimed a new approach to painting named 'Synthetism', a derivative of Cloisonnism. Gauguin held an auction of his paintings in Paris in 1891 to finance his first trip to Tahiti.

The Yellow Christ

1889
Oil on canvas, 92 x 73.5 cm
Albright-Knox Art Gallery, Buffalo

Gauguin's *Yellow Christ* is sometimes cited as the most important example of that most curious of art-historical hybrids, Cloisonnism, which was a mixture of Oriental — Japanese — and medieval influences with something of the look of cloisonné enamelling about it. In fact the standard formula of contrasting bright colours held apart by strongly drawn, mostly black lines, as demonstrated in Émile Bernard's *Buckwheat Harvest* from 1888–89, bears little or no relationship to the rich play of yellows and oranges that are brought together in Gauguin's painting. While there is a medieval look to the carved figure of Christ there is not much that could be described as Japanese in this picture. And the use of lines to give extra definition to forms is only ever extremely subtle and kept to the bare minimum. This is principally a painting about colour relationships — the building of a colour mood — and not so much about pattern. Neither is it strictly speaking a Synthetist work, although it was probably influential in the formulation of this new approach which was about playing down subject-matter and placing maximum emphasis on the abstract qualities of line, colour and form. Although colour is very much to the fore in Gauguin's *Yellow Christ*, it is clear that the content was important to him too.

The Vision after the Sermon (The Struggle of Jacob and the Angel), 1888. Oil on canvas, 73 x 92 cm
National Gallery of Scotland, Edinburgh

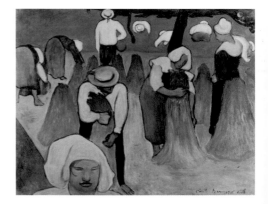

Émile Bernard, **The Buckwheat Harvest**, 1888–89
Oil on canvas, 56.5 x 45 cm
Josefowitz Collection, Lausanne

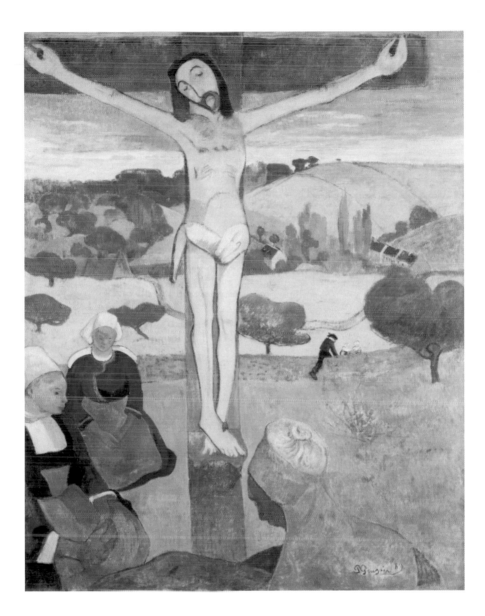

Brittany in the 1880s was a singular place, something of a throwback to pre-modern times. There remained a picturesqueness to Breton life the likes of which had almost entirely disappeared from the rest of France. The Breton people clung tenaciously to their superstitions and folklore, their traditional dress, their manners and their customs. A deep Celtic Catholicism went hand in hand with an even deeper agrarian primitivism and it is this that comes to the surface as content in the works of Gauguin, in paintings such as *The Vision after the Sermon* (1888) and in *The Yellow Christ*.

Vincent van Gogh

Van Gogh lived and worked in Arles in the south of France from February 1888 until May 1889. The experiment of sharing his daily routine with a fellow painter, Paul Gauguin, proved to be an emotional disaster. Although they were equals in terms of sensibility, van Gogh was no match for Gauguin's inflated ego and domineering personality. Gauguin arrived in Arles in October 1888 and left two months later in December after a fierce row. In 1889, after a spell in hospital in Arles, van Gogh admitted himself to the asylum in nearby Saint-Rémy, where he spent a year. After a short time in Auvers-sur-Oise in the care of the physician Paul Gachet, van Gogh shot himself on 27 July 1890.

Road with Men Walking, Carriage, Cypress, Star, and Crescent Moon

1890
Oil on canvas, 91 x 71 cm
Kröller-Müller Museum, Otterlo

'I still have a cypress with a star from down there, a last attempt — a night with a moon without radiance, the slender crescent barely emerging from the opaque shadow cast by the earth — one star with an exaggerated brilliance of pink and green in the ultramarine sky, across which some clouds are hurrying. Below, a road bordered with yellow canes ... an old inn with yellow lighted windows and a very tall cypress, very straight, very sombre. On the road, a yellow cart with a white horse in harness, and two late wayfarers. Very romantic ...'. Vincent van Gogh in a letter to Gauguin

The doctors at the asylum in Saint-Rémy provided van Gogh with a room to use as a studio and he was able to work there with great intensity. There is no doubt that something changed in his work after the split with Gauguin. A new and different kind of energy took possession of the paintings. This is particularly apparent in the landscapes. The more contained brushwork of paintings like *The Alyscamps* (1888) is replaced by the wind-driven arabesques and upward-rising, flamelike curls of paint that give such a chill feeling of unpredictability to paintings such as *The Starry Night* and *A Path Through the Ravine*, both painted in Saint-Rémy in 1889. The feeling is one of cosmic unrest despite van Gogh's repeatedly voiced intention to depict a state of natural tranquillity. It is for this reason that his own description of *Road with Men Walking, Carriage, Cypress, Star, and Crescent Moon* is so revealing. For most of his life he had followed and drawn his creative energy from 'the immense citron-yellow disc of the sun', but now, in what were to be the last few months of his life, his fixation seems to have shifted to the moon and the stars. The sun no longer shines, even to illuminate the moon, which he describes in a state of eclipse. Only a solitary star remains bright. The sun has left the sky. Night, it seems, has taken over from day. In some of his very late landscapes even the sky at midday is painted a dark inky blue.

The Alyscamps, Avenue at Arles, 1888
Oil on canvas, 73 x 92 cm
Kröller-Müller Museum, Otterlo

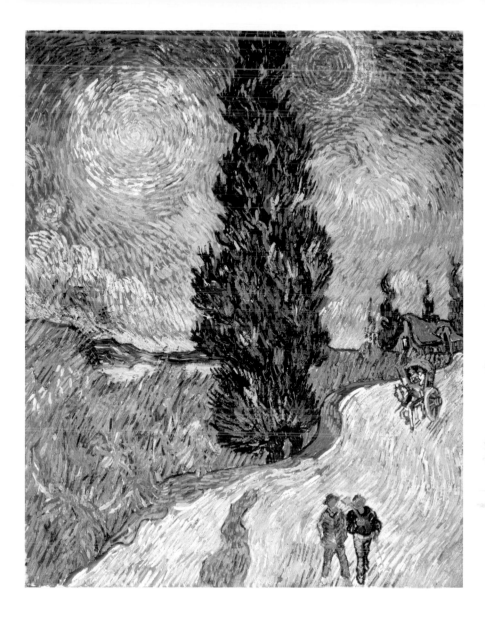

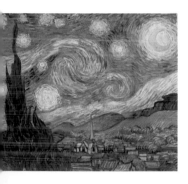

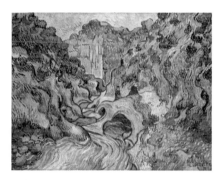

arry Night, 1889
anvas, 74 x 92 cm
seum of Modern Art, New York

A Path Through the Ravine, 1889
Oil on canvas, 72 x 92 cm
Kröller-Muller Museum, Otterlo

Georges Seurat

1890–91
Oil on canvas, 186 x 151 cm
Musée d'Orsay, Paris

Circus

Georges Seurat enjoyed nothing better than to attend the circuses and crowded popular theatres of his beloved Paris, mixing with the performers, carnival folk and the artistes from the music hall. For him this was a special domain where he could observe magical transformations new patterns of colour, light and shade. This preoccupation helped to shape much of his later work. Even the portrait of his secret mistress Madeleine Knobloch, *Young Woman Powdering Herself* (1889–90), depicts her as if she were a showgirl preparing to go on stage. And he addressed the subject directly in his last large-scale work, *Circus*, which was shown in an unfinished state at the Salon des artistes indépendants in the spring of 1891, just a month before his untimely death. The unfinished state of *Circus* provides us with a privileged insight into Seurat's working method. Looking at the most incomplete part of the painting the seated

Young Woman Powdering Herself
1889–90. Oil on canvas, 95.5 x 79.5 cm
Courtauld Institute of Art Gallery, London

audience in the top left-hand quarter of the picture — we can see that he worked from the outset with what Chevreul described as opposing extremes of tone and colour, in this case the axis between yellow and violet/blue Looking at the foreground of the painting, where Seurat is beginning to add 'points' of orange and red, we can also see how fixing the areas of maximum tonal contrast in this way is calculated to ensure richness in the dark areas and luminosity in the light areas of the finished painting. It is also apparent that the meticulousness of Seurat's method, whereby substantial forms are made to emerge from an almost limitless scatter of coloured 'points', is not simply a matter of technique, but is about the coming to consciousness of vision itself. Pointillism sets in train a visual argument between two quite different kinds of legibility. In the points of colour we recognize a minutely structured painted surface, but they also generate an illusionary pictorial space that is voluminous and entirely lucid.

Even so, viewed in the context of the rest of Seurat's work *Circus* is a very unusual painting. It is full of decorative arabesques whose purpose seems to be to synthesize movement. Drawing is used to generate rhythm. Pattern serves as a visual evocation of circus music. The overall effect is strikingly baroque. In this respect its studied artificiality, the way in which it reaches out to encompass all the senses, makes it the absolute antithesis of an Impressionist painting. It is arguable that, more than any other single work, *Circus* sounds the death-knell of the nineteenth century's obsession with appearances.

Le Chahut, 1889–90. Oil on canvas, 170 x 141 cm
Kröller-Müller Museum, Otterlo

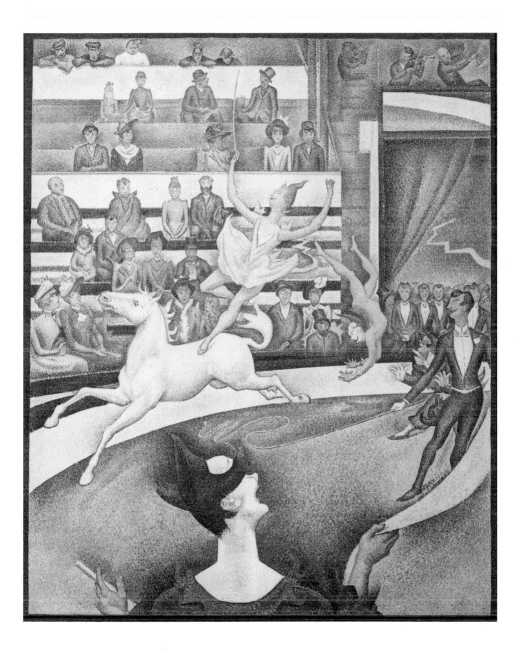

Paul Gauguin
Mata Mua (In Olden Times)

1892
Oil on canvas, 91 x 69 cm
Museo Thyssen-Bornemisza,
Madrid

When Paul Gauguin returned to Paris from his first visit to Tahiti in 1893, an exhibition of his work—mostly the Tahitian paintings—was presented at the gallery of Paul Durand-Ruel. However, his paintings were met by blank incomprehension from the art journalists and most of the art-going public. In Tahiti, Gauguin had been searching for an 'original paradise' under the sway of 'the old gods'—a Garden of Eden free from the censuring morality and decaying authoritarianism of the Christian world. He claimed to have found what he was looking for there and that it had returned him to health and allowed him to 'enter into his own truth'. He returned to Tahiti in 1895 where he stayed until 1901, when he moved to the Marquesas Islands in French Polynesia.

One of Gauguin's most elegant and ravishingly beautiful colour compositions, *Mata Mua* was included in the Durand-Ruel exhibition of 1893. It attracted little or no attention and even remained unsold when Gauguin auctioned his work in order to return to the Pacific in 1895. The painting pays homage to the presence in the world of the female Oceanic deity Hina (the moon), who in Tahiti holds sway over the affairs of women and women's work, the physiology special to their sex and their main character traits, namely to empathize and to deceive. The painting reads vertically as a ritual celebration. The domain of music, represented by the flute player, is in the foreground. The place of dance, where 'majestic' women are shown worshipping through the motion of their bodies, occupies the middle ground. And beyond, occupying the top half of the painting, is the forest and mountain habitation of 'the old gods'.

The composition of *Mata Mua*, its stack of flat, horizontal planes of strong colour rising from the bottom to the top of the painting, split through by the carefully modulated trunk of a massive tree—intended, perhaps, as a depiction of the masculine creation divinity Ta'aroa, who is said to reach from Earth to heaven—is both visually surprising and strangely compelling. It has real consequences for the act of looking by subdividing the image and turning it into a picture without a dominant centre. What we are left with is a series of intense colour zones containing separate visual episodes. Music is set against red and dance against green. The glorious explosion of the great yellow tree, which appears in so many of Gauguin's Tahitian pictures, is set against the dreamy purple-pink of distant mountains.

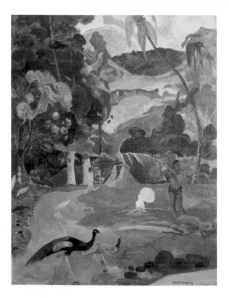

Matamoe, 1892
Oil on canvas, 115 x 86 cm
Pushkin Museum of Fine Arts, Moscow

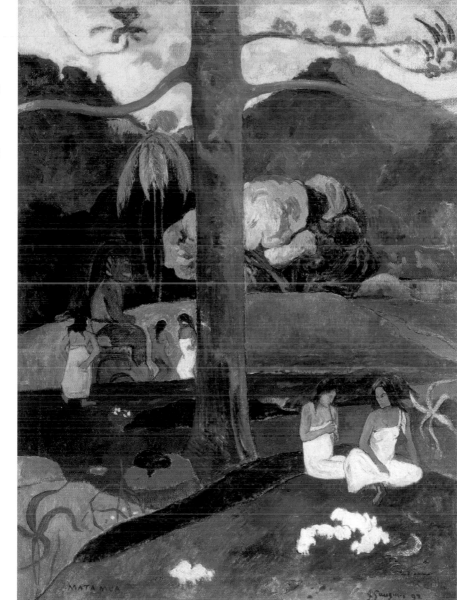

ing the path
borders
eashore,
t deep into
hicket which
quite far
he moun-
Got to a
valley.
some
itants
to live
ey did in
times.'
Gauguin

Colour: Knowledge or Intuition

Like his friend Vincent van Gogh, Gauguin schooled himself in colour theory by attempting to assimilate the Pointillist method in the late 1880s. Predictably though, he ended up preferring intuition to science and sought symbolic force before optical truth. Gauguin succeeded in finally disconnecting colour from mere representation and in this regard was probably the most influential painter of the late nineteenth century. More than any other, he pointed the way to the future.

Claude Monet

Rouen Cathedral, Symphony in Grey and Rose

1892–94
Oil on canvas, 100 x 65 cm
National Museum of Wales, Cardiff

The play of light on architecture was a favourite theme of Impressionist painters and writers. Their feeling was that 'light' is somehow in league with the passage of time, that light is gifted with the power to change not just the colour of things but their form and substance too. The most notable literary example of this occurs in the first volume of Marcel Proust's literary masterpiece *Remembrance of Things Past*, where he gives a lengthy description of the church at Combray:
The old porch was worn out of shape ... its memorial stones ... were no longer hard and lifeless matter, for time had softened them and made them flow like honey beyond their proper margins, here oozing out in a golden stream, washing from its place a florid Gothic capital.

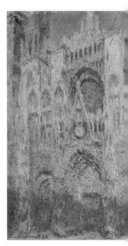

Claude Monet started to paint the main west façade of Rouen Cathedral in 1892, and completed some thirty paintings in all over a three-year period. Twenty-six of these works comprise a series showing the Cathedral at different times of day but seen from the same standpoint, as in *Rouen Cathedral, Symphony in Grey and Rose*. The artist set up his easel looking out of the first-floor window of a shop directly facing the Cathedral and worked systematically, switching to a different canvas every few hours in order to capture the changing pattern of sunlight and shadow throughout the day. He perfected this process during a lengthy visit to Rouen in 1893. However, he then continued to work on the paintings from memory back in his studio at Giverny until 1894. The result is a series of paintings with heavily encrusted surfaces that seem to take on some of the material characteristics of their subject-matter. These surfaces are so consistent throughout the series that it is hard to imagine they were not part of Monet's intention. It is as though he has managed to materialize light as substance. While this composition uses the axis of colour opposition between blue and its complementary, orange, at the same time it also ensures maximum vibrancy by working a discordant pink into the light areas and a discordant violet into the darker zones.

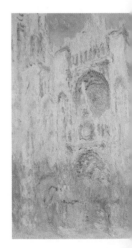

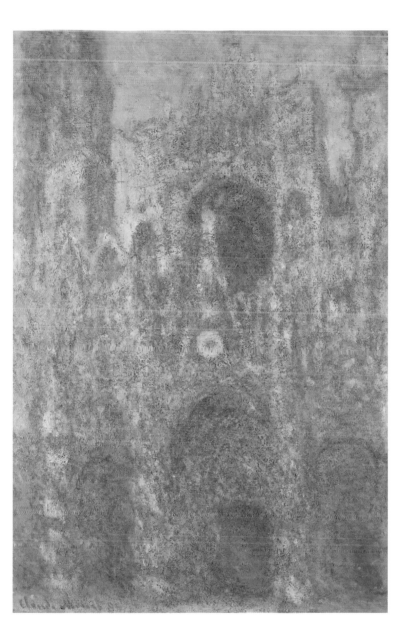

Painting in Series

Monet is generally thought of as the inventor of 'serial painting'. By the time he painted *Rouen Cathedral* he had already completed several series including the *Rocks of Belle-Île* (1886), the *Poplars on the Banks of the River Epte* (1890–91) and the *Haystacks* (between 1888 and 1891). Afterwards he went on to paint the series *Arm of the Seine, near Giverny* (1897) and, in London, the *Charing Cross Bridge* (1899–1904) and the *Houses of Parliament* (1900–04) series. Monet worked in series in order to explore changing light conditions, whereas those who followed him — artists such as Piet Mondrian, Alexei Jawlensky, Josef Albers, Morris Louis and Frank Stella — used it as a means to explore formal variations and different colour states.

Paul Cézanne

was born in Aix-en-Provence in 1839. After working for a short time in his father's bank, he decided to devote himself only to art in 1862 and followed his friend Émile Zola to Paris, where he studied at the Académie Suisse and got to know Pissarro, Renoir, Monet and Sisley. In 1887 he took part in the exhibition of Les XX in Brussels, and in 1895 he showed his work with the prestigious art dealer Ambroise Vollard.

Still Life with Plaster Cupid

c. 1895. Oil on paper, 71 x 57 cm
Courtauld Institute of Art Gallery, London

Formally, this still life is one of the most radical of Paul Cézanne's late paintings. Its spatial configuration is built around certain quite startling, seemingly contradictory effects. The still life is seen from above and yet the floor seems to rise vertically behind it. The three canvases propped against the wall behind the figure of Cupid zig-zag diagonally across the painting like a Chinese screen, cutting the space from front to back, and yet they seem to be entirely lacking perspective. The overall effect is to flatten the picture but also to push objects (the most distant of the apples, for instance) forwards into the space so that they all appear at the same scale and can be described on equal terms. Cézanne is usually seen as a rather taciturn, humourless man, but a close reading of this painting tells a very different story. Whether because of the presence of Cupid in the group—who represents lustful sensuality—or for more personal reasons, it is packed with clever visual puns, playful ironies and forthright sexual references. Most are conveyed by doubling and multiplying parts of the image. The apple lying on the floor in the upper right-hand quarter of the painting, for example, is echoed in Cupid's bulging cheeks and mouth, navel and belly. Everywhere there is the repetition of rounded forms—apples and onions—usually in pairs, resembling breasts and buttocks. And the artist creates an even more explicitly sexual allusion between the drapery in the painting in the left foreground of the picture, which seems to have been lifted by the erect stem of the onion, and the parted legs of a painted plaster figure in the background. There is also a suggestion of castration. The painted figure was a plaster cast of a flayed man attributed to Michelangelo that Cézanne kept in his studio. Here it is feminized—depicted without male genitalia—and in contrast to the erect onion stem to the left of Cupid, the one on the right is drooping and cut through by the leading edge of the table.

Still Life with Plaster Cupid, details

Realizing Objects in Space

The crucial focus in Cézanne's still-life paintings is the fixing of the edges of things
in relationship to each other. It seems that less importance is attached to traversing
the spaces in between things. Quite often canvas or paper is left unpainted.
In the oil paintings this shows itself in two quite different types of mark-making.
Lines run round and round the edges of objects to define their shape and size,
but also to make space for them. Even in a flattened world, painted objects have
to exist somewhere, and in Cézanne's paintings this 'somewhere' has something
of the character of a hollowed-out, shallow relief — which is where the second type
of mark comes into play. These take the form of small, diagonally regimented
brushstrokes that move away from, or towards, the centre of objects,
rather like chisel marks.

Henri (Le Douanier) Rousseau was born in Laval in 1844.

In 1870 he was appointed as a customs official in Paris, hence his nickname 'le douanier'. He was entirely self-taught, having learnt to paint by copying paintings in the Louvre. He participated in the Salon des Indépendants in 1886. He died in Paris in 1910.

The Sleeping Gypsy

1897
Oil on canvas, 130 x 180 cm
The Museum of Modern Art, New York

It is hard to believe that Rousseau's *Sleeping Gypsy* was painted around the time Cézanne embarked upon the first of his paintings in the grounds of the Château Noir. Cézanne was still entirely embroiled in the pictorial crisis resulting from Impressionism, while Rousseau—the self-proclaimed Sunday painter—simply sidestepped the issue and achieved a thoroughly revolutionary spatial language in the process.

The subject was described by the artist himself in a letter to the mayor in his native town of Laval: 'A wandering Negress, playing her mandolin, with her [water] jar beside her, sleeps deeply, worn out by fatigue. A lion walks by, detects her, but doesn't devour her. There's an effect of moonlight, very poetic. The scene takes place in a completely arid desert. The Gypsy is dressed in oriental fashion.' Typically, Rousseau describes the confrontation between the gypsy and the lion as if it is a brief episode in a theatrical narrative of some kind, and certainly there is a feeling that something might yet happen. The suggested progress of the story, however, is strangely at odds with the mood of absolute stillness pervading the whole picture. Everything sleeps, with the possible exception of the lion's tail, which seems poised to lash around wildly.

Rousseau's paintings are always very finished: as images, in the sense that nothing is left unresolved, and as painted surfaces. The paint is carefully smoothed out and unified by a final coat of varnish. The lion is seen in silhouette, held in place by the profile of the nearest sand dune. But the really surprising thing about the painting is the way in which the figure of the gypsy is tilted forwards as though seen from above, in shallow relief. This device connects her pictorially with the 'flattened' vase and mandolin. There is something highly reminiscent of a Synthetic Cubist still life about this spatial invention, over twenty years before Juan Gris painted his *Guitar and Fruit Dish* (1921) and Amédée Ozenfant his *Guitar and Bottles* (1920).

Juan Gris, **Guitar and Fruit Dish**, 1921
Oil on canvas, 61 x 95 cm
Private collection

Amédée Uzentant, **Guitar and Bottles**, 1920
Oil on canvas, 80.5 x 100 cm
Peggy Guggenheim Collection, Venice

Edvard Munch

The Dance of Life

1899–1900
Oil on canvas, 125.5 x 190.5 cm
Nasjonalgalleriet, Oslo

The Norwegian artist Edvard Munch was born in 1863 in the small town of Løten. The family moved to Christiania (the modern Oslo) the following year, in 1864. Munch entered the city's Royal School of Design in 1881, but left after only a year to take a studio with a group of young artists under the influential mentorship of the painter Christian Krohg. In 1885 he travelled by way of Antwerp to Paris, where he spent some weeks studying paintings in the Louvre. In the mid-1880s he also joined the radical, anarchist group Kristiania Bohemia, led by Hans Jaeger. It is likely that it was Jaeger who inspired Munch to write about his life, his spiritual experiences and his thoughts on love and death in what are now known as the *Literary Diaries*. With a dark, troubled imagination—prey to his passions and fears—Munch led a turbulent emotional life and this is powerfully reflected in his paintings. He spent the early part of his working life between Oslo and the village of Åsgårdstrand but later in life moved to Ekely, where he died of pneumonia in 1944.

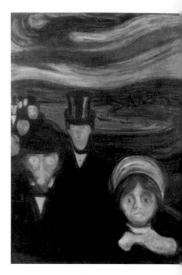

Anxiety, 1894. Oil on canvas, 94 x 73 c
Munch-museet, Oslo

The painting shows a moonlit dance by the waterside. The dancing couples seem to be isolated, moving in their own predestined orbits. Their silhouettes are fluid yet they remain strangely static, their bodies joined together in a timeless, trancelike amour. As a result, Munch's painting seems to be more dreamlike than real and has some of the ambiguities of reading that we associate with 'dreamwork'. Indeed, Munch's own description points to several profound ambivalences at the heart of the painting. The spiritual is set against the carnal; male sexual desire against the unfulfilled, negative feminine. The dance of life is thus transposed into a joyless tableau, invoking its mythical opposite: a frozen moment in the ritual dance of death. Perhaps the most extraordinary aspect of Munch's composition is its use of oppositional and contradictory feminine identities. A beautiful, young woman dressed in white, spurned and unloved, is transmogrified into her opposite: an aged, gaunt and wrinkled woman in black. We see in the painting a destructive marriage of positive and negative psychological energies.

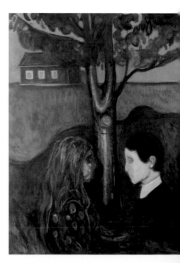

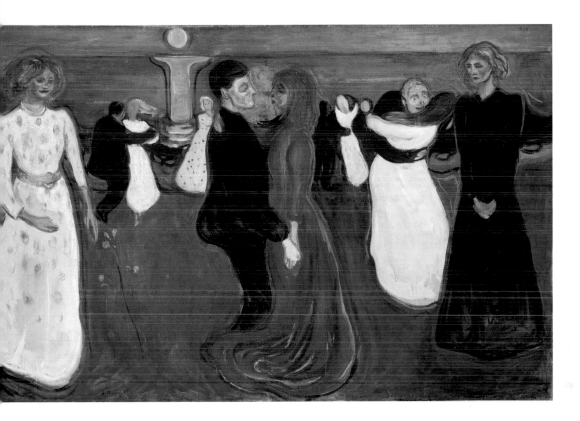

'I am dancing with my true love — a memory of her. A smiling blonde-haired woman enters who wishes to take the flower of love, but it won't allow itself to be taken. And on the other side one can see her again, dressed in black, troubled by the couple dancing, but rejected ... from their dance.' **Edvard Munch,** *Literary Diaries*

Eye, 1893
canvas, 136 x 110 cm
-museet, Oslo

Odilon Redon

was born in Bordeaux in 1840. While still at school, he showed an outstanding talent for drawing. In 1857 he failed the entrance examinations to study architecture at the École des Beaux-Arts in Paris. After a brief and disastrous stay at the studio of the academic painter Jean-Léon Gérôme in Paris, he returned to his native Bordeaux. About this time he met Rodolphe Bresdin, who introduced him to the graphic works of Rembrandt and Dürer. Redon eventually moved to Paris in 1870, but remained relatively unknown until the publication in 1884 of Joris-Karl Huysmans's novel *À rebours* (Against the Grain), which featured a wildly decadent aristocratic collector of Redon's works. He continued to produce black-and-white prints and drawings, often with sombre or disturbing subject-matter, and to exhibit at the Salon des Indépendants until the 1890s. From about 1890 he began to use strong colour and his paintings took on an almost celebratory air. Redon was awarded the Légion d'Honneur in 1903; he died in Paris in 1916.

Joan of Arc

1900. Pastel on paper, 52 x 27.5 cm
Musée d'Orsay, Paris

Redon was sometimes referred to by his contemporaries as 'the scholar of Bordeaux'. This was in part due to his general demeanour. He was unfailingly serious and had a studious, rather literary turn of mind. He was a devotee of the writings of Gustave Flaubert, Charles Baudelaire and Edgar Allan Poe and a friend of Stéphane Mallarmé and Joris-Karl Huysmans. As an artist, he worked very much outside the mainstream. He resisted influences and avoided using conventional symbolism, either classical or Christian, preferring instead to delve into his own extremely fertile imagination. Perhaps the most remarkable fact of Redon's working life is his emergence as a great and highly original colourist, following his sudden 'conversion' after some forty years working solely in black and white. His was a non-systematic approach to colour, deeply intuitive, the very opposite of Seurat. While his colours are certainly about intensity, it is an intensity that is intended to work through the emotions rather than simply registering itself on the retina. It is never subservient to appearances either,

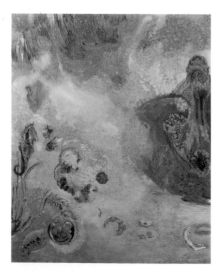

but is used to elevate and transfigure the subject. In Redon's pastel-painting *Joan of Arc*, for example, the red serves chiefly as a radiance emanating from the aquamarine blue of Saint Joan's hair. Surprisingly —inexplicably, in theoretical terms—it seems to infuse a luminous, almost subliminal glow of violet into the picture that modulates the flesh tones and intensifies the inwardness of the Saint's facial expression. Where traces of the same colour combination recur at the top of the painting, they do so as part of a ghostly, inverted version of Saint Joan's head, which seems to be somersaulting away into a dark and earthy void.

Underwater Vision, *c.* 1910
Oil on canvas, 93.5 x 74.5 cm. The Museum of Modern Art, New York

'The only aim of my art is to produce within the spectator
a sort of diffuse but powerful affinity with the world
of the indeterminate.' **Odilon Redon**

Gustav Klimt

was born in 1862 in Baumgarten near Vienna. He studied architectural decoration at the Kunstgewerbeschule in Vienna and spent the early part of his professional life painting murals for large public buildings. With a keen interest in cultural politics, Klimt helped to found the Jugendstil movement known as the Vienna Secession in 1897, its aim being to oppose academic art and to provide support for innovative young artists. He was also the prime mover behind the group's periodical, *Ver Sacrum*. After disagreements between members of the group, he left the Secession in 1905 to form a new association called Kunstschau (Art Show). He painted what is perhaps his most famous painting, *The Kiss*, in 1907–08. However, like many of his figure-based works, it was generally considered too erotic and condemned by the art critics of the day. Lake Attersee and its surroundings formed the most frequent subject of his landscape paintings from the early 1900s onwards. Gustav Klimt died in Vienna in 1918.

The Large Poplar II (The Gathering Storm)

1903
Oil on canvas, 100 x 100 cm
Leopold Museum, Vienna

The poet and essayist Karl Kraus famously remarked 'eroticism is present in all of Klimt's work, including the landscapes'. This is certainly true of *The Large Poplar II*, painted a year after he completed his monumental *Beethoven Frieze* —a free visual interpretation of the finale of Beethoven's Ninth Symphony—in Joseph Maria Olbrich's iconic Secession building in Vienna. In the *Beethoven Frieze* he successfully combined linear sensuality with ornamentation and this became a feature of his work thereafter. In *The Large Poplar II* it shows itself in the flame-like, upward-soaring, thoroughly ambiguous silhouette of the tree, spotted minutely with red, which can be read as male or female—phallus or invagination—and a carefully crafted symbolic feature that, according to the critic Werner Hofmann, represents the aristocratic isolation of the male. Certainly it is the most moody and portentous of Klimt's landscapes. The darkly mottled sky is heavy with brooding psychological affect, suggesting that the expected storm is likely to be as much in the painter's mind as in the world outside. In the foreground a solitary figure cuts across the palely glowing wall of a house, producing a skull-like form. Not for the first time Klimt has brought together death and sexuality in the same image, albeit in a heavily disguised form.

Beethoven Frieze: The Hostile Powers, 1902
Casein paint on stucco, 220 x 632 cm
Österreichische Galerie Belvedere, Vienna

The idea of 'Secession' played a major part in the evolution of modern art in Germany and Austria. Put simply, it means a break with the past, usually by younger artists rejecting the values of the preceding generation. The first 'secession' was declared in Munich in 1892 by the painter Lovis Corinth who also took the idea to Berlin later the same year, where he became a co-founder of the Berlin Secession, along with Max Liebermann, Fritz von Uhde, Hans Thoma and Franz von Stuck. The Vienna Secession, led by Gustav Klimt, came five years later in 1897. Its declared intention was to take art outside the confines of the academic tradition. Leading Austrian artists, designers and architects took part, including Egon Schiele, Oskar Kokoschka, Carl Moll and Otto Wagner. The idea of 'secession' re-emerged in New York just after the turn of the century when Alfred Stieglitz and his friends formed the Photo-secession group to encourage a more abstract, less pictorial approach to the photograph.

Pablo Picasso

La Vie

1903
Oil on canvas, 197 x 127 cm
Cleveland Museum of Art

This painting comes at the end of Picasso's 'Blue' period, which lasted from the winter of 1901 to the autumn of 1904. It is in the form of the life-cycle paintings made popular by the Symbolists, but with one very important difference. Whereas the Symbolists' paintings celebrated life as a continuity through a cycle of endless renewal, Picasso's painting tells of creative stasis, the despair that comes from the curtailment of the life cycle.

The scene is set in the artist's studio. On the left are two naked standing figures, the artist and his female lover. They stand close together. Her knee presses against his inner thigh: a testimony to their intimacy. But they have an air more of sadness than of passion. On the right, a heavily draped mother enfolds a baby in her arms. The man gestures towards her with his left hand. At first it seems that he is pointing out the child to his lover, but a more careful examination shows the gesture to be more particular than that. He seems to be asking the mother not to speak, an impression that is reinforced by the mildly resentful expression on her face. Two unfinished paintings are visible between the protagonists. One hangs on the wall and the other stands below it on the floor. The top one shows a woman comforting a man curled up in a semi-foetal position. Both figures stare out of the canvas with black, frightened eyes. The lower painting repeats the male figure — like a memory or an echo — this time in an even more closed position.

Study for 'La Vie'
1903. Indian ink, 26 x 19 cm
Private collection

Death of Casagemas
1901. Oil on wood, 27 x 35 cm
Musée Picasso, Paris

Picasso's 'Blue' Period

No one can be absolutely certain why, in the winter of 1901, Picasso suddenly switched the dominant colour key of his paintings to one of sombre blues, blacks, grey-greens and chilled flesh pinks. The most common explanation is that he was in mourning for his friend the young Catalan painter Carlos Casagemas. In 1900 the two men travelled to Paris together. Casagemas fell in love with a model named Germaine, found himself to be sexually impotent and shot himself. Picasso immediately set about trying to paint a memorial to his young friend. The first attempt was the earliest of the 'blue' paintings, a funeral scene entitled *Evocation*, painted shortly after Casagemas's suicide in 1901. Following this, he concentrated on melancholic images of human suffering for over two years. It was not until *La Vie* that he succeeded in making a picture he felt was a fitting tribute to his friend. The preparatory drawings featured Picasso himself as the naked artist. Research has shown that it is Carlos Casagemas who appears in the finished work.

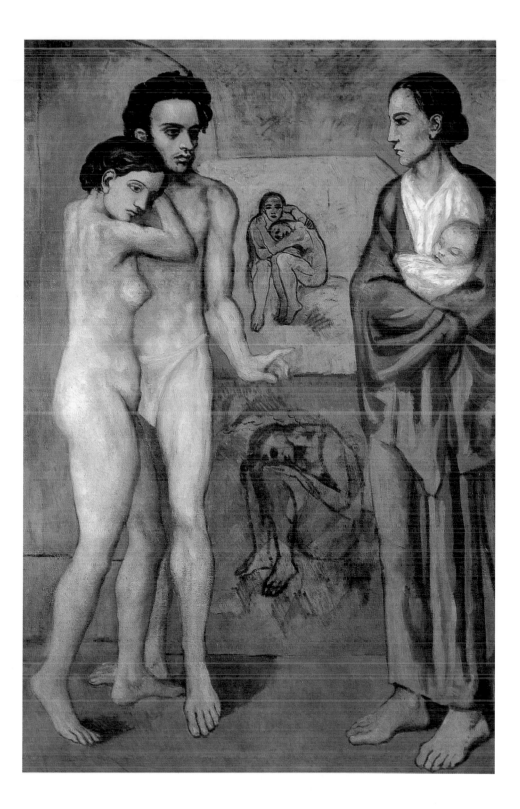

Paul Cézanne

In 1897 Cézanne settled permanently in Aix-en-Provence. After three of his paintings had been on display at the World's Fair held in Paris in 1900, his work also became known abroad and increasingly came to influence such younger artists as Maurice Denis, Pierre Bonnard, and Édouard Vuillard. Cézanne is now regarded as one of the crucial figures in modern art. He died in Aix in 1906.

The Grounds
of the Château Noir

c. 1900–06
Oil on canvas, 90.7 x 71.4 cm
The National Gallery, London
(on loan to Tate, London)

Paul Cézanne discovered the abandoned estate of the Château Noir in 1899 and immediately fell under its spell. While Mont Sainte-Victoire viewed from Les Lauves provided him with an utterly spatialized subject, all vistas and aerial openness, the Château Noir was its absolute opposite. Here everything was to be seen up close. This was an overgrown, wild landscape filled to overflowing with detail: variations of surface texture and differences of scale, weight and substance. He made several paintings of the ruined house, seen through the trees, and a number of more general landscape paintings in the grounds.

The National Gallery painting is particularly striking because of its muted colours and limited tonal range. Faced with the estate's dense weave and variety of natural forms — the chaos of rocks, trees and foliage — Cézanne was led to experiment with something close to monochrome painting as a way of achieving formal clarity. The resulting pictorial architecture is almost cathedral-like and carries with it something of the mysterious foreboding that local people associated with the Château. The near vertical tree trunks to right and left that support the canopy of foliage above also frame a dark, faceted space beyond the rocks that tumble through the middle ground of the painting, reinforcing the impression of an interior space. Here the use of the painting technique known as *passage* — the merging together of adjacent forms by giving a degree of autonomy to each brushstroke — is very much in evidence.

Cézanne and Cubism

Cézanne died in 1906 and two major memorial exhibitions followed in 1907 in Paris. The most important took place at the Salon d'Automne towards the end of the year. It comprised some fifty-six oil paintings and watercolours, many from the last years, including works from the Château Noir. This exhibition was visited by Braque and Picasso before they went to paint the landscape at L'Estaque and La Rue-des-Bois.

The link, frequently made, is between *Houses and Trees* by Braque and Cézanne's *The Big Trees*, painted in 1903. But influence is seldom as clear-cut as this suggests. At the Château, Cézanne enjoyed the working conditions he most craved, namely complete isolation. He was free to entertain a range of new ideas which he then successfully communicated to the next generation.

The Big Trees, 1903
Oil on canvas, 81 x 65 cm
National Gallery of
Scotland, Edinburgh

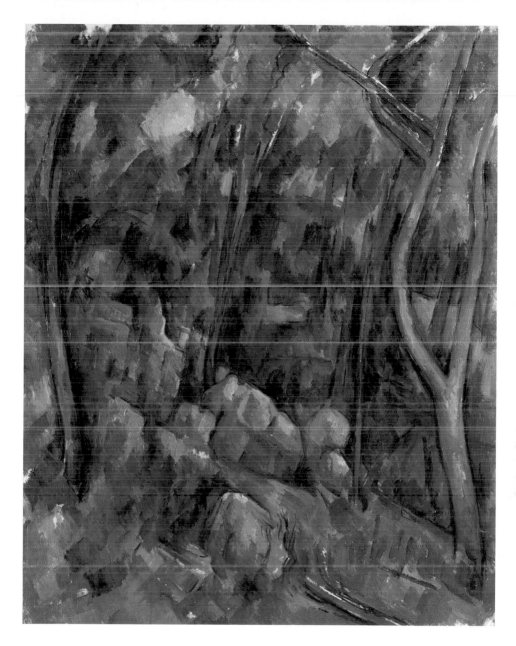

Georges Braque, **Houses and Trees**,
also known as **Houses at L'Estaque**, 1908
Oil on canvas, 73 x 60 cm
Kunstmuseum Bern, Stiftung Hermann und Margrit Rupf

André Derain

was born in Chatou near Paris in 1880. Having originally intended to train as an engineer, he abruptly changed his mind in his mid-teens and set about teaching himself to paint by copying Old Masters in the Louvre and painting the landscape near where he lived. Eventually he went on to study at the Académie Julian. In Paris he shared a studio with Maurice de Vlaminck, became a close friend of Henri Matisse and a regular visitor to the studios in the Bateau Lavoir (a run-down block in Montmartre) to meet Georges Braque and Pablo Picasso. Two events seem to have shaped his early work: the Vincent van Gogh exhibition that took place in Paris in 1901 and his meeting with Vlaminck, who became his close friend and working companion.

Charing Cross Bridge

1906
Oil on canvas, 81 x 100 cm
Musée d'Orsay, Paris

Derain made his first, brief visit to London in 1905, when he painted the *Reflection of the Sun on the Water*. Although more aggressively painted, it nevertheless echoes some of the Impressionist features and mood of Claude Monet's last London paintings (1903–04). Derain returned to London the following year at the suggestion

Effects of Sunlight on the Thames
1906
Oil on canvas,
80 x 99 cm
Musée de l'Annonciade,
Saint-Tropez

The Two Barges, 1906
Oil on canvas,
80 x 97.5 cm
Musée national
d'Art moderne,
Centre Georges
Pompidou,
Paris

of his Paris dealer, Ambroise Vollard, and painted some thirty pictures, of which *Charing Cross Bridge* is a notable example. By now all traces of Impressionism have disappeared, to be replaced, in the light areas, by Divisionist brushstrokes —alternating dabs of yellow, pink and blue that create a vibrant equivalent of bright sunlight reflected on water—and flat, interlocking areas of brilliant colour. The object of Derain's London paintings was to achieve maximum overall intensity through the use of carefully pitched contrasting colours.

Derain was mainly concerned with the play of light—he once famously declared that 'the substance of painting is light'. In these early works he seems to have had no wish to elaborate or deepen the reading of the painting beyond the depiction of the scene itself. Neither did he share Matisse's interest in grand mythological subjects and exotically coloured Arcadias. Although both were regarded as Fauvist, their approach to colour was entirely different. Where Matisse translates the visible world into an entirely new symbolic language in which emotional and psychological resonances play an important part, Derain simply substitutes colour for tone: blues and violets for the dark areas and yellows and pale orange-pinks for the lighter zones.

Henri Matisse

Henri Matisse was born in the northern French town of Le Cateau-Cambrésis in 1869. Having studied law in Paris in 1887–88, he was subsequently employed as a legal clerk in a notary's office. However, in 1890, while convalescing at length from an attack of appendicitis, he took up painting. Following this, he moved to Paris in 1891 to work in the studio of the academic painter Adolphe-William Bouguereau, but soon moved on to the École des Beaux-Arts to study with Gustave Moreau. By the late 1890s he had absorbed the influence of Paul Gauguin, Paul Cézanne and Vincent van Gogh. He met Paul Signac in 1903 and began to experiment with Divisionism. At first he used small 'dots' of pure colour in the Pointillist manner of Georges Seurat, but afterwards modified this technique by using much bolder brushstrokes. By 1905 he had established common cause with André Derain and Maurice de Vlaminck, a grouping that the critics of the day referred to as Les Fauves — 'the wild beasts'.

The Joy of Life

1905–06. Oil on canvas, 174 x 238 cm
The Barnes Foundation, Merion, Pennsylvania

Matisse completed his first unashamedly Arcadian picture, *Luxe, calme et volupté*, in 1904–05. It was in every respect a transitional work, awkwardly poised between his Pointillist, Seurat-influenced phase and the full-blooded Fauvism that finally surfaced in works completed the following year, pictures such as *Girl Reading* and *Vista de Collioure*. However, by far the most radical painting of this time was his second great Arcadian composition, *The Joy of Life*.

In this large and very elaborate picture, Matisse finally abandoned Divisionism in favour of an improvised orchestration of colour of quite staggering originality and complexity. Not only is the painting surprising for its overall brightness and luminosity, but also for its daring, almost kaleidoscopic shifts in scale, hue and tonality. Large, flat, contrasting areas of vivid pigment are augmented by small dark accents and linear arabesques. The influence of Paul Gauguin's use of colour in his Tahitian paintings with their exuberant rawness and naked emotionality is plain to see, but Matisse has carried it much further. Gauguin successfully detached the language of colour from mimetic representation — it was no longer necessary for a tree to be green, a body to be pink or brown, or even for a banana to be yellow — but in *The Joy of Life* Matisse has turned colour into an entirely synthetic thing. If bodies are pink, then preferably an entirely unnatural pink. But they could just as easily be blue, red or orange, depending on where they are located in the picture and the role they are re-quired to play in the overall organization of colour. In Matisse's new Arcadia, grass is yellow or purple, the sky is pink and the trees — it seems — are seldom, if ever, green.

In many ways *The Joy of Life* was a prophetic work that, conceptually speaking, leapfrogged over the Matisse of the 1920s and 1930s and anticipated the more 'musical' and rhythmical paintings of the late 1940s and the collages he made towards the end of his life.

Luxe, calme et volupté
1904–05. Oil on canvas,
98 x 118 cm
Musée d'Orsay, Paris

Girl Reading, 1905–06
Oil on canvas, 75 x 60 cm
The Museum of
Modern Art, New York

Pablo Picasso

Two Brothers

1906
Oil on canvas, 142 x 97 cm
Kunstmuseum Basel

Painted in the small Catalan village of Gósol in the Sierra del Cadí, where Picasso spent the summer of 1906, this canvas marks the end of the painter's 'Rose' period. It is a mesmeric work with a very simple, almost primitive image that is nevertheless strangely compelling.

A naked adolescent boy carries a younger boy (a brother presumably, although the title is not Picasso's) through a featureless landscape. A horizontal line makes the division between earth and sky, nothing more. There is an extraordinary atmosphere of tenderness in the picture — between the two boys, in the trusting way that the three hands join together at the older one's throat, and between the painter and his subject. Paint is licked on in smallish brushstrokes. Contours are gently coaxed into existence. The modelling that gives volume and precise weight to the older boy's body is applied with great restraint and an acute awareness of the way that light might play on a spare and immature musculature. The pose, proportions and formal simplification are reminiscent of Attican *kouroi* from around 600 BC. The most detailed, most resolved part of the image is the head of the older boy, who is looking sideways out of the picture, so winsomely. There is something familiar about his short-cropped hair, dark eyes and elfinlike expression. He first appears in the 'rose' works of the previous year, say *Harlequin's Family* and *Two Acrobats with a Dog*. According to friends who visited Picasso at the time, the model was a young male prostitute who had a room in an apartment block in Paris known as the 'Bateau Lavoir'.

Picasso's 'Rose' Period — Clearing the Ground for Cubism

The transition from 'Blue' to 'Rose' period was not sudden. By the end of 1903 Picasso was feeling trapped by the dark introspection of the 'blue' paintings and keen to develop a more positive outlook that would move his work forwards. This was the main impetus behind the paintings of the 'Rose' period and all the transitional work that preceded *Les Demoiselles d'Avignon*, completed in 1907. The colour key changed slowly with the gradual introduction of warmer hues and lighter tones. It was more than two years before the full-blown terracotta pink paintings emerged. The subject-matter changed slowly too — from emaciated musicians, clinging alcoholic couples and hollow-cheeked, sad-eyed children, to acrobats, circus performers and the family of the *commedia dell'arte*.

At first Picasso experimented with the classical tradition of French figurative painting in works like his *Family of Saltimbanques* of 1905. But this failed to satisfy his fiercely radical turn of mind. He wanted to take painting back to its primitive roots and this was the reason for his trip to Gósol: to escape the sophistication of the Paris art world and to seek out a more immediate, more vital reality. His *Two Brothers* was the culmination of this search.

Family of Saltimbanques, 1905
Oil on canvas, 212.8 x 229.6 cm. National Gallery of Art, Washington

...ding a **Horse**, 1905–06
...anvas, 220.3 x 130.6 cm
...seum of Modern Art, New York

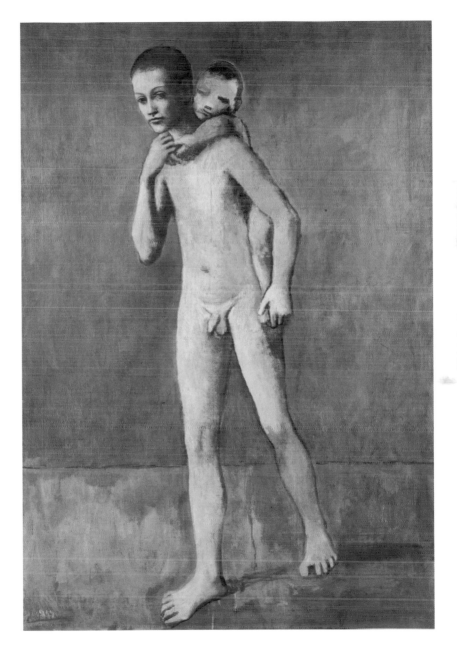

...a Marble Statue of a Youth
...), mid 6th century BC
...du Louvre, Paris

Walter Richard Sickert

was born in Munich in 1860 to a Danish-German father and an English mother. Although he came from a family of painters, at first he wanted to become an actor. He learnt painting from James McNeill Whistler, who worked alternately in England and France. This is how he came into contact with Edgar Degas in Paris. The two men became good friends, and Degas exerted a strong influence on Sickert's work. In London he was a member of the Camden Town Group, which was officially founded in 1911, but whose members had already been meeting one another since 1905. This is the period of his 'black paintings'. In the 1930s he did a number of paintings based on news photographs, thus anticipating the work of such artists as Gerhard Richter and Andy Warhol. Sickert died in Bath in 1942.

Noctes Ambrosianae

1906. Oil on canvas, 63.5 x 76 cm,
City of Nottingham Museums, Castle Museum and Art Gall

The work of Walter Richard Sickert, a close friend of Edgar Degas, has only recently been afforded the art-historical status it deserves. A renewal of interest in figurative painting has had something to do with this, but it was the organizers of major exhibitions in Europe and America during the 1980s who led the way. Like Oscar Wilde, Sickert's social life was split between hob-nobbing with the gentry—royalty and the aristocracy—and inhabiting the twilight world of the prostitution and petty criminality that so disfigured the lives of many ordinary people in Victorian London. Just as Degas haunted the dance studios of Paris, so Sickert was a compulsive habitué of the music hall, and this obsession with bawdy, popular theatre came to dominate his work overall. But a glance beyond the subject-matter shows Sickert to be both a trenchant social commentator and a highly innovative artist.

Noctes Ambrosianae is one of a group of works that Sickert referred to as his 'Black Paintings'. These also include his controversial paintings of

the *Camden Town Murder*, notably the darkly brooding *L'Affaire de Camden Town* (1909) for which Sickert is said to have used Robert Wood—the man tried and acquitted of this murder—as his male model. These compositions were said to have been painted on a black ground but this is not the case. Rather they are built up from layer upon layer of rich, dark violets and browns. Sickert's use of the term 'black' is largely metaphorical. It refers more to the subject, the prevailing social atmosphere, and his own depressive turn of mind. Despite its sombre mood, *Noctes Ambrosianae* is a virtuoso display of brushwork. The phantasmagoria of pinched, pink faces is executed with an economy of means reminiscent of Daumier.

The painting shows the highest tier—commonly referred to as 'the gods'—in a music hall called the Middlesex Music Hall in Drury Lane and nicknamed 'Old Mo'. 'The gods' were where the street boys went to keep warm and to watch

L'Affaire de Camden Town, 1909
Oil on canvas, 61 x 40.5 cm. Private collection

'adult' entertainment. Typically, Sickert's title hints at several meanings: ambrosia was, of course, the food of the gods and this provides for the 'blackest', most sexualized reading. But the title also refers to one of Sickert's favourite 'watering holes', a public house called Ambrose's Tavern, and to a series of imaginary dialogues published in *Blackwood's Magazine* that were supposed to have taken place there.

Sickert on Social Realism

'A painter must tell his story with relentless impartiality ... pack it tight until it is dense with suggestion. Oddly enough our insular decadence in painting can be traced back to Puritan standards of propriety. If you may not treat pictorially the ways of men and women and their resultant babies as one enchained comedy or tragedy, human and "de mœurs", the artist must needs draw inanimate objects — picturesque if possible. We must affect to be thrilled by scaffolding, or seduced by oranges.'

Paul Cézanne
Mont Sainte-Victoire from Les Lauves

1904–06. Oil on canvas, 60 x 73 cm. Kunstmuseum Basel

Cézanne made many paintings of this, his 'favourite mountain'. The Basel version, which he worked on over a period of three years and was still 'unresolved' when he died in 1906, is the most innovative of them.

At first sight it is the simplest of paintings. A horizon line divides the canvas a third of the way down. Mont Sainte-Victoire rises into the sky above and the valley sketches out below it. It is only when you compare this painting with the earlier Courtauld version, that the strangeness of the image becomes apparent. Cézanne has made a radical departure from the traditional approach to landscape, with its emphasis on the horizontal, by stretching the vertical axis of vision. The effect is to tilt the whole visual field upwards and towards the viewer, turning it into a shallow dishlike space. This is no longer a distanced world to be looked at from afar, but one that completely envelops the viewer.

The handling of the paint is softer and more varied, too. In the Courtauld painting the treatment is hard, crystalline even. The forms are carved out. In the Basel painting everything is in motion around and towards the centre. The brushstrokes are more open and there is less use of the *passage* method of painting that was so dominant in his Château Noir paintings.

The centrifugal energy of this painting is such that it begins to render the corners of the canvas spatially fugitive, a feature that was picked up by Braque and Picasso in the analytical phase of Cubism, leading them to experiment with elliptical images. Later on, it influenced the early, transitional, 'semi-impressionistic', abstract paintings of the American painter Philip Guston.

Mont Sainte-Victoire, *c.* 1887
Oil on canvas, 67 x 92 cm
Courtauld Institute of Art Gallery, London

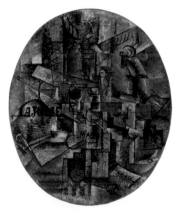

Pablo Picasso
The Architect's Table, 1912
Oil on canvas mounted on panel, 72.5 x 59.5 cm
The Museum of Modern Art, New York

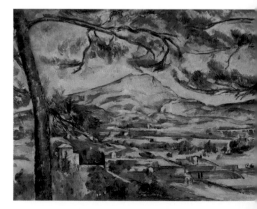

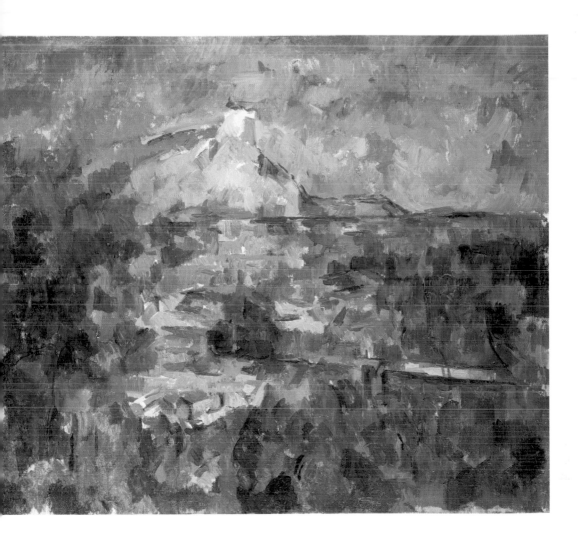

Kant and Cézanne

There is a remarkable coincidence between the ideas outlined by Kant in *The Transcendental Aesthetic* and Cézanne's perceptual 'atomism' —his *'petites sensations'*—and the chronic state of material uncertainty we experience in Cézanne's paintings. Kant writes that 'in general, nothing which is intuited in space is a thing in itself, and that space is not a form which belongs as a property to things ... objects are quite unknown to us in themselves ... [they are] mere representations of our sensibility'. While there is nothing to suggest that Cézanne built a painting method from his reading of Kant, it seems that he did find some kind of solace there.

Pierre Bonnard

was born in 1867 at Fontenay-aux-Roses near Paris. At the same time as reading law at the University of Paris, he attended drawing classes at the Académie Julian. There he met Henri-Gabriel Ibels and Paul Ranson and also became a close friend of Paul Sérusier and Maurice Denis. These five artists together formed the Society of Nabiim or the 'Nabis'—the prophets—in 1888. The first exhibition of the society took place in 1891 at Le Barc de Boutteville. In 1893 Bonnard met the sixteen year-old Marthe de Méligny (real name Maria Boursin). She quickly became the main subject of his painting and remained so until her death in 1942. A prolific painter, Bonnard also made posters, illustrated books and designed for the theatre. He worked on the infamous 1896 production of Alfred Jarry's *Ubu Roi* for Aurélien Lugné-Poe at the Théâtre de l'Oeuvre.

Woman Bending Over

1907. Oil on canvas, 72 x 85 cm
Niigata City Art Museum

The diminutive Marthe is said to have been obsessed with bathing and washing and her obsession seems to have been well matched to Bonnard's intensely sexual voyeurism. There exist a hundred or more intimate paintings of Marthe relaxing in the nude or performing her toilette. In many of them the sense of the painter's breathless proximity is almost overpowering, and if Bonnard's paintings are to be believed, she must have retained the body of a young girl into later life: small tight breasts, a flat stomach and slim but shapely thighs. Only very occasionally, as in the provocative *Indolence* of 1899, does Bonnard show her looking out towards the viewer. This seeming refusal to acknowledge another's presence adds greatly to th erotic charge. In *Woman Bending Over*, Marthe has one foot on a stool so that she can reach over to dry her lower leg. She is entirely absorbed in her task. The imag is very precisely structured. Two rectangles, one moving in from top right and the other from bottom left, neatly frame her naked body, a compositional device that testifies to Bonnard's fascination with the Japanese Ukiyo-e wood-block prints of Hiroshige, Kunisada and Kuniyoshi. The rectangles make for a diagonal movement across the painting from left to right. In rhythmic contrast, Marthe's stooping, naked body curves dramatically towards the left.

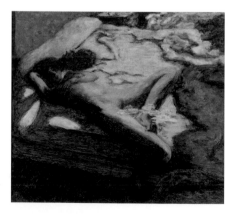

Indolente, *c.* 1899
Oil on canvas, 92 x 108 cm
Musée d'Orsay, Paris

Marthe in the Tub, *c.* 1908–10

94

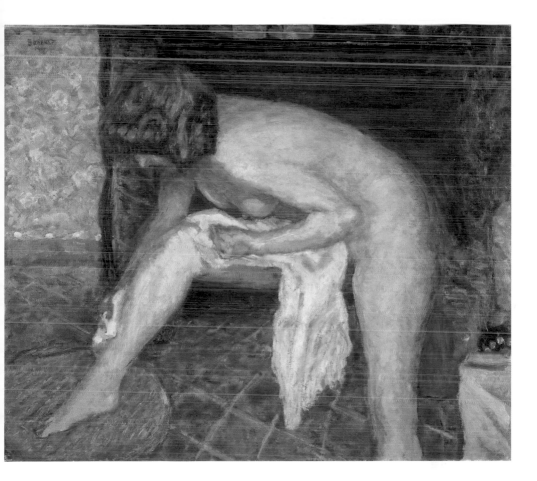

A Bridge to Impressionism

Most artists of the *fin de siècle* were trying to escape the dominance of Impressionism. Only Pierre Bonnard and Édouard Vuillard seemed content to pick up where the earlier movement left off. Bonnard's use of paint owes much to his early interest in Auguste Renoir and the pastel paintings of the 1890s by Edgar Degas. The liveliness of Bonnard's colour comes in part from his love of Japanese art—his fellow Nabis often referred to him as 'the Nipponized Nabi'—and from his deep admiration for the Pont-Aven paintings of Paul Gauguin.

Kuniyoshi Utagawa, **Woman with Wine Cup**,
from the series **Excellencies of Mountain and Sea Illustrated**, 1853
Wood-block print, 35 x 24 cm
The University of Manchester, The Whitworth Art Gallery and Museum, Manchester

Pablo Picasso

Les Demoiselles d'Avignon

1907
Oil on canvas,
224 x 233 cm
The Museum of Modern Art, New Yor

Perhaps the most inexplicable and radical painting of the modern period, this composition shows all the signs of intense struggle. While the first studies date from 1906, it was not completed until the summer of 1907, significantly — it has been argued — after Picasso's visit to the Musée d'Ethnographie du Trocadéro, where he encountered African sculpture. As the title suggests, the painting pictures a scene in a brothel and

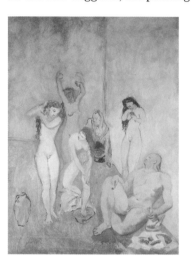

The Harem
1906
Oil on canvas,
154.5 x 110 cm
Cleveland
Museum of Art

in many respects echoes the 'Rose' period painting *Harem* of 1906. The image is simple. Five naked women disport themselves in variou poses with a bowl of fruit in the foreground. The manner of realization is far from simple and is surprising, even today. Staccato, zigzag and arching lines make for a wild rhythm that takes over the whole picture surface. All traces of perspective have been eradicated. Flaring white brushstrokes shatter the tonal coherence of the painting. The art-historical discussion of sources and influences has been largely short-circuited by the idea of an unholy marriage between Cézanne and African art, even though the most cursory glance reveals nothing of Cézanne and only the occasional detail that might be said to be African in feel.

The truth is — and it is evident throughout the painting — that there are many conflicting points of reference for the painting. Picasso was trying to recover the primordial life force through painting, and he looked to many so-called 'primitive' sources for his inspiration: Assyrian stone reliefs; funerary carvings from the early Athenian period; Boeotian bronzes and Cycladic figurines as well as African tribal sculpture, masks and fetish figures. The quest for origin, which began in the 'Rose' period, reached its apotheosis with *Les Demoiselles d'Avignon*.

Absolute Beginnings
Modern painting is haunted by the idea of the *tabula rasa*: an empty canvas waiting for the inaugural moment when a new vision comes into being. It hardly ever happens; some would say never. Even so, there are moments that come close to it, and the painting of *Les Demoiselles d'Avignon* is one. It seems even to have taken Picasso by surprise. He made many working drawing: as he went along and none of them shows anything of the violent energy that animates the finished work. Most of what we see was realized directly on the canvas. Just as it has no real historical precedent, it is not an obvious precursor of Cubism either. In many respects, it stands quite alone.

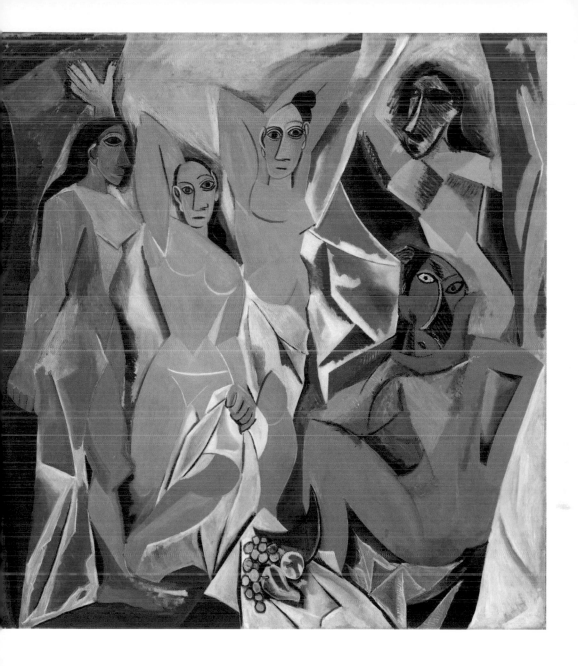

Les Demoiselles
d'Avignon, detail

Mbuya mask from Pende, Congo
Painted wood, fibre and cloth, 26.5 cm
Royal Museum for Central Africa, Tervuren

97

Winslow Homer

was born in Boston in 1836. After a two-year apprenticeship with a commercial lithographer in Boston, he moved to New York, where he became a freelance illustrator for *Harper's Weekly*. Homer's major task, and one that brought him instant recognition, was to make visual reports on the day-to-day lives of Republican soldiers during the American Civil War. After the defeat of the Confederacy he turned his attention to studies of American life, especially the outdoor activities of children and young people. It was only after he spent two years in the fishing village of Cullercoats in the north-east of England between 1881 and 1882 that his work took on an altogether darker mood, which he deployed to great allegorical effect on his return to America. Homer died at Prout's Neck in 1910.

Driftwood

1909. Oil on canvas, 62 x 72.5 cm
Museum of Fine Arts, Boston

Although not a particularly sociable man, Winslow Homer always aligned himself with progressive politics. In the 1870s he painted a number of pictures depicting the life of former slaves in which he allegorized their unfulfilled ambitions. The most famous of these, *Dressing for the Carnival* (1877), has as its central figure an African-American being decked out by his own people as a figure of fun. The plight of the American Blacks is cited again in the much later sea painting, *The Gulf Stream*, painted in 1899, which depicts an escaping slave adrift in a rudderless boat on a towering, hostile sea. Homer is usually referred to as a Realist, but he is much closer to his subject-matter than an observational term like Realism might suggest. During his time in England he had lived cheek-by-jowl with hardworking fisherfolk, watching each day as the men sailed out into the darkening sky of a storm-ridden North Sea, leaving their womenfolk behind to mend nets and prepare for the day's catch. In Cullercoats, the sea, its unpredictability and its capacity for indiscriminate violence, became for Homer a defining allegorical force through which he could refer to the nobility of working people. In the very late *Driftwood* (1909) the sea seems to have taken over completely. The fisherman in the foreground is dwarfed by it; the once tall and straight pine tree—the driftwood of the title—has been laid low and stripped bare by it. The sea is self-evidently uncontrollable. It swells and rages against the land.

The Carnival (Dressing for the Carnival), 1877
Oil on canvas, 51 x 76 cm
The Metropolitan Museum of Art, New York

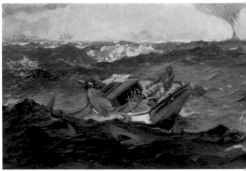

The Gulf Stream, 1899
Oil on canvas, 71.5 x 125 cm
The Metropolitan Museum of Art, New York

Winslow Homer's Sea Paintings and the Agenda for Social Reform

It is significant that Homer turned his attention to painting the sea in the early 1880s when the United States were in the throes of the first social crisis brought about by accelerating industrialization and the rapid growth of urban poverty. The reform movement had its roots in the white middle classes who had the most to lose. They feared industrial unrest leading to chaos in the inner cities, yet they took scant notice of the growth of a Black underclass. Given Homer's long-standing interest in the plight of African-Americans, it would not be at all surprising if the bleakness and underlying pessimism of *Driftwood* were not related in some way to the formation of the short-lived National Association for the Advancement of Colored People that took place in the same year.

Emil Nolde
(born Emil Hansen), the son of deeply religious peasant farmers, was born in 1867 in Nolde, a village in northern Germany. Having completed an apprenticeship in wood carving in Flensburg (1884–88), in 1888 he went as a wood carver and draughtsman to Karlsruhe, where he attended classes in drawing. In 1889 he took a job as a furniture designer in Berlin and studied the Old Masters in the museums in his spare time. From 1892 to 1897 he taught draughtsmanship at the Museum of Industrial Arts at St Gallen, Switzerland. After a year in Munich he went to Paris, where he enrolled at the Académie Julian and spent much of his time studying in the Louvre. Following his move to Copenhagen and his marriage to Ada Vilstrup in 1902 (at which point he also changed his name to Nolde), he found himself dogged for a long time by financial difficulties, many of them caused by Ada's ill health. He and Ada retired to an isolated cottage in Alsen, where he was visited by Karl Schmidt-Rottluff, who invited him in 1906 to join the Die Brücke group of artists. In 1910 he was expelled from the Berliner Sezession for anti-Semitism. A year later he joined forces with the Neue Sezession and helped formulate its more aggressive aims. In 1913–14 he and his wife accompanied an official expedition to the South Pacific. Later the Noldes moved to Seebüll on the Danish–German border, where Nolde designed and built a house with a studio for himself. In 1935, convalescing after an operation for stomach cancer in a Swiss nursing home, he met and became a close friend of Paul Klee's. In 1937 his work was condemned as 'degenerate' by the Nazis and was removed from German museums; in 1941 he was officially prohibited from painting, but continued to do so clandestinely. After the Second World War he again exhibited at home and abroad and received numerous awards. He died in 1956 at the age of eighty-eight.

Mocking of Christ

1909. Oil on canvas, 86 x 106.5 cm
Brücke Museum, Berlin

During 1909 Nolde painted three major religious paintings, *The Last Supper*, *Pentecost* and the *Mocking of Christ*. He had discovered the work of Paul Gauguin and Vincent van Gogh during his stay in Paris in 1899, but it had taken some time for the impact of their painting to show itself in his work. The influence of van Gogh —with whom Nolde felt a particular affinity—first came to the fore in 1908, when he painted a number of highly coloured, vigorously executed canvases, the best known of which is *Flower Garden (Girl and Washing)*. Here the paint marks—short stabs of bright pigment—seem to have been hurried onto the surface; made to swirl and mix with each other to produce a restlessly moving morass of paint that has something of the character of the subject about it. The paint seems almost to behave like dense clumps of flowers caught by a slight breeze on a blazing hot summer's day. And there is a similar sense of urgency and painterly jostle—the same crowded, almost fetid feeling—about Nolde's *Mocking of Christ* painted a year later. Christ is caught at the centre of a gathering of physiognomic grotesques. Their faces are illuminated by a sickly yellowish light—a light that is seemingly generated from within the painting, out of the disquieting array of dissonances that

exists between yellow-orange and emerald green. The narrative focus of
the painting is on the mouths that mock and the glances that look daggers.
Eyes and teeth. Flashes of white amidst a torment of yellows, greens and
browns. But on a deeper level, the painting is also about passion: an 'energy',
as Nolde called it, that spoke to him directly from within. As he wrote, 'without
prototype or model ... without any well defined idea ... a vague sense of
glow and colour was enough ... or else the painting took shape on its own'.

Flower Garden
1908. Oil on canvas.
65.5 x 83 cm
Kunstmuseum, Dusseldorf

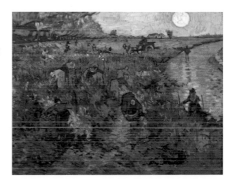

Vincent van Gogh
The Red Vineyard, 1888
Oil on canvas, 75 x 93 cm
Pushkin Museum of
Fine Arts, Moscow

Wassily Kandinsky

was born in Moscow in 1866. He first studied and afterwards taught law at Moscow University. He moved to Munich in 1896 and took painting and drawing classes at an independent art school in order to gain entrance to the Munich Kunstakademie. By 1903 he had achieved some recognition as an important, sometimes controversial, artist and was exhibiting widely throughout Europe. Kandinsky met Franz Marc in 1910 and together they formed the editorial collective Der Blaue Reiter. The first edition of the Blue Rider *Almanach* came out in 1912, a year after Kandinsky had published his seminal book on the source and importance of abstraction in painting, *On the Spiritual in Art*. Kandinsky went to Moscow at the outbreak of the First World War and returned to Germany only in 1922, this time to live and work in Berlin. From 1923 to 1933 he taught at the Bauhaus alongside such figures as Paul Klee, Lyonel Feininger, Oskar Schlemmer, Walter Gropius and Arnold Schönberg. He moved to Neuilly-sur-Seine near Paris in 1933 and died there in 1944.

Study for Composition II

1909–10. Oil on canvas, 97.5 x 130.5 cm
Solomon R. Guggenheim Museum, New York

'Colour is the keyboard, the eyes are the hammer, the soul is the piano with the strings. The artist is the hand that plays, touching one key after another to cause vibrations in the soul.'
Wassily Kandinsky

Kandinsky came from a cultured, rather musical family and this influenced his attitude to painting from the outset. Although musical sound can carry impressions of places, natural events and even of particular characters, it does so through non-mimetic or abstract means and it was this knowledge that pointed Kandinsky towards an exploration of the abstract qualities of colour, mark, line and shape.

It was for this reason, too, that he started to use musical terms such as 'composition' and 'improvisation' to refer to different strands within his work. The two main musical influences prior to his meeting with Arnold Schönberg in 1911 came from Richard Wagner's notion of the *Gesamtkunstwerk*, a 'total work of art' incorporating words, music and vision — and Aleksander Scriabin's quest to establish a systematic relationship between colour and musical sound. This last came close to Kandinsky's expressed desire to link colours to feelings in painting. Kandinsky painted seven 'Compositions' before the outbreak of the First World War, the last five of which overlapped his burgeoning friendship with the composer Schönberg, the inventor of atonal music.

Composition II 1910, destroyed. Oil on canvas, dimensions unknown

Composition VII 1913. Oil on canvas, 195 x 300 cm
State Tretyakov Gallery, Moscow

Although some individual forms are carried over from one into the other, this study for the second of Kandinsky's 'Compositions' is strikingly different from the final version, which was destroyed during the Second World War. Where the final painting was vertical in format, as we know from photographs, the study is horizontal. Where the finished painting had a closed and controlled look to it, the study is more open and spontaneous in feeling, much more in tune with Kandinsky's intention to produce 'unconscious expressions of events from one's inner nature ... that occur suddenly'. Like much modern music that rejected melodic continuity and worked instead with disruptive dissonance, Kandinsky's vision seems at first sight to be fragmentary: a landscape that has been construed in fits and starts, populated by partly realized, just about recognizable animate and inanimate presences calling to mind people, animals, trees, rocky outcrops, hills and sky. Ultimately it is the artist's use of colour, the way that he threads the reds and yellows through and across things that gives this study its visual coherence.

Ernst Ludwig Kirchner was born in Aschaffenburg in 1880.

Between 1901 and 1905 he studied architecture and engineering at the Saxon Institute of Technology in Dresden. He continued to live in Dresden until 1911 when he moved to Berlin. In Dresden he was the founder, with Fritz Bleyl, Erich Heckel and Karl Schmidt-Rottluff, of the Expressionist group of artists who adopted the name 'Die Brücke' (The Bridge). Their collective aim was to live the arcadian, communal life of the noble 'savage', free from the rule-based existence of modern urban life. Kirchner moved to Switzerland for health reasons in 1917, where he concentrated on mountain landscapes and wrote his *Davos Diaries*. He died there in 1938.

Marcella

1909–10. Oil on canvas, 76 x 60 cm
Moderna Museet, Stockholm

Marcella is a typical Dresden-period painting. It represents one of three strands that tend to dominate Kirchner's work in the early years of Die Brücke: city landscapes; exotic female entertainers and prostitutes; and, as in the case of *Marcella*, young pubescent girls. It is startlingly direct, both as a painting and as an image. Kirchner's early work was influenced by Vincent van Gogh. He first came across van Gogh's work during a six-month stay in Munich, where he was studying composition at the Educational and Experimental Studio for Applied and Liberal Arts, and later at the Arnold Gallery back in Dresden. Although uncomfortable with the feelings of anxiety he felt permeated van Gogh's work, Kirchner greatly enjoyed the vigour and breadth of the Dutchman's colours and his daring use of 'discordant' hues, as taught him by Georges Seurat. Both are seen in *Marcella*. The reddish-pink body, folded arms and crossed legs are dashed in using very few brushstrokes; the drawing of the face and arms is picked out with sudden flashes of intense green. There are two obviously van Gogh-like features: the seat-cover and decorative Japanese screen on the left of the painting and the discordant use of a blue-grey line to separate wall and floor on the right. The image is both daring and forthright, even sexually provocative. The subject, Marcella, a flat-chested adolescent with the beribboned hair of a schoolgirl and large, painted-black, very appealing eyes, looks straight out of the picture at the painter/viewer.

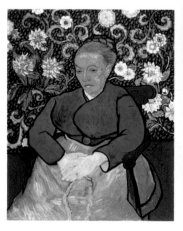

Vincent van Gogh, **Portrait of Augustine Roulin** 1889. Oil on canvas, 92 x 73 cm
Kröller-Müller Museum, Otterlo

Die Brücke and Dreams of Sexual Freedom

The sexual aspect of Die Brücke is not often discussed. Basing th thinking on what was something misconception about the sex live primitive peoples, in particular t in Melanesia and Polynesia, who were widely thought to enjoy tot: sexual freedom—copulation with end—the artists of Die Brücke wanted to create a similarly free existence in Dresden. Imitating customs of the natives of the Pal Islands, they set up 'houses of m in their studios—something between a den of seduction and a shrine—as places of sexual ce ration and conquest. In Kirchner case, under the guise of 'studyin;

the nude in all its natural simplicity', it seems
to have involved having fantasy, if not real,
sexual relationships with young girls, alongside
his promiscuous involvements with female 'Negro'
dancers and what he called 'foreign' prostitutes.
The name Die Brücke was suggested by the painter
Schmidt-Rottluff in a conversation with Kirchner
and Heckel. Apart from referring to the many
bridges crossing the River Elbe in Dresden —
'linking', as Kirchner said, 'one side with the other'
— it was not fixed and carried with it several
different meanings.

Franz Marc was born in Munich in 1880. He planned to study philology, but after
a year of military service changed his mind and enrolled at the Munich Academy
of Art instead. While still a student he visited Paris to see the work of the Impres-
sionists. After completing his studies he returned there and this time came under
the influence of Vincent van Gogh and Paul Gauguin. In 1910 he visited the Henri
Matisse exhibition in Munich, which left a deep impression on him. Marc had
his first solo exhibition in 1910 and through it made friends with August Macke.
In 1911 he joined Wassily Kandinsky and Alexei Jawlensky in the young artists'
group known as the Neue Künstlervereinigung München (NKVM). With Kandinsky
he formed the breakaway organization called 'Der Blaue Reiter' (The Blue Rider),
originally a name they had given to their *Almanach*, one of the most important
art manifestos of the 1900s. Marc enlisted in the army at the outbreak of the
First World War and died at Verdun in 1916.

Horse in a Landscape

1910
Oil on canvas, 85 x 112 cm
Folkwang Museum, Essen

In 1909, when Marc left Munich for the countryside of Upper Bavaria, he was
hoping to discover something of the natural world's 'purity, truth and beauty'.
It almost certainly helped him to simplify and condense both the pictorial language
and the content of his paintings. His declared aim was to discover 'the absolute
essence' of art, which he felt required a new kind of precision, a degree of abstract
stylization applied to recognizable things — trees, birds and animals — powered by
a new 'expressiveness' of line and colour. *Horse in a Landscape* (1910) is one of the
earliest paintings in which Marc managed to escape the habit of naturalistic colour.
He had spent the late summer discussing painting with August Macke, who
had convinced him of the abstract and symbolic potential of pure colour. Marc
immediately set about inventing his own symbolic theory of colour, which he
invested with powerful psychological content. He started out by attributing specific
qualities to the three primary colours. He saw 'blue' as the masculine element
representing austerity, durability and intelligence; 'yellow' as the feminine
characteristics of gentleness, joy and sensuality; and 'red' as standing for the
material world — heavy, combative and brutal. To mix these primary colours
was also to mix their particular properties. Add yellow to red and you temper its
heaviness and brutality with gentleness and sensuality. Add blue to red and you
temper its combativeness with austerity and durability. To read Marc's *Horse in
a Landscape*, bearing in mind the fact that he painted it at the same time that
he was evolving his symbolic theory of colour, changes it from a simple picture
into a compelling psychological drama.
Marc said on many occasions that he preferred the 'unadulterated' purity of
animals to the 'ungodliness' of human beings. And it seems that he favoured
animals in painting as vehicles for his own strongest feelings and emotions.
A notable example is the prophetic *Fate of the Animals*, painted in 1913 with
the First World War pending, in which a noble 'blue' antelope rears up in fear
at the onset of cataclysmic darkness.

the Animals, 1913
anvas, 195 x 263.5 cm. Kunstmuseum, Basel

August Macke, **Vegetable Fields**, 1911
Oil on canvas, 47.5 x 64 cm. Städtisches Kunstmuseum, Bonn

Henri Matisse

Music

1910
Oil on canvas, 260 x 389 cm
State Hermitage Museum, St Petersburg

Between 1907 and 1910 Henri Matisse painted a number of medium- and large-scale figure compositions; seemingly simple in form and colour, they picked up on some of the discoveries of *The Joy of Life* (1905–06). The subject-matter of these new paintings was people at play, dancing and making music. By this time Matisse had followed his friend and fellow Fauvist André Derain to the south of France and had taken a studio in Collioure near Perpignan on the Mediterranean coast, close to the Spanish border.

'What I dream of is an art of balance, of purity and serenity devoid of troubling or disturbing subject-matter ... a comforting influence, a mental balm — something like a good armchair.'
Henri Matisse

Given that all paintings — all works of art — generate sympathetic responses in the mind, the nervous system and sometimes even in the flesh of the viewer, it is not unreasonable to say that paintings are always about the body. But this is much more obviously true where the figure is the focus and subject-matter of the work. Take a painting like Matisse's *The Dance* (1909–10) — we seem to understand it as much with the body as with the mind. Through a form of kinaesthetic empathy we can enjoy the rhythmic pleasures of the dance, the almost airborne movement of the body and the fluid articulation of limbs, without experiencing any of the physical stresses and strains that might accompany the actions themselves. In *Music* a very different kind of empathic response is called into play: that of synaesthesia. The overall image — the closeness of tone between the green, the blue and the red — resonates like a composite sound, a single chord, while the figures form a 'visual' cadence. Like single notes sounded for their own precisely delineated span of time, they are made to rise and fall within the overall space of the painting by the way that they act against the ground.

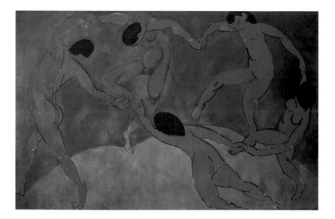

The Dance, 1909–10
Oil on canvas, 260 x 390 cm
State Hermitage Museum, St Petersburg

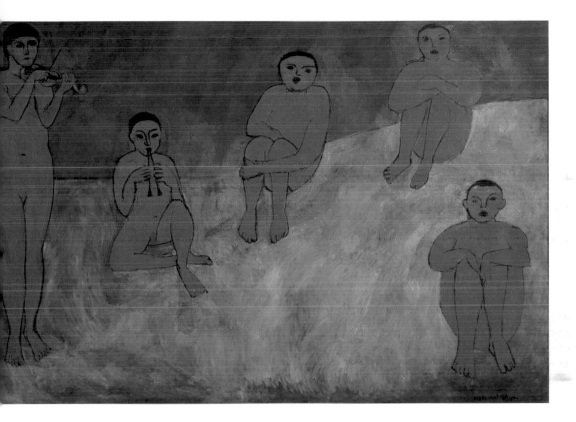

Matisse, European Colour Painting and
American Colour-Field Painting

There is no doubt that by putting the emphasis on flat, interlocking areas of high-saturation colour, Matisse — treading in the footsteps of Paul Gauguin — was largely responsible for defining the Modernist approach to colour in European painting. Many of the most prominent painters of the late School of Paris were influenced by him, as were a number of the best-known British painters of the postwar period, artists such as Patrick Caulfield, David Hockney and Howard Hodgkin. But Matisse was also important to the evolution of American abstract painting and colour-field painting in particular. The link was the greatly respected Matisse-obsessed painter Milton Avery, who, although he remained a figurative painter, wielded considerable influence through his friendship with Mark Rothko and Barnett Newman.

Pablo Picasso

Daniel-Henry Kahnweiler

1910
Oil on canvas,
100.5 x 72.6 cm
The Art Institute
of Chicago

Picasso spent the summer of 1910 painting in
the Catalan coastal village of Cadaqués; he later
described his visit there as a time of intense struggle.
In his paintings of figures he was still trying to
dispense with volumetric form: the 'naturalistic'
topology of the human body. He felt he was stuck
with a hybrid visual language that clung stubbornly
to the figurative and resisted the degree of abstraction
he was seeking. At Cadaqués he tried to tackle this
problem head on and was reasonably successful
where drawing was concerned, but was unable
to transfer the advances made on paper into
the final painting.

Portrait of Ambroise Vollard
1910. Oil on canvas, 93 x 66 cm
Pushkin Museum, Moscow

In September, after his return to Paris, Picasso
started the portrait of Kahnweiler, and it became
clear that he had made an important breakthrough in
Cadaqués. As Kahnweiler himself was to assert some
years later, where the analytical phase of Cubism was
concerned, 'he had taken the great step ... had pierced
the closed form ... a new technique had been invented
to fulfil new purposes'. To illustrate the change to
which Kahnweiler refers, we need only compare
the portraits of Wilhelm Uhde and Ambroise Vollard
painted in the spring and summer of 1910 with that
of Kahnweiler, completed later in the same year.
In the earlier paintings, the painted planes function
almost as surface embellishments to naturalistic
and volumetric forms that still show through from
underneath. By contrast, in the portrait of Kahnweiler,
all is surface construction. The subdued colour range,
chiaroscuro illumination and the insistent 'Divisionist'
mark-making turn the surface into something
reminiscent of a carved relief. There are no volumes

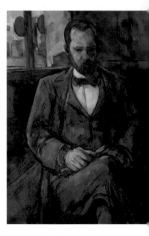

Paul Cézanne
Portrait of Ambroise Vollard,
Oil on canvas, 100 x 81 cm
Musée du Petit Palais, Paris

as such, indeed the overall pictorial space is too shallow to contain them.
Even the planes are rendered insubstantial and appear — most of them —
to melt away as transparencies or into shadow.
By abandoning illusionistic form, Picasso had removed the traditional framework
upon which likeness in portraiture had always been hung. In his painting of
Kahnweiler, he invented a whole new way of signalling a particular identity by
turning characteristic features — the dealer's quiff, his long nose and his clasped
hands, for example — into the signs that we now refer to as 'tags' or 'keys'.

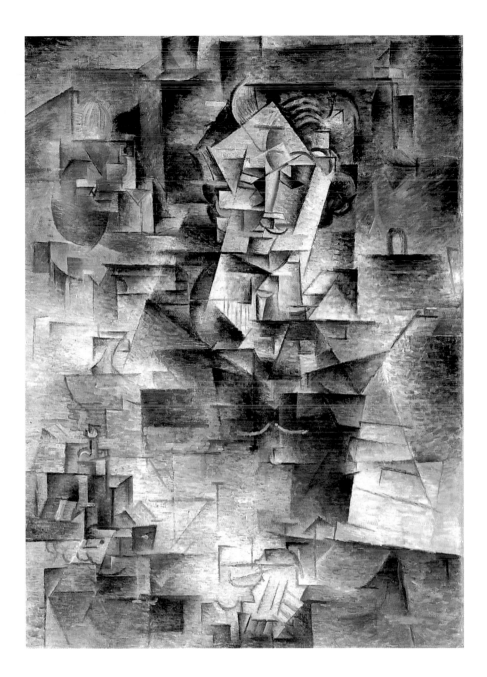

'Divisionism' The term as first used to describe the painting method of the Pointillist Georges Seurat. In its original usage, then, it meant the systematic placing of small dots of pure colour that, at an appropriate viewing distance, would 'mix in the eye' to form solid but luminous masses of tone and colour. The term became more widely used and lost something of its specificity when it was adopted by the Symbolists, the Orphists and the Fauve painters to mean any regular but broken pattern of brushmarks. In Analytical Cubism it refers to the flickering horizontal marks that are used to open up the surface of the picture in order to render 'things' less substantial.

Umberto Boccioni

was born in Reggio Calabria in 1882. He spent his childhood in Forlí, Genoa, Padua and Catania. Having arrived in Rome in 1899, he enrolled at the Scuola libera del nudo, where he studied drawing and also met Giacomo Balla, Gino Severini and Mario Sironi; Boccioni and the other three now set about evolving their own version of Divisionism. During 1906 he visited Paris and travelled in Russia. Eventually, he settled in Milan in 1907. Boccioni met Filippo Tommaso Marinetti in the winter of 1909–10 and at the writer's insistence joined the Milan Futurist Group. He signed the *Manifesto of Futurist Painters* in 1910 and the first of his States of Mind paintings came later in the same year. In 1912 he wrote the *Technical Manifesto of Futurist Sculpture* in which he contested Balla and Severini's idea of the 'space/time continuum' — an immediate, dynamic and ever-present reality — arguing instead for a synthetic amalgam of 'what one remembers and what one sees'. In 1915, with other leading members of the Futurist group, he enlisted in the Lombard Volunteer Battalion of Cyclists and Motorists and served at the front. Having been reassigned to the field artillery, he died a year later at the age of thirty-three, after falling from a horse.

'We create the new aesthetic of speed. We have almost abolished the concept of space and notably diminished the concept of time. We are thus preparing the ubiquity of multiplied man.' **Filippo Tommaso Marinetti**

States of Mind I: Those Who Go

1911. Oil on canvas, 70 x 95 cm
Civico Museo d'Arte Contemporanea

While he was keen to pay lip-service to the achievements of the Cubist painters, Umberto Boccioni also expressed his reservations, claiming that their paintings 'appear more daring than they really are'. Despite its modernistic 'atomization', he felt that Analytical Cubism was still wedded to the static, well-balanced image and so failed to reflect the dynamic conditions of modern life. The depiction of movement — Boccioni and his circle were entranced by the idea of 'speed' — was central to the Futurist project. As Marinetti suggests, through 'speed' it seemed possible to collapse space and compress time into a new 'noctambulism', a lived combination of day and night in which time appeared to stand still. In Boccioni's case, because of his insistence upon the importance of memory, this vision acquired

States of Mind II: Those Who Stay, 1911
Oil on canvas, 70 x 95.5 cm
Civico Museo d'Arte Contemporanea, Milan

States of Mind I: The Farewells, 1911
Oil on canvas, 70.5 x 96 cm
The Museum of Modern Art, New York

a crucial psychological dimension. While the 'speed' of modern life might very well bring a new quickness to the human spirit, it also threatens a more intense awareness of loss, new possibilities for psychological pain, and new levels of anxiety. In Boccioni's paintings the Divisionist brush work takes on real psychological significance. A number of the paintings have a moody, almost oceanic feel to them. While the figures being lashed into active wakefulness by modernity's storm in a painting like *States of Mind I: Those Who Go* experience heady feelings of acceleration, they are also being bent and reshaped by it. Meanwhile the contrasting companion painting, *States of Mind II: Those Who Stay,* has a vertically drenched look to it and the figures have been turned into detached, semi-aqueous creatures that move about like sleepwalkers, hardly conscious of each other.

Egon Schiele

was born in 1890 in Tulln an der Donau, near Vienna. He was just sixteen when he was accepted as a student at the Akademie der bildenden Künste in Vienna. In 1907 he met Gustav Klimt, who was greatly impressed by his ability as a draughtsman. After disagreements with his professor, he left the Academy in 1909 to form the Neukunstgruppe (New-Art Group). He had his first one-person show in 1911 at the prestigious Galerie Miethke in Vienna. In 1912 Schiele was arrested and charged with the corruption of a minor. In the event, the charge was dropped, but he was convicted instead for allowing children access to the 'immoral' drawings in his studio. He spent twenty-four days in prison and was forced to witness the ceremonial incineration of one of the offending works. He exhibited his paintings for the first time with the Vienna Secession in 1913, the same year in which he joined the staff of the Berlin periodical *Die Aktion* with the promise of a special issue devoted to his drawings. Schiele was conscripted into the army in 1915 and remained in military service until his death from Spanish influenza in 1918. He was still only twenty-eight years old.

Black-Haired Girl with Skirt Turned Up

1911
Gouache, watercolour
and pencil, 55.9 x 37.8 cm
Leopold Museum, Vienna

The story goes that Schiele discovered his ideal female body in the person of the American dancer Ruth Saint-Denis, the international star of 'free, expressive dance', who performed in Vienna in the summer of 1909. However, according to his biographer Arthur Roessler, there was someone else much closer to home, an exotic dancer known as Moa, the female partner of his friend and fellow artist Erwin Osen. Roessler's description of Moa conjures up a very particular Schiele type, 'a willowy dancer with a bone-white face, frozen into masklike immobility beneath blue-black hair . . . an unseeing look in big jet-black eyes which glinted dully beneath the heavy, long-lashed eyelids with their brown-blue shadows'. We do not know who the model for *Black-Haired Girl with Skirt Turned Up* was, but she is certainly a similar bodily and facial type. Here, though, the erotic undertone familiar from drawings like the *Standing Nude*, also from 1911, has become entirely explicit through the provocative uncovering of the model's genital region. More significantly, the uncovering also takes on something of the character of a wounding, giving rise to an altogether more ambiguous and violent reading. It is an image in two halves—top and bottom—but it is also split between inside and outside. At first sight, the figure seems merely to be at rest, apparently sleeping and dreaming, but she also lies callously exposed. The truncated legs render her helpless and a site of imminent violation. As a subject she is caught between her own pleasurable fantasies and the more disturbing thoughts that Schiele puts into the mind of the viewer.

1
, watercolour and
paper, 48 x 31 cm
ollection, on extended loan to
eum of Modern Art, New York

'The erotic work of art has a sanctity all of its own.' Egon Schiele

Standing Nude, 1911
Watercolour and black crayon
on paper, 53.5 x 28 cm
Private collection

Marcel Duchamp was born in 1887 near Blainville in Normandy.

His father was a notary and his mother, the daughter of a painter and engraver. In the teeth of some paternal opposition, Duchamp and his two older brothers all chose to become artists. The oldest, Gaston (a painter), took the name of Jacques Villon and the second brother, Raymond (a sculptor), called himself Duchamp-Villo Marcel Duchamp moved to Paris to join Jacques Villon in 1904 in order to attend classes at the Académie Julian. He exhibited publicly for the first time at the Salon des Indépendants of 1909. At this time, besides meeting the Cubists Albert Gleizes Jean Metzinger and Fernand Léger, he was also introduced to Francis Picabia, with whom he established a firm and lasting friendship. Duchamp referred to 1912 the year in which he painted his *Nude Descending a Staircase, No 2*, as one of the most significant in his development as an artist, but it is arguable that the crucial shift in his thinking really occurred in 1911 with the painting *Sad Young Man on a Train*.

Sad Young Man on a Train

1911. Oil on textured cardboard, 100 x 73 cm. Peggy Guggenheim Collection.

By 1911, at the time of his transitory yet acute interest in Cubism, Duchamp had discovered the chronophotographic images of human movement made by the physiologist Étienne-Jules Marey and the work of his contemporary, the British-born, American photographer Eadweard Muybridge. Marey's invention, the rotatin disc shutter, allowed him to record multiple exposures on one plate, and his metho of drawing white lines and spots onto figures dressed from head to foot in black so as to produce a sharper and more diagrammatic image seems to have led Duchan to deploy the progressive slitlike forms — he himself christened the technique 'elementary parallelism' — moving across the canvas, that appear for the first time in *Sad Young Man on a Train*. Significantly, this painting is inscribed on the back 'Marcel Duchamp nu (esquisse) Jeune homme triste dans un train'. We must read it, then, as an autobiographical work that involves self-exposure. Duchamp himsel said that it refers to a particular journey he made — smoking a pipe — between Paris and Rouen to visit his recently married sister Suzanne. When asked why the young man is sad — '*triste*' — he said that it was merely a matter of having discovered an attractive alliteration between '*triste*' and '*train*', but there was clearly something more personal at stake. It is thought that Duchamp had a more than brotherly affection for Suzanne and came to view her marriage in 1911 as an act of betrayal. In the immediate aftermath of the wedding and prior to paintin; *Sad Young Man on a Train*, Duchamp made three works that record his feelings of frustration and loss, *Yvonne and Magdeleine Torn in Tatters*, followed by *Apropos of Little Sister* and the distant *Dulcinea*, a real woman whom Duchamp quite regularly saw on the Avenue de Neuilly walking her dog, but never spoke to.

Yvonne and Magdeleine Torn in Tatters, 19
Oil on canvas, 60 x 73 cm
Philadelphia Museum of Art

a, 1911
nvas, 146 x 114 cm
ohia Museum of Art

'Under an appearance of almost romantic
timidity, he [Duchamp] possessed
an exacting dialectical mind, in love
with philosophical speculation
and absolute conclusions.'
Gabrielle Buffet-Picabia

Egon Schiele

Cardinal and Nun (Caress)

1912
Oil on canvas, 70 x 80.5 cm
Leopold Museum, Vienna

The year 1912 was a difficult time for Egon Schiele. His arrest and subsequent imprisonment took up most of the month of April, and when he was released he wanted nothing more than to travel and clear his head. He spent the month of May in Carinthia and Trieste before returning to Vienna in June. He borrowed Erwin Osen's studio for the summer and found one of his own only in November. Even so he painted some memorable and important works during 1912, including *Cardinal and Nun (Caress)*.

Intended as an affectionate parody of his friend Gustav Klimt's famous painting *The Kiss* (1907–08), Schiele's *Cardinal and Nun* wittily reverses the older artist's winsome Austrian romanticism. While Klimt's sumptuously robed man is being attentively seductive and the woman is at the point of accepting — with already closed eyes in anticipation of the more intense sexual adventure that is yet to unfold — Schiele's cardinal is aggressively predatory and his nun seems to be in a state of shock and doing her level best to resist his advances. Typically, though, things are not quite what they seem at first sight. Though they are kneeling as if in prayer, underneath their habits they are both more naked than is proper. We have no way of telling whether the outward show matches the hidden reality. A comparison of the language of hands tells it all. In Klimt's *Kiss*, the man's hand — the only one that is visible — holds, touches and caresses, while the woman's hands have all the sensuality and gestural grace of an Indian temple dancer. In Schiele's parody, the hands of both the cardinal and the nun seem possessed by the cold rigidity of institutionalized prayer. It is as if each has interposed his/her body between the praying hands of the other. Even so the painting has a powerful erotic charge, which, as with the Klimt, is in part due to the upwardly moving phallic form pitched against the void. Colour plays an important part in this, too. Red and black speak of the admixture of attraction and repulsion — the 'alloying', as Freud calls it — of sex and death, blood and the earth.

Schiele and Klimt

Schiele's *Cardinal and Nun* is not just a parody, it is also a slightly tongue-in-cheek homage to his mentor. Klimt had supported Schiele since his rebellious student days. He defended him against his critics, ensured his inclusion in major exhibitions and regularly introduced him to gallerists and important collectors. A few weeks before embarking on *Cardinal and Nun*, Schiele painted its compositional forerunner, *Hermits*, a double portrait of himself and Klimt. The older man stands behind the younger. Both are dressed in priestlike black robes. However, far from being a dominant presence, Klimt is shown here as a dreamily parasitical, even a dependent figure. Behind them, treading the distant horizon and connected to them by white lines, is the red-headed model Wally Neuzil, rumoured to have been the mistress of both men.

Gustav Klimt, **The Kiss**, 1907–08. Oil and gold on canvas, 180 x 180 cm
Österreichische Galerie Belvedere, Vienna

Hermits, 1912. Oil on canvas, 181 x 181 cm
Museum Leopold, Vienna

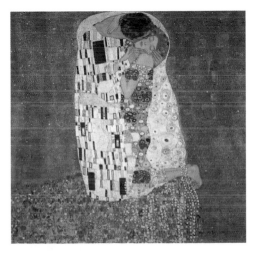

Marcel Duchamp

Nude Descending a Staircase, No 2

1912
Oil on canvas,
146 x 89 cm
Philadelphia
Museum of Art

In 1912 Duchamp made four, art-historically important paintings on canvas.
The first of these, *Nude Descending a Staircase, No 2*, came early in the year;
it was followed in the spring by *The King and Queen Surrounded by Swift Nudes*
(Duchamp's favourite work from that time) and in the summer by *The Passage
from Virgin to Bride* and *Bride*. After that he made only four more paintings: two
versions of *The Chocolate Grinder*, which came in 1913 and 1914 respectively,
followed by *Network of Stoppages* (1914) and the commissioned work *Tu m'* (1918).
The first of the 'readymades' (not yet described as such), *Bicycle Wheel*, was made
in 1913, followed by *Pharmacy* and the first true readymade, *Bottle Rack*, in 1914.
For Duchamp, the invention of the readymade marked the end of painting as a
possibility by rendering obsolete the craft-based aesthetic on which it relied.
As he said in an unpublished interview with Harriet, Sidney and Carroll Janis
in 1953, it allowed him to 'reduce the idea of aesthetic consideration to the choice
of the mind, not the ability or cleverness of the hand'.

By the time Duchamp came to paint this second and final version of *Nude
Descending a Staircase* he was already feeling sceptical about the activity of
painting. He had begun to formulate his opposition to what he called the 'retinal
shudder', in other words, the reduction of painting to the merely visual as opposed
to its traditional function as a vehicle for conveying religious, philosophical and
moral ideas. With this in mind, we can identify several different concerns in *Nude
Descending*, some of which are conveyed directly and others which are broadly
speaking metaphorical. The influence of Étienne-Jules Marey's photographic
analysis of human kinetics is immediately apparent, as is the artist's interest
in Analytical Cubism, especially in its use of the muted, earthy colours that he
discovered on his visits to the studios of Georges Braque and Pablo Picasso.
Duchamp also had more than a passing interest in mathematics. The year 1910 had
seen the publication of the first volume of Alfred North Whitehead and Bertrand
Russell's *Principia Mathematica*. Volume Two followed in 1912, in effect paving the
way for a 'meta-logical' approach to phenomena. After *Principia Mathematica*, as
the Austrian mathematician and logician Kurt Gödel would point out later, there are
no 'single decision problems, decisions are made incrementally, minute by minute'.
The male figure in *Nude Descending*, like the chronophotographic image of a man

walking down a slope made by Marey, is a cumulative
image. The naked figure is shown 'in passage' through
the painting from left to right; it is not contained by
the composition. The metaphorical suggestion, then,
is of an endless iteration — perpetual motion — but
also of energy running down.

Étienne-Jules Marey, **Man Running**, 1886–90, detail. Chronophotography

Reluctant Cubist

Duchamp was clearly
ted to the intellectual
te surrounding the Cubist
ers in Paris between 1910
912, and was influenced
ne aspects of their work,
s suspicious of their
ll direction, which he
s just another turn in the
ical screw of 'retinalism'.
knowledged the 'colour
ony' of the Cubists but
red that, in his case,
s 'applying a slightly
ent formula' He was
y dismissive of the
ists, whom he described
han Impressionists',
e expressed support,
ertain reservations,
e Surrealists, whom he
ded as taking a stand
st the 'retinal'.

The King and Queen Surrounded by Swift Nudes, 1912
Oil on canvas. 114.5 x 128.5 cm
Philadelphia Museum of Art

Robert Delaunay

was born in Paris in 1885. On completing his schooling, he took an apprenticeship with a firm of theatre designers and scenic painters. He started to paint in 1903 and had a measure of success almost straight away. His early work was neo-Impressionist in style, influenced by Paul Cézanne and the colour theory of Michel-Eugène Chevreul. He did his military service between 1907 and 1908 in Laon, and when he returned to Paris he came under the sway of the Cubists. He made the first of the 'Eiffel Tower' paintings in 1909. The following year he married the Russian artist Sonia Terk. At Wassily Kandinsky's express invitation, Delaunay participated in the first Blaue Reiter exhibition, held in Munich in 1911–12. His first one-person exhibition took place at the Galerie Barbazanges in Paris in 1912, the year in which he made the first of the 'Window' paintings. The Delaunays spent the First World War in Spain and Portugal, where they met and became friendly with Sergei Diaghilev, Leonide Massine and Igor Stravinsky and designed costumes and stage sets for the Ballets Russes. In the postwar period they undertook many public commissions. Delaunay died in Montpellier in 1941.

Window into Town

1912. Oil on canvas, painted pine frame, 46 x 40 cm. Hamburger Kunsthalle

The 'Window' paintings represent an important moment in the evolution of Delaunay's work. Here his earlier experiments in Impressionism, Divisionism and Cubism come together to form something that is distinctively his own. The poet and critic Guillaume Apollinaire quickly recognized their originality and importance and applied the term 'Orphism' to them (after the mythical poet and musician Orpheus because of their lightness, lyricism and musicality. Fascinated by the way that light transformed and recoloured the architecture and the internal space, Delaunay drew his original inspiration from the sunlight streaming through the stained-glass windows of the Church of Saint-Séverin in Paris. He had already painted a number of versions of the same interior in 1909 and 1910, all of them stolidly monochromatic and Cubist in manner. By contrast, the later paintings are all colour and light — luminosity and transparency. There is nothing in them that is solid; they are made entirely of advancing and receding, prismatically modulated, translucent layers of paint. In *Window into Town*, the overall permeability of the painted image is given further emphasis by the addition of a painted frame mounted flush with the canvas edge. The picture surface is unified, but we are made conscious of the space flowing across and moving in and out of the frame. This device gives real point to the deliberate ambiguity inherent in the title, namely the idea of a window 'into' (not onto) the outside world. This conflating of inside and outside gives the painting a poetically inflected, formal complexity of a kind that subsequently only surfaces in the early encaustic paintings of Jasper Johns.

Eiffel Tower in Trees, 1910
Oil on canvas, 126.5 x 93 cm
Solomon R. Guggenheim Museum, New York

'In order that art attain the limit of sublimity, it must draw upon our harmonic vision: clarity. Clarity will be colour with proportion; these proportions are composed of diverse elements, simultaneously involved in an action. This action must be the harmonic, synchronous movement of light which is the only reality.' **Robert Delaunay**

Saint-Séverin No. 3, 1909–10
Oil on canvas, 114 x 88.5 cm
Solomon R. Guggenheim Museum, New York

Gino Severini was born in the Italian hill town of Cortona in 1883 and moved to Rome in 1899. He studied drawing at the Scuola libera del nudo at the Accademia di Belle Arti, where he met Umberto Boccioni. At the time Severini was interested in Socialism and was reading the works of Karl Marx and Mikhail Bakunin, as well as the writings of Arthur Schopenhauer and Friedrich Nietzsche. In 1906 he moved to Paris, attracted by the city's open, cultural life. He was quick to absorb the lessons of Analytical Cubism and in 1910 travelled to Milan to sign the *Manifesto of Futurist Painters*. He kept his fellow Futurists informed about cultural events in Paris through a typically outspoken correspondence with Boccioni. Although he shared the Futurists' interest in modern technology, prior to the First World War the subject-matter of his work had a distinctly French feel to it, especially in his paintings of Parisian concert cafés. Declared unfit for military service, Severini nevertheless produced some of the most compelling images of war. After 1920 he divided his time between Paris and Rome. He died in Paris in 1966.

The Blue Dancer

1912. Oil and sequins on canvas, 61 x 64 cm
The Gianni Mattioli Collection, Milan

The Blue Dancer is Severini's best-known work. It manifests all the characteristics of his early Parisian phase. While retaining some elements from Analytical Cubism it also employs a vocabulary of forms and devices for dealing with the figure in motion that belongs entirely to Futurism. Where the Cubists fragment things by imagining an observer who moves to take up different viewpoints (without relinquishing a strong sense of the static unity of the object), the Futurists see even inanimate objects as endlessly restless, vitally alive and in motion. The unitary form —body or thing—is allowed to multiply and expand to encompass everything in its immediate vicinity, in the words of Carlo Carrà, 'in a cacophony of planes, tones and colours ... which is like life itself'. Futurist forms tend to be more firmly drawn than their Cubist equivalents, which seem to exist in a space that is at once more uncertain and more fluid. In *The Blue Dancer* the insistent interlocking pattern of tonally modelled, arcing planes produces an almost audible, metallic equivalent of the dance, which is strongly reinforced by Severini's application of sequins to the areas of the picture plane closest to the viewer's eye.

Dynamic Hieroglyph
of the Bal Tabarin
1912
Oil on canvas,
161.5 x 156 cm
The Museum
of Modern Art,
New York

Carlo Carrà, **Words-in-Freedom:
Interventionist Demonstration**, 1914
Collage on pasteboard, 38.5 x 30 cm
Private collection

Futurism and the Vitalist Inheritance

Out of its origin in Greek metaphysical thought, Vitalism favours the fluid
state of 'becoming' over the state of completion suggested by the notion of
'being'; it prefers movement to stillness, values action above inaction and
enjoys flux more than structure. In short, Vitalism envisages life in terms
of a force that arises from within and produces its own very special type
of order. For this reason shades of Vitalist thinking frequently emerge in
the thinking of artists and this is particularly true when, like the Futurists,
they are speaking on behalf of some imagined, new universal order.
As Carlo Carrà wrote in 1913: 'We Futurists seek to identify with the core
of things through the power of intuition, so that our Ego will merge with their
uniqueness in a complex whole. Thus we depict the planes of a picture like
a spheric expansion in space, obtaining the sense of perpetual motion which
is innate in every living thing. Only this way can we express the soul
and atmosphere of all things.'

Marcel Duchamp

Bride

1912
Oil on canvas, 89.5 x 55 cm
Philadelphia Museum of Art

In 1912 Duchamp spent the months of July and August 'in exile' in Munich. Later he described these months as 'the scene of my complete liberation'—without further explanation. However, we know that it was during his stay there that he first conceived the large-scale work that he initially named (in a drawing) *The Bride Stripped Bare by her Bachelors*. The final version of this work, with the addition of the word 'Even', is now commonly referred to as *The Large Glass*. It was in Munich that he began to assemble the collection of sixteen written and drawn notes that, along with the drawing *Avoir l'apprenti dans le soleil* (To Have the Apprentice in the Sun), formed the cryptic guide to *The Large Glass* which was first made public as the *Green Box* of 1934.

If *Nude Descending a Staircase* deals with the idea of 'passage' in an external sense by picturing a body passing through space, the two paintings that followed, *The Passage from Virgin to Bride* and *Bride*, turned it into something that was conspicuously internal, unseeable and deeply erotic. In *The Passage from Virgin to Bride* the term 'passage' straight away assumes a vaginal significance, but it also points to the invisible change of status, with all of its sexual and social ramifications, incurred by a supposedly virginal woman when she consummates her marriage. *Bride* carries the sexual metaphor of 'passage' a significant stage further by both abstracting and mechanizing it. Duchamp's image of the bride refers to nothing that we can see and only analogously to real processes occurring in the female body. Instead, it presents us with a picture of sexual exchange in the instrumental guise of an imaginary fluid. Here we are implicitly asked to conceive of a liquid in 'passage' through a device that is pictured by the painting, but is not its subject. *Bride* was only ever seen by Duchamp as one step in the complex procedures and methods that would eventually be deployed in the making of *The Large Glass*. Initially, the image was made to be transferred photographically to the upper, 'bride' section of *The Large Glass*. It shows the 'virgin' as a 'motor'

powered and lubricated by 'love gasoline' drawn from the 'sex cylinder' or 'oscillating tub' and ignited by a spark from the magneto, to produce beyond the limits of the canvas, the 'cinematic blossoming' of Duchamp's bride.

The Passage from Virgin to Bride, 1912
Oil on canvas, 59,4 x 54 cm
The Museum of Modern Art, New York

Influence of
Raymond Roussel

...amp went to see a stage
...n of Raymond Roussel's
...tic novel *Impressions*
...ica with Francis
...a, the latter's wife
...elle Buffet-Picabia, and
...ume Apollinaire in May
...e 1912, shortly before
...: Paris for Munich.
...he returned he was
...y citing it as an
...tant influence on *The*
... *Glass*, declaring that 'it
...oussel who showed me
...ay'.

...nfluence seems to have
...its mark on two levels.
...y Duchamp was greatly
...: by the writer's belief
...: work of literature
...: contain nothing real,
...:servation of the world,
...g but combinations of
...:etely imaginary objects'.
...dly he was entranced by
...el's style which involved
...:ate word games, puns
...:rbal distortions, all
...:ted in an entirely
...:-of-fact way.

The Bride Stripped Bare by her Bachelors, Even (The Large Glass), 1915–23
Oil, varnish, lead foil, lead wire, and dust on two glass panels, 277.5 x 176 cm
Philadelphia Museum of Art

Giorgio De Chirico, the older brother of Andrea De Chirico (later

known as Alberto Savinio), was born to Italian parents in the Greek town of Volos.
He was educated at home under his mother's supervision; the main emphasis
of his schooling was on classical history, languages and Greek mythology.
He was also taught different systems of technical drawing by his father, who
was a railway engineer employed by the Greek government. De Chirico studied
drawing and painting at the Higher School of Fine Arts in Athens and afterwards
at the Akademie der Bildenden Künste in Munich and the Accademia di Belle Arti
in Florence, where he fell under the spell of the Symbolist painters—the Swiss-
born Arnold Böcklin and the German Max Klinger—and the philosophy of
Friedrich Nietzsche.

1913. Oil on canvas, 73.5 x 100.5 cm. Peggy Guggenheim Collection, Venice

The Red Tower was painted during what is commonly referred to as the

'Piazza period' of De Chirico's work: paintings and drawings made between 1910
and 1913 that were affected by De Chirico's reading of Nietzsche. The earliest of
these works were directly influenced by the imagery of Böcklin, but this connectio
quickly receded into the background as De Chirico deepened his reading of
Nietzsche and his understanding of the idea of *Stimmung*, which refers to both
'atmosphere' and 'mood'. The Piazza, with its regimented colonnades, its desert-
like open spaces and very particular *Stimmung*—seen at noon when there are no
shadows, or in the late afternoon as dusk falls and long shadows form mysterious
pools of darkness—seems the perfect setting for 'metaphysical revelation'.
The tower is a common feature in these works, but it signifies a transcendent forc
—the Nietzschean 'will to power'—rather than symbolizing the unconscious,
phallic energy suggested by Freud.
Most of the key characteristics of De Chirico's work from this period are found
in *The Red Tower*: a stagelike operatic space; raking sunlight; symmetrical,
almost paper-thin architecture; false or contrived perspectives; a cloudless deep
blue sky that lightens dramatically towards the horizon; a landscape of red
and yellow earth tones; disappearing boxcars and truncated monuments.

**The Departure
of the Poet**, 1912
Oil on canvas, 86 x 66 cm
Private collection

In Memoriam Friedrich Nietzsche

The talismanic, half-silhouette of the equestrian statue of King Carlo Alberto
that still stands in the Piazza that bears his name at the head of the Via Carlo
Alberto in Turin ties De Chirico's *Red Tower* absolutely to the person of Nietzsche.
Indeed, its presence turns the painting into a homage to the great philosopher.
The Via Carlo Alberto was where Nietzsche lived during his time in Turin and where
he wrote his last great work, the heavily ironic yet elegant *Ecce Homo*, completed
in 1888. Most significant of all, the Piazza Carlo Alberto was the site of Nietzsche's
collapse in January 1889 and the onset of his descent into madness.

and Enigmas of a Strange Hour, 1913
vas, 83.5 x 129.5 cm. Private collection

Wassily Kandinsky

made his first completely abstract watercolour in 1910 but it was 1914 before all deliberate referential traces disappeared from his larger works. During this transitional period he mainly focused his attention on landscape painting that seemed to offer the best opportunity to explore abstract visual language, while at the same time retaining some notion of an identifiable subject. His inclination was towards non-figuration but he required firm theoretical ground upon which to make the final move. Some of the necessary underpinning he provided for himself through his own theoretical writing, supported by his reading in philosophy and theosophy, notably the cosmological writings of Madame Blavatsky and Rudolf Steiner's *Theosophie* (1904). Of particular importance was Wilhelm Worringer's classic work *Abstraction and Empathy*, first published in 190 Kandinsky was greatly taken with Worringer's notion that the 'work of art is an independent organism on the same level as nature'.

Painting with Green Centre

1913. Oil on canvas, 108.9 x 118.4
The Art Institute of Chicago

is one of the first paintings where Kandinsky uses a descriptive, self-referential title. Most of the works prior to this used generic titles, often with a qualifying place name such as *Improvisation 6 (African)* (1909), or titles that referred directly to something in the depicted landscape, as in the case of *Landscape with Church* (1913). Central to Kandinsky's theory of abstraction was the idea that there is such a thing as 'inner necessity' that is capable of determini the outward form of a work of art without reference to anything else. The task for the artist is first to establish and then to maintain contact with his 'inner sound' a then to search for and commit to canvas its visual equivalent as form and colour. As in *Painting with Green Centre*, which hints at the presence of phenomena at the very edge of recognition, images might emerge that are analogous to things in the natural order—a patch of blue might begin to look like sky, or a certain configuration of marks look like a man or a fish—but this should not be part of the painter's intention. In this painting everything circles around the dominant central green that is held in place—stabilized—by the curtainlike sweep of complementary red that cuts through the right-hand third of the painting. All the rest of the shapes and marks seem to be in motion.

First Abstract Watercolour, 1913
Pencil, watercolour and ink on paper, 50 x 65 cm
Musée national d'Art moderne,
Centre Georges Pompidou, Paris

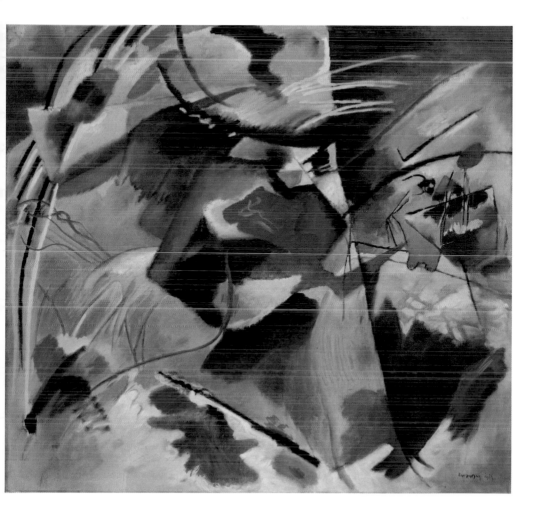

Beginning of Abstract Painting
In 1888, Paul Sérusier, working under the tutelage of Paul Gauguin at Pont-Aven, came very close to complete abstraction in his painting *The Talisman*. But this was not his objective; indeed, it was not until the early twentieth century that certain artists began to regard abstraction as central to their creative intention. Kandinsky moved into abstraction during 1912–13; in 1912 Frantisek Kupka presented the first entirely abstract works to be exhibited in Paris; also in France Robert Delaunay exhibited his first 'circular form' or 'disc painting' in 1913. In Holland, after a lengthy transitional period that started as early as 1905, Piet Mondrian made his first 'non-figurative' paintings in 1914. And in Russia, Kasimir Malevich painted his new 'non-objective', geometric, Suprematist works in 1915.

e with **Red Spots I**, 1913
vas, 78 x 100 cm. Folkwang Museum, Essen

Karl Schmidt-Rottluff

Born in 1884, Karl Schmidt-Rottluff was a friend of Ernst Ludwig Kirchner and a founding member of Die Brücke (The Bridge) in Dresden. Although very much the thinking member of the group—he had met Henrik Ibsen and Johan August Strindberg while still in his late teens and was well versed in the writings of Friedrich Nietzsche—he was not a particularly active one. He was extremely wary of their communal activities. In 1911 he moved to Berlin, in advance of Kirchner; he also established a small working studio in Hamburg. He died in Berlin in 1976.

Four Bathers on the Beach

1913. Oil on canvas, 88 x 101 cm
Sprengel Museum, Hannover

A late Die Brücke period painting—the group finally broke up in May 1913, shortly after this work was completed—*Four Bathers on the Beach* shows Schmidt-Rottluff at his most fluent. His great passion was for the countryside around the village of Dangast, where he spent his summers painting landscapes and making nude studies in the open air. He had no real interest in city-based subjects, so this coastal setting was where he gathered the visual material necessary to support his painting through the winter. *Four Bathers on the Beach* is clearly a product of this process. It is a composite studio painting rather than a *plein-air* study. Unlike Schmidt-Rottluff's paintings from the motif in works such as *Landscape in Dangast* (1910), in this case there is no perspective to speak of, and the figures retain something of the separateness of individual life-studies such as his *Girl at Her Toilette*, painted in Dangast in 1912. The year before he painted his *Four Bathers on the Beach*, Schmidt-Rottluff had taken part in the 'Sonderbund' exhibition in Cologne, where he saw Cubist works by Picasso and Braque. This, in turn, led him to look closely at African sculpture. On his return to Hamburg, he embarked on a series of works in which he experimented with 'Africanized' Cubist forms. For a short time, his figure painting became more chiselled and angular and the faces more masklike, as in *Two Women* (1912). Something of this influence remains in *Four Bathers on the Beach*, but it is greatly softened here by the circulating flow of forms and high colour contrasts that seem to develop something of a musical sonority.

Landscape in Dangast, 1910
Oil on canvas, 76 x 84 cm. Stedelijk Museum, Amsterdam

Two Women, 1912
Oil on canvas, 76 x 84 cm. Tate Collection, London

The Break-up of Die Brücke — the Rejection of Collectivity

The main protagonists of Die Brücke were all in their early twenties when
they met. Their original intention was quite simply to live and work together.
They wanted to harness youthful creativity to the task of transforming social life.
One of their earliest published statements puts it very clearly: 'We call together
all young people, and — as young people who bear the future — we want to
acquire freedom for our hands and lives against the well-established older
forces. Everyone belongs to us who renders, in an immediate and unfalsified
manner, everything that compels him to be creative.' But what started out as
a collective social ideal quickly turned into a semi-regulated aesthetic project
with paintings that had a somewhat similar look. After their move to Berlin,
the members of the group developed themselves in different directions and
the group started to fall apart. Things came to a head in May 1913 when
Kirchner published his 'Chronicle of the Brücke', in which he claimed
to be the leading style-maker and most significant artist in the group.

Giacomo Balla

was born in Turin in 1871. He attended classes for a short time at the Accademia Albertina di Belle Arti and the Liceo Artistico, both in Turin. Following this, he studied at the University of Turin with the psychiatrist and criminologist Cesare Lombroso. He moved to Rome in 1895, where he worked as an illustrator for a number of years. A key figure in the emergence of Futurism, Balla introduced Gino Severini and Umberto Boccioni to the Divisionist techniques that gave early Futurist painting its distinctive look. In 1910 he signed the *Manifesto of Futurist Painters* and the *Technical Manifesto of Futurist Painting*. In 1914 he began to make sculpture, as well as designing Futurist furniture and clothing. In 1915 Balla and his painter friend Fortunato Depero wrote a manifesto entitled *The Futurist Reconstruction of the Universe*. Like many of his fellow Futurists, Balla had strong Fascist leanings and in the postwar period his reputation suffered because of his earlier political beliefs. However, he continued to work and to exhibit and in the end he was made a member of Rome's prestigious Accademia di San Luca. He died in Rome in 1958.

Abstract Speed + Sound

1913–14. Oil on board, 54.5 x 76.5 c
Peggy Guggenheim Collection, Venice

The Futurists' obsession with speed assumes its starkest and most uncompromisin form in Balla's paintings from 1913. At one extreme there are rough, tough paintin like *Abstract Speed*, from which even the objects in motion have disappeared. Matter has been dematerialized and its place taken by a rolling sequence of abstract vortices and carefully regimented flights of fast-moving points causing the whole ensemble to pass swiftly from left to right. At the other extreme, there are more poetic but equally assertive works such as *Abstract Speed + Landscape* (1913) and *Abstract Speed + Sound* (1913–14). These last works incorporate a roun sectioned 'frame' so that the lines of movement — some of which move across the centre of the painting, while others radiate outwards from it — rather than sudden stopping at the painting's edge, turn away before disappearing out of sight.
The effect is to force the centre of the painting forwards, so that, optically, it takes on something of the character of a semi-transparent, airy, open-structured relief. The experience of these paintings by Balla is very different from that provided by analytical Cubist painting, for which the most appropriate, ready-to-hand metapho — because of its dense, closely worked surface — is of an obliquely illuminated,

Abstract Speed + Landscape
1913. Oil on pasteboard,
49 x 71 cm. Private collection

carefully sculpted wall. By comparison, the forms in the Balla have no substance. They exist only as trajectories of colour and light swooping and gliding through an abstract space. The 'added' element of synaesthesia suggested by the title, *Abstract Speed + Sound*, possesses none of the chromatic sonority of grand classical music or the fluent agility of jazz; it probably has more to do with the metallic clamour and high-pitched whine of the motor-racing circuit.

Marsden Hartley

Born in Lewiston, Maine, in 1877, Marsden Hartley studied at the Cleveland Art Institute and afterwards—in New York—in the studio of William Merritt Chase, who introduced him to the work of Albert Pinkham Ryder. He also made friends with the poet Walt Whitman at this time. His first one-person show was at Alfred Stieglitz's 291 gallery in 1909, where he continued to show in the company of Georgia O'Keeffe, John Marin and Arthur Dove. Between 1912 and 1915 Hartley lived in Europe—for a short time in Paris, where he was looked after by Gertrude Stein and visited the studios of Picasso and Matisse, and afterwards in Berlin (a c much more to his taste), where he met and exhibited with artists such as Wassily Kandinsky, Paul Klee and Franz Marc. Back in New York in 1916, the so-called German Soldier Paintings were accused of celebrating German militarism and remained unsold. Hartley spent the next several years moving from place to place until, in 1932, he set up house (and a studio) back in Maine, where he painted loca scenes showing the landscape and people going about their daily lives. Towards th end of his life he made a series of witty, emblematic portraits of prominent histori figures, and an outrageous self-portrait in which he appears as a blond, tattooed a jewel-bedecked, gay muscle-man. He died in Maine in 1943.

Portrait of a German Officer

1914. Oil on canvas, 173.3 x 105.1 cm
The Metropolitan Museum of Art, New

An important figure in the evolution of American Modernism, Marsden Hartley remains an enigmatic figure, his painting barely remarked upon outside of his nativ America. Not particularly well educated, he was a naturally intelligent man, a sou critical thinker and a gifted writer, a poet as well as an artist. A homosexual, he found the homophobic atmosphere of New York stifling and in 1912, aged thirty-fiv at the prompting of his gallerist, Alfred Stieglitz, set out to find a more sympatheti environment in Europe. It was in Paris, in the company of Gertrude Stein, that he met two young German army officers, Arnold Rönnebeck and Karl von Freyburg. The latter became the first great love of Hartley's life and the inspiration for the series of between twelve and fourteen German Soldier Paintings, of which *Portrai of a German Officer* is the first and the best known. Hartley moved to Berlin in

the company of von Freyburg in 1913 and together with Rönnebeck they shared a life that mixed the ritualized machismo of young, off-duty soldiers at play with the decadent excesses of Berlin's extensive homosexual subculture. At the outbreak of war, Hartley, who at this time openly supported the Kaiser, welcomed it as affordi 'the only modern religious ecstasy'. But within months elation had turned into devastation when Karl von Freyburg was killed in action. It was the pain and the 'unendurable agony' of this experience that powered the German Soldier Paintings. *Portrait of a German Officer* was intended by Hartley as a posthumous celebration— an emblematic portrait—of his friend who had been

Sustained Comedy, 1939. Oil on board,
71.5 x 56 cm. Carnegie Museum of Art, Pittsburgh

awarded the Iron Cross for gallantry only hours before he died. Most of
the symbolism is easily read. The decorative trappings of rank that had
adorned his friend's uniform are wrapped around with regimental pendants
and the imperial German banner. At the top of the painting, von Freyburg's
Iron Cross is set in a circle within a triangle, symbolizing the friendship
between Hartley, von Freyburg and Rönnebeck.

Oskar Kokoschka

was born in Pöchlarn in Austria in 1886. After a childhood
spent mostly in Vienna, he enrolled at the Kunstgewerbeschule in Vienna to study
painting, but was abruptly dismissed in 1908 after exhibiting work that did not
meet with the school's approval. At this time he became a friend of the architect
Adolf Loos, who gave him unswerving public support. In these early years, as well
as being a painter, Kokoschka was a poet and a playwright and has been credited
with the invention of Expressionist drama. His first one-person exhibition took
place at the Paul Cassirer Gallery in Berlin in 1910. In the period leading up to
the First World War, he was living between Berlin and Vienna, but when war broke
out he volunteered for military service. He was badly wounded in action on the
Ukranian front and during his convalescence went to live in Dresden. He was
appointed to a chair at the Art Academy there in 1919. In 1931, with the rise of the
National Socialist Party, he left Germany and went to live in Prague. In Germany
his work was declared 'degenerate' and removed from public exhibition. Kokoschka
fled to England in 1938, where he took British citizenship. He died in Montreux,
Switzerland, in 1980.

Still Life with Cupid and Rabbit

1913–14
Oil on canvas, 90 x 120 cm
Kunsthaus Zürich

Oskar Kokoschka was twenty-seven when he painted *Still Life with Cupid
and Rabbit* and it remains one of his strangest and most enigmatic works. It is
described as a still life but almost everything in it moves or is capable of movement.
It has all the trappings of visual allegory without specifying either a subject or a
narrative. Even more curious is the fact that the central, most active participant
in the picture, the rampant barred cat or young tiger, is not mentioned at all in
the title of the work. Like everyone else in Vienna after the turn of the century,
Kokoschka had been reading Freud's *Interpretation of Dreams* (1900), and his
poetry from this time has a dreamlike quality. It is packed with Expressionist and
surreal elements, nightmarish fantasies of sexual submission and unprovoked
violence. His dramas — short plays like *Mörder: Hoffnung der Frauen* [*Murderer:
Hope of Women*], later turned into an opera by Paul Hindemith — are peopled with
individuals who have fallen prey to their animalistic drives. It would be surprising,
then, if there were not also some symbolism at work in his *Still Life with Cupid
and Rabbit*. Perhaps the most obvious connection is with his recently abandoned
love affair with Alma Mahler (wife of the composer Gustav Mahler), a relationship
that had been vehemently opposed by Kokoschka's mother. She had even threatened
Alma with personal violence. Cupid is certainly looking extremely disconsolate
and seems to have turned his back on the action. The cat — the unmentionable
Madame Kokoschka, perhaps — has taken centre stage, while the rabbit —
Kokoschka himself — stays perfectly still (is this the still life referred to
in the title?), content to watch, rather pathetically, from afar.

of
...hler, 1912–13
...nvas, 62 x 56 cm
...nal Museum
... Art, Tokyo

Kasimir Malevich

was born in Kiev in the Ukraine in 1878. He attended the local drawing school before going to Moscow where he studied at the Moscow School of Painting, Sculpture and Architecture between 1904 and 1910. With his friends Aleksandra Ekster and Vladimir Tatlin, he exhibited with the Union of You as well as with the Moscow-based group Donkey's Tail. In 1914 Malevich's work was included in the Salon des Indépendants in Paris, and in 1915 he published his Suprematist manifesto *From Cubism to Suprematism*. A gifted and committed teacher, during his mature years he taught at the Vitebsk Practical Art School in Belarus, the Leningrad Academy of Art, and the Kiev State Art Institute. In 1926 he published his famous didactic treatise on modern art *The Non-Objective World*. Persecuted, his work confiscated by the regime of Josef Stalin, Malevich died in poverty in Leningrad (St Petersburg) in 1935.

'This was no "empty square" which I had exhibited but rather the feeling of non-objectivity.' Kasimir Malevich

Black Square

1915. Oil on canvas, 80 x 80 cm
State Tretyakov Gallery, Moscow

The aim of Suprematism, as declared by Malevich in his manifesto of 1915, was to cast aside 'art-ideas, concepts and images' in order to reach a 'desert in which nothing can be perceived but feeling'. This realization came at the end of a length period of apprenticeship, during which Malevich had excavated, diligently reworke and thoroughly absorbed the lessons of the main avant-garde movements of the d —Cubism and Futurism—and it represented the necessary next step in the evolution of what he called 'non-objective art'. The key initiatory work was his own *Black Square* painted in 1915 when he was living and working with other Suprematist artists in a peasants and artisans' collective in the Ukrainian village of Skoptsi. There is nothing hidden or complicated about the work. It is quite simp what the title suggests: a black square placed centrally on a white ground, with a carefully worked surface and sharply defined edges.

To comprehend fully the importance that Malevich attached to this work, we must first try to understand something of what he meant by 'feeling'. For Malevic the problem with the world, as we see it, is its 'wilful' clutter, its tendency to manifest itself as a multiplicity of objects and ideas. He was convinced that

Black Circle
1923–29
Oil on canvas,
79 x 79 cm
Private collection

Four Squares
1915
Oil on canvas,
49 x 49 cm
A.N. Radischev State
Art Museum, Saratov

somewhere beyond the world of things — and outside the realm of ideas that
the objective world gives rise to — there lay an altogether different order of
experience that showed itself as 'non-objective feeling'. He further believed that
this 'feeling' was best expressed through pure geometric forms, set against and
seen in opposition to a condition of universal emptiness. Malevich described this
alternative order in the form of a simple equation: 'The black square = feeling,
the white field = the void beyond this feeling'. He followed his *Black Square*
with the Suprematist compositions *Black Circle* and *Four Squares*.
Malevich made four versions of his *Black Square*: the first painted in 1915
is in the Tretyakov Gallery, Moscow; the second painted in 1923 is now in
the State Russian Museum in St Petersburg; the third, from 1929, is also
in the Tretyakov Gallery; the fourth, believed to have been painted in
the late 1920s or early 1930s, despite the fact that the year 1913 is inscribed
on the reverse, is in the Hermitage, St Petersburg.

Francis Picabia
Very Rare Picture on the Earth

1915
Oil and metallic paint on board, silv
and gold-leaf on wood, 125.7 x 97.8
Peggy Guggenheim Collection, Veni

Born in Paris in 1879, Francis Picabia studied at the École des Arts Décoratifs and later in the studios of Fernand Cormon and Ferdinand Humbert. His first solo exhibition of paintings (in an Impressionist style) took place at the Galerie Haussmann in 1905. Between 1905 and 1912, influenced by Fauvism and Cubism, he eventually evolved a semi-abstract style that was distinctively his own. In 1912, he met and began to associate with Guillaume Apollinaire and Marcel Duchamp, and was included in the 1913 Armory Show in New York, where he made the acquaintance of the photographer and gallerist Alfred Stieglitz. The year 1915 saw the beginnin of Picabia's Mechanomorphic phase and a deepening of his involvement in the evolution of international Dada. He went to live in Spain in 1916, from where he published his journal 391. Disappointed by what he saw as its failure to renew itself, Picabia renounced Dada in 1921, and the following year moved to Tremblay-sur-Mauldre outside Paris, where he turned to figurative painting again. In 1925 he went to live in Mougins, and during the 1930s he became a close friend of Gertrude Stein's. Picabia returned to Paris at the end of the Second World War and died there in 1953.

Picabia's *Very Rare Picture on the Earth* represents a key moment in the evolutio of modern art. As well as being one of the earliest of the artist's machine-based works—the beginning of Mechanomorphism—it is arguably the firs 'painting' to deny its inheritance as painting, the first to seek a mor open identity for the painting as a 'painted object'. This 'picture' has cut-out wooden forms applied as relief elements and a carefully recessed, painted frame, that works as an integral part of a shallow constructed diagrammatic space. Like Duchamp's *The Bride Stripp Bare by Her Bachelors, Even (The Large Glass)*—started in the same year but not completed until 1923—Picabia's *Very Rare Pictu on the Earth* is in the strictest sense 'anti-pictorial'. Despite its seeming lucidity, it 'pictures' nothing, hence its 'rarity'. Even as a diagrammatic representation of an imaginary mechanical device i is surprisingly unreadable. It seems to refer to something functiona but tells us nothing about its purpose. The twin cylinders and syste of interlinked tubing suggest some sort of pump for liquid or for gas but close examination shows the pattern of tubes to be contradictor even nonsensical. Even so, in general terms it seems to share some of the mechanized sexual concerns of Duchamp's *Large Glass*. The machine provided a crucial metaphorical resource for the Dadaists, linking the human body and its several libidinal urges to the emotion-free, indiffere world of mechanical production and reproduction. In particular it allowed them to metaphorize the sexual act as a repetitive, autoerotic and near-autonomous functio removed entirely from what Tristan Tzara called 'specialized moral judgment' (that is, emanating from the institutions of the Church, the law and the state).

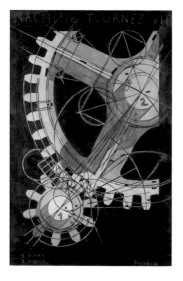

Machine Turn Quickly
1916–18. Brush and ink
with watercolour and
shell gold on paper,
49.5 x 32.5 cm
Private collection

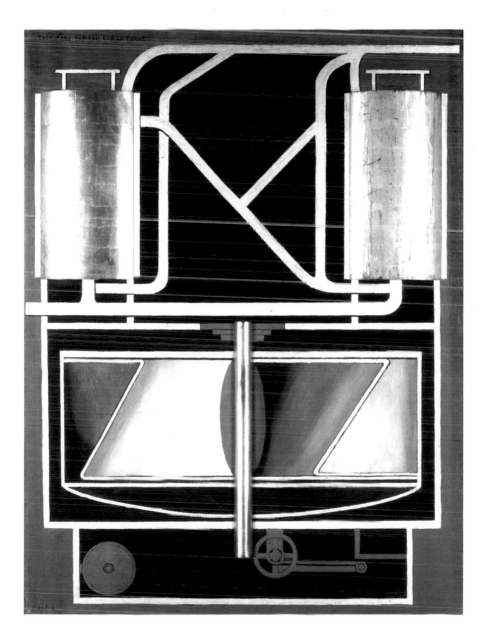

Dada, a Footnote The reason for the choice of the name Dada (French word for hobby-horse) is uncertain. The most common explanation is that it was picked at random out of a French/German dictionary at an early meeting of the group in Zurich in 1916. Commonly described as an 'anti-art' movement, it in fact started out with a much more specific aim: namely, to counter the brutality of the First World War, which the Dadaists attributed to the suffocating intellectual dominance of bourgeois interests in everyday life.

Juan Gris

was born in Madrid in 1887. Having first studied technical drawing at the Escuela de Artes y Manufacturas (1902–04), he then went on to study painting in the studio of José Moreno Carbonero. Gris moved to Paris in 1906, where he quickly became friendly with Henri Matisse, Georges Braque and Fernand Léger. He earned his living working as an illustrator for satirical journals such as *Le Rire* and *Le Charivari*. Encouraged by his fellow countryman Pablo Picasso, he began to paint seriously in 1910. At first he worked in an Analytical Cubist style but by the middle of the decade had progressed to his own very particular version of Synthetic Cubism. In 1922 he made ballet sets for Sergei Diaghilev. In 1924, Gris gave his famous lecture 'Des Possibilités de la peinture' at the Sorbonne. He died in the Boulogne-sur-Seine district of Paris in 1927 when he was just forty years old.

Still Life with Newspaper

1916. Oil on canvas, 73 x 60 cm
The Phillips Collection, Washington

Juan Gris is the most persistent and specialized of the leading trio of Cubist painters. He spent nearly all of his comparatively short working life painting still lifes in a Synthetic Cubist manner. Despite his friendship with Braque and his admiration for Picasso, he remained a very different kind of painter from either of them. And this difference showed itself early on in the Analytical Cubist paintings that Gris made in 1910–11. Compare Gris's *Le Livre* (1911) with Picasso's *Still Life with a Bottle of Rum* painted in the same year, for example, and a very different approach to the object emerges. While Picasso is happy to shatter and disperse his bottle, interleaving its fragments into the entire spatial organization of the canvas, Gris seems intent on preserving the material integrity of each object. Although his coffee pot, his kettle and his cup are pinched this way and that, although they have been remodelled according to shifting viewpoints, they nevertheless have real or suggested boundaries that serve to separate them from everything else in the picture. Gris's respect for the integrity of objects is also evident in the important series of Synthetic Cubist still lifes painted around 1916, of which *Still Life with Newspaper* is one of the most elegant and lucid examples. Here each object is given its own ideal geometric space in which to exist. The liquor glass stands in a transparent tube, and when the viewpoint shifts so that the table can be seen from above, it is the tube that it dissects, rather than the glass itself. And Gris uses the same device in the case of the fruit bowl.

Flatness acquires almost literal significance, with the whole assembly of forms — where they are not transparent — having the look of cut, folded and collaged paper. The overall sense of precision and the way in which Gris is able to move so easily between plan and elevation (clearly in evidence down the left-hand side of the painting) seem to owe much to his early training as an engineering draughtsman.

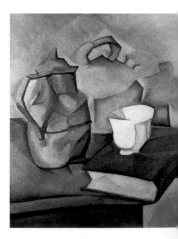

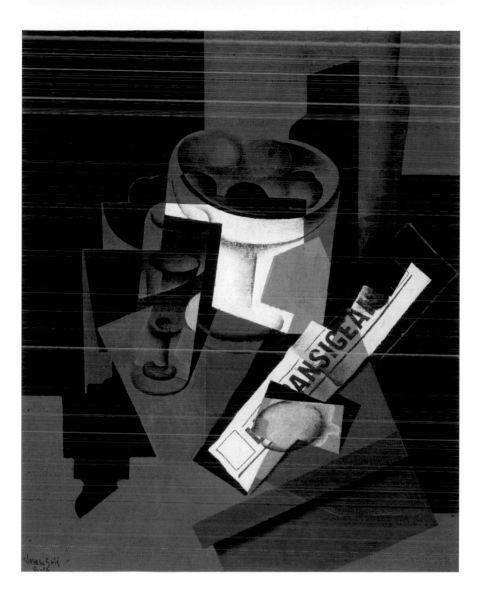

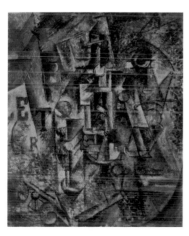

Pablo Picasso
Still Life with a Bottle of Rum, 1911
Oil on canvas, 61.5 x 50.5 cm
The Metropolitan Museum of Art, New York

Giorgio De Chirico

1916–17. Oil on canvas, 96.5 x 74 cm. Staatsgalerie, Stuttg

Metaphysical Interior with Large Factory

Giorgio De Chirico joined his brother Andrea (Savinio) in Paris in 1911. His work was shown in the Salon d'Automne in 1912 and 1913 and in the Salon des Indépen in 1913 and 1914. He and his brother returned to Italy in 1915 because of the First World War and were given military postings in Ferrara. It was here that De Chiric met Filippo de Pisis and Carlo Carrà — the three of them later formed the core of the Scuola metafisica — and started to make regular contributions to the magazine *Valori Plastici* (1918–22). De Chirico stayed in Ferrara for nearly three years, dur which time he made some of his finest metaphysical paintings. He was transferre to Rome in 1918 and published his manifesto *Noi Metafisici* (We Metaphysicals) there in 1919. In 1924 De Chirico moved to Paris, where he was greeted with grea enthusiasm by the Surrealists. De Chirico's novel *Hebdomeros* was published in 1929. In the 1930s he divided his time between Paris and Rome. He settled down to live and work permanently in Rome in 1944 and he died there in 1978 shortly after his ninetieth birthday.

If De Chirico recast Turin as the city of Friedrich Nietzsche by 'revealing' the mys of its piazzas, its statuary and its colonnades, then the paintings he made in Ferra

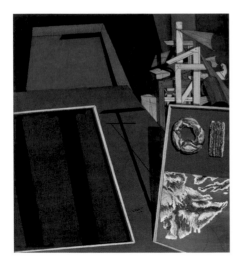

between 1915 and 1917 turned that place for ever in the city of Giorgio De Chirico — immortalized throu his images of its biscuits, its iced sweetmeats, its f terrine moulds, and its hotel architecture. De Chiri Metaphysical theory was founded on the notion tha everything in the visible world has two modes of existence, a routine one that is 'seen by people generally' and another mode, which he describes as a 'spectral or metaphysical manifestation ... see only by rare and isolated individuals in moments of clairvoyance'.

The purpose of metaphysical painting was quite sir to penetrate and pass through the first in order to the second, and then to record the emotions that th other reality inspired. We can see this process at w in *Evangelical Still Life I* (1916), for instance, whe powerful feeling of existential uncertainty is genera by a combination of paper-thin architecture, contrived perspective and a tangle of indecipherable geometric forms. Only De Chirico's beloved biscuits are granted a modicum of solidity in a world that otherwise seems to be entirely without substa This sense of an alternative 'spectral' reality beyond appearances is given a muc sharper twist in *Metaphysical Interior with Large Factory*, completed just a few months later at the beginning of 1917. Here De Chirico employs the device of 'the picture within a picture' to draw a parallel between the two realities but also to p up the difference between them. In the framed picture that occupies the centre o the painting, the factory is drawn in true perspective — modelled in light and shad

Evangelical Still Life I, 1916. Oil on canvas, 80.5 x 71.5 cm. Osaka Municipal Museum of Art

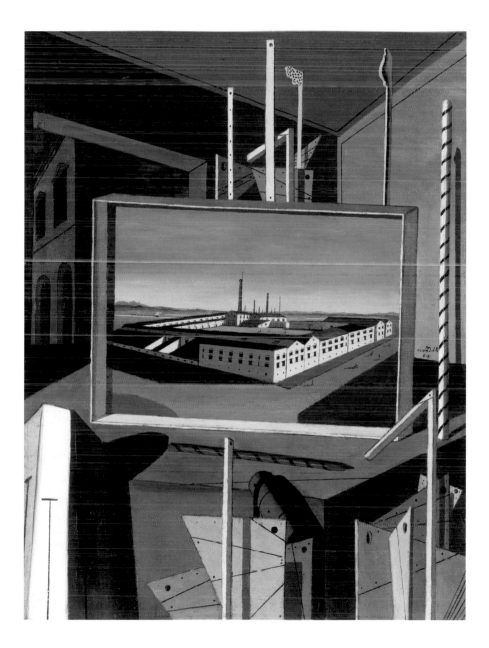

It extends across a sunlit plain with sea and mountains in the distance; the whole
ensemble is seen against a blue Mediterranean sky. By contrast, the twilight world
that surrounds it — the outward manifestation of De Chirico's 'metaphysical interior
impenetrable to sunlight' — possesses no such visual logic. Although things are
precisely delineated, they are without weight. Objects that have no clear identity
or purpose seem to stand without any apparent means of support. It is a world
that teeters on the edge of diagram.

George Grosz

was born Georg Ehrenfried Groß in 1893 in Berlin. He studied first at the Dresden Academy of Art and afterwards at the School of Applied Art in Berlin. He enlisted in the army in 1914 and was discharged for health reasons in 1915, but was recalled again in 1917. Later the same year he attempted suicide and, after striking an officer, was sent to a prison-hospital to await execution. His sentence was commuted when the authorities decided that he was suffering from shell-shock, and he was finally discharged from the army in 1918. When the war was over, he joined forces with John Heartfield, Otto Dix, Max Ernst and Kur Schwitters to form the German Dada group. Grosz joined the Communist Party in 1919 but resigned his membership in 1922 after visiting Russia and meeting Le and Trotsky. He was invited to be a guest artist and teacher at the Art Students League in New York in 1932. Grosz was outspokenly anti-Nazi and when the National Socialists came to power a year later, he left Germany and went to live in America. In his absence works by him held in German museums were confiscated and destroyed. George Grosz became an American citizen in 1938. He returned to live in West Berlin in 1959 and died shortly afterwards.

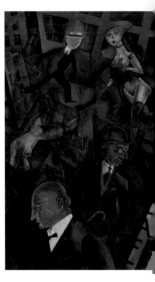

Metropolis, 1917. Oil on board, 68 x 47.5 cm
The Museum of Modern Art, New York

Metropolis

1916–17. Oil on canvas, 100 x 102 cm.
Museo Thyssen-Bornemisza, Madrid

When Grosz returned to his studio in 1916 it was to be an all too brief respite from his 'miserable existence as a soldier'. Grosz was deeply anti-authoritarian by nature and although he had re-sisted the brutality and routine bullying of army life at every turn, by 1916 he was a beaten and broken man. He celebrated his release by imme-diately starting work on what was to be one of his greatest paintings, *Metropolis*. As it turned out, this composition was to convey a curious mixture of elation and pessimism, nostalgia for past freedoms and fear for the future. In its imagery the work looks back at the life Grosz had led during his first years Berlin when he was entirely besotted by the city. It shows its rush and raucousne its myriad cinemas, theatres, music halls, rowdy cafés, night-clubs and brothels — phantasmagoria of exposed city flesh and city faces, all bathed in the roseate glow of red neon. The flip side of this nakedly hedonistic mirage is to see it as a vision of Hell, and in this, Grosz's *Metropolis* can be read as a modern equivalent of Hieronymus Bosch's visions of the nether world, peopled by tortured souls illu-minated by glowing coals and sudden flashes of flame. At the centre of the image Grosz has pictured Berlin's *Olympia* cinema and residential complex, built in 191 at the junction of Kantstrasse and Hardenbergstrasse. By aligning an exaggerate tall lamp-post with the corner of the building, he has succeeded in creating a kalei scopic feeling of implosion and collision. This is the fault line where city pleasure and city violence turns in upon itself.

'In 1915 I was discharged from military service ... given leave of absence on the understanding that I might be recalled within a few months. And so I was a free man, at least for a while. The collapse of Germany was only a matter of time. All the fine phrases were no more than stale, rank printer's ink on brown substitute paper. I watched it all from my studio in Südende, living and drawing in a world of my own.' **George Grosz**

Claude Monet

Water Lily Pond at Giverny

1917
Oil on canvas, 117 x 83 cm
Musée de Grenoble

The Impressionist movement effectively came to an end in 1890 when Claude Monet announced that he was not in favour of a proposed ninth 'united' Impressionist exhibitio[n]. In fact, any claim to a unity of purpose had long since given way to disputes amongst the group's older artists, even about such founding principles as painting outdoors directly from the motif. In Monet's case, the quest for immediacy had long since been overtaken by a painstaking striving to express his feelings. As he wrote in a heartfelt letter to the writer Gustave Geoffroy in October 1890, 'I am becoming a very slow worker and this depresses me more than ever, the things that come easily, in a single brushstroke, disgust me [but] I am keener than ever to set down what I feel.'

Between 1883 and his death in 1926, Monet spent nearly all his time at Giverny, where he transformed the garden into a grand pictorial setting for himself to paint. He started work on his famous water garden in 1893; with its luminescent Nymphaea (water lilies) and tall, water-loving Iridaceae (flag irises), the nominal subjects of so many of his late works, it became the absolute obsession of his last years. By the time he painted *Water Lily Pond at Giverny* Monet's sight was already starting to fail. Cataracts were beginning to cloud his vision in both eyes. The subtle, impressionistic melding together of optical colours so characteristic of the earlier 'Water Lily' paintings, of necessity gave way to bigger, brighter and bolder mark-making. The pursuit of the impression was no longer a matter of stylistic choice, but a consequence of the physical condition determining his apprehension of his own paintings. Colours flowed together and were mixed quite literally in the vision, achieving pictorial unity despite the darkening imperfection and uncertainties of Monet's failing eyesight. As this example demonstrates, these last paintings are both visually coherent and expressively powerful.

Monet's Late Paintings and Clement Greenberg

Writing in the mid-1940s the distinguished American critic Clement Greenberg declared that because the late paintings of Claude Monet are so bent on recording visual phenomena, their concerns are 'extra-aesthetic', more to do with science than with painting. As a consequence, they 'lack form'. No matter how big they are, Greenberg argues, 'they look like segments cut out of much larger paintings'. Later on, writing in the 1960s, he laid claim to these same paintings as essential precursors of the 'optical' wing of American Abstract Expressionism— Jackson Pollock to Jules Olitski—and painting that seeks

Weeping Willow, 1920–22
Oil on canvas, 116 x 89 cm
Musée Marmottan, Paris

ies

nvas.
O cm

an.

more and more 'the condition of flatness'. Looking at a work like *Water
Lily Pond at Giverny*, there seems to be a degree of blindness on both counts.
Although it has little that might be described as a formal geometry it is certainly
not lacking in structure, which is here carried in the weave and movement of the
brushstrokes across the surface. By the same token, its version of flatness is not
the forward-moving one that we associate with Abstract Expressionist painting.
There is a real recessional space in Monet's painting and not just an optical
thickening of the painting's field.

Max Beckmann

Born in Leipzig in 1884, Max Beckmann studied painting at the Art Academy in Weimar (1900–03), where he received a thorough academic training, working from life models and Classical casts. A strong draughtsman and an accomplished painter, he moved to Berlin in 1904 where, after 1910, he became a prominent member of the Berlin Secession, which included artists such as Lovis Corinth, Max Liebermann and Max Slevogt. Beckmann discovered his taste for large-scale cityscapes and allegorical figure compositions during the years leading up to the First World War. With the onset of war, he volunteered to serve as a medical orderly but suffered a nervous breakdown. He was discharged after a year and by the time he started to paint again in 1917 his work had changed. The new paintings were almost Gothic i their complexity, with lightly modelled forms pressing together in a shallow, semi-Cubist space. By 1920 he was already linked critically that the emergence of Neue Sachlichkeit, or New Objectivity, the art movement that arose in Germany in the early 1920s as an outgrowth of Expressionism and that was embraced by painters such as Otto Dix and George Grosz. By the early 1930s, he was the most celebrate German painter of his generation, but his fortunes took a sharp downturn when Adolf Hitler became chancellor in 1933. Declared 'degenerate' by the Nazis, nearly six hundred of Beckmann's works were confiscated and removed from Germany's art museums. Forced to flee the country, he and his family sought refuge in Amsterdam. In 1947 he left Amsterdam for the United States, where he taught and painted for the last three years of his life. He died in New York in 1950.

'My heart beats faster for a raw average, vulgar art which doesn between sleepy, fairy-tale mood poetry, but allows direct entran the fearful, commonplace, spler and grotesque banality of life.'

Max Beckmann

Night

1918–19. Oil on canvas, 133 x 154 cm. Kunstsammlung Nordrhein-Westfalen, Düsseldor

Night, one of Max Beckmann's most important paintings, comes at the very beginning of his Neue Sachlichkeit period. Intended as a political allegory, its message was directed not just at his native Germany, which, when he was starting the painting, was suffering the starvation, civil unrest and lawlessness that led to the 'revolution' of 1918, but also to the civilized world outside, politically paralysed by the events of the First World War. His declared intention for the painting was to provide 'mankind with a picture of its fate'. It derives its allegorical force from the depiction of a brutal invasion of a private, domestic space by semi-official forces from outside. Three debt-collectors have forced their way into an attic room in-habited by a poor family with few belongings. The man, his body pulled up towards

Great Scene of Death, 1906
Oil on canvas, 131 x 141 cm
Bayerische Staats-gemäldesammlungen, Staatsgalerie moderner Kunst, München

cent from
s, 1917
ivas,
cm
eum of
.rt, New York

the top left-hand corner of the painting, is in the process of being hanged.
The woman, legs splaying across the front ground of the picture, is tied up and
partly stripped of her clothes, it seems after having been raped. The daughter is
begging the men to stop. The grandparents, powerless to intervene, are shown
in the left background, weeping and praying. Tonal contrasts are sharply defined
so that overall the painting has a shattered feeling to it. The shallowness of the
space and the way in which the forms seem to crowd and jostle each other is
reminiscent of Cubist painting in 1911–12, but there is no fragmentation of bodies
here. Limbs are stretched, twisted and oddly flexed, but they remain whole
and are anatomized in some detail; sinuous muscles attach themselves to taut
tendons; veins surface only to disappear again; toes and fingers curl and grip.
The drawing throughout is sharp and angular, brittle, friable even.
Beckmann's world is just about holding itself together.

Amedeo Modigliani

was born in Livorno, Italy, in 1884. Bouts of pleurisy and typhoid in his early teens put an end to his schooling. By the age of fifteen he was studying painting in the studio of the Italian artist Guglielmo Micheli (a proponent of *plein-air* painting). In 1902 he went to Florence, where he fell unde the spell of the fourteenth-century artists Duccio and Simone Martini. This interes stayed with him and greatly influenced his later style. In 1906 — after short periods studying in Florence and Venice, where he discovered the work of Henri de Toulouse-Lautrec at the Biennale of 1905 — he left Italy for Paris. He set up a studio in Montmartre, where he joined a circle of artists that included Gino Severi André Derain and Pablo Picasso. In 1909 Modigliani moved to Montparnasse, where he became the neighbour and close friend of Constantin Brancusi.

He declined an invitation to sign the Futurist manifesto of 1910. At about this time, under Brancusi's influence, he made nearly thirty elongated, carved stone heads. Primarily a portrait artist, many of Modigliani's finest paintings are of his close friends and fellow artists, including Jean Cocteau, Chaïm Soutine, Jacques Lipchitz and Moïse Kisling. The late work is dominated by portraits of his young mistress Jeanne Hébuterne, whom he met in 1917 and with whom he had one daughter. By then Modigliani was already a sick man. He died in 1920, having been rushed into hospital suffering from tubercular meningitis. Jeanne Hébuterne committed suicide one day later.

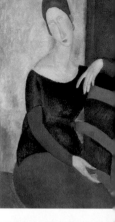

Portrait of Jeanne Hébuterne

1918–19
Oil on canvas,
91.4 x 73 cm
The Metropolitan
Museum of Art, New York

Modigliani's paintings acquired greater simplicity and a new lyricism after he met the beautiful nineteen-year-old art student Jeanne Hébuterne. It seems that he never became tired of painting her, despite his failing health. Taken together these portraits capture her every mood and all of them are characterized by a new gentleness of touch, with simpler forms circumscribed by lazily curving lines. Neither is this new feeling confined to the paintings of his young lover. It is also carried over into other portraits that Modigliani painted in 1918 and 1919, works such as *Peasant Boy* and *Seated Boy with Cap* (1918). Even so there is something very special about the paintings he made of Jeanne and this is especially noticeab in the Metropolitan Museum's *Portrait of Jeanne Hébuterne*. The picture is loving voluptuous in its every detail, from her long almond-shaped face framed by softly falling auburn hair, her swanlike neck, gently sloping shoulders and slender arms, to her wonderfully feminine wrists and hands. Particularly telling is the gesture of her left hand, with one finger flexed backwards and pressing rather quizzically

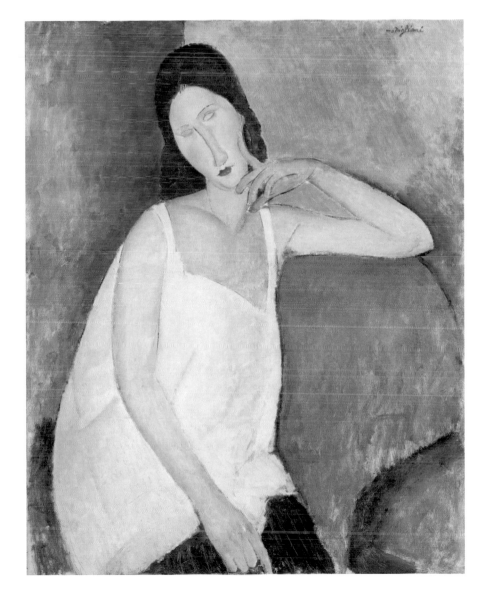

against her cheek in a gesture that is highly reminiscent of Jean Auguste
Dominique Ingres's great portrait of Madame Moitessier (1856).
In terms of its form, this painting is very simple, consisting of a series of curves
that move with and against each other. The upward-moving curve of Hébuterne's
white shift turns across the top of her shoulders to be picked up by the down-
ward-moving edge of the orange drape on the right hand side of the painting.
Set against that is the slightly serpentine movement up the left-hand side of her
body, which ends in the tilt of her neck and head. With regard to its colouration,
the painting uses subtle shades derived from the complementary opposition of
blue and orange.

Giorgio Morandi

was born in Bologna in 1890. From his twentieth year, he lived and worked (and later died) in the same house in the Via Fondazza, looked after by his mother and three sisters. He studied at the Bologna Academy of Fine Arts from 1907 to 1911, during which time he first saw reproductions of the paintings of Paul Cézanne. He also journeyed to Florence, Arezzo and other Italian towns to acquaint himself with the paintings of Giotto, Uccello and Piero della Francesca. After a short flirtation with Futurism in 1913–14 and a brief spell in the army that precipitated a period of intense mental crisis lasting until 191 he painted his first 'Metaphysical' works: twelve still lifes painted over a period of eighteen mo (the *Still Life* of 1919 being one of them). These established Morandi as a major figure in the S metafisica. His so-called break with Metaphysical painting came in 1920 when he came face to with Cézanne's paintings at the Venice Biennale. Morandi cared little about the art world or the art market; he earned his living by teaching engraving techniques at the Bologna Academy where he remained for twenty-six years. He died in Bologna in 1964.

Still Life

1919. Oil on canvas, 60 x 70 cm. Pinacoteca di Brera, Milan

It would not be far off the mark to describe Morandi as the thinking person's painter. Wid read and especially knowledgeable in the field of classical philosophy, as a young man he was a talented mathematician who might well have followed a career in mathematics. Th interests allowed him to enter the arena of Metaphysical painting in a very focused way. While Giorgio De Chirico was enmeshed in the highly elliptical thought of Nietzsche, Mo chose to breathe the rather clearer air of Platonic metaphysics. In works like his *Still Li* of 1919, he seems to be positing a thoroughly lucid immaterial world of platonic forms, w because it is without substance, has greater stability than the one disclosed to our sense The most obvious visual model is found in the foreground of Paolo Uccello's *The Battle of San Romano* where the Florentine master establishes the ground-plan by laying down the discarded and broken weapons strictly according to the rules of the 'new' science of perspective. However, while Uccello is engaged in experimentation and tries to make perspective work for him pictorially, Morandi typically exploits the anomalies that occur single-viewpoint perspective when objects are brought close to the picture plane. Witnes the plaster cast plus shadow that occupies the centre of the picture, echoing the soldier' helmet in Uccello's *Battle of San Romano*: it operates on two quite different axes. One o them, represented by the edge of the shadow, is strictly perspectival. The other, implied cutting through the centre of the cast, is isometric. This device allows this more complex form to be fully described whilst occupying the same idealized space as everything else.

Still Life, 1918
Oil on canvas,
65 x 55 cm
Civiche Raccolte
d'Arte, Milan

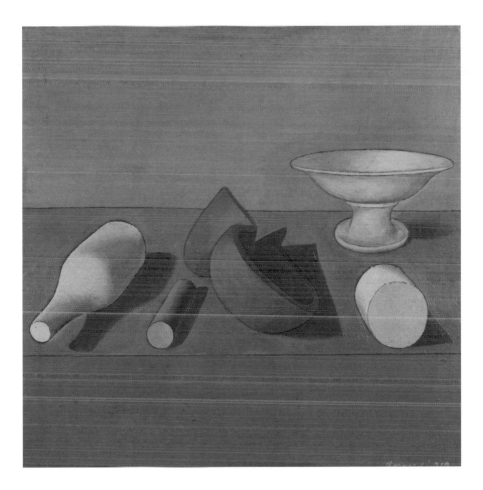

cello
le of
ano
40

20 cm
nal
ondon

Politics and Art in Italy after the First World War

Like many artists and intellectuals from the Italian middle classes, the fear of
Bolshevism in the wake of the First World War led Morandi to embrace the politics
of the right. He attended Futurist meetings as early as 1913 and participated in
the first Futurist Exhibition at the Galleria Sprovieri in Rome a year later. Just when
he joined the Fascist Party is unclear, but there is firm evidence that by the early 1920s,
several years before Hitler came to power in Germany, he was a supporter of Mussolini
and already a card-carrying member of the Party. He was a founder member and
an active participant in the Strapaese, a loosely knit group of right-wing artists and
intellectuals dedicated to a Fascist 'revolution' intended to lead to the wholesale
renewal of Italian cultural life. Disillusioned by and, for a time, openly critical of
Mussolini's regime, Morandi fell silent on political matters after the early 1930s and
withdrew more and more into his own domestic routine of painting and teaching.
There is no evidence that he ever finally denied Fascism despite the attack on him
in the Fascist journal *Quadrivio* in 1939 by his old friend — Fascist party member,
artist and teacher — Luigi Bartolini.

Piet Mondriaan (Mondrian) was born in Amersfoort

in Holland in 1872. He studied at the Rijksakademie in Amsterdam from 1892
to 1897 and joined the Theosophic Society in 1909. Having acquired the skills
of academic landscape painting, by 1909/10 he was experimenting with Pointillism
and by 1911 was engaging with Cubism. In 1911 he saw Cubist paintings by Pablo
Picasso and Georges Braque at the first 'Moderne Kunstkring' exhibition in
Amsterdam and decided to move to Paris the following year. Mondrian spent
the war years in Holland, where he evolved his non-objective, Neo-Plastic method
and became one of the founder members of De Stijl, an artists' group that include
Theo van Doesburg, Bart van der Leck and Georges Vantongerloo. The group
was committed to extending the influence of Neo-Plasticism into the realms of
architecture, graphic design and industrial design. He returned to Paris in 1919
but remained committed to De Stijl until 1925, when he fell out with van Doesburg
for introducing diagonal elements into his work. The Second World War forced
Mondrian to move to London in 1938 and from there to New York, in 1940,
where he died in 1944.

1920. Oil on canvas, 60.3 x 61 cm
The Museum of Modern Art, New Yo

Composition C (Composition with Red, Blue, Black and Yellow-Green)

The founding principle of Neo-Plasticism was clearly stated by Theo van Doesbur;
'The work of art must be completely conceived and formed by the mind before
execution ... it must not receive any formal impressions from nature, nor from
the senses, nor from sentiment ... we exclude lyricism, dramatism, symbolism,
and so on.' Viewed from this rather strict standpoint we would have to declare
Mondrian a failure. For a start, his paintings were not conceived in advance but
were worked out on the canvas — often through a lengthy process of adjustment
as his unfinished paintings show. Neither are they without any formal impressions
drawn from nature or the senses. The importance that Mondrian gives to the
opposition between vertical and horizontal elements, for example, was arrived
at after a long period of studying and working from nature and, far from being
coldly objective, his paintings appeal directly to the senses. They are full of
visual energy and gain their strength from their formal tautness.

Composition C is one of a small group of transitional works from the early non-
figurative period (1917–21) in which Mondrian uses quite a varied range of colours
and a subdued approach to tonal contrast. In his later work he switched his
attention to more 'naked' colour dynamics: patches of pure red, yellow and blue
held in place by a grid of black lines, all pitched against expanses of pure white.
In *Composition C* the focus is more on grey-tone harmonics. Three subtly differer
shades of grey are set against carefully modulated primary colours. The red is
tinged with orange, the blue is lightened slightly by the addition of white, the yellc
moves quite decisively towards green and the black towards brown. The grid is
painted in two different mid-tone greys that serve to link colours and separate
tones. The overall effect is of a precisely controlled forward and backward
movement of coloured planes in a very shallow picture space.

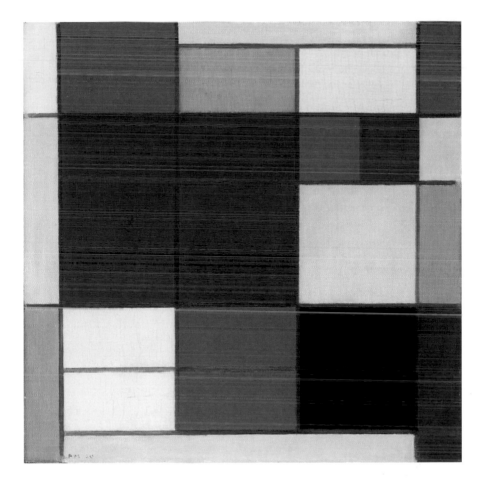

Composition in Colour B, 1917
Oil on canvas, 50 x 44.5 cm
Kröller-Müller Museum, Otterlo

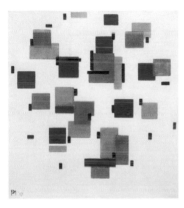

Composition with Grey and Ochre, 1918
Oil on canvas, 80.5 x 49.5 cm
The Museum of Fine Arts, Houston

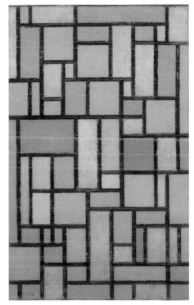

Fernand Léger

was born in Argentan in the Basse-Normandie region of France in 1881. He moved to Paris when he was nineteen years old. Having failed the entrance examination to the École des Beaux-Arts, he enrolled at the École des Arts Décoratifs and supported himself by working as a draughtsman in an architect's office. By 1909 he had achieved recognition as a Cubist painter and in 1911 he joined the Puteaux group of artists—the Orphic Cubists—where he mixed with artists such as Robert Delaunay, Marcel Duchamp and Francis Picabia. Thereafter his work became increasingly abstract. He joined the army at the outbreak of the First World War and was invalided out after suffering the effects of mustard gas. He renounced abstraction in 1917 and developed the characteristic tonal modelling of simplified figural forms—'everyday poetic images' as he called them — of his mature style. He spent the Second World War in America, where he executed many major public commissions. He died at home in Gif-sur-Yvette in 1955.

Three Women (Le Grand Déjeuner)

1921. Oil on canvas, 183.5 x 251.5 cm. The Museum of Modern Art, New York

In many respects Léger is the quintessence of a Modernist painter, entirely devoted to the depiction of contemporary life, its chaotic changeability, its noise and dizzying visual brashness. More than any other painter, it was Léger who succeeded in finding a pictorial equivalent for the clatter of the factory and the building-site as well as the rush of the metropolitan street. But he was also very much the classical artist, capable of refined and powerful pictorial architecture, as his *Three Women* shows. The painting pits a carefully managed—quite varied and subtly disguised—array of vertical elements against an insistent horizontality. The deliberately mechanistic effect of such a strategy is softened and humanized by the use of curved forms that move through and across this gridlike structure. The overall effect is both highly decorative and aggressively monumental in feeling, a combination of flat pattern, looping lines, the baroque repetition of forms and extreme tonal contrasts. Like most of Léger's paintings, the image is brutally frontal in the address that it makes to the viewer, almost intimidatingly so. It also presents an entirely unfamiliar and radical picture of women.

By emphasizing and mechanizing their feminine attributes, it seems to be proposing a newly constituted gender equality as part of a distinctively modern social order. In this respect, Léger's *Three Women* can be seen as a highly political painting.

The Two Women at their Toilet, 1920
Oil on canvas, 92 x 60 cm
Private collection

160

'If pictorial expression has changed it is because modern life has necessitated it ... the thing that
is imagined is less fixed today, the object exposes itself less than it did formerly.
When one crosses a landscape by automobile or express train, it becomes fragmented,
it loses descriptive value but gains in synthetic value. The view through the door
of a railroad car or an automobile windscreen, in combination with speed, has
entirely altered the normal look of things.' **Fernand Léger**

n and
1922
as,
cm
eum Basel

161

Mario Sironi

was born in Pausania in the Sassari region of Sardinia in 1885. He matriculated to study engineering and mathematics at Rome University, but left after just one year to become a painter. In 1904–05 he practised life-drawing at Rome's Scuola libera del nudo, where he met Umberto Boccioni and Giacomo Balla. In 1914 he moved to Milan and by 1915 he was a member of the Futurist movement and showing his work from time to time at Sprovieri's Galleria futurist He was a co-signatory, with Filippo Tommaso Marinetti and Umberto Boccioni, of the manifesto *Orgoglio italiano* (Italian Pride) published in 1915, which demanded that Italy should enter the war. As good as their word, Sironi, Marinetti and Boccioni all enlisted in the Battaglione lombardo volontari ciclisti e automobilisti (Lombard Volunteer Battalion of Cyclists and Motorists). After the war Sironi join the Fascist Party and was appointed art editor for the journal *Il Popolo d'Italia*. He became increasingly disillusioned with Futurism after 1920 and by 1922 he was denying any connection with the movement. Due to his espousal of Fascism he spent the last twenty years of his life in poverty and obscurity. He died in Milan in 1961.

Urban Landscape with Chimneys

1921
Oil on canvas,
50 x 68 cm
Pinacoteca di Brera, Milan

Throughout the time that Mario Sironi was working on *Urban Landscape with Chimneys*, he was also painting his homage to Benito Mussolini, *The White Horse and the Pier*, which was finally completed in 1922. It depicts the future Fascist dictator riding a high-stepping, juggernautlike, white charger through a sleeping dockland landscape. The intended message is clear: Mussolini is depicted as a heroic, purifying force, destined to bring a new progressive spirit to the everyday lives of the Italian people. But it also reveals the profound duality that lay at the root of Italian Fascism. This duality is reflected in Sironi's oeuvre as a whole, spli as it is between the dark and brooding, industrial cityscapes painted in the 1920s and the monumental figure paintings and classical murals of the 1930s and later. *Urban Landscape with Chimneys* is typical of Sironi's work in the early 1920s. The scene is dully illuminated by a raking light that sharpens the boxlike geometr of the buildings. It is a similar device to that used by Giorgio De Chirico in his 'arcade' paintings, but where De Chirico's paintings are warm and mysteriously benign, Sironi's are cold and threatening. The drawing throughout has a brutal simplicity about it. The paint is thick and pastelike, without a trace of translucenc However, it is no easy task to arrive at some understanding of Sironi's political intention in such a work. Is it a sympathetic, quasi-symbolic representation of the forces that shape alienation in modern industrial societies, or a morbid exercise in moral despair, a Fascistic indulgence in cultural pessimism? Given the complexities and ideological uncertainties of Italian politics at that time, it is perfectly possible that Sironi might have tolerated both readings.

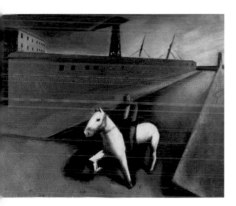

**The White Horse
and the Pier**
c. 1920–22
Oil on canvas,
44 x 56 cm
Private collection

**Synthesis of the
Urban Landscape**
1919. Oil on canvas,
40 x 42 cm
Private collection

The Fascist Spirit in Italian Culture and Art

There are a number of speeches in which Benito Mussolini describes himself as being imbued with the spirit and mind of the artist. In his famous address to the art community at the opening of the first exhibition of the new Novecento italiano grouping in 1926, he declared that 'the "political" creation, like the artistic one, is a long elaboration and a sudden divination. At a certain moment, the artist creates with inspiration and the politician with decision. Both work the material and the spirit.'

Chaïm Soutine

was born in 1893 in the Jewish ghetto of Smilovitchi, near Minsk, in present-day Belarus. Having first studied painting in Minsk, he went to the Vilnius Academy of Fine Arts in Lithuania before moving to Paris in 1913, whe he joined the class of the painter Fernand Cormon at the École des Beaux-Arts. He took a studio in La Ruche — the famous 'beehive' — where he met Marc Chagall Fernand Léger and Amedeo Modigliani. His early work, of which very little has survived, was influenced by Fauvism, but Soutine was much too emotional a character to apply the kind of disciplined colour translation Fauvism demanded. A depressive who did not make friends easily, he attempted suicide on a number of occasions. In the Second World War, as a registered Jew and fearful of arrest by the Gestapo, he was forced to flee Paris during the German occupation hidden in a coffin. During the war, he lived in the French countryside in Champigny-sur-Veude He died in a Paris hospital in 1943 after emergency surgery for a neglected and seriously aggravated stomach ulcer.

View of Céret

1922. Oil on canvas, 74 x 75 cm. The Baltimore Museum of A

This composition is one of a series of landscapes painted by Soutine during the three years that he lived and worked in the village of Céret in the French Pyrenees. These paintings have a very different look and a much more sultry atmosphere than the luminously green, slightly wind-swept paintings he made two years later at Cagnes, for which he is best known. Thick, parallel brushstrokes of red, orange and ochre are slashed through with purple-black and dark grey, making this

Céret Landscape
c. 1919. Oil on canvas,
53.5 x 65.5 cm
Private collection

View of Céret
c. 1920–21. Oil on
canvas, 54 x 73 cm
Cincinnati Art Museum

particular *View of Céret* the most Spanish-looking of all of Soutine's mountain landscapes. In the Pyrenees, he evolved an entirely new way of describing space and form. The use of aerial perspective seems artificial when one's viewpoint is endlessly shifting in order to make visual connection between things, and this dro Soutine to evolve a more immediate — less rule-bound — response to what he saw. These are paintings that record the 'event' of looking, rather than the processes o perception, and this gives them an unnerving, vertiginous feeling. This is landsca apprehended in the act of tumbling through space. Even so, they have all the forc of true observation about them.

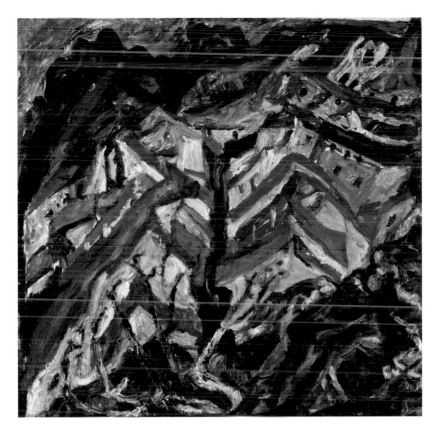

Soutine is frequently described as a 'Jewish Expressionist', but both terms require careful qualification. His is definitely not the highly cerebral, strategically directed Expressionism that we associate with groups like Die Brücke or Der Blaue Reiter, rather it is something deeply felt—an emotional force that wells up from within. It would be much more appropriate to think of it as an excess of 'expressiveness'. Whether this is a particularly Jewish trait is also open to question, although as a characteristic approach, it certainly seems to tie him to other Jewish painters like Oskar Kokoschka, David Bomberg and, more recently, the British painters Leon Kossoff and Frank Auerbach.

Soutine and Dr Barnes

View of Céret was one of fifty-two paintings bought from the painter's studio by the American collector Albert C. Barnes in two lots during 1922 and 1923. Some he kept for his own collection, the others he sold on to art dealers in New York and Paris. By doing so Barnes probably saved many works that might otherwise not have survived. The painter destroyed many of the Céret works before leaving the village and a good many more shortly after his return to Paris.

Kurt Schwitters

was born in Hanover in 1887. He studied at the Kunst-gewerbeschule there before transferring to the Kunstakademie in Dresden (1909–14). In 1918, after a short period during which he experimented with Cubism, he turned his attention to collage and invented the term *Merz* (a shortening of *Kommerz*) to describe his new approach to materials, content and method. In the end the term was applied to everything he did: collages and constructions, concrete poetry and music, performances and installations. A fringe member of the Hanover Dada group, he was a close friend of Jean Arp and Raoul Hausmann. Schwitters founded the *Merz* magazine in 1923 and it continued as an occasional publication until 1932. Having started on his first *Merzbau* (Merz Construction) in the family home in Hanover in 1923, he worked on it until 1936 when he was forced to flee from the Nazis. This first *Merzbau* was completely destroyed in an air raid in 1943. Schwitters and his son Ernst went to Norway, where he set about constructing a second *Merzbau*, but once again had to abandon the project, this time due to the German invasion of 1940. It was later destroyed in a fire in 1951. Schwitters finally escaped to Britain, where he was interned as an 'enemy alien' for a period of sixteen months. After his release he lived in London, before moving to Little Langdale in the Lake District. Although he started work on a third *Merzbau*, he was unable to complete it before his death in 1948.

Merzbild Kijkduin

1923. Mixed materials on panel, 74.3 x 60.3 cm
Museo Thyssen-Bornemisza, Madrid

Kurt Schwitters was one of the most important innovators of the modern movement. His invention—the Merz Construction—was a crucial step along the road to an entirely new category of artwork, distinct from both painting and sculpture. Today we refer to some works of art as 'objects'. 'Objects' are not primarily concerned with spatial illusion (the main concern of painting) or with

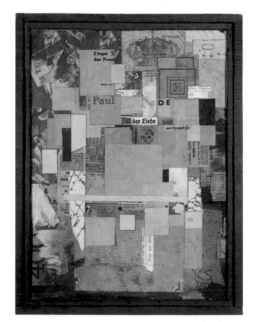

the articulation of forms in space (the main concern of sculpture), but with the intrinsic properties of things in themselves. Schwitters defined *Merz* very simply as the discovery of 'new forms' and 'new methods of forming' retrieved from 'the world as it is'. For this reason, the most important *Merzbild* (Merz Picture) techniques were collage and assemblage. Both worked with

Merz Picture 12 b Plan of Love, 1919–23
Mixed media on paper, 43 x 32.5 cm
The Metropolitan Museum of Art, New York

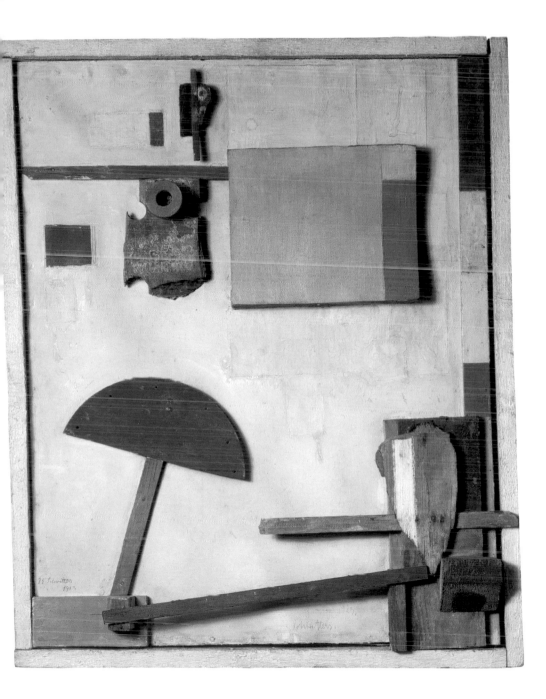

'*Merz* stands for freedom from all fetters, for the sake of artistic creation.
Freedom is not lack of restraint, but the product of strict artistic discipline.'
Kurt Schwitters

Untitled (Merz Construction), 1923
Mixed media on board, 34.5 x 29 cm
Museum Ludwig, Cologne

the world's detritus — found materials and objects and bits and pieces more often than not chosen for their texture or colour, picked up from the floor of the studio, on waste tips or in the street. *Merzbild Kijkduin* is mainly an assemblage. Its component parts are by and large as Schwitters found them. It seems to be proposing a 'comical' mechanics of some kind: a series of non-functioning levers and balances that treat colour 'weight' as if it were real weight, capable of effecting real change in the disposition of real things.

Typically, the apparent simplicity of Schwitters's method belies the complexity of his thinking, which surfaces fully only in his attempts to create a *Gesamtkunstwerk* — a total work of art — in the three Merz Constructions.

The Hanover *Merzbau:* The Cathedral of Erotic Misery

The underlying philosophy of *Merz* brings together a wide range of different interests and concerns from Expressionism to Constructivism, from alchemy to architecture, from ancient Teutonic nature mysticism to contemporary criminology. Hermeticism — alchemy in particular — is the central factor in Schwitters's thinking. His attachment to the idea of turning 'the refuse of society' into works of art is clearly borrowed from the metaphorical task of the alchemist: to turn base-metal into gold. In this respect, the project of the *Gesamtkunstwerk*, for Schwitters, was inescapably bound up with the idea of *Lebensform*, the goal of achieving a new and greatly enriched approach to life, and this is why the first *Merzbau*, constructed in Hanover between 1923 and 1936, attempted to incorporate every aspect of life into a single emblematic, architectural representation. The project started quite modestly with the rearrangement of objects and furniture in the artist's studio but gradually grew in size and complexity until, by the time Schwitters had to abandon it in 1936, it had spread to encompass eight rooms, all but filling the family's Hanover apartment. It even leaked out of the building and travelled down the façade to join with the water cistern in the yard beneath. A bewilderingly complex work, it involved every kind of aesthetic action from the large-scale modification of the internal architecture of the house to the meticulous application of small-

Merz Building,
Grand Group, c. 1932
Mixed media,
c. 393 x 580 x 460 cm

Untitled
(Merz Column)
1923–25,
destroyed
Mixed media,
dimensions unknown

Merz Building, Grotto
in Memory of Molde
1935, destroyed
Mixed media, dimensions unknown

scale *Merz* components: collaged scraps of paper,
assembled found objects and fragments of wood,
glass and metal.

In terms of its content the starting point for the first
Merzbau is generally thought to have been the three *Merz
Columns* that Schwitters made between 1917 and 1923,
the most notable being the *Merz Column* (1920–23) that,
in its final version, incorporated the death mask of his son
Gert, and the *Great Column* (1923), subtitled *The Cathedral
of Erotic Misery*. As the term 'Cathedral' suggests,
Schwitters saw it as the equivalent of a religious site,
with its architecture connecting the Earth to the heavens.
He whitewashed the windows so as to exclude the outside
world and built an internal space that was labyrinthine
in its complexity. As well as being a highly personal project,
it contained a multitude of small grottoes and private chapel-like spaces,
each dedicated to iconic cultural or criminal persons or events:
theatre pieces, operas, murders; a notable historical figure or a friend;
animals and objects; curious obsessional devices, habits and states of mind.

Felice Casorati

was born in Novara in 1883. He spent his early years in Milan and Padua and as a child showed a talent for both art and music. A graduate in law from the University of Padua (1906), he lived in Naples from 1908 to 1911. In 1919, having served in the First World War, he went to live and work in Turin, where, in tune with contemporary artists like Achille Funi and Arturo Martini, Casorati developed a lucid style of figurative painting that typified what was called 'the return to order' in the arts in the postwar period. He was briefly arrested in 1923 for anti-Fascist activity. Thereafter he chose to avoid confrontation with the regime and gradually became a leading figure in Italian cultural life. In his later life, Casorati spent much of his creative energy designing for the theatre and the opera. He died in Turin in 1963.

Portrait of Hena Rigotti

1924. Tempera on canvas, 77 x 60 cm
Galleria Civica d'Arte Moderna e Contemporanea, Turin

'The return to order' manifests itself in Italian painting as a search for new values in the great art of the past. Casorati, like Funi, looked to the Mannerists Bronzino and Pontormo and beyond them to the paintings of Piero della Francesca and Paolo Uccello. In Funi's work this takes the form of a mildly erotic, slightly sinister 'high camp', not dissimilar to the work of the German Neue Sachlichkeit painter Christian Schad. In the paintings of Casorati it surfaces as a finely judged pictorial geometry. He was a particularly good portrait painter and his *Portrait of Silvana Cenni* (1922), with its crisp light and shade, studied symmetry and Pieroesque

perspective linking the interior to the exterior space, is one of the key works in the Italian art of the early 1920s. There is something convincingly ethereal and intro-spective about the person of Cenni in Casorati's painting. It has the ring of truth about it — as does the very different, but equally accomplished *Portrait of Hena Rigotti*, painted just two years later in 1924. Here, the dramatic use of tonal contrast combines with the controlled simplification of line and modelled form to produce a very distinctive — classically ironic — atmosphere: an intense feeling of detached calm. Although its construction is less obvious than the symmetrical portrait of Cenni in which the forms have a rather 'metaphysical', almost weightless feel to them, the structure in the *Portrait of Hena Rigotti* is palpably present. Everything has visible bodily weight, from the cloth to the lusciously painted bowl of fruit, from the fruit to the coolly composed figure of Hena Rigotti herself.

Portrait of Silvana Cenni, 1922
Tempera on canvas, 205 x 105 cm
Private collection

Otto Dix

Otto Dix was born in 1891 at Untermhaus near Gera in Thuringia, Germany. Following an apprenticeship in decorative painting he studied at the School of Applied Art in Dresden and later, after military service during the First World War, at the Dresden Academy and the Düsseldorf Academy of Art. Dix was appointed Professor of Painting at the Dresden Academy of Art in 1927 but was removed from his post in 1933 and withdrew from public life to live in isolation at Hemmenhofen on Lake Constance. In 1937, with the continued rise of the Nazi Party, he was branded a 'degenerate'. Many of his works were confiscated and some were destroyed. In 1950 Dix was appointed Professor at the Düsseldorf Academy of Art. He died in the German town of Singen on the River Rhine in 1969.

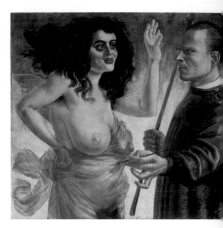

Self Portrait with Muse
1924. Oil on canvas, 81 x 94 cm
Karl Ernst Osthaus-Museum, Hagen

Hugo Erfurth with his Dog

1926
Oil and tempera on
wooden panel, 80 x 100 cm
Museo Thyssen-
Bornemisza, Madrid

Otto Dix's painting of the famous portrait photographer Hugo Erfurth with his dog belongs to the realist period of Dix's work, following his early Expressionist phase and a brief flirtation with Dada. Although he is often spoken of alongside George Grosz and, like Grosz, subscribed to Neue Sachlichkeit, he was actually a very different kind of painter. Where Grosz was determinedly political and used his work to be openly critical of the public figures and institutions that dominated German life in the Weimar Republic, Dix was altogether more circumspect in his approach. He did not believe that art was a good instrument for bringing about political change. As far as he was concerned, the artist was a comparatively insignificant part of the social order, too 'small'—as he put it—to assume the role of political activist. Instead, he saw his responsibility—and the responsibility of artists in general—as that of the dispassionate reporter, someone with highly developed observational powers whose role it was to record and reflect the current state of the social world.

Dix's portrait of Erfurth is clearly intended as an affectionate and humorous turning-of-the-tables on the photographer who had himself photographed Dix on a number of occasions. The stooping, pale-eyed, seemingly myopic figure,

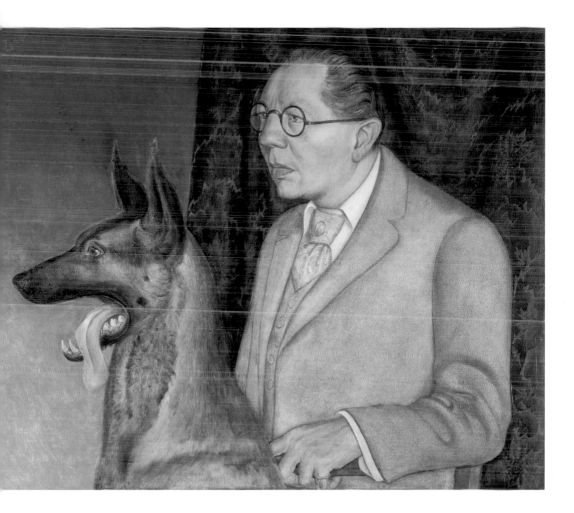

with his jewelled tie-pin and his jade ring, is presented as the epitome of the
well-dressed, bourgeois professional. His German shepherd dog, ears pricked,
seems at once more alert and panting for action. The image is very precisely
detailed. As befits a tempera painting — which, in the classic manner, is finished
off by the application of oil and varnish glazes — skin, fur, slicked-back hair,
silk and woollen cloth are all simulated with meticulous care. The luminous
aquamarine-blue that dominates the left side of the painting is threaded
through the browns and greys in carefully controlled quantities to give
the painting its overall feeling of pictorial unity.

Georgia O'Keeffe

was born in 1887 in Sun Prairie, Wisconsin. She studied at the Art Institute of Chicago and the Art Students League of New York. On completing her studies in 1908, she abandoned the idea of becoming an artist and instead moved into the field of art education. She took classes at Columbia University, where she came under the influence of the radical artist/educator and Orientalist Arthur Dow. Teaching continued to be her main interest until, in 1916, she met the renowned photographer and New York gallerist Alfred Stieglitz, who put on her first one-person exhibition at his gallery 291 in 1917. O'Keeffe lived and worked with Stieglitz in New York (marrying him in 1924) until his death in 1946, when she moved to live in her Ghost Ranch House in Abiquiu, New Mexico. She stopped making large paintings in the mid-1970s when her eyesight began to fail, but continued to make drawings, watercolours and small sculptural objects until two years before her death in 1986 at the age of ninety-eight.

Black Iris

1926
Oil on canvas, 91.4 x 75.9 cm
The Metropolitan Museum of Art, New York

O'Keeffe's first solo exhibition at gallery 291 comprised 'abstracted' landscapes of quite startling simplicity. She was teaching at a school in Texas at the time and the paintings seem to embody the huge, wrap-around flatness — low horizons and big skies — of the Texas plains. Even so, the interpretive debate that — even today — continues to surround certain of O'Keeffe's paintings, including *Black Iris*, was instigated by these canvases. Some critics thought that the landscapes demonstrated a new, distinctly American approach to pictorial space. Others saw them as 'symbolic', womblike and therefore quintessentially feminine. O'Keeffe, herself, argued that she was quite simply painting what she saw, filtered through her long-standing interest in Oriental design. But the problem of interpretation refused to go away and was greatly intensified and sexualized with the arrival of the botanical paintings, *Black Iris* from 1926 and the series of six *Jack-in-the-Pulpit* paintings made in 1930. It is hard — perhaps impossible even — not to view *Black Iris* as an intensely sexual painting. On one level it is quite simply an image of the *Black Iris* of its title, but on another it reads both figuratively and symbolically as the opened-out sexual parts of a woman. Furthermore, far from offsetting the feeling of intimacy suggested by its secondary reading, the size of the image — its

ly
o paint
see.'
ia
ffe

ning
ains
.7
ur on paper.
m
ter

n

a

vas
on

cm
of
useum
son

e-Pulpit
30
vas.
.2 cm
Gallery
shington

gigantism — seems to make it all the more intense. However, the size
of O'Keeffe's botanical paintings and their sheer intensity can also be
accounted for in another way. One of the favourite exercises that Arthur
Dow gave to his students was to place a flower very close to the eye,
so as to maximize and intensify colour sensation. The shallowness
of field and the almost suffocating feeling of proximity in *Black Iris*
seem to recall this kind of experience.

'Nobody sees a flower — really — it is so small it takes time.
We haven't time and to see takes time, like having a friend takes time.'
Georgia O'Keeffe

Joan Miró
Landscape

1927
Oil on canvas, 129.9 x 195.5 cm
National Gallery of Australia,
Canberra

Joan Miró Ferra was born in Barcelona in 1893. After studying painting for three y
at La Lonja's Escuela Superior de Artes Industriales y Bellas Artes, at the same t
as attending business school, he took a position as a clerk. Following a nervous br
down and leaving his job in business, he attended Francesc Galí's Escola d'Art (191
Having made his first trip to Paris in 1920, he went there to live in 1921. He met an
became friendly with Pablo Picasso. In 1924 he met André Breton and began to
associate with Breton's circle of artists and writers, which included Max Ernst an
André Masson. However, wary of Breton's demanding personality, he avoided joini
the Surrealist group, preferring to maintain a degree of creative independence.
He returned to Spain in 1940 and remained there throughout the Second World W
He had his first major international retrospective at the Museum of Modern Art,
New York, in 1941. In 1956 he commissioned the renowned Modernist architect
Josep Lluis Sert to build him a house and studio in Palma de Majorca, where
he lived and worked until his death in 1983.

Miró set his face firmly against the use of traditional painting values and methods
when still in his mid-twenties. The figurative paintings he made between 1918 and
works such as *Vegetable Garden and Donkey* (1918) and *Interior: La Masovera* (
already show scant interest in illusion. Instead they are made up of decorative,
rhythmically repetitive elements arranged in a flat pictorial space. By 1925, when
painted *Circus Horse* and *Dancer*, all reference to a 'real' topography in his work
disappeared and he had opened up the picture space, turning it into a unified colo
ground. In effect, Miró had begun to make 'figure field' paintings well in advance
anything of the kind in American painting. By 1928 he had begun to experiment wi
pared-down versions of traditional genres, producing his 'Dutch' interiors (includi
those after Jan Steen) and the six Montroig landscapes in which the canvas is div
horizontally into two abutting colour fields, each containing its own figural forms.
The National Gallery of Australia's *Landscape* (sometimes called *Landscape with
Rabbit and Flower*) contrasts two of Miró's favourite colours: a downward-falling
curtain of softened cobalt blue descends over an expanse of dusty red. Each colou
area is inhabited by its own very special creature: the blue area by what Miró
described as an 'illuminated egg', tethered to the Ea
by the finest of lines, and the red area by what he ca
—rather implausibly—a rabbit's head. Miró later
said that the image had its origin in the real landsca
namely the redness of the earth in nearby Cornudell
where his grandfather came from.

Vegetable Garden and Donkey, 1918
Oil on canvas, 64 x 70 cm. Moderna Museet, Stockholm

'A picture must be fertile. It must give birth to a world.
Whether you see in it flowers, people, horses, it matters little,
so long as it reveals a world, something alive.'
Joan Miró

Dancer II, 1925
Oil on canvas, 115.5 x 88.5 cm. Private collection

René Magritte

was born in Lessines near Tournai in French-speaking Belgium
in 1898. He spent his childhood in Châtelet and Charleroi. He attended the Académie des
Beaux-Arts in Brussels from 1916 to 1918. There he met the brothers Victor and Pierre
Bourgeois and the painter Pierre-Louis Flouquet. In 1919 Magritte contributed to the first
issue of the review *Au Volant* published by the Bourgeois brothers. After a year of military
service he worked as a designer, first of all for a wallpaper manufacturer in Brussels
and then as a freelance designer of posters, publicity materials and exhibition stands.
He painted his first acclaimed Surrealist painting, *The Lost Jockey*, in 1926 and in the
same year, along with the other Belgian Surrealists, signed the declamatory leaflets
Two Disgraces and *The Married Couple of the Eiffel Tower*. Between 1927 and 1930
Magritte lived in Le Perreux-sur-Marne near Paris, during which time he became
acquainted with Hans Arp, André Breton, Salvador Dalí, Paul Eluard and Joan Miró.
Magritte's provocative essay 'Words and Pictures' was published in the last issue
of *La Révolution Surréaliste* in 1929, a year after he painted *The Empty Mask*.

The Empty Mask

1928. Oil on canvas, 73 x 92 cm. Kunstsammlung Nordrhein-Westfalen, Düs

Although René Magritte was happy to accept the
label 'painter', he disliked being called an artist. He
thought of painting as a fairly tedious occupation, but
one that at least had the merit of being chiefly con-
cerned with thinking and the lucid transmission of
thought. For Magritte, the problem of painting was
deeply embedded in the much larger and more funda-
mental question of language. The painted, figurative
image — if it is to avoid mere replication — must
engage with the question of intelligibility. How do
languages relate to the world of things and what (or
where) is the shared ground that enables different
languages to become intelligible to each other?
It was questions such as these that led Magritte
in the late 1920s and early 1930s to embark on
a visual exploration of the relationship between
the name and the thing named, between description
and the conditions governing the thing's existence.
It was in 1926 that Magritte made the first of the
'pipe' paintings, a crude image with the words '*la
pipe*' scrawled underneath it. Both affirmative and
contradictory at one and the same time, the device
forces a linguistic 'translation' to occur. The words
are read in terms of the image and the image in
terms of the words. By 1928 Magritte had extended
this simple mechanism to encompass the more
complex, negative word-and-image game of *The
Treachery of Images*. Here an illusionistic picture
of a pipe is countermanded by the written statement
beneath it: 'Ceci n'est pas une pipe' (This is not a
pipe). The implication is that images are ghostly

The Treachery of Images, 1928–29
Oil on canvas, 60 x 81 cm
Los Angeles County Museum of Art

traces and not to be confused with things. Furthermore, words, or to be more precise the authority — truthfulness — of written language, can be rendered fugitive by the beguiling nature of the image.

Magritte painted *The Empty Mask* shortly before *The Treachery of Images* and it is clear that its main address is to painting and painting's claim to representation. The term 'mask' suggests that something is being hidden or disguised and we are bound to conclude that it is the picture facing away from us. We are allowed to view only its back: an irregular, slightly crazy stretcher divided into four uneven parts, standing in a darkened, stagelike space. Each section is labelled with a studiedly ambiguous word or phrase: '*ciel*' meaning the sky, the firmament or the heavens; '*corps humain (ou forêt)*', the human body, as an individual, a collective or even a habitus (forest); '*rideau*', a curtain or a screen; '*façade de maison*', the front of a house ('front of house' in the theatre). Consideration of these four sites helps to fix in the viewer's mind the limitations of representation: the place where the world of material things slips away into the metaphysical, where reality is overtaken by illusion, where the instrumental use of words is turned, as if by magic, into poetry.

retation
, 1930
vas.

lection

Joan Miró
Dutch Interior II

1928
Oil on canvas, 92 x 73 cm
Peggy Guggenheim
Collection, Venice

Joan Miró visited the Netherlands in 1928, where he became fascinated with the work of the Dutch Baroque painters in the Rijksmuseum in Amsterdam. The story goes that he returned to Paris with several postcards of their works and that these postcards provided the basis for the two extremely free pictorial 'transcriptions' he painted that summer: *Dutch Interior I* (after Hendrick Martensz Sorgh's *Lute Player*) and *Dutch Interior II* (after Jan Steen's *Cat's Dancing Lesson*).

Jan Steen, **The Cat's Dancing Lesson**
c. 1665–68. Oil on panel, 68.5 x 59 cm
Rijksmuseum Amsterdam

It is not difficult to see why Miró would find himself attracted to seventeenth-century Dutch paintings. Not only are they packed with amusing narrative incident, they also combine energetic composition and well-managed pictorial space with a wealth of beautifully articulated detail. And a painting like Steen's *The Cat's Dancing Lesson* has yet more ingredients that would have charmed the Catalonian painter: rustic types, musical instruments, domestic animals. Miró's transcription allows none of these things to escape the viewer's attention. Indeed, they are all carefully re-presented in a reinvigorated and highly comical form. In Miró's painting, for example, Steen's laughing child with a head that is too big for its body becomes all head, losing its trunk and limbs altogether. The dog has developed the rear end of a goat, complete with milking teat and lolloping tail, while at its front end its tongue explodes from its mouth like a flower rudely and monstrously red. In Miró's picture the dancing cat with its white belly exposed has developed feet like musical notes and the musician's blue dress has completely enveloped her. She has become the limpid sound she makes:

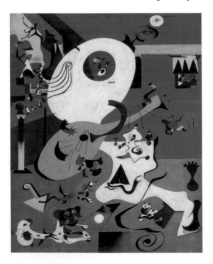

an abstracted solitary yet intensely voluptuous blue note, rising up and floating free. In fact Miró's transformative games, shift of shape and scale, pick up perfectly on the erotic undertow in Steen's *The Cat's Dancing Lesson*. The Dutch painting is about 'animal' bodies and the way they move or — to be more precise the way in which music can make them move. The crucial visual metaphor, then, is between the pipe-playing musician and the rampant barking dog. And the brilliance of Miró's transcription lies in the fact that besides finding a modern pictorial equivalent for Steen's lively domestic scene, Miró has succeeded in extending the reach of his vocabulary of mark-making to encompass the realm of sound.

Dutch Interior I, 1928
Oil on canvas, 92 x 73 cm. The Museum of Modern Art, New York

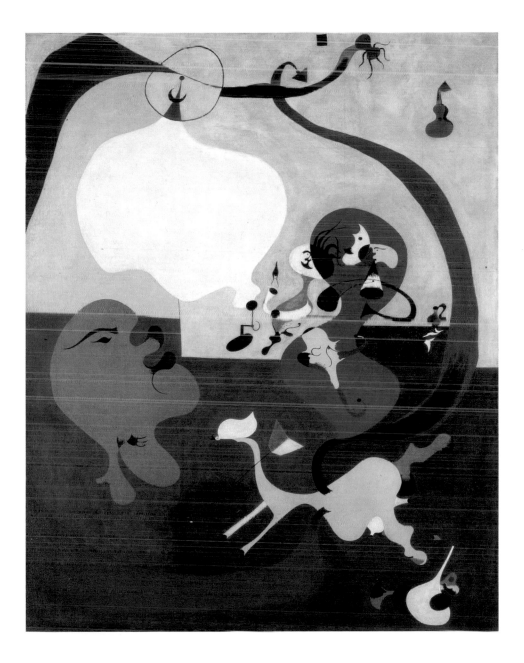

Alberto Savinio, the younger brother of Giorgio De Chirico,

was born in 1891 and christened Andrea (De Chirico). A musical child prodigy, he graduated with honours from the Athens Conservatory when he was only twelve years old. Afterwards, he studied composition under Max Reger in Munich and his first full-length opera, *Carmela* (1906), was given its first public performance shortly after his seventeenth birthday. It was greatly praised by his fellow composer Pietro Mascagni. Andrea De Chirico changed his name in 1912 to avoid being confused with his brother. While continuing to work as a composer and a 'metaphysical' novelist, poet and playwright, in 1924 — encouraged by his brother — he started to paint and in 1927, when he was in his mid-thirties, had his first solo exhibition at the Galerie Jacques Bernheim in Paris, to where he had moved the year before. He returned to Italy in 1933 and died in Rome in 1952.

The Isle of Charms

1928. Oil on canvas, 114 x 162 cm
Museo d'arte moderna Mario Rimoldi,
Cortina d'Ampezzo

Savinio's *Isle of Charms* is roughly based on *The Island of the Dead* (of which five versions were painted between 1880 and 1886) by the Swiss-born Symbolist painter Arnold Böcklin. Savinio first discovered Böcklin, along with the writings of Friedrich Nietzsche, during the years he spent with his brother Giorgio studying in Munich. And in the years to come, Böcklin and Nietzsche remained central to their joint theory of 'metaphysical' painting, although Savinio once remarked rather disparagingly of 'metaphysical' painting that 'it is nothing. It's in the family: a family language.'

Like his brother, Savinio was a sceptical 'modern'. He doubted the efficacy of an idea like 'progress', particularly since it had been advanced by the Italian Futurists. For Savinio, art required an 'objective, unifying, mythological fabric' of the kind provided by the ancients. The 'metaphysical' key lay in a process of 'revelatory anamnesis': the remembrance of a Platonic pre-existence.

Thus Savinio's isle is a site of mnemonic revelation. Like Böcklin's, it exists 'somewhere between waking and sleeping, between death and life'. As might be expected from a musician of Savinio's standing, *The Isle of Charms* sparkles with visual music. Carved and richly illuminated monuments rear up and tumble about, brought back to life by what Savinio called *les chants de la mi-mort* — the singing of the 'half-dead'.

The Lost Ship, 1928
Oil on canvas, 81.5 x 55.5 cm
Private collection

Nietzsche, De Chirico and Savinio

In Nietzsche's most celebrated work, *Thus Spoke Zarathustra* (1883–85), Zarathustra's disciples live on 'blissful isles' a region echoing with sad song and melancholy poetry. This mirrors Nietzsche's increased feelings of isolation and foreboding. By the mid-1880s he was already beginning to experience the bouts of intense depression that presaged his final mental breakdown of 1889. Both De Chirico and Savinio claimed to be the reincarnation of Nietzsche. Never of a retiring disposition, De Chirico claimed to be the beneficiary of a kind of transmigration of intellect and soul.

Daedalus, 1929
Oil on canvas, 73 x 60 cm
Private collection

Christian Schad

was born in Miesbach, Bavaria, in 1894. He studied for one year at the Akademie der Bildenden Künste in Munich immediately prior to the outbreak of the First World War. At the same time he was also contributing woodcu illustrations to magazines such as *Die Aktion* and *Die Weissen Blätter*, and founde the magazine *Sirius* with the Dada artist and writer Walter Serner. Schad moved t Zurich in 1915, where he joined the Dada group, made 'Merz-like' collages and reliefs, and developed a keen interest in experimental photography. He made his first 'schadographs' using camera-less 'photogram-like' techniques in 1918. Schad moved to Naples in 1920, where he made his first Realist paintings. By 1928, after a short stay in Vienna, he was back in Germany and living in Berlin, where he quickl became associated with Neue Sachlichkeit (New Objectivity) and with artists such as Otto Dix, Max Beckmann and George Grosz. Schad stopped painting in the 1950 and returned to photography. He died in Stuttgart in 1982.

Portrait of Dr Haustein

1928. Oil on canvas, 80.5 x 55 cm
Museo Thyssen-Bornemisza, Madrid

Between 1927 and 1929 Christian Schad made some of the most distinctive paintings of the Neue Sachlichkeit movement. The images, mostly single or double portraits, painted in a flat Mannerist style, not only capture the sense of spiritual exhaustion that followed the First World War, they also express something of the moral bankruptcy of middle-class German society in the Weimar years, which helped to pave the way for the rise of the National Socialists. Although the original aim of Neue Sachlichkeit was to show society as it really was, artists like Dix and Grosz did not hesitate to use caricature and exaggeration as ways of carrying the work beyond objectivity into the domain of political satire. By contrast, as can clearly be seen in a painting like that of the transvestite *Sonja* (1928), Schad stays much closer to appearances, relying on the selective sharpness of his observations and careful attention to detail to give an added note of strangeness to his images. The portrait of the gynaecologist *Dr Haustein*, like *Agosta, the Pigeon-Chested Man, and Rasha, the Black Dove* (1929), is typical in its allusions to what Sigmund Freud called *Unheimlichkeit* (the uncanny), wherein the seemingly ordinary exists side by side with the disturbing and even the downright weird. The dapper doctor, with his direct, confident, but slightly quizzical gaze, slender wrists and delicately folded surgeon's fingers, seems to be entirely unaware of the horror that stalks the wall behind him. An 'extra-terrestrial' shadow, with a large foetal head and clawlike fingers, seems to function as a Svengali-like parody of his profession and professional life.

28
...vas,
m
e Museen
Neue
...lerie

...ne
...hested
Rasha,
Dove

...vas,
5.5 cm
...ction,

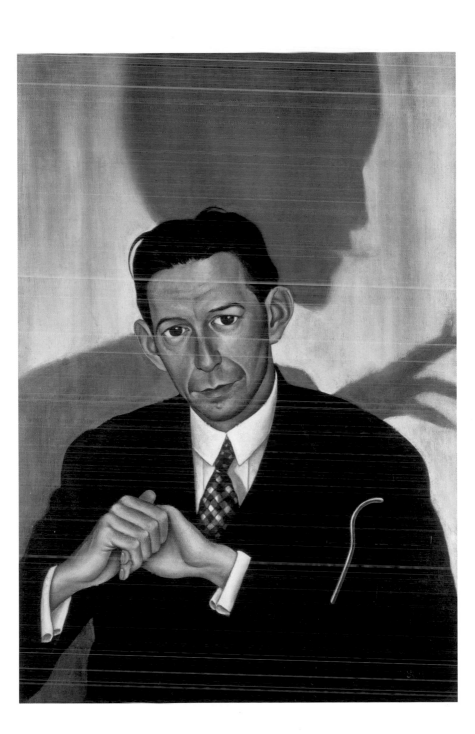

Georges Braque

was born in Argenteuil-sur-Seine in 1882. He spent his early years in Le Havre, where he also attended evening classes at the École des Beaux Arts. Braque's father was a craftsman house-painter, and Georges was sent to Paris to study with a master decorator; he received his craftsman's certificate in 1901. A year later he enrolled at the Académie Humbert to study painting. There he met Marie Laurencin and Francis Picabia. He turned to painting in the Fauvist style and showed his paintings publicly for the first time at the Salon des Indépendants in 1907, attracting the attention of the gallerist Daniel-Henry Kahnweiler. From 190 Braque and Pablo Picasso worked together to evolve the Cubist style, matching each other move for move. Their collaboration lasted until 1914 when Braque went to serve in the French army; he was wounded and invalided out of the army in 191 In 1917, after an enforced period of convalescence, he entered into a close working friendship with Juan Gris and together, during the next decade, they brought the synthetic phase of Cubist painting to its most refined form. Braque spent the duration of the Second World War in Paris. Ill health dogged his footsteps during his last years and he died in Paris in 1963.

Still Life: Le Jour

1929. Oil on canvas, 115 x 146.7 cm
National Gallery of Art, Washington

The synthetic Cubist still lifes of Braque have their own very special qualities, which make them entirely distinct from those of either of his two great collaborato in the Cubist project, Pablo Picasso and Juan Gris. Picasso's still lifes, paintings like *Studio with Plaster Head* (1925), tend to be shot through — shattered almost — by sharp contrasts of tone and colour, while Braque's are subdued, verging on the reticent. The still lifes that Juan Gris painted towards the end of his life, *The Blue Cloth* (1925) for example, depend on carefully weighted tonal relationships linked an almost subliminal use of colour, while Braque uses tone as pattern and enliven his still lifes with a range of subtly edgy, acidic colour dissonances. Like so many Braque's paintings, the colour mood of *Still Life: Le Jour* has a slightly nervy feel it. The uneasiness emanates from the discordant relationship between yellow-gre and burnt ochre-brown that dominates the background of the picture. And Braque has introduced a similar colour irritant into the group of objects arranged on the

Pablo Picasso, **Studio with Plaster Head**, 1925
Oil on canvas, 98 x 131 cm
The Museum of Modern Art, New York

Juan Gris, **The Blue Cloth**, 1925
Oil on canvas, 81 x 100 cm
Musée national d'Art moderne, Centre Georges Pompidou, F

'If a painting doesn't disquiet,
then what is it?' **Georges Braque**

table: the swatch of violet-grey that runs down the side of the jug to form
the pool of shadow on the table, which strikes an uneasy discord with the
shaded lemon-yellow of the fruit and the crust of bread. Braque said that
a successful painting for him is one that reaches into the 'intellectual void'
where ideas have been obliterated and only uncertain feelings remain.
It is clear from paintings like *Still Life: Le Jour* that, for him, feelings
were very much attached to the interaction of colour and the creation
of unusual colour relationships.

Constant Permeke

was born in Antwerp in 1886. His father was a landscape painter who later became the director of the Museum of Fine Arts in Ostend. Permeke studied painting at the academies in Bruges and Ghent and in 1909 went to live and work in the artists' colony at Sint-Martens-Latem. Throughout his career he painted pictures of working life, starting with the fishermen of the Belgian coast. Having initially painted in an Impressionist style using a high-colour key, he quickly abandoned this in favour of a darker, more brooding palette influenced by the early paintings of Vincent van Gogh. Wounded during the siege of Antwerp at the beginning of the First World War, Permeke was sent to convalesce in England, where he turned his attention to landscape painting. Back in Belgium in 1919, he returned to painting pictures of fishermen and farm workers. During his lifetime, there were major exhibitions of his work in Madrid and London, and a retrospective in Paris in 1947. He died in Ostend in 1952.

The Potato Digger

1929. Oil and turpentine on paper and triplex board, 164 x 126 cm
Provincial Museum Constant Permeke, Jabbeke

Constant Permeke's paintings after 1919 are profoundly linked to the Belgian landscape. They present a vision of an elemental relationship between farm labourers and the soil they work. The labourers act on the land, transforming it with their hands and in return the land acts on their bodies, making heavy their fingers, hands and wrists, thickening and lengthening their arms, broadening their shoulders and stiffening their backs. The potato digger kneels on the ground, naked above the waist—skeletally thin—her arms are covered by protective sleeves leaving her broken hands exposed. She turns her face towards the viewer in what seems to be a gesture of supplication. As in this case, Permeke liked to open up the picture space either to the left or to the right in order to provide a frame for certain drawn details that then assume an allegorical significance within the image as a whole. In *The Potato Digger* the figure is positioned to the right, allowing for the inclusion—on the left— of her basket and a scattering of potatoes that seem to merge with and emerge from the bare, brown earth. In the Tate's *Harvest* (1924–25), the displacement is to the left, creating a recessional space to the right that frames an abandoned plough and beyond it a farmer using a horse-drawn harrow to break up the soil.

My Window at Evening, 1911
Oil on canvas,
96.5 x 83.5 cm
Private
collection

Harvest
1924–25
Oil on canvas,
128 x 165 cm
Tate Collection,
London

In both cases the device introduces a temporal dimension to the reading of the picture. The lateral moves—from right to left or left to right—switching the focus between foreground and background also tend to introduce shifts in narrative time. Thus the basket comes to symbolize the potato digger's life: her past, her present and her future.

Edward Hopper

was born in 1882 in the small town of Nyack on the Hudson River. He studied with William Merritt Chase and the Ashcan realist painter Rober Henri, commuting to New York for lessons. Between 1906 and 1910 he visited Paris London and Amsterdam before returning to live in New York. Three years later, he took the apartment and studio in Washington Square North where he lived and worked until his death in 1967. He married the painter Josephine 'Jo' Nivison in 1924, thereby embarking on an argumentative and sometimes violent relationsh that seems nevertheless to have been equally important to both of them.
They lived in each other's pockets. Hopper was a pathologically jealous man, jealous even of the attention his wife paid to her cat, Arthur. Jo worked as his housekeeper and his model, and although she felt oppressed by the relationship she was fiercely loyal and supportive of Hopper and his painting.

'My aim in painting has always been
the most exact transcription possible of
my most intimate impression of nature.' **Edward Hopper**

1931
Oil on canvas, 152.4 x 165.7 cm
Museo Thyssen-Bornemisza, Madric

Hotel Room

is one of the most complete paintings of Hopper's middle period. A lone woman sits on the edge of a bed reading a book, silhouetted against a greenish-white light filtered through a net curtain. Her coat is thrown casually across an armchair; her bags are still unpacked. On one level the image is entirely commonplace and yet it has a quality of sustained tension about it, almost a breath lessness, that makes us pause to study it more closely. As with all of Hopper's best paintings, we are aware that the image has been hard won. But it is a feeling of psychological depth that conveys this more than any signs of the artist's labour. In fact, as a painting, it is remarkably easy on the eye. The brushwork is almost prosaic and there is nothing unexpected or out of place in the disposition of forms within the space of the canvas, except perhaps for the slightly awkward cropping of the woman's feet — a device that seems to belong more to photography, or even the cinema, than to painting. However, on closer scrutiny it appears that it is this detail, dead-centre on the lower edge of the picture, that serves to compress the image and give it its feeling of claustrophobia.

Early Sunday Morning, 1930. Oil on canvas, 89.5 x 153 cm
Whitney Museum of American Art, New York

John Huston
Still from **The Maltese Falcon**, 1941

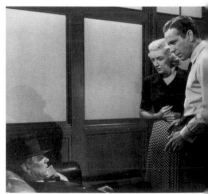

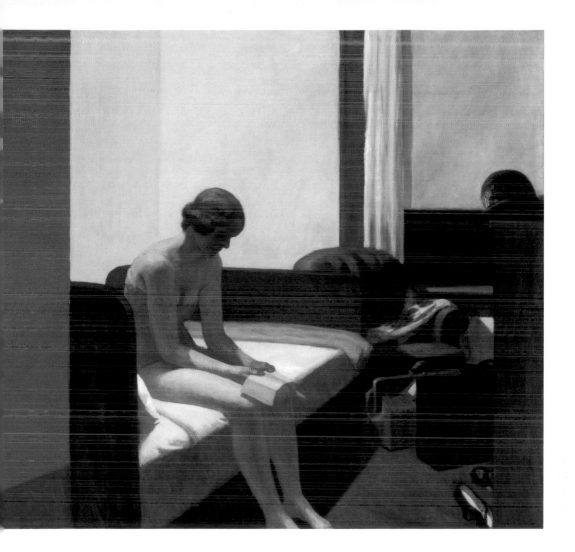

Hopper and the Cinema

Hopper's teacher, the realist painter Robert Henri, advised the younger artist to look closely at the theatre for ways of framing an image in terms of time and space. It seems that this advice was well received and understood. There is clear evidence of a calculated theatricality throughout Hopper's oeuvre. What is more difficult to assess is the influence of the cinema. There are examples of Hopper paintings that today look powerfully cinematic, *Early Sunday Morning* (1930), for example, or *Nighthawks* (1942), but it is hard to tell whether this was because he was absorbing cinematic techniques or because film-makers such as Alfred Hitchcock, John Huston, Elia Kazan and, more recently, Mike Figgis have all looked to Edward Hopper's paintings for ways of capturing a distinctively American feeling, spatial psychology and pictorial mood.

Frida Kahlo
Henry Ford Hospital

1932
Oil on metal, 31.2 x 39.4 cm
Museo Dolores Olmedo Patiño,
Mexico City

Frida Kahlo was born in the small town of Coyoacán on the outskirts of Mexico Ci
in 1907. At the age of six she contracted polio, which left her with a withered right
leg. In 1922 she was sent to the famous National Preparatory School, where she fi
met Diego Rivera, twenty years her senior, who was to become a celebrated mura
painter and whom she later married. In 1925 a bus in which she was travelling wa
struck by a trolleybus and Kahlo suffered a broken spinal column, a crushed pelv
multiple fractures of her right leg, a crushed right foot and more. Severe internal
injuries meant that she was unable to carry a child to full term. For the rest of
her life she suffered bouts of intense pain, had to spend long periods in hospital
and underwent more than thirty operations, mostly on her back and right leg.
She started to paint while she was recovering from the accident, and her work,
taken as a whole, serves as a stark depiction of her suffering. She married Diego
Rivera in 1929. It was a stormy relationship. He was a compulsive philanderer
and she was openly bisexual, numbering amongst her conquests the exiled Soviet
revolutionary Leon Trotsky and the American dancer and singer Josephine Baker
She died in Mexico City in 1954.

Frida Kahlo's paintings are sometimes mistakenly categorized as Surrealist.
In reality she is a Symbolist painter who focuses on the events of her own extra-
ordinary life and, beyond that, on women's lives in general. As she later said,
it took her some time to accept that she would not be able to have children, and l
painting *Henry Ford Hospital*, completed seven years after her accident, depicts
Kahlo in bed after one of her many miscarriages. Her bed stands in the open air
somewhere between the remote, industrial power of the United States and the
earth of her native Mexico—between the modern and the ancient world. Above
and below her in the picture and connected to her by red threads that pass toget!
through her hand, are six symbols. Three are seen against the clear blue of the s
and represent her dreams of completion, the much-hoped-for gift of medicine, he
ancestors and her body. The other three are identified with the earth and represe
physical trial, temptation, corruption and death. As is usual in Kahlo's paintings,
the frankness with which she deals with her subject
given added force by the almost naive didacticism w
which the elements of the image are laid out. Like h
husband Rivera, she was committed to and active ir
the cause of revolutionary Socialism. Her paintings
thus had to be readable and understandable to peor
who had little or no education, which is why she use
the mythology, symbolic language and narrative
vernacular of her Amerindian ancestors.

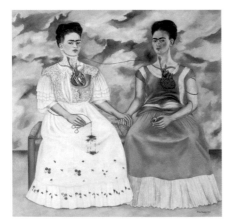

The Two Fridas, 1939
Oil on canvas, 173 x 173 cm
Museo de Arte Moderno, Mexico City

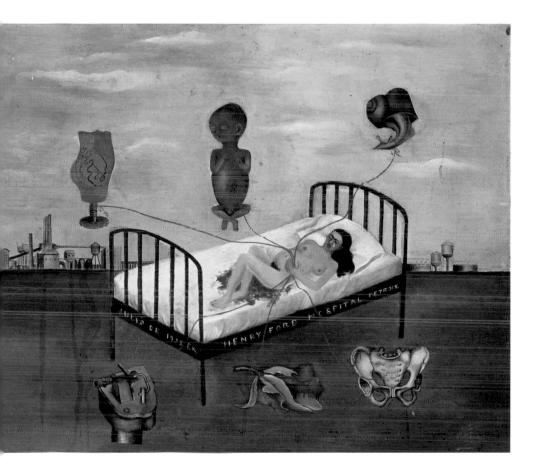

The Little Deer, 1946
Oil on masonite, 22.5 x 30.5 cm
Private collection

Mario Sironi

Shepherd

1932
Oil on canvas, 90 x 50 cm
Museo Revoltella, Trieste

Benito Mussolini was formally invited
to become Prime Minister of Italy in
1922 after the Fascist-led 'March on
Rome'. He assumed dictatorial powers
as the Duce in 1925. Prior to this there
were several attempts to influence
his cultural policy, most notably the
founding of Novecento by Mussolini's
lover, Margherita Sarfatti, the writer
and critic who is said to have been
the architect of Italian Cultural
Nationalism. The exhibition organized
by the fledgling movement, entitled
'Sette Pittori del Novecento' (Seven
Painters of the Twentieth Century),

The Family, 1929. Oil on canvas, 167 x 210 cm. Private collectio

was opened by Mussolini in March 1926. Mario Sironi and Achille Funi were
the best known of the artists taking part. Sironi's connection with Novecento
was short-lived and although his political outlook remained the same, after
the mid-1920s he was never again associated with avant-garde tendencies,
schools or artistic movements.

Although he had known Umberto Boccioni since 1905 and was closely associated
with the Milan-based Futurist group for almost a decade, Mario Sironi was never
entirely comfortable with some aspects of Futurist painting. Over the years he
became increasingly critical of its reliance on stylistic devices borrowed from
Fauvism and Analytical Cubism: the breaking up of the image into planes and
a certain reliance on Divisionist paint techniques, namely the use of small dabs
of colour to produce a chiselled, relieflike, vibrantly coloured pictorial space
as typified by Boccioni's *Matter* (1912). Sironi felt that this technical method
and approach to painting was not the best way of re-
presenting progressive Fascist ideals and, shortly after
he severed links with the movement in 1922, began
to argue for the values disseminated by the magazine
Valori Plastici, the mouthpiece of the rump of the
Scuola metafisica grouped around Alberto Savinio.
This abrupt change of focus proved a stepping-stone
towards a much simpler form of image-making that
was in line with the call by Giuseppe Bottai, the Fascist
Party's cultural polemicist and Minister of Education,
for 'an anti-rhetorical style in art ... constructions
that are increasingly solid, ample and strong, in
the manner of the great tradition of Italian art'.

With its combination of Classicism and rustic monumentality, *Shepherd* is
a fine example of Sironi's later easel-painting style. The shepherd of the title
appears physically 'ample and strong'—even powerful—as suggested by
the thick wooden staff he is holding in his left hand, but he is also gentle.
He is very much a contemplative figure as well as a man of action.
The wearing of the Phrygian cap suggests the Classical figure of the shepherd
as a poet/musician. Viewed as propaganda, this painting could be said to picture
the cultured, natural nobility and resilience of those who work on the land
and thus to represent one wing of Mussolini's declared political intention
to create a productive liaison between the countryside and the town.

Boccioni
12
vas,
cm
llection

Piet Mondriaan (Mondrian)
Composition with Blue and Yellow

1935. Oil on canvas, 73 x 69.6 cm. Hirshhorn Museum and Sculpture Garden, Smithsonian Institution, Washington

The split between Theo van Doesburg and Piet Mondrian that occurred in Paris in 1924–25 is usually attributed to van Doesburg's introduction of diagonals into the formal vocabulary of Neo-Plasticism. But it was about much more than this. Through practice, Mondrian had arrived at a model of reality—a philosophy and a view of the world—that he believed properly accounted for the place of the 'vertical' human subject within the natural and spiritual order of things. He saw van Doesburg's move as destabilizing that model, a view that—for good or ill—is supported by the evolution of van Doesburg's work between 1925 and 1930. By 1930 van Doesburg's use of the pure diagonal in works such as *Counter-Composition XIII* (1925–26) had given way to the more fluid and vertiginous dynamics seen in works such as *Simultaneous Counter-Composition* (1929), just as Mondrian was entering what was, compositionally speaking, his most puritanical phase.

The mid-1930s saw Mondrian's use of the evolved vocabulary of Neo-Plasticism or De Stijl—with its carefully placed intermeshing verticals and horizontals pinching into place precisely weighted areas of pure colour—at its most sparse and most refined. In works like *Composition with Blue and Yellow* (1935) and *Composition with Red and Blue* (1936), the black, linear elements have been thinned against the white to make them less invasive. As a result, the white has gained in presence and intensity, and the coloured areas in luminosity. The reading of the white ground in Mondrian's paintings is critical to arriving at a proper understanding of them. Seen in reproduction, the black lines often appear to have been drawn, very direct, over a white ground. In reality each white area has been worked so that it fully abuts the black lines that frame it, thereby producing an even intensity of whiteness overall. This equality between line and plane—this commonality of surface— is crucial to the painting's presence as a fully unified 'relational' entity.

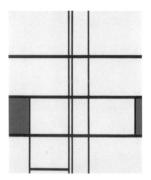

Composition with Red and Blue, 1936
Oil on canvas, 98.5 x 80.5 cm
Staatsgalerie Stuttgart

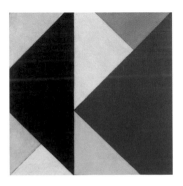

Theo van Doesburg
Counter-Composition XIII, 1925–26
Oil on canvas, 50 x 50 cm
Peggy Guggenheim Collection, Venice

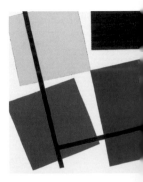

Theo van Doesburg
Simultaneous Counter-Composition
Oil on canvas, 50 x 50 cm
The Museum of Modern Art, New York

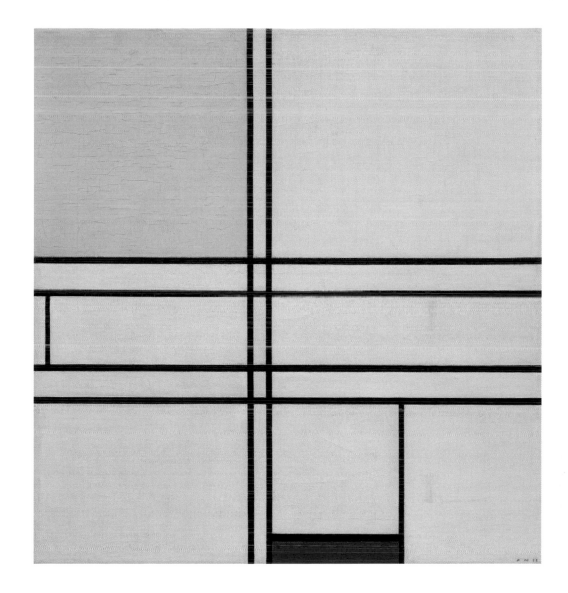

drian and *Gestalt:* Theories of Relationship Mondrian's initial

search for a set of basic principles underlying perception ultimately became a
full-blown theory of relationship: a set of rules governing our apprehension of
the world that made it seem more complete and more reliable. It was the same
quest that underlay the evolution of *Gestalt* psychology and occurred at more or less
the same time. In 1931 the German psychologist Kurt Koffka declared order to be
a 'non-objective category' and the aim of *Gestalt* to be that of seeking out 'which
parts of nature belong as parts to functional wholes, to discover their position in
these wholes, their degree of relative independence and the articulation of larger
wholes into sub-wholes'. This could stand as an almost perfect procedural
description of Mondrian's approach to relationship in painting.

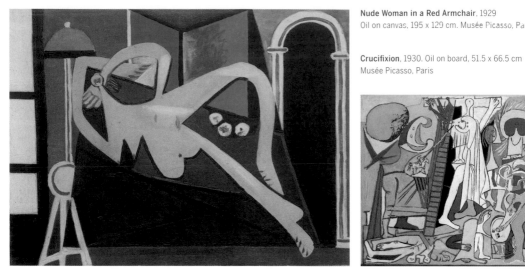

Nude Woman in a Red Armchair, 1929
Oil on canvas, 195 x 129 cm. Musée Picasso, Paris

Crucifixion, 1930. Oil on board, 51.5 x 66.5 cm
Musée Picasso, Paris

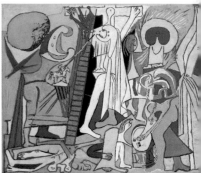

For Picasso—his anger fuelled by false denials of involvement by Franco, the German military and the Vatican—the event assumed such overwhelming symbolic force that he immediately set to work on a series of preparatory drawing for the 'mural' in the Spanish Pavilion. In order to provide maximum support to the Republican cause, Picasso was determined to carry out the work as much as possible in the public eye, and, with the help of Dora Maar, to assemble a complete photographic record of its making.

In general terms, Guernica is perhaps best described as a history painting, albeit a history painting of a very special kind. Usually such paintings provide a descriptive account of a specific event and the use of symbolism is kept within the mode of description. In Guernica absolutely nothing is described: every presence, object thought or feeling is translated into a symbol. Since the late Synthetic Cubist period Picasso had been steadily accumulating a portmanteau of signs and symbols through which to refer to emotions, moods and states of mind. The tilted-back, screaming head, for example, occurs in Nude Woman in a Red Armchair (1929) an the crawling figure with grotesquely flexing feet and hands in the bottom right-hand corner of Guernica appears for the first time in Crucifixion (1930). The celebrated Vollard Suite of intaglio prints, one hundred plates drawn between 1930 and 1937, is rich with symbolic material, some of which re-emerges in a more condensed and explicit form in the large-scale etching Minotauromachia (1935), which is generally thought of as an important pictorial precursor to Guernica.

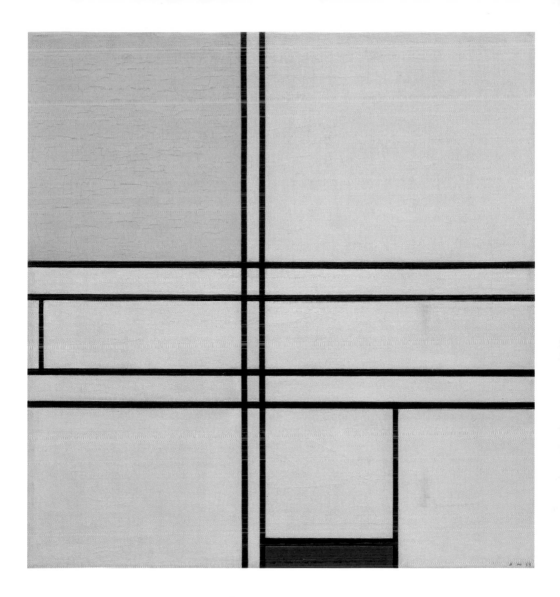

drian and *Gestalt:* Theories of Relationship　Mondrian's initial

search for a set of basic principles underlying perception ultimately became a
full-blown theory of relationship: a set of rules governing our apprehension of
the world that made it seem more complete and more reliable. It was the same
quest that underlay the evolution of *Gestalt* psychology and occurred at more or less
the same time. In 1931 the German psychologist Kurt Koffka declared order to be
a 'non-objective category' and the aim of *Gestalt* to be that of seeking out 'which
parts of nature belong as parts to functional wholes, to discover their position in
these wholes, their degree of relative independence and the articulation of larger
wholes into sub-wholes'. This could stand as an almost perfect procedural
description of Mondrian's approach to relationship in painting.

Pablo
Picasso

Guernica

1937
Oil on canvas, 350.5 x 782.3 cm
Museo Nacional Centro
de Arte Reina Sofía, Madrid

'The bull is not Fascism, but
it is brutality and darkness....
The horse represents the people,
in this the Guernica mural
is symbolic, allegoric.
That is why I used the horse,
the bull and so on. The mural
is for the definite expression
and resolution of a political
problem and that is why
I used symbolism.'
Pablo Picasso

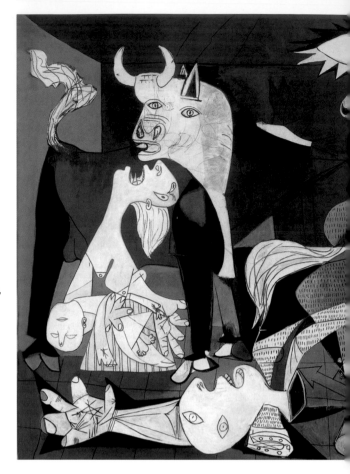

Pablo Picasso's friend and agent, the art dealer Daniel-Henry Kahnweiler, once
described him as 'the most political man I ever knew'. Certainly Picasso, a card-
carrying member of the Communist Party, was deeply engaged with European
politics and, most particularly, with the turbulent politics of his native Spain,
despite living in exile in Paris. The Spanish Civil War broke out in 1936, shortly
after the installation of the Republican Government of the Popular Front,
which had won the elections. One of the government's first decisions in matters
cultural was to ask Picasso to become Honorary Director of the Museo del
Prado, an invitation that he readily accepted. They also asked him to contribute
a major work to the Spanish Pavilion at the Exposition Universelle de Paris
to be held in the summer of 1937, and again Picasso was pleased to accept.
So began the preliminary work that eventually led to his great, politically
inspired masterpiece *Guernica*.
It is clear that Picasso intended from the outset to make a propagandistic,
anti-Franco painting. In January 1937, some four months prior to the bombing
of Guernica, he made two etchings: *The Dream and Lie of Franco I* and *II*.
The first of these was almost childishly scatological, likening the general to

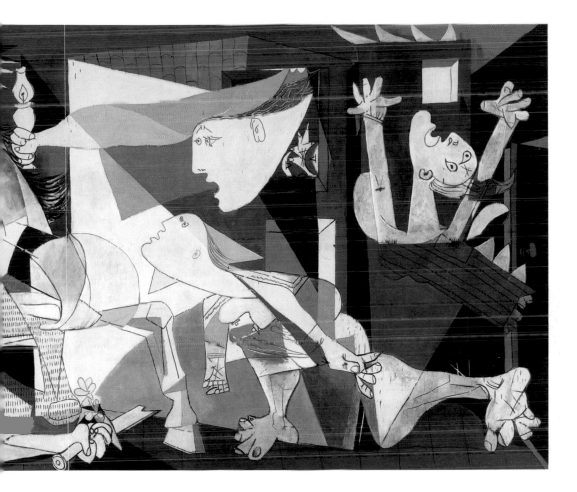

a 'turd'. The second was an altogether more substantial, heavily worked piece that, in a rather chaotic form, already has something of the symbolic range of *Guernica*. Although the general thrust of these works — like the poem Picasso wrote to accompany them — is unequivocal, they still lack the metaphorical focus needed to make a large-scale public work emblematic of the plight of the Spanish people. The gratuitous destruction of the ancient Basque town of Guernica — place of the Gernikako Arbola, the historic symbol of Basque culture and freedom — provided Picasso with precisely the point of focus he needed.

There is no doubt that this unprecedented joint operation between the Italian air force and the Condor Legion of the German Luftwaffe was bent upon nothing short of total destruction. In just a few hours, successive waves of bombers dropped twenty-two tons of heavy bombs and incendiary devices on a town of some 5,000 souls. There could have been no other purpose than first to raze Guernica to the ground and then to destroy what was left of the town and its inhabitants by fire-storm. History shows that it was the Luftwaffe's first experiment with *Blitzkrieg* as a way of terrorizing and demoralizing a civilian population.

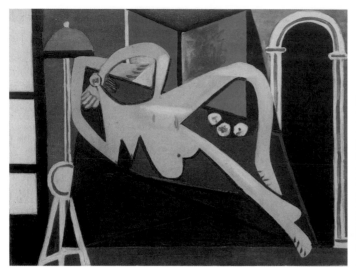

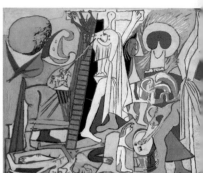

Nude Woman in a Red Armchair, 1929
Oil on canvas, 195 x 129 cm. Musée Picasso, Paris

Crucifixion, 1930. Oil on board, 51.5 x 66.5 cm
Musée Picasso, Paris

For Picasso—his anger fuelled by false denials of involvement by Franco, the German military and the Vatican—the event assumed such overwhelming symbolic force that he immediately set to work on a series of preparatory drawings for the 'mural' in the Spanish Pavilion. In order to provide maximum support to the Republican cause, Picasso was determined to carry out the work as much as possible in the public eye, and, with the help of Dora Maar, to assemble a complete photographic record of its making.

In general terms, *Guernica* is perhaps best described as a history painting, albeit a history painting of a very special kind. Usually such paintings provide a descriptive account of a specific event and the use of symbolism is kept within the mode of description. In *Guernica* absolutely nothing is described: every presence, object, thought or feeling is translated into a symbol. Since the late Synthetic Cubist period Picasso had been steadily accumulating a portmanteau of signs and symbols through which to refer to emotions, moods and states of mind. The tilted-back, screaming head, for example, occurs in *Nude Woman in a Red Armchair* (1929) and the crawling figure with grotesquely flexing feet and hands in the bottom right-hand corner of *Guernica* appears for the first time in *Crucifixion* (1930). The celebrated Vollard Suite of intaglio prints, one hundred plates drawn between 1930 and 1937, is rich with symbolic material, some of which re-emerges in a more condensed and explicit form in the large-scale etching *Minotauromachia* (1935), which is generally thought of as an important pictorial precursor to *Guernica*.

Minotauromachia, 1935
Etching and engraving, 50 x 70 cm
Musée Picasso, Paris

The Dream and Lie of Franco II, 1937
Etching and aquatint, 31.5 x 42 cm
Musée Picasso, Paris

However, while there is an obvious continuity between *Guernica* and some of the artist's earlier work in terms of symbolic raw material, the overall manner of the painting is radically different from anything that Picasso had painted before. *Guernica* is a 'super-flat' painting. The symbols are almost ironed onto its surface. And the reduced colour range of inky blacks, milky whites and brown and blue-greys gives it a luminously transparent, even a crystalline feeling. While the colour is used to generate a powerful sense of pictorial unity, the tonal contrast swings dramatically from one extreme to the other—from pitch thickened darkness to pure translucent light—thereby shattering and fragmenting the picture plane and making it read like a cracked and faceted sheet of mirrored glass. Trapped in this contradictory space, symbols and signs come and go, fall apart and reassemble themselves. Sharply etched lines hinge, fold and reshape the surface as the eye moves from one symbol to another. Truncated figures and detached limbs gather and disperse. Mouths snap as mutilated bodies collide with each other. Indeed, the visual language of *Guernica*, especially the symbolic marriage that it makes between the suffering of mankind and the sacrificial horse of the *corrida de toros*, seems to embody rather than depict the stark violence of its chosen subject at the same time as translating it into a universal symbolic order applicable to every type of human conflict.

Stanley Spencer

was born into a family of artists and musicians in the Berkshire village of Cookham-on-Thames in 1891. He took lessons in painting and drawing from a local artist and at the Maidenhead Technical Institute, before enrolling at the Slade School of Fine Art in London, where his contemporaries included David Bomberg and Paul Nash. Not wishing to leave behind village life, he commuted to London each working day. At the Slade he won a number of prizes for painting and drawing. He enlisted in the Royal Army Medical Corps at the outbreak of the First World War and served in the front line during the Macedonian Campaign, returning to Cookham in 1919. In 1924–27 he painted the impressive *Resurrection, Cookham* (now also in the Tate Collection), which formed the centre-piece of his first one-person show at the Goupil Gallery in London. Towards the end of the same year he embarked on the great cycle of murals in the war memorial Sandham Chapel, in the village of Burghclere, which he completed in 1932. In 1940 he was commissioned by the War Artists Advisory Committee to paint a series of shipbuilding murals in the Lithgow shipyard in Glasgow. He was knighted in 1959 and died the same year at Cliveden in Berkshire.

Double Nude Portrait: The Artist and His Second Wife or The Leg of Mutton Nude

1937
Oil on canvas, 91.5 x 93.5 cm
Tate Collection, London

Stanley Spencer's relationship with Patricia Preece started in 1932 and produced some of his most sexually explicit paintings. It also led to divorce from his first wife Hilda (with whom he had two children), in 1937. He married Patricia just four days later. They went to St Ives in Cornwall for their honeymoon but Patricia was accompanied by her long-time lesbian lover, the artist Dorothy Hepworth, and the marriage as such remained unconsummated. Spencer and Patricia Preece never lived together under the same roof, but they were never divorced either. Viewed in the light of these rather odd events, the painting assumes a brutally frank and somewhat self-deprecating autobiographical dimension. Despite the fact that she was not that much younger than Spencer, Patricia's body is shaded a lively pink and peach, while Spencer's body has an ashen, flayed and slightly deathly tinge to it, echoing the look of the piece of butcher's meat lying in the foreground. He seems to be captivated by her nakedness, while she is entirely indifferent his gaze. His unrequited sexual desire is vividly

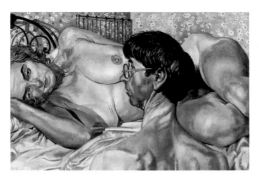

Self-Portrait with Patricia Preece, 1936
Oil on canvas, 61 x 91.5 cm
Fitzwilliam Museum, Cambridge

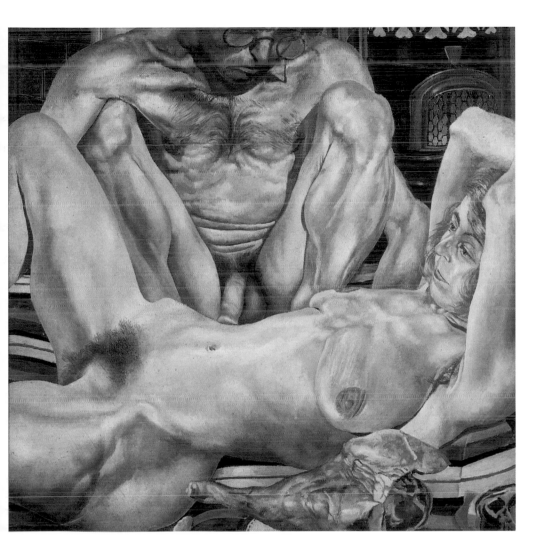

metaphorized by the blazing gas fire in the upper right-hand corner of
the painting. By the time of his second marriage, Spencer was still only in his
mid-forties. Even so, the fact that the meat is described in the title as 'mutton'
and not 'lamb' seems to suggest that the painter was already beginning to
be aware of the physical effects on his body of the ageing process, and this
preoccupation shows in the way he treats the skin that sags and wrinkles
around his midriff and the puttylike lumpiness of his flesh.

Salvador Dalí

was born in Figueras, Catalonia, in 1904. Encouraged by his mother, he had his first drawing lessons when he was ten, and he was introduced to modern and contemporary art by the painter Ramón Pichot when he was just twelve years old. In 1922 he moved to Madrid to study at the Academia de Bellas Artes de San Fernando, where he met and became friends with Luis Buñuel and Federico Garcia Lorca. In Madrid he experimented first with Cubism and then with Dada. Dalí was expelled from the art academy in 1926 after he declared that no one there was competent to teach him. He made his first visit to Paris the following year, and while he was there he met Pablo Picasso. In 1929 Dalí and Buñuel joined forces to make the most important film in Surrealist cinema, *Un Chien Andalou*. Shortly afterwards Dalí met his future wife, Gala, and joined the Montparnasse Surrealist group. He and Gala married in 1934. In 1939 he was expelled by the Surrealist group for supporting Franco's assumption of power in the wake of the Spanish Civil War. He died in Figueras in 1989.

Mountain Lake: Beach with Telephone

1938. Oil on canvas, 73 x 92.5 cm
Tate Collection, London

is a particularly fine example of Dalí's painting. The main characteristics of his mature style are all present: smoothly rendered, simplified landscape features set off by incidents of minute detail and dramatic shifts of scale; the luminous, unifying afterglow of a setting sun that carries with it the memory of the afternoon heat as well as promising the cool of the evening; strange coincidences and ambiguities of form that arrive easily at the eye yet are puzzling and perplexing; apparently simple identities that suddenly switch to become something else. All of these are routine Surrealist tricks and devices and yet, in Dalí's hands, they acquire a weight and significance that carries them beyond mere trickery or a painter's sleight of hand. There is something genuinely disturbing about this painting. Beyond the strangeness that accrues from the unusual combinations of objects, nothing is quite what it seems to be. By far the most disquieting presence in the painting is the fish-shaped 'lake' of the title, a conspicuously phallic form that extends the full width of the painting in the foreground. Its identity is impossible to resolve. Read as a fish, it is a portmanteau image: its tail belongs to the landscape behind; its body is neither convex nor concave, round nor flat and, paradoxically, it picks up its fishlike detail through reflection from the rocky headlands beyond.

For Dalí, the lake invoked the dead older brother that he had never met—also called Salvador—whose ghostly presence he felt to be haunting him throughout his life. According to the painter, the telephone and the broken connection allude to the doomed negotiations between Neville Chamberlain and Adolf Hitler in 1938 at the time of the German advance into Sudetenland.

Still Life with Full Moon, 1927
Oil on canvas, 190 x 140 cm. Museo
Nacional Centro de Arte Reina Sofía, Madrid

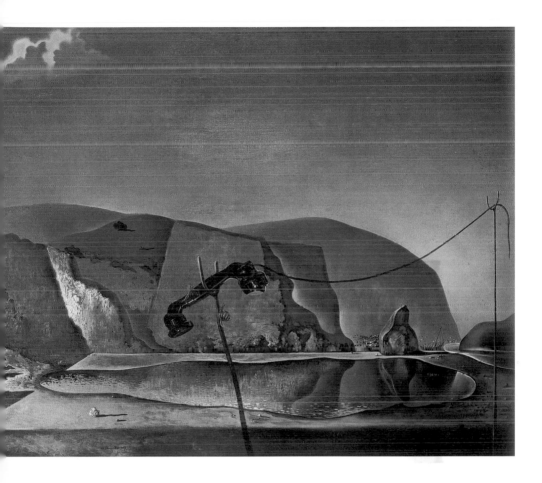

Portrait of My Dead Brother, 1963
Oil on canvas, 69 x 69 cm
Salvador Dalí Museum, St Petersburg (Florida)

Max Ernst

was born in Brühl, near Cologne, in 1891. He enrolled at the University of Bonn in 1909 to read philosophy, but soon abandoned his university studies for art. In 1914, he went to Paris, where he met Guillaume Apollinaire and Robert Delaunay. Later that same year he went to visit Paul Klee. After serving in the army during the First World War he formed the Cologne Dada group with Jean (Hans) Arp and Alfred Grünwald. In 1922 he moved again to Paris where he became a prominent figure amongst the Montparnasse community of artists and writers and was instrumental in the genesis of Surrealism. At the outbreak of the Second World War, having been classified as an enemy alien, he escaped to the United States with Peggy Guggenheim; they were married in New York in 1942. This, his third marriage, lasted less than two years, and in 1946 he married again. His new wife was the artist Dorothea Tanning; the wedding was a double ceremony with Man Ray and Juliet Browner. He and Dorothea lived together in Arizona until they moved to the south of France in 1963. Max Ernst died in Paris in 1976.

Attirement of the Bride

1940. Oil on canvas, 129.6 x 96.3 cm
Peggy Guggenheim Collection, Venice

Max Ernst's *Attirement of the Bride* is a product of the highly detailed, illusionistic phase of his Surrealism and demonstrates just how well he had grasped a whole range of very traditional painting techniques: under-painting, colour blending and colour glazing. It is also a meticulous piece of pictorial construction that combines influences as disparate as early German painting — especially the work of Lucas Cranach the Elder, whose great *Judgement of Paris* (*c.* 1530) he must have known from his childhood in Cologne — French Symbolist paintings in the manner of Gustave Moreau and the Pittura metafisica of the Italian Giorgio De Chirico, a style that Ernst is known to have admired. *Attirement of the Bride* is a deliberately exotic picture that combines realistic rendition with fantastic and phantasmagoric subject matter. Symbolically, it references both the menstrual and the phallic. It also conflates positive with negative sexuality by seeding Eros to the devil. The diminutive figure of the multi-breasted succubus squatting down in the lower right-hand corner of the painting suggests the voluptuous fecundity that attends upon perverse sexual desire.

The painter had been characterizing himself as a birdlike creature (called Loplop) since before 1930, and he appears again in *Attirement of the Bride* in the guise of a blackish-green bird with a crooked neck and sharp beak who is approaching the Bride from behind and threatening

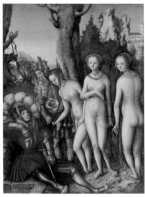

Lucas Cranach the Elder,
The Judgement of Paris, *c.* 1530
Oil on panel, 43 x 32 cm
Wallraf-Richartz-Museum, Cologne

Gustave Moreau, **The Unicorns**, *c.* 1885
Oil on canvas, 115 x 90 cm
Musée Gustave Moreau, Paris

her emerging nakedness with an arrow pointed at her pudenda.
Significantly, like all supernatural presences, Loplop—Ernst's
alter ego—does not appear in the mirror hanging on the wall
behind the group, even though it is used to replicate rather
than reverse the scene in front.

Edward Hopper
Nighthawks

1942
Oil on canvas
84.1 x 152.4 cm
The Art Institute of Chicago

Edward Hopper's charismatic teacher Robert Henri, leader of
the Ashcan School of realist painters, sent his students out into
the streets of New York 'to paint the city and city life as it really
is'. Mainly a studio painter himself, Henri rarely applied the
formula to his own work. However, his fellow realists, painters
like John Sloan and George Bellows, did follow the rule, producing
a rough and tough kind of painting that, in the case of Bellows,
was an important precursor of Abstract Expressionism. Hopper,
too, despite the fact that he chose subjects that fitted Henri's
prescription, was also a studio painter. He worked mostly from
drawings, taking a long time to evolve a design for the picture
that was later modified—sometimes quite substantially—during
the often highly attenuated process of completing the painting.

Hopper's stunningly cinematic painting *Nighthawks* is one of the
most reproduced paintings in the history of art. It is hard to know
precisely why, except, perhaps, for the fact that we all recognize
something of its truthfulness from within our own life experience.
It is a picture that speaks of the alienating presence of the modern
city. Several individuals—the nighthawks of the title—are
gathered together in the brightly lit window of a night café that
spills its pale bluish light out into the street, casting a shadow on the pavement,
yet barely holding a threatening inrush of darkness at bay. Beyond its reach,
anything might be happening in the darkness. Psychologically speaking, these
people are isolates, thrown together as a group, but also locked within themselves
prey to their own fears and fancies. It is a picture of city life in the small hours
when an unnatural silence and an uncanny stillness take hold, tugging suggestive
at the senses of hearing and vision.
It has been said that Hopper's rather flat and undemonstrative way of painting is
at its most eloquent in *Nighthawks* because it holds the image at the very edge

Automat, 1927
Oil on canvas, 71.5 x 91.5 cm
Des Moines Art Center, Iowa

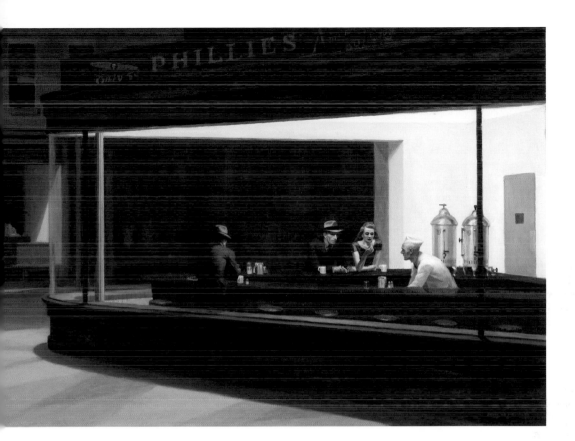

of realization. There is certainly a sense in which his rendering of architecture here is more model-like than real. The café seems thin, insubstantial, as if it is made out of cut and folded paper. Arguably, though, it is this very lack of substance that gives the image its dramatic force. The plight of the 'nighthawks' lies in their vulnerability and we register this fact almost instantly. The apparent fragility of their illuminated place of refuge stands in stark contrast to the surrounding darkness that seems to come alive with unknowable presences even as we look.

America at War

It is reasonable to look for the symbolic force of Hopper's painting in the events of late 1941–42. The Japanese attack on Pearl Harbor came on 7 December 1941 and President Roosevelt declared war on Japan the next day. Early in 1942 the United States suffered a second, humiliating military setback when the Japanese forced the surrender of their garrison in the Philippines. For the very first time, a defiant American people felt threatened and under siege.

Balthus

(Balthasar Klossowski de Rola) was born in Paris in 1908. His father was a well-known art historian and the family was deeply embedded in Parisian cultural life. Regular visitors to the house included the writers Rainer Maria Rilke, André Gide and Jean Cocteau, who is reputed to have modelled his novel *Les Enfants terribles* in part on the Klossowski children. At the age of eighteen Balthus travelled to Italy, where he fell under the spell of Italian Renaissance painting, especially the work of Piero della Francesca. He took his first studio in Paris in 1933 and a year later shocked the Paris art world when he exhibited *The Guitar Lesson* (1934), with its open display of lesbian eroticism. In 1940, with the German invasion of France, he moved with his family to Savoy and in 1942 to Switzerland, living first in Bern and afterwards in Geneva, where he met and became friendly with André Malraux. It was Malraux who, as French Minister of Culture, appointed Balthus to the post of Director of the French Academy at the Villa Medici in Rome, a position that he held from 1961 to 1977. After his time in the Italian capital, he returned to Switzerland to live in his Grand Chalet in the town of Rossinière. He died there in 2001 at the age of 92.

Sleeping Girl

1943. Oil on board, 79.7 x 98.4 cm. Tate Collection, London

Balthus is often described as the greatest of the anti-Modernists, but such a description is misleading. Like Giorgio De Chirico, whom Balthus greatly admired, he deplored the rejection by his contemporaries of the craft of painting and their apparent indifference to the work of the Old Masters. More than anything else, he was deeply suspicious of the way in which they had allowed the space of painting to be invaded by words—excessive verbal explanations and elaborate critical arguments. Instead, he wanted to insist upon the immutable, untranslatable visual richness of the painted image. None of this makes him 'anti-modern', indeed, despite (or maybe because of) their slightly old-fashioned staginess—the bourgeois decor—close examination of his paintings reveals him to be a painfully acute observer of today's socio-sexual neuroses, matched only perhaps by another painter whom Balthus greatly admired, his friend and one-time mentor Pierre Bonnard. Neither is it entirely accurate to describe Balthus's paintings as voyeuristic. While there is no doubt that he derived a certain libidinal enjoyment from the images he made—this is clearly present in the paintings—there is nothing illicit or sneaky about his painter's gaze. It is always unfailingly frank and deals with his sometimes quite problematic sexual interest head on. *Sleeping Girl* is exemplary in this respect. It expresses what for Balthus is the electrifying, central issue for a painter who works directly from the live model: the ever-present duality between the viewing subject and the subject in view. The girl is entirely unaware of her own presence to the breathless, desiring eye of the painter, and Balthus presents this hiatus in the economy of desire as a suspended moment in time. Nothing can be allowed to move or else the spell will be broken.

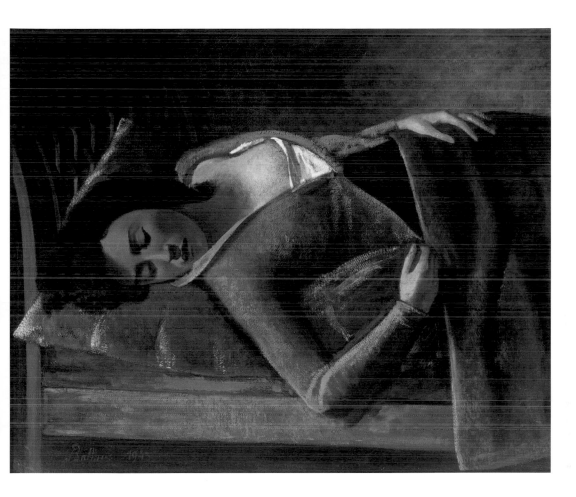

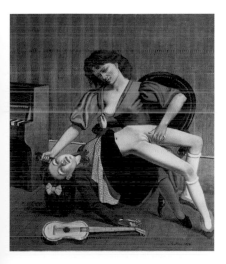

The Guitar Lesson, 1934
Oil on canvas, 161 x 138.5 cm
Private collection

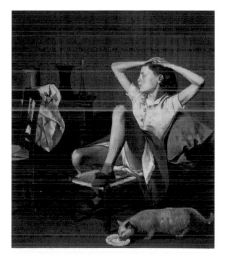

Thérèse Dreaming, 1938
Oil on canvas, 150.5 x 130 cm
The Metropolitan Museum
of Art, New York

Jackson Pollock
was born in Cody, Wyoming in 1912 and spent his early year
in Arizona and California. In 1930 he moved with his brother, the painter Charles
Pollock, to New York to study at the Art Students League under Thomas Hart
Benton. Pollock's early figurative work was influenced by the Mexican mural
painters, especially David Alfaro Siqueiros whose experimental painting workshop
he attended in 1936. He worked in the WPA Federal Art Project between 1935
and 1942, at which time he became interested in the psychoanalytical writings
of Carl Jung. Pollock started to make the 'pour' or 'drip' paintings in 1947.
Shortly after their first showing at the Betty Parsons Gallery, Pollock was
described in a feature article in *Time* magazine (1951) as 'the greatest living
American artist'. A cyclical depressive and an alcoholic, he died some five years
later in a single-vehicle, drink-induced car crash. He was just forty-four years old.

Guardians
of the Secret

1943. Oil on canvas, 123.8 x 190.5 cm
San Francisco Museum of Modern Art

belongs to what is sometimes described as Pollock's symbolist
period. Pollock subscribed to the idea of the painting as a site where meaning is
made rather than given, so it is packed with signs and pictographic configurations,
many of which are intentionally obscure. Even so there are clear references
to native American masks, echoing the use of African masks in Picasso's
Les Demoiselles d'Avignon, and the overall look of the painting—its insistent
frontality—owes much to the early synthetic phase of Cubism. But if Picasso was
the main visual influence on Pollock's work of the early 1940s, it was the thinking
of Carl Jung that shaped its intellectual terrain. Acquaintance with Jungian
constructs like that of the 'collective unconscious' and the 'theory of archetypes'
led Pollock to look towards the mythologies of other religions and cultures as
a means of bringing greater authenticity to his own work. It also led him to read
the French Symbolist poets and to form a particular attachment to the work of
Charles Baudelaire. This influence is most sharply focused in slightly earlier
works such as *The Moon Woman* of 1942. Here Pollock
draws his basic iconography from Baudelaire's prose poem
'Favours of the Moon' to create an image of the destructive
aspect of Jung's feminine archetype, the 'anima'. By the time
Pollock came to paint *Guardians of the Secret*, however,
such highly specific references had largely disappeared.
We recognize individual signs—the masks, the red cock,
the crouching dog, faces and sentinel figures—but there
seems to be no overarching framework that might help
us to fix an interpretation.

Guardians of the Secret (d

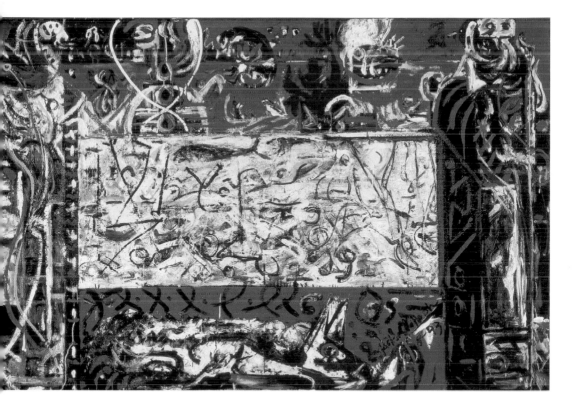

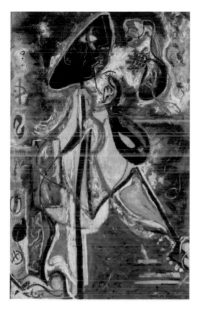

The Archetypal Image

Jung borrowed the idea of 'archetypes'
—the notion of a collective set of trans-
cultural, autochthonous mythological
figures—from Friedrich Nietzsche's
Human, All Too Human where the
philosopher writes that 'in our sleep
and our dreams we pass through
the whole thought of earlier humanity'.
For painters like Pollock, the pursuit
of archetypal images seemed to offer
a way of guaranteeing universal access
to what might otherwise have remained
a largely personal — even a private —
language of signs and symbols.

André Masson

The Kill

1944
Oil on canvas,
55.2 x 67.9 cm
The Museum of Modern Art, New York

André Masson was born in Balagny-sur-Thérain, France, in 1896. He studied at the
Académie Royale des Beaux-Arts in Brussels and afterwards at the École National
Supérieure des Beaux-Arts in Paris. He volunteered for military service in the
First World War and was seriously wounded in the chest in the Chemin des Dames
offensive. He had his first solo exhibition in Paris at Daniel-Henry Kahnweiler's
Galerie Simon in 1924. At about the same time, Masson joined André Breton in
the Surrealist group and became an exponent of Automatism. His first break
with Surrealism came in 1928. In 1933 Masson designed sets and costumes for
the Ballets Russes, before moving to Spain, where he lived until 1936. In 1937, back
in Paris, he rejoined the Surrealists but was forced to leave France again in 1941
in advance of the German occupation. This time he chose the United States as
his destination, and went to live in New Preston, Connecticut. He finally severed
his connections with Surrealism in 1943, before returning to France in 1945.
He died in Paris in 1987.

It seems that Masson was attracted to manifestations of violence from an early age
He volunteered for military service because he wanted to confront 'the ecstasy of
death', and later described being wounded as a transfiguring experience in which I
appeared to himself bathed in light. Thereafter, violence, either as subject-matter o
as an energizing force within an abstract image, seems to have been integral to his
manner of thinking and working. In the series of works he called *Massacres*, made
between 1930 and 1934, he used uncompromising images of death and destruction
as a metaphor for anarchistic revolution. In Spain this same obsession found its
ritualistic outlet in his fascination with the bull-fight. The almost fatalistic gyre
of the *corrida de toros* fed by his long-standing interest in Automatism produced a
new kind of symbolism—partly figurative and partly abstract—which, transferred
to the American context, proved to be crucial to the early evolution of Abstract
Expressionism. *The Kill*, an abstract rendition of the final phase of a bull-fight,

**Emblematic
View of Toledo**
1936
Oil on canvas,
162 x 122 cm
Private
collection

Panic, 1963
Oil on canvas,
162 x 130 cm
Musée national
d'Art moderne,
Centre Georges
Pompidou, Paris

came towards the end of Masson's time in the United States, when the
looping formations that he had discovered through experimenting with
automatic writing had given shape to a new kind of pictorial language.
The painting shows an impressive control over the distribution and
weighting of marks that are allowed to float freely in a vertically flattened
and extremely shallow picture space. This sense of verticality and
'all-overness' that came to dominate much of Masson's later work
had an important impact on the early work of Arshile Gorky,
Willem de Kooning, Jackson Pollock and Mark Rothko.

Pierre Bonnard's long and passionate relationship with Maria 'Marthe' Boursi

ended with her death in 1942. She was the chief subject of his paintings for nearly fifty years, during which time she also became his wife, in 1925. Mostly she is depicted on her own, but very occasionally artist and model appear together. The most notable and sexually forthright example is *Man and Woman* painted in 1900, currently in the collection of the Musée d'Orsay. Bonnard painted himself on other occasions during his working life, sometimes posing as a boxer, but in the few year before and after the death of his wife, Bonnard began to give very close attention to his own appearance. He died in 1947, two years after *Portrait of the Artist in the Bathroom Mirror* was completed.

Portrait of the Artist in the Bathroom Mirror (Self-Portrait)

1943–45
Oil on canvas, 73 x 51 cm
Musée National d'Art Moderne,
Centre Georges Pompidou, Paris

Significantly, Bonnard's two late self-portraits are seen through the bathroom mirror, sited in Marthe's favourite room of the house where he had painted her on so many occasions. In this extremely poignant image, her toiletries still occupy the bathroom shelf in the foreground of the painting, and seem to be the subject of Bonnard's somewhat distracted gaze. The painting is about loss, not simply about the loss of a loved one, but also the losing of the self through grief. In this respect it is a profoundly psychological self-portrait. It configures the artist's state of mind rather than his character or even his appearance. Marthe is present in her absence: Bonnard is absent to himself in his very presence. In the painting that preceded *Portrait of the Artist in the Bathroom Mirror* — Bonnard called it *The Last Self-Portrait* — he pictures himself playing with Marthe's ring which is hanging on a chain around his neck. Highly paradoxical for a self-portrait, Bonnard also depicts himself with his eyes closed.

There is something very distinctive about the way Bonnard portrays himself in his closing years. The paintings were difficult to resolve, often taking two or three years to complete and, unlike Picass who, in his paintings and etching after 1960, becam more and more preoccupied with the outward signs of his failing sexu powers, Bonnard seems to convey accelerating sens of inwardness in his self-portraits.

Man and Woman. 1900
Oil on canvas,
115 x 72.5 cm
Musée d'Orsay,
Paris

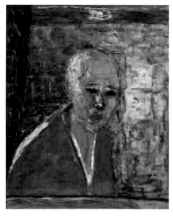

Portrait of the Artist by Himself (Self-Portrait), 1945
Oil on canvas, 56 x 44 cm. Fondation Bemberg, Toulouse

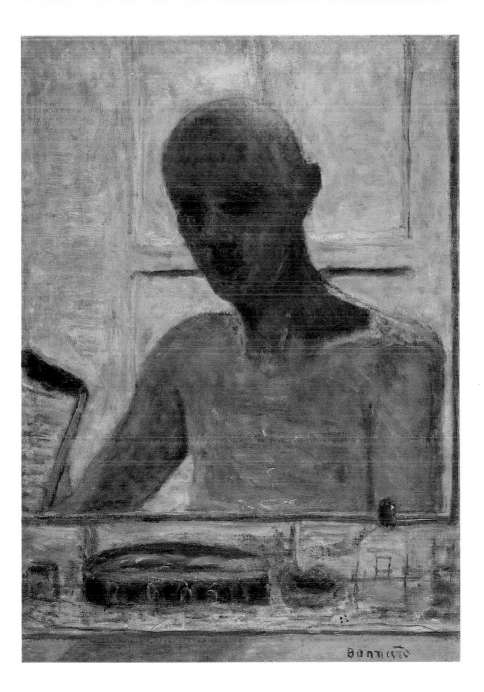

In the self-portrait completed the year before Marthe's death and in *The Last Self-Portrait*, he uses his spectacles as a device for closing off the outside world, and in *Portrait of the Artist by Himself* his eyes are downcast: a clear refusal to engage with his own—the painter's—gaze. The glowing yellowish-green of the background and the purplish-red flesh tones suggest that the last two paintings were painted at night by artificial light; in many ways the orchestration of different tonalities is reminiscent of a photographic negative.

André Derain

During the 1930s André Derain spent much of his creative energy designing for the theatre, mostly for the Ballets Russes and the Paris Opéra; he also completed a number of illustration projects including Ovid's *Héroïdes* (1932) and Oscar Wilde's *Salomé* (1938). Having returned to Chambourcy after the German occupation in 1944, it seems that a new spirit of experimentation came into his painting. This showed itself in a less stolid, more lyrical approach to picture-making and a relaxed style of painting that is almost Oriental in feeling. In the 1940s he also undertook more illustration work for books by authors as diverse as Rabelais and Antonin Artaud. Derain's eyesight began to deteriorate in the early 1950s and he died in 1954 after being hit by a car.

Still Life on a Black Ground

1945. Oil on canvas, 97 x 130 cm
Musée d'Art Moderne, Troyes

André Derain first explored the potential of using black as a ground on which to paint in the late 1930s, albeit not very successfully. The most notable example from this period is his *Still Life with Fruit* from 1938. He was not the first painter to experiment in this way. In the first decade of the century, the English painter Walter Richard Sickert had used it to produce some of his most sombre and imposing works of social commentary, including the grim and gloomy *Summer Afternoon (What Shall We Do for the Rent?)* (1908). Significantly, perhaps, both men were involved with the theatre: Sickert as a habitué of the music hall, which was the source of much of his imagery, and Derain as a designer, necessarily involved in the technicalities of theatrical production. Theatres create their images by projecting light into the darkness, and certainly this phenomenon was what first led Sickert to work with modulated lighter tones against a black ground. In Derain's case, too, the focus seems to be on how things become illuminated, on how they reveal themselves by picking up accents of light from within a darkened space. In this respect Derain's choice of objects in *Still Life on a Black Ground*, the semi-liquid form of the glass jug and bowl and the bifurcating leaves, stems and flowers that drift across the lower left-hand corner of the picture, are all calculated to exploit light effects as a figurative shorthand for objects and material qualities. This comparatively late work has an elegance and lightness of touch that is unusual in Derain's work. The initial unifying presence of the ground seems to have freed him from the burden of having to build a coherent pictorial space, a preoccupation that so dominated earlier still-life paintings such as *The Full Table* (1921–22) and the monumental *The Kitchen Table* (1924).

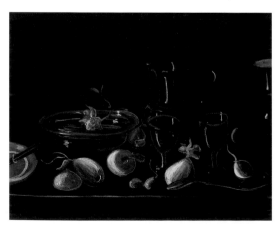

Still Life with Fruit, 1938. Oil on canvas, 66 x 82 cm
Stanford University Museum of Art, Palo Alto

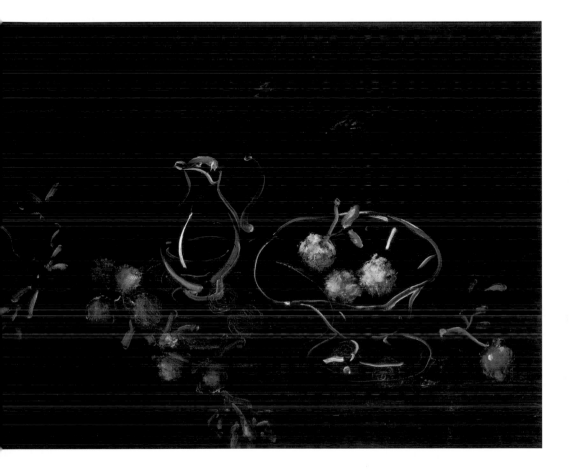

Walter Richard Sickert
**Summer Afternoon
(What Shall We Do
for the Rent?)**, *c.* 1908
Oil on canvas, 51 x 41 cm
Kirkcaldy Museum
and Art Gallery

The Kitchen Table, 1924. Oil on canvas,
119 x 119 cm. Musée national de l'Orangerie, Paris

Arshile Gorky, whose real name was Vosdanik Adoian, was born in

Khorkom in the Van region of Armenia in 1904. His family were refugees from the Turkish invasion, and his mother died during a forced march of deportees. Gorky himself left Armenia in 1915 and went travelling, before eventually arriving in America in 1920 where he was reunited with his father, who by then was living in Providence, Rhode Island. He moved to New York and in 1925 changed his name to Arshile Gorky — literally, 'Achilles the Bitter One' — before enrolling as a student at the Grand Central School of Art. His time as a student proved to be short-lived. Gorky was a naturally talented draughtsman and although he was almost entirely self-taught, he was invited to join the teaching staff in 1926 as a specialist tutor in drawing, a post he held until 1931.
During the 1930s he became a close friend of Stuart Davis and Willem de Kooning, with whom he shared a studio for a time. Gorky's first one-person show took place at the Mellon Gallery in Philadelphia in 1931 and his first show in New York was at the Boyer Gallery in 1938. He worked on the Federal Art Project from 1935 to 1941. After 1945 a number of tragic events, including a studio fire that destroyed a great many of his most important works, serious illness and a broken marriage, led to his suicide by hanging in 1948.

The Betrothal II 1947. Oil on canvas, 128.9 x 96.5 cm. Whitney Museum of American Art, New Yo

The Betrothal II was painted a year before Gorky's death. By this time he had passed through the influence of Surrealism, which had dominated his work throughout the 1930s, and had established his own very distinctive style. The key paintings in this process of transition were undoubtedly the nostalgic and deeply melancholic *Garden in Sochi* series made between 1941 and 1943. Gorky tended to think of Armenia as a lost paradise — its flowing landscapes, hills and lakes, its folklore and customs, its dancing and its music — as an idyllic

Garden in Sochi, 1943
Oil on canvas, 78.5 x 99 cm
The Museum of Modern Art, New York

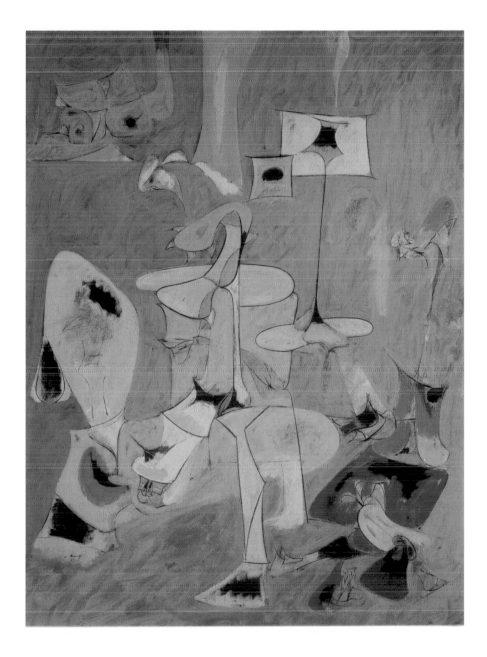

thal I, 1947
vas, 128 x 99.5 cm
rsity Art Gallery, New Haven

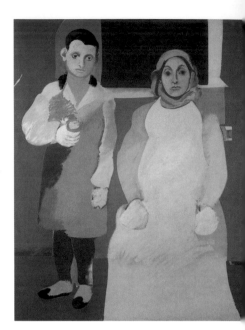

The Artist and His Mother, 1926–36
Oil on canvas, 152.5 x 127 cm
Whitney Museum of American Art, New York

life that had been cruelly taken away from him. The *Garden in Sochi* was based in part on his father's garden as he remembered it from his childhood. But this is overlaid by a vision of his 'lost' mother — 'queen of the aesthetic domain', as the painter called her — and the other women of Khorkom tearing open their clothes and rubbing their bare breasts on a sacred tree festooned with strips of clothing left by passers-by as personal acts of homage. The first of the *Gardens*, painted in 1941, still shows the influence of Joan Miró, whereas the latest remaining one of the series, painted in 1943, shows Gorky's fully developed, mature style.

Gorky's skill as a draughtsman — his fascination with tense, incisive, springy lines — re-emerges strongly in the last phase of his work. Throughout his working life he continued to draw upon natural forms for his paintings, and *Betrothal II* is full of fragmentary references to plants, animals, birds, airborne seeds and flying insects. This collection of colourful bits and pieces also acquires a carefully managed — and not immediately obvious — second existence as the bride, who occupies the centre of the canvas, the bridegroom who stands on the right, and the vocalizing priest who seems to be addressing the couple from the left. Gorky is said to have remarked that although he had tried, he had always found it impossible to make an abstract painting, that one way or another he inevitably found himself thinking of and referring back to things and events in the real world.

'The tradition of art is the grand group dance of beauty and pathos in which the many individual centuries join in the effort and thereby communicate their particular contributions to the whole event just as in o dances of Van.... The soloist can emerge onl after having participated in the group dance
Arshile Gorky

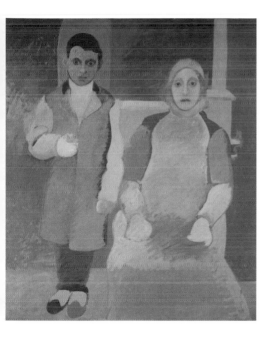

The Artist and His Mother, c. 1926–42
Oil on canvas, 152.5 x 127 cm
National Gallery of Art, Washington

Arshile Gorky: The Link Between European and American Painting

More than any of his expatriate contemporaries, Gorky tried to stay true to his European cultural heritage without at the same time turning his face against the new possibilities offered by an emergent, raw but vital American art scene. For him personally, as the two extremely moving versions of *The Artist and His Mother* that he worked on for more than fifteen years between 1926 and 1942 show, this link was sustained and given poignant force by the memorial image of his dead mother. He often remarked that it was his mother who was responsible for his creativity, and it was the memory of his mother that provided the vital link with his European past. The attentive eye that he directed towards Europe revealed itself most strongly in the influences he cultivated during his working life; these included Pablo Picasso, André Masson and Joan Miró. This quality of intelligent engagement was recognized and valued by his fellow artists, who came to see him as the guardian of inherited values and an important moral influence on how they thought about what they did in their studios. In one way or another Gorky touched the lives of most of the important artists of his generation, from the colour-field painters Mark Rothko and Barnett Newman, to the most committed of the Abstract Expressionists, Jackson Pollock and Willem de Kooning. However, this is not to say that he was a dogmatic figure. On the contrary, he always had the ability to spice critical truths with wit and poetry. Shortly after Gorky's suicide in 1948, Willem de Kooning, who was closest to him, wrote in a letter to *Art News*, 'I am glad that it is impossible to get away from his [Gorky's] powerful influence. As long as I keep it within myself I'll be doing all right. Sweet Arshile, bless your dear heart.'

René Magritte

The Pictorial Contents

1947
Oil on canvas, 73 x 50 cm
Private collection, Brussels

René Magritte lived in Paris from 1927 to 1931 but had to wait until 1948 for his first one-person exhibition in the French capital. The invitation to show his work at the Galerie du Faubourg came just as he had finished with his Impressionist experiment, described by Magritte himself as 'Surrealism in full sunlight' and now referred to as his 'Renoir period'. He had already achieved substantial recognition in Britain and the United States and the story goes that he felt a certain lingering resentment at the indifference with which he had been treated by the Parisian art establishment and the French art-buying public. He resolved, therefore, as a jokey riposte, that his first show in Paris would be strikingly different from anything that might be expected of him. The result was a set of works —fifteen oils and ten gouaches—that Magritte called his *vache* ('vicious') paintings. The intention to shock was only partially successful. Some critics simply dismissed the show as a demonstration of low-level Belgian humour. Even by Magritte's standards, the *vache* paintings are pictorially provocative. In *The Cripple* (1948), for example, a red-hatted, bearded and bespectacled man in a checked shirt is smoking eight pipes at once, three from his blue-painted mouth and one each from his forehead, his eye, his cheek, his chin and his neck. He is holding up a gold watch with a scrambled dial with matching gold chains attached. An apelike tuft of black hair bursts from the cuff of his shirt. The way this work is painted is uncharacteristically direct, even wild. The impression is of a painting that has been made at breakneck speed. But this spirit of recklessness is only one side of the *vache* paintings; the other, of which *The Pictorial Contents* is probably the best example, is altogether more considered and harder to read. Although the title is rather didactic in tone and seems to suggest a simple check-list of parts and qualities, it is a highly complex and fairly obscure image, full of half-formed metaphors and crude sexual asides. The central, scarecrowlike figure is an agglomeration of different materials and things. Tan shoes give way to a brown suit, one trouser leg of which has transformed itself into a head that is biting at an orange-yellow form rising up from the ground beneath. The rest of the suit is slashed through and erupting with different-coloured ties and scarves. On the top is perched a yellowish, rubberoid head, extended to include three birdlike creatures. Two of them are spewing coloured liquid onto the shoulders of the figure below and the third has pecked one of his eyes out. In his left hand the man is holding a banana with its skin peeled back: an obvious sexual metaphor which is further reinforced by the fact that he is firing a pistol with his right hand. Taken overall, there is a brash triumphalism about the figure in *The Pictorial Contents*. He is shown silhouetted against the sky, quite literally, it seems, standing on the top of the world.

The First Day, 1943
Oil on canvas, 60.5 x 55.5 cm
Private collection

The Cripple, 1948
Oil on canvas mounted on panel
59.5 x 49.5 cm
Private collection

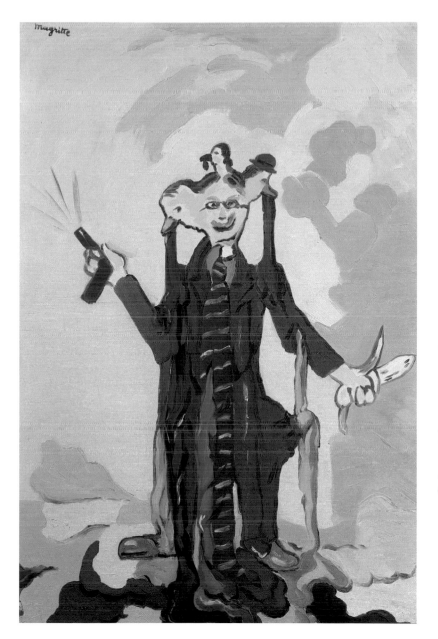

Magritte, the *Vache* Paintings and the New Pictorialism

Magritte's *vache* paintings were not always appreciated, even by his most
loyal supporters. Seen as nothing more than a passing moment in his work,
they were not given full attention until a number were included in the exhibition
'Westkunst', curated by Kasper König in Cologne in 1981, where they were
presented as the precursors of the then new figurative movements in painting:
Nouvelles Images, Transavantgardia and the Neue Wilde.

Jackson Pollock

Enchanted Forest

1947
Oil on canvas, 221.3 x 114.6 cm
Peggy Guggenheim
Collection, Venice

If the story is true, Jackson Pollock first experienced dripping and pouring paint with the intention of making an image in the experimental painting class taught by the Mexican painter David Alfaro Siqueiros that took place in New York in 1936.

'My painting does not come from the easel. I hardly ever stretch the canvas before painting. I prefer to tack the unstretched canvas to the hard wall or floor.... On the floor I am more at ease. I feel nearer, more a part of the painting. This way I can walk around it, work from the four sides and literally be in the painting. This is akin to the methods of the Indian sand painters of the West.' **Jackson Pollock**

Enchanted Forest comes right at the beginning of Pollock's period of 'pure' Action painting between 1947 and 1950. It had taken him two years to perfect the method of pouring, dripping and splashing paint onto primed, unstretched canvas pinned out on the studio floor. A very lucid example of Action painting, *Enchanted Forest* shows just how completely Pollock was able to shape the evolution of the painting through the dexterity and control he brought to the mark-making process. The pattern of marks is simultaneously 'all-over' and contained, with drips looping along the edges of the canvas as well as circling and crossing its centre. It has been said that Pollock's shift from working vertically to working horizontally was inspired by the experience of watching a Navajo 'singer' (medicine man) making sand painting at a public demonstration arranged by the Museum of Modern Art in New York, but this was only one of several influences. Clearly his experience with and admiration for David Alfaro Siqueiros was also a contributing factor, as was his long-standing interest in Surrealism. Pollock had met the French Surrealist painter André Masson at Peggy Guggenheim's New York gallery in 1943 and discussed free-wheeling, automatist techniques with him. Later, when called upon to describe the state of mind necessary for the successful completion of an Action painting, he came close to the prescriptive formula that Masson applies to automatic writing. 'Nothing can go wrong … there are no accidents. The painting has a life of its own and I try to let that come through … try to stay in contact with it. It is only when I lose touch that it ends up a mess.'

< David Alfaro Siqueiros,
Collective Suicide, 1936
Enamel on wood with
applied sections,
124.5 x 183 cm
The Museum of
Modern Art, New York

> André Masson
Antille, 1943
Oil, sand and tempera
on canvas, 128 x 84 cm
Musée Cantini, Marseille

ck's Vision and rican Utopianism

French semiologist
Marin, writing about
as More's *Utopia*, pointed
at Utopias are always
ived of in plan—always
tured from above as
visions of squares—and
hc Utopian vision is
ably a vertical one, its
purpose, paradoxically,
that of surveillance and
ol. He might have been
ibing Manhattan, not only
lanned city space but
or the view it affords of
n existence. In Manhattan
thing acts downwards
st the ground, even those
tures that seem to be
upon defying gravity.
larin's model also provides
h a very different way
lerstanding Pollock's
from painting on the wall
nting on the floor. Here,
verything is in motion
st the ground, until, that
painting is returned to
all where it becomes not
ure—not a representation
kind—but a pure,
y-free, materially
ent transparency

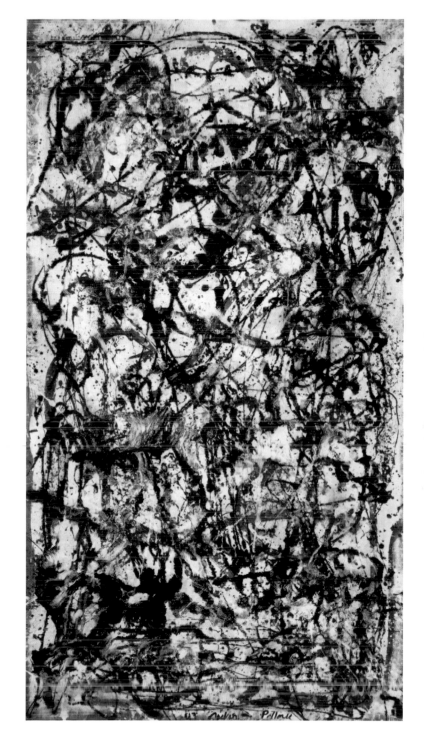

Max Beckmann

The Argonauts

1949–50. Oil on canvas in three panels, centre 205.8 x 122 cm; right 185.4 x 85 cm; left 184.1 x 8 National Gallery of Art, Washington

Beckmann completed nine triptychs during the course of his working life; a tenth triptych remained in his studio, unfinished. *The Argonauts* was his last major work and was finished the day before his death in 1950. His use of the triptych format stemmed from an early interest in medieval ecclesiastical painting and the opportunity it gave to juxtapose contrasting or supporting narratives, different orders of reality and different worlds.

The Argonauts was Beckmann's second choice of title for this triptych. It was originally going to be called 'The Artists' and a pointer to this theme can still be seen in the left-hand panel. A bearded, rather anxious painter, palette tucked under his arm, is working on a canvas. In the foreground of the picture, a curvaceous model, posing as the vengeful Medea brandishing a toy sword, is perched on the scowling, hollowed-out head of a decapitated Greek hero. Thus the real world, Beckmann's world of make-believe, myth and fantasy—pleasures, phobias and secret fears—are all brought together in one most amusing image. The right-hand panel takes up, and seems to magnify, a single strand of the same thematic material: a certain ambivalence towards women. A group of siren musicians, singing and making music—temptresses and antique chorus in one— seems poised to lure any passing band of adventurers onto the rocks. The large central panel pictures an earlier moment, before the mythic origin of Medea's desire for vengeance. It depicts the two young heroes—Orpheus, facing away, and Jason, in profile, leaning against the rocks to the right—about to set sail in search of the Golden Fleece and receiving a prophecy from the ancient sea god Glaucus. They are to suffer many trials but eventually their enchanted vessel, the *Argo*, will bring them safely to the kingdom of Colchis, where they will succeed in recovering the Golden Fleece. In the event, not only does Jason retriev the Fleece but he also carries off Medea, the beautiful enchantress, daughter of Aeëtes, King of Colchis, to be his wife. Thus the drift towards tragedy is set in motion, signalled here by the dark eclipse of sun and moon that can be seen just to the left of Orpheus' head.

Hans von Marées
Youth Picking Oranges
1873–78. Oil on canvas,
198 x 98 cm
Staatliche Museen
zu Berlin, Neue
Nationalgalerie, Berlin

Young Men at the Sea, 1905
Oil on canvas, 148 x 235 cm. Kunstsammlungen zu Weimar

As is so often the case when Classicism resurfaces in Western painting
in the form of the male nude, it is shaded with homo-eroticism. This
is true of Beckmann's *Argonauts* just as surely as it is of so many of
Picasso's paintings from the Blue and Rose periods. When still a student,
Beckmann discovered the work of the German nineteenth-century Idealist
painter Hans von Marees, well known for his treatment of the male figure.
Beckmann's Orpheus strongly resembles the figure in von Marées's
painting *Youth Picking Oranges* (1873–78). Of the two Beckmann paintings
often cited as earlier reference points for *The Argonauts*, both *Young
Men at the Sea* (1905) and *Young Men by the Sea* (1943) looked back —
according to the artist himself — to Hans von Marées's painting *The Four
Ages of Man* (1877–78). Not a surprising connection to make, perhaps,
for a painter who felt that he was approaching the end of his life.

Young Men by the Sea, 1943
Oil on canvas, 101.5 x 100.5 cm
The Saint Louis Art Museum

Willem de Kooning

Born in Rotterdam, the Netherlands, in 1904, de Kooning attended the Rotterdam Academy of Arts from 1916 to 1925. In 1926 he stowed away on a British freighter, the SS *Shelley*, bound for Newport News, Virginia. He lived for a short time in Hoboken, New Jersey, working as a house painter, before moving to New York in 1927. There he became a close friend of Arshile Gorky, who influenced him during the early 1930s. Working on the WPA Federal Arts Project from 1935 to 1937 enabled him to devote all his energy to painting and drawing for the first time, and by 1938 he had begun to establish a very personal sense of direction. First came the distinctive figure paintings of the early 1940s that led, in turn, to seminal 'abstract' works such as *Pink Angels* (1945). The 'black' paintings, works such as *Light in August* (1946) and *Black Friday* (1948), followed and then the 'white' paintings, of which *Excavation* is the most important. The influential American critic Clement Greenberg, who deplored de Kooning's return to figuration after 1950, argued that *Excavation* was de Kooning's greatest painting and that his work declined thereafter.

Excavation

1950. Oil and enamel on canvas, 203.2 x 254.3 cm. The Art Institute of Chicago

Although Willem de Kooning is quite properly described as an abstract painter, his work was never 'non-figurative' as such. This is an important consideration in reaching a sound understanding of a work like *Excavation*, which is packed full of figurative references and is perhaps best read as a miasma of jostling body parts. The painter once remarked that every mark he made took on figural significance. Far from causing him anxiety, this fact seems to have excited and energized him. *Excavation* is heavily worked, and the combination of opaque, thickly applied white oil paint and Ripolin enamel gives it the feeling of a wildly animated, shallow relief. De Kooning himself related it to a film he had seen in Italy, *Bitter Rice*, which included a sequence of women wrestling in a muddy rice field by the banks of the River Po, and it certainly has something of that sensation. The bodies, as they reveal themselves in *Excavation*, only ever appear as fragments. They seem to emerge out of a unifying substance of some kind only to disappear back into it again. A notable formal feature of the painting is the way in which the forms seem to push outwards towards the viewer at its centre and to gather together to chase

each other around its edges. This reflects de Kooning's longstanding interest in the analytical period of Cubism, but also in a more recent discovery, the large-scale paintings of the German Expressionist painter Max Beckmann. From 1938 onwards Beckmann's work was regularly shown at the Buchholz Gallery in New York, and in 1948 he had his first major American museum exhibition. More than anything else, *Excavation* reveals de Kooning's extraordinary skill as a draughtsman. This is a painting that depends upon certainty of line, and here the linear elements sweep and dance, stretch and twist their way across the canvas to generate an explosive inner tension that seems both to threaten and secure its unity at one and the same time.

Pink Angels, 1945. Oil and charcoal on canvas, 132 x 101.5 cm
Frederick Weisman Company, Los Angeles

'Whatever an artist's personal feelings are, as soon as he fills a certain area of canvas or circumscribes it, he becomes historical. He acts from and upon other artists.'
Willem de Kooning

Black Friday, 1948. Oil and enamel on pressed wood panel, 125 x 99 cm
Princeton University Art Museum

231

Jean Dubuffet
L'Oursonne (Corps de Dame)

1950
Oil on canvas, 116 x 89 cm
Neue Nationalgalerie, Berlin

Dubuffet was born in Le Havre in 1901. He attended classes at the local École des Beaux-Arts, before moving to Paris in 1918 to study at the Académie Julian. He ended his studies after six months to work and learn on his own. At this time he made friends with Suzanne Valadon and Max Jacob and visited the studio of Raoul Dufy. Suffering serious doubts about the value of culture, Dubuffet stopped painting in 1924 for over eight years, during which time he travelled widely. He started painting again in 1933. His interest in the work of unschooled artists first came to the fore in 1942. Later he coined the term Art Brut and when, in 1948, he read Dr Hans Prinzhorn's seminal book *Artistry of the Mentally Ill*, he decided with the support of others, including André Breton, to set up the Compagnie de L'Art Brut. Its purpose was to collect, preserve and study the work of psychotic and unschooled artists and children. He published his powerful anti-cultural statement *L'Art Brut préféré aux arts culturels*, a year later in 1949. Gifted with tremendous energy, Dubuffet continued to work right up until his death in 1985.

Following on from the figures in the landscapes painted during 1949 — the *Paysages Grotesques* — Dubuffet started the *Corps de dame* series in 1950 and completed the cycle the following year. The subject is the same throughout, the naked female body, which in most of the paintings is shown exfoliated in such a way as to expose genitals and buttocks — front and back — and breasts all at the same time.

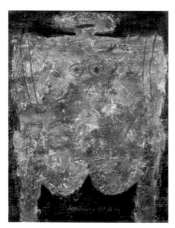

There is a powerful morphological dimension to these works too, as if the figures are in the process of emerging — finding their shape — from within an accumulation of inchoate organic matter. It is immediately apparent that Dubuffet is deliberately pursuing a 'primitivist' agenda in these works, the purpose of which is to critique the routine

Corps de dame, pièce de boucherie, 1950
Oil on canvas,
116 x 89 cm
Fondation Beyeler,
Riehen

values of what he saw as a moribund, word-centred, humanist culture, 'a dead tongue that has nothing to do with the language now spoken in the street'. By positing a world of matter, bodies and physical sensation in opposition to the world of 'words' and 'ideas', Dubuffet is also asking important questions about the nature of art and its place and purpose in the modern world. The argument hinges on the French word *brut* (both raw and pure), which he uses to raise the issue of source or point of origin. 'Where', Dubuffet is asking, 'does the creative impulse begin and end?' And in his highly polemical lecture 'Anti-cultural Positions' delivered in Chicago shortly after the completion of the *Corps de Dame* series,

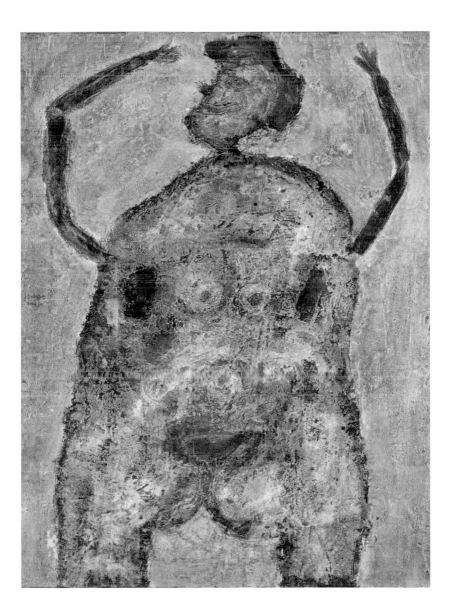

, 1950
nvas,
cm
ger
le

he provides the answer: not with ideas, which he argues are 'a kind of outer crust formed by cooling', but deep down, with the roots of existence itself, 'where I am sure the sap is far richer'.

Art Brut: Dubuffet's Definition

Art Brut is 'anything produced by people who are untainted by artistic culture; works in which mimicry ... has little or no part ... pure artistic operation, unrefined and thoroughly reinvented in its every aspect by its maker acting entirely on his (her) own impulse'. **Jean Dubuffet**

Willem de Kooning

Woman I

1950–52
Oil on canvas, 192.7 x 147.3
The Museum of Modern Art
New York

In 1950, shortly after completing *Excavation*, Willem de Kooning embarked upon a series of six numbered paintings, entitled *Woman (I–VI)*, and when, in 1953, these works were shown at the Sidney Janis Gallery they shocked the New York art world. In part this was because they seemed to fly in the face of the current tendency towards non-figurative painting, but it was mainly because of the almost brutal frankness of the images themselves. On the one hand, they seemed to represent a view of women that played upon men's deepest sexual fears; and on the other, to reduce women to some kind of primitive, all-seeing, highly ambivalent female archetype. It is interesting that the French painter Jean Dubuffet also embarked upon his *Corps de Dame* paintings in 1950.

'I find I can paint pretty young girls, yet when it is finished I always find that they are not there, only their mothers.'
Willem de Kooning

Willem de Kooning's *Woman* series marks his return to a theme he had treated before in the more geometrical figure paintings of the late 1930s and early 1940s. In these the influence of the School of Paris is still very evident, but in the *Woman* paintings of the early 1950s this has been supplanted by a vigorous form of mark-making that very definitely belongs to the emergent tempo of American abstract painting. The first of the series, *Woman I*, took de Kooning two years to complete and passed through many dramatic transformations in the process, some of which were recorded in photographs. These reveal a radical, session-by-session reconstruction of the painted image in its totality as opposed to a gradual process of accumulation and modification. De Kooning was determined to achieve a feeling of 'immediacy' and, when answering questions about the length of time that it had taken him to complete *Woman I*, he argued that the time taken was unimportant as long as in the end the painting looked 'freshly made', as if it had been completed in a single session. Although de Kooning was very much a painter's painter, at this time he was still using a wide range of cultural references, from advertising imagery to classical mythology. Certainly, in *Woman I*, he had in mind the highly ambivalent figure of the Sibyl: prophetess, sorceress and an old crone — both monstrous and comic — but also the fecund and nurturing Earth Mother.

Killing the Father

Following the showing of his *Woman (I–VI)* series, Willem de Kooning was seen by many as the most influential painter working in New York. Indeed, his success spawned many imitators, to the extent that he became the figure to be symbolically expunged by the generation of Jasper Johns and Robert Rauschenberg. In a simultaneous gesture of rejection and respect, in 1953 Rauschenberg begged one of the *Woman* drawings from de Kooning with the express intention of systematically erasing it, line by line. He named the new work *Erased de Kooning Drawing* and exhibited it in a gold-leafed frame.

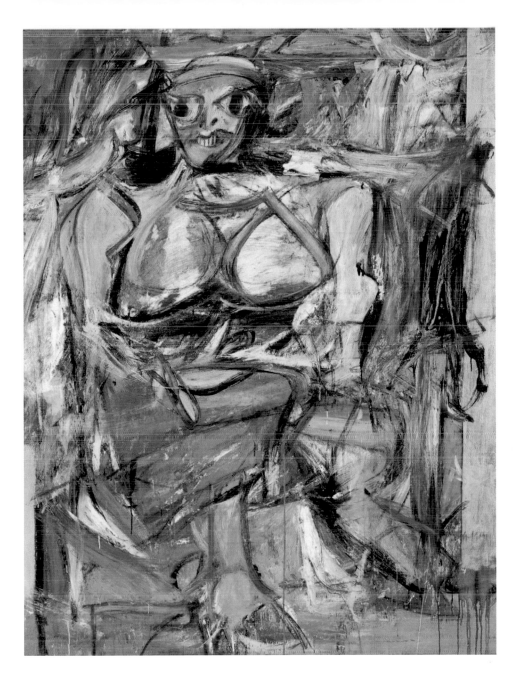

Woman

harcoal
nile
5 cm
ohia
of Art

, 1952–53
harcoal on
54.5 x 114.5 cm
Gallery of
, Canberra

Woman VI. 1953
Oil and enamel on
canvas, 174 x 148.5 cm
Carnegie Museum
of Art, Pittsburgh

Matta

(Roberto Sabastien Matta Echaurren) was born in Santiago, Chile, in 1911 where he was educated as an architect and interior designer. In 1933 he travelled to Europe and worked for two years in the studio of Le Corbusier in Paris. In 1937 he came across a reproduction of Marcel Duchamp's *The Passage from Virgin to Bride* in an old copy of *Cahiers d'art*; this was to be a life-changing experience. Based in London at the time, he dropped everything to go to Paris in search of Duchamp. They became firm friends and Matta was one of the first to buy a copy of *The Green Box*. At Duchamp's instigation, Matta went to see André Breton who was impressed by his drawings and introduced him to the Surrealist circle. At Breton's insistence, Matta's drawings were included in the Paris International Surrealist Exhibition of 1938. At the outbreak of the Second World War Matta moved to New York, where he stayed until 1948. He became an influential and at times controversial figure in the New York art world. Matta returned to Europe in 1948 and settled in Rome. He died in nearby Citavecchia in 2002.

Pecador Justificado (Justified Sinner)

1952
Oil on canvas, 117 x 177.5 cm
Museo Tamayo Arte Contemporáneo, Mexico City

Famously, to coincide with the International Surrealist Exhibition, Matta delivered a short paper entitled 'Psychological Morphology' in the famous Paris art café Les Deux Magots, ostensibly to the general public, but in the event mostly to the Surrealists and their fellow travellers. It was entirely impenetrable to all those present, including André Breton, who sat through it in silence and afterward declared that he had not understood a word. For the most part the text is as obscure today as it was then except, perhaps, for three key ideas that remained central to Matta's painting throughout his working life. The first of these is the notion that what is seen by the eye — the world of appearances — is only a thin visual slice through what is a much bigger supra-visual reality and that it is possible to make a morphological diagram of this bigger reality but not to picture or represent it. The second is the idea of time as a medium, similar to 'gelatinous water', in which we see everything distorted and transformed, transparent and in flux. The third — a reworking of the Surrealist preoccupation with dream imagery — is the notion that the language of the unconscious is dynamic and in constant change and, as a consequence, that its imagery is not confinable to the making of complete and coherent dream-pictures. These three principles are clearly demonstrated in *Pecador Justificado*. The overall feeling is of a complex, somewhat scattered image in the process of coming into being, a diagram of a psychological event, a crazy psycho-drama peopled by half-realized caricatures (creatures apparently, inspired by pre-Columbian mythology),

The Apples We Know, 1943
Oil on canvas, 95 x 128 cm. Private collection

rather than a fully realized image or picture. The figures are operating machines that are slightly rubberoid, their shafts oddly flexed, and the whole assemblage seems to exist in a limitless space with a distinctly subaqueous feel to it.

Matta and Abstract Expressionism

The paintings of Matta are often referred to as bridging European Surrealism and American Expressionism. He travelled to New York in the company of Yves Tanguy in 1939 and there he first made contact with Robert Motherwell and Arshile Gorky. He introduced Gorky to automatist techniques, persuaded him to work more spontaneously and pursue a more lyrical feel in his paintings.

He organized weekly seminars on topics ranging across art, literature and science that were attended by many young artists including Jackson Pollock, Willem de Kooning and Philip Guston. He was a mercurial and charismatic character, and Motherwell described him as 'the most energetic, poetic, charming, brilliant young artist I ever met'.

Arshile Gorky, **Summation**, 1947. Pencil, pastel and charcoal on buff paper mounted on composition board, 202 x 258 cm. The Museum of Modern Art, New York

Larry Rivers (Yitzroch Grossberg) was born in the Bronx, New York, in 1923.

As a young man, he played the saxophone in the clubs of New York, most famously the Knickerbocker Bar. Later he studied theory and composition at the Juilliard School of Music. In 1947 he enrolled at Hans Hofmann's school to study painting, and went on from there to New York University, where he was taught by William Baziotes, who introduced him to Willem de Kooning and Jackson Pollock. Rivers was fascinated by modern literature and numbered several important writers in his circle, including the Beat authors Allen Ginsberg, Gregory Corso and Jack Kerouac. For a time he had a close live-in relationship with Frank O'Hara and worked with him on a number of theatrical projects. In the 1970s he taught painting at the University of California in Santa Barbara. He died in California in 2002.

Washington Crossing the Delaware

1953. Oil on canvas
212.4 x 283.5 cm
The Museum of
Modern Art, New York

In 1953, at the suggestion of his friend John Myers, Larry Rivers read Leo Tolstoy's *War and Peace* and it was this experience that gave him the idea of making an 'epic', historic work. He chose the subject of George Washington's crossing of the Delaware River in the American War of Independence for two reasons. Firstly, because it marked an event of great historical importance: arguably, nothing less than the birth of America as a nation. And secondly, because this was also the topic of the most popular and most reproduced American history painting, *Washington Crossing the Delaware*, painted a hundred years earlier in 1851 by the German-American academic painter Emanuel Leutze.

In the early 1950s, the Cold War and the McCarthy purges were at their height and the subversive, high camp, ironic tone of the Rivers' version of this theme is inescapable. While depicting Washington as a Napoleonic poseur — thereby undermining the grandiloquent heroism of Leutze's original painting — it also fragments and disperses the event itself into a number of small, barely legible, transhistorical vignettes referencing warfare in general. The painting is thus corrosive of historical certainty, which is additionally underlined by Rivers' painting method, central to which are the twin processes of obliteration and erasure. He first states the image and then wipes part of it away or paints over it. The technique is derived from the layering of marks in Abstract Expressionist painting but is used by Rivers for a very different end: that of holding apart the pictorial components to allow different readings to occur.

Emanuel Leutze, **Washington Crossing the Delaware**
1851. Oil on canvas, 372.5 x 637.5 cm
The Metropolitan Museum of Art, New York

The Greatest Homosexual, 1964
Oil, collage and pencil on canvas,
203 x 155 cm. Hirshhorn Museum
and Sculpture Garden, Washington

Jacques-Louis David, **The Emperor
Napoleon in His Study at the Tuileries**
1812. Oil on canvas, 203.9 x 125.1 cm
National Gallery of Art, Washington

'Pop Camp' and the Politics of Individual Freedom

On the domestic front, if the Beat Generation was about anything it was about the wholesale rejection of middle America and, most especially, its claim to safeguard the freedoms of the individual. Ginsberg's *Howl* was a strident cry against the repressive conformism and normative moral values dominating American cultural attitudes. Kerouac's *On the Road* celebrated the free-wheeling world of sex and drugs that existed in the dormitory areas of America's inner cities. Larry Rivers was a key figure in the Beat movement and, like Gregory Corso, discovered an alternative world and personal freedom in the 'gay bathhouses' (as he described them) of New York. Acting and painting 'camp' was Rivers' way of expressing what he called 'queerdom' as a 'country' in which to live and 'have fun'; at the same time it was also his way of parodying the jingoism that coloured so much of American popular culture. A vivid picture of the life of Rivers and his friends can be seen in the film *Pull My Daisy* (1959) directed by Robert Frank and the painter Alfred Leslie. The actor/participants include Gregory Corso, Allen Ginsberg, Jack Kerouac, Peter Orlovsky and Rivers himself. Rivers turned to the subject of Napoleon in 1964 with a Pop Camp reworking of Jacques-Louis David's *Napoleon in His Study*, which he named *The Greatest Homosexual*.

Clyfford Still

was born in 1904 in the town of Grandin, North Dakota, but he spen
most of his childhood and early teens on a small farm in the Canadian prairie state
of Alberta. There he experienced real poverty. A collapsing agricultural economy
brought on by successive seasons of drought was further weakened by the onset
of the Depression. Returning there in 1946, Still referred to it as the 'lost land'.
The fact that he was largely a self-taught artist is apparent in 'prairie' paintings
such as the apocalyptic *Row of Grain Elevators* (1928), painted while he was still
in his early twenties. Clyfford Still met Mark Rothko in 1943. It was a meeting
of minds and, more importantly, a matching of temperaments; they quickly
became close friends. In 1961 Still moved to a farm near Westminster, Maryland,
where he continued to work until his death in 1980.

Untitled 1953

1953. Oil on canvas, 235.9 x 174 c
Tate Collection, London

Clyfford Still had an intensely romantic outlook on painting.
He described the act of painting — the 'violent' application of thick,
impasto slashes of pure colour — as 'an ecstasy and a joy' that
came 'suddenly upon him' and was 'over in just a few minutes'.
His mature style, of which *Untitled 1953* is a fairly early example, has its origins in
the totemic works that he painted in the mid-1940s. The spare yet clearly figurative
iconography of paintings such as *July 1945-R* (1945) was already only a very short
step away from complete abstraction, and the fully abstract, meandering forms of
Untitled 1946 a short step from the great vertically stretched, sometimes fragment
fields of pure colour that Still was to paint from 1948 onwards. There is a strongly
morphological quality in Still's later work. The paintings are like living creatures.
The toughly textured fields of colour seem almost to be spreading and growing

before our very eyes. Still himself described their insistent
verticality in 'vitalist' terms: as an upward-moving surge
of energy coming from the ground.
Untitled 1953 is entirely self-contained. Still felt that paintings
should be neither illustrations, pictures nor puzzles, but should
'make themselves visible'. By this he meant in part that the colo
red and blue in *Untitled 1953*, for example — should feed each
other, thereby intensifying the overall experience of the painting
He also felt that his paintings had power to move beyond
'the bounds of their limiting fields' and to function episodically,
as part of one very large 'symphonic' work.

July 1945-R, 1945
Oil on canvas, 175.3 x 81.3 cm
Albright-Knox Art Gallery, Buffalo

The Passionate Outsider

Still was a prickly character who never found it easy to 'join in'.
He was deeply suspicious of the art world, especially as it configured
itself in New York from the mid-1940s onwards. He didn't much care for
the role that certain art critics had carved out for themselves, and even
less for the kinds of political alliances that were being forged between certain
artists, critics and dealers. He felt that these various alliances operated
according to the principle of 'divide-to-rule', creating stylistic divisions where
in reality there was none. He was particularly outspoken about the controlling
influence that critics like Clement Greenberg and Harold Rosenberg were
beginning to exercise on artists, public institutions and public taste.

Philip Guston (Philip Goldstein) was born to Ukrainian immigrant parents

in Montreal, Canada, in 1913. He was brought up in Los Angeles and attended
the Manual Arts High School, where he was a student with Jackson Pollock.
As a young artist, he was greatly impressed by the Mexican mural painters
and their determination to make large-scale, ideologically motivated, historically
important paintings. He watched José Clemente Orozco paint a mural in California
in 1930 and spent part of 1934 in Mexico City assisting David Alfaro Siqueiros. He
moved to New York in 1935, where he became a respected member of the New York
School and one of its most important thinkers. Once embedded in the New York art
scene, he slowly evolved a style of abstract painting that was very different from
that of the rest of the Abstract Expressionists, altogether more European in
flavour. He returned to figurative painting in the late 1960s and showed the first
of the startlingly new, 'imagistic' works in 1970. He died of a heart attack in
Woodstock in 1980.

Painting

1954. Oil on canvas
160.6 x 152.7 cm
The Museum of Modern Art, New York

Throughout his working life, Guston remained a keen student of the history
of painting and continuously referred to it when speaking about his own work.
Accordingly, there were two key influences on the works he made during the
early fifties: Claude Monet's paintings of the water-lily ponds at Giverny and Piet
Mondrian's seascapes — the 'Pier and Ocean' paintings. Both Monet and Mondrian
had made radical contributions to Modernism's redefinition of painterly space.
Monet notably made the surface of the painting coincide with its subject. In this
sense, the Giverny paintings were not 'pictures' of a conventional kind so much
as metaphorically enriched surfaces that, visually speaking, behaved to a marked
degree like the thing they represented (still or slow-moving water). Meanwhile,
Mondrian redefined painterly space by treating the picture plane as a transparency
in which opposing vertical and horizontal forces form and reform themselves into
non-perspectival, optically mobile grids. In works such as *Painting*, Guston achieves
a marriage between these two (at first sight) quite different approaches. Viewed
from a distance, his paintings seem to possess a diffused and luminous, optically
thickened surface similar to that in Monet's late works. Close up, they have the
character of woven fabric. Small directional marks move across and against each
other and show a tendency to coalesce towards the centre of the painting.
Any forms are suggested rather than described or defined: they are emergent

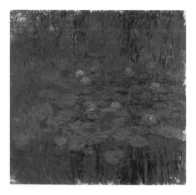

rather than fully present. Whereas previously paintings
— even abstract paintings — had been made up of discrete
forms existing in illusionary spatial locations, in these early
works by Philip Guston the distinction between form and
location no longer holds up. The limits of the canvas do
not function compositionally, but define an active space
in which we can observe the painting coming into being.

Claude Monet, **Water Lilies**, *c.* 1916–19
Oil on canvas, 200 x 200 cm. Musée du Louvre, Paris

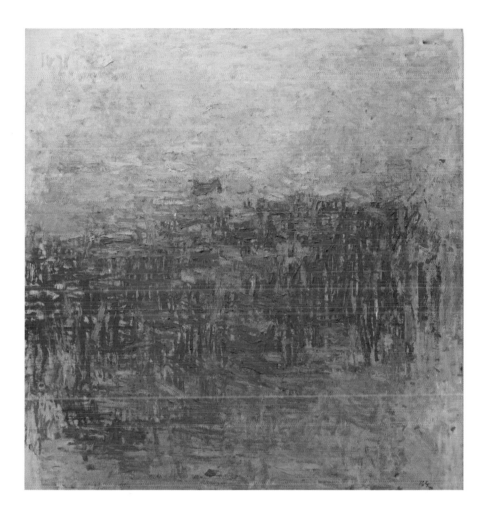

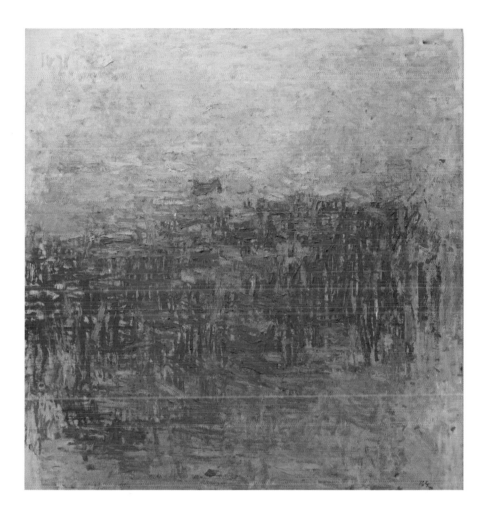

Mondrian, **Pier and Ocean V**, 1914
and gouache on paper, 88 x 111.5 cm
eum of Modern Art, New York

Lyrical Abstraction — a More Radical Approach to Picture-Making

The term 'lyrical abstraction' was first used
by the critic Lawrence Alloway to describe the
paintings made by Guston between 1951 and 1954
(sometimes referred to as 'the pink paintings'),
To quote Alloway: 'These are the works in which,
under the mask of discrete lyricism, he has been
most radical, presenting paintings that are the sum
of their discrete visible parts.... One reason for
suggesting that these paintings are "radical"
is that they make almost no use of one of
the most persistent conventions of Western art,
the hierarchic ranking of forms.'

Giorgio Morandi

1954. Oil on canvas, 49 x 54 cm. Fondazione Magnani Rocca, Mamiano di Traverset

The Courtyard of the Via Fondazza

It is one of the more curious facts of art history that the two true followers of Paul Cézanne were Swiss and Italian: namely, Alberto Giacometti and Giorgio Morandi. Cézanne's project of fixing a picture of the world according to the phenomenology of 'apprehension' is picked up and carried forwards in Giacometti's drawings and paintings; Morandi, for his part, takes up the related issues of imminence and transience as they surface in Cézanne's landscape paintings after 1898. At this poin Cézanne had begun to realize his images according to the activity and occasion of looking as opposed to constructing them in relation to the frame. The resultant sen of the coming-into-being of the image that we find in works like Cézanne's *Mont Sainte-Victoire and Château Noir* (now in the Bridgestone Museum, Tokyo), in whi the image seems to rise and push forward out of a semi-fluid, fairly amorphous foreground, also became a feature of Morandi's landscapes after the mid-1930s.

Giorgio Morandi left Italy only twice in his lifetime, in each case for a brief visit to Switzerland. And after 1920 he only occasionally left his native city of Bologna and i immediate environs. He lived most of his life between his studio and the Academy where he taught. *The Courtyard of the Via Fondazza* shows the view from Morandi studio and, although he must have seen this view every day of his working life, this painting has a compelling immediacy about it as though the artist were looking out of his studio window for the very first time. It has often been suggested that Moran ceased to concern himself with metaphysics in 1920 but it is arguable that, on the contrary, his interest in metaphysics deepened as he increasingly turned his attent to the physical world. The metaphysical point of view implies a degree of scepticisr about the reliability and permanence of things and an acceptance of constant chan; as an absolute condition of the visible world. Key to the expression of this kind of metaphysical transience in works of art is the endlessly varied play of light. In the paintings of Cézanne this is conveyed by means of the brushwork; in Morandi's landscapes it shows itself in their feeling of imminence. It is as though they have been apprehended in the blink of an eye and could disappear just as easily. While the term 'landscape', with all its art-historical baggage, may seem altogether too grand for these works, they nevertheless have a haunting and persistent presence.

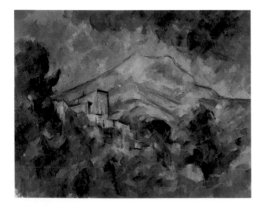

Paul Cézanne, **Mont Sainte-Victoire and Château Noir**, 1904–06
Oil on canvas, 65.5 x 81 cm. The Bridgestone Museum of Art, Tokyo

Morandi the Recluse;
Silence in the Face of Renewal

The Courtyard of the Via Fondazza was painted in 195 the year that is generally thought to mark the beginnin of the renewal of Italian Modernism after the Second V War. In Turin, Lucio Fontana and Piero Manzoni voiced their support for the Movimento Nucleare, founded in

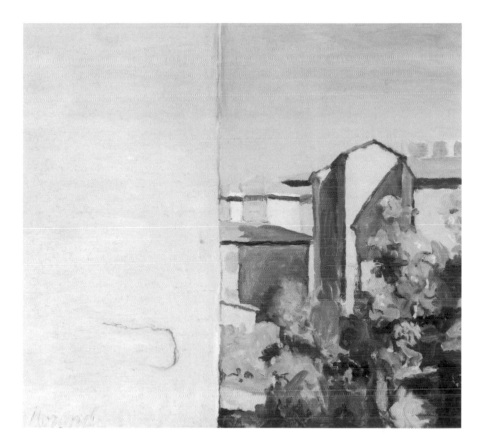

1951 by Enrico Baj, which later became an affiliate of the MIBI (Mouvement International pour un Bauhaus Imaginiste), inaugurated by Asger Jorn, with its declared aim being the representation of 'post-nuclear man' and the promotion of the wider-ranging *art informel*. As one who was entirely sceptical about the political machinations of the art world and who saw the condition of 'change' as intrinsic to existence itself, the increasingly reclusive Morandi seems not to have been affected by this renewed interest in internationalism.

Village, 1935
Oil on canvas, 60 x 71 cm
Galleria Civica d'Arte Moderna
e Contemporanea, Turin

The Courtyard of the Via Fondazza
1954. Oil on canvas, 55.5 x 45.5 cm
Museum Boijmans Van Beuningen,
Rotterdam

Jasper Johns

was born in 1930 in the small town of Allendale in South Carolina. He studied painting for a short time at the local university before moving to New York in the early 1950s, where he met the composer John Cage, the dancer and choreographer Merce Cunningham and the artist Robert Rauschenberg. It was at about this time, too, that he journeyed to Philadelphia to see Marcel Duchamp's *Large Glass* and began to take an interest in Duchamp's 'invention', the 'readymades'—common-or-garden, manufactured objects that he had resited as works of art through a simple act of designation. From a very early stage Johns had set his face against the emotional excesses of the Abstract Expressionists and sought instead to make a 'cool' and 'logical' painting, finding intellectual support for such an approach in the writings of the Austrian linguistic philosopher Ludwig Wittgenstein.

Target with Plaster Casts

1955. Encaustic and collage on canvas with objects, 129.5 x 111.8 cm
Collection of Mr and Mrs Leo Castelli, New York

'There may or may not be an idea, and the meaning may just be that the painting exists.'
Jasper Johns

All of Johns' early works, including the 'Target' paintings, were made with encaustic, a painting method that goes back to the ancient Egyptians. Pure pigment is ground into wax on a hot plate and applied directly to the canvas, which is heated with a hot iron from behind. Encaustic is a slow and labour-intensive process that guarantees a high degree of permanence and the maximum intensity of hue. It seems likely that Johns chose this method—with the addition of licked-in strips of newsprint—in order to produce a dense, textured surface without losing brilliance. *Target with Plaster Casts* is not only the most controversial of Johns' early works, it is also the most conceptually complete. The target itself is nothing more than a sign, but a sign that turns into an image the more we look at it. What starts out as a device for centring the vision and measuring the actions of the body, is here rendered strangely neutral yet utterly real in its absolute singularity. In Wittgenstein's terms, it fulfils the two prime 'truth conditions' (about which there can be no argument), 'contradiction' and 'tautology'. It both is and is not a target and an image of a target. By contrast, the plaster casts of the sensing parts of the human body (Johns calls them objects), arrayed in boxes above the target, are rendered 'unnatural' by being coded in different colours. This process of 'de-naturing' functions as an invitation for us to exercise prior knowledge and name the body parts anew—hand, ear, nose, penis etc.—thus turning the sensing body into a system of signs.

Painting as Object and Sign

The late 1950s saw a number of artists turning to the writings of Wittgenstein as an aid to rethinking or redefining the work of art. They were attracted by a terminology that seemed directly applicable, with words like 'picture', 'form', 'object', 'symbol' and 'sign', and drawn to seemingly simple statements such as 'sign languages are pictures even in the ordinary sense of what they represent', or 'a sign is what can be perceived of a symbol', or 'space, time and colour (being

Tennyson, 1958. Encaustic and collage on canvas, 186.5 x 122.5 cm. Des Moines Art Center, Iowa

246

coloured) are forms of objects'. All these statements can be applied quite directly
to a reading of Johns' *Target with Plaster Casts*. Targets, like flags, numbers and
proper names, are simple signs and represent simple things, but they also inhabit
a symbolic order that reaches far beyond what we see. Similarly, they are 'coloured'
objects that exist in space and time. However, it is important to understand that such
a simple reading of Wittgenstein is also a misreading. Notions like 'object' and
'form' in Wittgenstein's philosophy are not simple, but are subject to all kinds
of technical caveats derived from the discipline of symbolic logic.

Richard Hamilton

was born in London in 1922. He enrolled as a student at the Royal Academy Schools in 1938, and also studied print-making in the evenings at the Central School. With the outbreak of the Second World War, the Royal Academy Schools closed and Hamilton, too young for conscription, was sent to train as an engineering draughtsman. In 1946, he returned to study at the Royal Academy but was expelled for 'not profiting from the instruction', which made him liable to call-up. After eighteen months of military service in 1946–47, he studied painting at the Slade School of Art from 1948 to 1951. There he met Nigel Henderson, Eduardo Paolozzi and William Turnbull, who were to become the artistic nucleus of the influential 'think-tank' The Independent Group, formed at the Institute of Contemporary Arts (ICA) in London in 1952. Hamilton's oeuvre embraces a wide range of different activities and media. In recent years he has concentrated much of his energy on print-making.

Just what is it that makes today's homes so different, so appealing?

1956
Paper collage, 26 x 25 cm
Kunsthalle Tübingen

In 1955–56 Hamilton worked on two seminal exhibitions. He was initiator and curator of 'Man, Machine and Motion' at the Hatton Gallery in Newcastle, which later travelled to the ICA in London, and a key participant in 'This is Tomorrow', curated by the Archigram architect Theo Crosby, for the Whitechapel Gallery in London. The collage *Just what is it that makes today's homes so different, so appealing?* was originally conceived as an 'iconic' poster image for the Whitechapel exhibition, but was never used for that purpose. Taken together, image and title provide a comprehensive view of what it meant, in 1956, to be absolutely in tune with the time; on a more personal level they reflect Hamilton's desire to be 'progressive' and his passion for living the contemporary idyll. The collage manifests an almost naïve enthusiasm for the proliferation of consumer products, a keen acceptance of the emerging power and influence of new technologies — most especially in the related fields of communications and the media — and, more generally, advances a powerful case for expanding the definition of culture to embrace popular cultural preoccupations and the resulting range of new artefacts. Hamilton's approach to this collage was typically thorough. He first listed the categories that would make it suitably rich, witty and complex: man, woman, humanity, history, food, newspapers, cinema, TV, telephone, comics, words, tape recordings, cars, domestic appliances, space. Then his wife Terry Hamilton and fellow Independent Group member Magda Cordell cannibalized a large number of magazines (many brought back from the United States by another member of the group, John McHale) to find appropriate images for each heading. They had to be sharply contemporary in feel, but also the right colour and size. Hamilton's intention from the outset was to produce an image with a more-or-less coherent perspective space, and this was what determined his final choice of collage components.

The Beginnings of Pop Art

The late 1950s saw the emergence of Pop Art on both sides of the Atlantic. In the United States, Jasper Johns made his 'Target Paintings' in 1955, a year before Hamilton's collage, in which the word 'POP' is used for the first time, but Pop Art in America only really got under way at the turn of the 1960s. Roy Lichtenstein's first comic-book pictures came in 1961 and Andy Warhol exhibited his 'Campbell's Soup Cans' for the first time in 1962. In Britain, Pop Art came into being at about the same time but as an art-school phenomenon centred on the Royal College of Art, where Derek Boshier, David Hockney, Allen Jones and Peter Phillips were students. At the RCA, they came under the influence of both the young American painter Ron Kitaj (born in 1932) and—at a distance and from a more conceptual point of view—Richard Hamilton.

Glorious Techniculture, 1961–64
Oil and collage on asbestos panel, 122 x 122 cm
Private collection

Yves Klein
was born in Nice in 1928. Both his parents were artists. He was baptized into the Roman Catholic faith and his life dedicated to the service of St Rita of Cascia. His first passion was judo and he reached the level of black belt with three dans. At the age of nineteen, he came across Max Heindel's book *La Cosmogonie des Rose-Croix*. A year later he joined the Rosicrucian Society and began the systematic practice of Rosicrucianism. He made his first monochrome at the same time by attaching a plain blue disc to the front cover of his 'spiritual' notebook. When he died of a heart attack in his Paris apartment in 1962, he was just thirty-four years old.

Untitled Blue Monochrome (IKB 219)

1956
Dry pigment in synthetic resin on fabric on board, 78 x 56 cm
Staatsgalerie Stuttgart

The earliest blue monochromes were made in 1955 as part of a group of single-colour works of different shapes and sizes; two of them were made using the same intense ultramarine blue pigment that he was to rename 'International Klein Blue' in 1957 and register under the brand-name 'IKB' in 1960. A crucial stage in the evolution of his work, this also helped shape his public identity as an artist. Not only was he annexing 'blueness' and turning it into a highly personalized aesthetic domain, he was also branding himself through a simple act of 'naming'. Henceforth, to recognize IKB would be to acknowledge Klein's presence, invoke his brand of metaphysical speculation and his place in history as master of the 'Blue Epoch'. It was a brilliant piece of self-promotion.

The first exhibition of blue monochromes, the '*Proposte Monocrome, Epoca Blue*' (*Monochrome Propositions, Blue Epoch*), took place in 1957 at the Galleria Apollinaire in Milan.

The series of blue paintings, of which *IKB 219* is one example, combines high-flown speculative thought with technical innovation. Klein wanted to go beyond the materiality of the painting and to deny it any strong sense of surface. He thought of the colour blue as being without dimensions and he wanted to produce it as a pure evanescence. It was to be delivered to the eye with no variations in intensity, 'like a single sustained note played on a flute'. Only then would it achieve a level of abstraction close to 'the near nothingness of things'. Only then would it become a 'phenomenon of pure contemplation'. This required colour-saturation equivalent to dry pigment in its pure form and Klein was quick to discover that traditional tools and painting methods were of little use to him. He jettisoned brushes in favour of the roller—he was probably the first artist to do so—and abandoned oil paint in favour of one of the new matt synthetic resins. This allowed him to build up the intensity of the colour layer by layer and still retain a non-reflective surface. Most important of all, he could use the final layer as a glue with which to apply a coat of dry pigment with a reasonable expectation of permanence.

Klein and Rosicrucianism

Klein came to Rosicrucianism through his interest
in astrology; he joined the Rosicrucian Society
of Oceanside, California, in 1948. He completed
three courses in the philosophy of the movement
in successive years. This included aspects of
early Greek thought, Christian mysticism,
Oriental philosophy, alchemy and the cabbala.
His fascination with the colour blue derived
from Heindel who cast it as 'limitlessness,
a void in which ... divine oneness prevails'.
Heindel's *Cosmogonie* predicts the end of
the age of physical matter and a return to one
of 'space and pure spirit'. This notion greatly
appealed to Klein, who used it to describe
the main drift of his work long after he
had ceased to practise Rosicrucianism.

Untitled Blue Monochrome (IKB 46), 1955
Dry pigment in synthetic resin on fabric on wood, 66 x 46 cm. Private collection

Milton Avery

Born in Altmar, New York, in 1885, Milton Avery moved to Connecticut in 1898 and as a twenty-year-old attended life-drawing classes at the Connecticut League of Art Students. For some years he practised painting as a dedicated amateur, working on his canvases during the day and earning his living at night as a shift worker in a factory. He started to describe himself as an artist in 1911. His first one-man exhibition was held in the Annex Gallery of the Wadsworth Atheneum (Hartford, Connecticut) in 1915. An important influence on the paintings of many of his contemporaries — he was a close friend of Marsden Hartley, Mark Rothko, Adolph Gottlieb and Barnett Newman — it is now widely recognized that Milton Avery's work was crucial to the evolution of American 'colour field' painting. He died in New York in 1965.

Sea Grasses and Blue Sea

1958
Oil on canvas, 152.7 x 183.7 cm
The Museum of Modern Art, New York

The paintings of Milton Avery provide an essential link between European colour painting and the evolution of abstract art in the United States in the postwar period. While the influence of Matisse was very evident in Avery's work in the early 1940s, it gradually receded towards the end of that decade as his own very personal style of colour painting started to emerge. Already in works like *Adolescence*, painted in 1947, earlier abstracted, figural forms that relied on a coded spatial language had been translated into a flat pattern of coloured areas that lock each other into place like a free-form jigsaw puzzle. And this process of abstraction continued to accelerate into the 1950s. By the time Avery painted *Sea Grasses and Blue Sea* in 1958, the somewhat heavy-handed segmentation of the picture plane familiar from his earlier paintings had disappeared, leaving his compositions perfectly 'flat'. *Sea Grasses and Blue Sea* is a softly lyrical, abstract painting that teeters on the brink of the non-figurative. It treats landscape more as an atmospheric dreamscape than as a picture of the real world. Typically, it employs a family of colours — different values of blue — to create a unified, powerfully evocative, colour-induced mood.
At a time when the quality of a painting was measured according to its material force and conceptual rigour, the gentleness and luminous beauty of Avery's paintings attracted negative responses from the critics, many of whom failed to recognize their truly radical qualities. Happily these qualities were not lost on generations of American painters from Georgia O'Keeffe to Jules Olitski and Larry Poons.

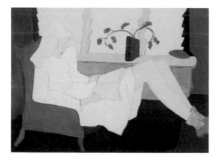

Adolescence, 1947
Oil and graphite on canvas, 76 x 102 cm
Terra Foundation for the Arts, Chicago

Black Sea, 1959
Oil on canvas, 127 x 170 cm
The Phillips Collection, Washington

What is 'Colour Field' Painting?

The term 'colour field' starts from the very simple concept of a single area of one colour that spreads over the canvas edge to edge and top to bottom. This 'field' is then used as a sounding-board against which separate 'colour-forms' are set and from which they gain their resonance.

It is a strategy that Milton Avery himself never used. Even so, the connection is plain to see in what is perhaps his most abstract painting, *Black Sea*, painted in 1959. Of the three artists who are usually referred to as 'colour field' painters, Mark Rothko, Barnett Newman and Clyfford Still, only Rothko's paintings could be said to conform to the classic definition. By contrast, Newman's 'zips' divide the field form top to bottom and anchor the painting's edges, while Still's painted surfaces tend to be heavily directional. They have none of the neutrality required by the term 'field'. Still was of the opinion that the tendency towards 'abstraction' took many different forms, even within the work of one artist, and that the category 'colour field' painting was quite simply an invention of critics seeking to secure their own sphere of influence.

Piero Manzoni

was born into an aristocratic family at Soncino near Milan in 1933. He studied briefly at the Accademia di Brera, but was mainly self-taught. During his teens he had fairly regular contact with Lucio Fontana, who was a friend of the family; his first mature works were influenced by both Fontana and the material-based approach of artists such as Alberto Burri and Jean Fautrier. Manzoni saw the monochrome blue paintings of Yves Klein in Milan in 1957 and later the same year came up with the first of his own monochromatic works, the all-over white Achromes. A key figure in the evolution of Arte Povera and — internationally — of Concept Art, Manzoni was the first artist to use eating as a medium for making art. He was also the first to elevate authorship itself to the status of a work of art by publicly signing a naked model and the first to parody consumerism by canning his own shit. Manzoni worked for only eight years. He died of a heart attack in his Milan studio in 1963.

Achrome

c. 1958
Kaolin on canvas, 94 x 75 x 4 cm (framed). Walker Art Center, Minneapolis

This is an early, classic example of an Achrome in which a secondary skin of canvas soaked in a mixture of china-clay and glue, is stretched across the surface of the canvas and gathered slightly on its vertical edges before being tacked into place from behind. The effect is a smooth, unified, slightly pleated, but curiously immaterial surface that denies image, mark or colour. Manzoni said of the Achromes that they were intended to rid painting of both reference and abstraction. They neither point to things outside themselves, nor seek to move beyond their own phenomenal nature. It follows, then, that Achromes can 'only be measured in their own terms'. They are not spaces awaiting our imaginative projections but genuine 'blanks', sites of 'origin', places where something new might occur. In a sense this comes close to the distinction the philosopher Maurice Merleau-Ponty makes between an 'objectifying space' and the 'space of representation'. In the case of an 'objectifying space' there can be no reality but 'appearance' — illusion and perception are made one. There is nothing to read either. In the case of representational space, contesting modes of reality exist side by side from the outset: the vehicle that carries the representation and the representation itself. Illusion and perception are held apart and eventually reconciled through an act of reading. As 'objectifying spaces' the Achromes belong absolutely to the category

(the world) of *things in themselves* and, as such, represent a crucial art-historical moment: the evolution of the art 'object' in opposition to painting and sculpture. The later Achromes incorporated a variety of manu-factured objects and materials: bread rolls, cotton wool and glass-fibre bundles, drinking straws etc.

Achrome, 1961–62
Bread rolls glued on wood and varnished, 90 x 85 cm
Private collection

Manzoni: Thinker and Activist

A passionate believer in the effectiveness of collective action and gifted with a sharp philosophical mind, Piero Manzoni helped to found, or joined, a number of radical Modernist groups during his short working life. Before Gruppo Nucleare, he formed a 'Manifesto' group with Ettori Sordini, its purpose to 'seek out the unconscious universal values common to all men'. He was joint author of two manifestos for the Gruppo Nucleare: *For an Organic Painting* and *Manifesto Against Style*. In 1959 he was made an associate member of the Zero Group, then based in The Hague, and in 1960 he was a co-signatory of the *Manifesto Against Nothing*, along with Enrico Castellani, Heinz Mack and Otto Piene.

'Being is all that counts.' Piero Manzoni

Mark Rothko

Marcus Rothkowitz — Mark Rothko — was born in Dvinsk (present-day Daugavpils, Latvia) in 1903. An orthodox Jewish family, the Rothkowitzes suffered violent persecution and emigrated to Portland, Oregon, in 1913. In 1921 the academically gifted Rothko won a scholarship to study at Yale University. He enrolled on the General Humanities course with the intention of becoming a lawyer but dropped out after two years. The year 1923 saw him in New York, and in 1925 he worked in the studio of the painter Max Weber. Through Weber he met the colour-painter and Matisse devotee Milton Avery, who was to have an important influence on his early development. With Adolph Gottlieb and Joseph Solman, Rothko became a founding member of 'The Ten', a group devoted to 'abstraction' in painting. During the later thirties he had to rely on the WPA project, set up to support the unemployed during the Great Depression. Success finally came when, in 1945, Peggy Guggenheim gave him a one-man show at her gallery, Art of this Century, in New York. Mark Rothko committed suicide in his New York studio in 1970.

Four Darks in Red

1958. Oil on canvas, 259.1 x 294.6 cm
Whitney Museum of American Art, New York

Rothko is probably best described as a religious or, better still, a mystical painter. As a child he was educated in the Talmud and was introduced to the more arcane reaches of Jewish mysticism. This produced a mindset that never really left him. It surfaced in his aesthetic thinking as a deep fascination with symbolism, which, in later life — after the experience of psychoanalysis — acquired a distinctly Jungian flavour. The idea of painting as a medium that could tap into some kind of universal symbolic energy is present in Rothko's work from the outset. As with Jackson Pollock, it shows itself in the experimental works of the early 1940s in primitivistic totemic forms that hug the centre of the canvas. By 1945 these forms had become less solid as they began to fragment and disperse to fill the whole of the canvas. Four years later, the blurred, lozenge shapes, moving horizontally across the surface of the canvas — so characteristic of Rothko's mature style — are seen in works like *Number 22*, painted in 1949.
Four Darks in Red shows Rothko at the height of his powers as a colourist. The intensely emotive axis between black, brown and red is one that Rothko

Sea Phantasy, 1946
Oil on canvas,
111.8 x 91.8 cm
National Gallery
of Art, Washington

No. 5/No. 22, 1950
Oil on canvas,
297 x 272 cm
The Museum of
Modern Art, New York

often used, as in a number of his easel paintings and in the mural projects for the Seagram Building and the Rothko Chapel in Houston, Texas. It is a very demanding colour range, requiring absolute control of colour temperature if it is not to appear strident and overblown. Rothko manages it with consummate skill, subtlety and apparent ease. The red field against which the four dark forms float is first tinged with crimson, then with orange, then with brown. The lozenge shapes complement these shifts. The one closest to the lower edge of the canvas is a slightly blackened crimson. Moving vertically upwards, the next is more violet. The large area of black is first shaded with blue and then with green. And finally, squeezed in at the top of the canvas there is a thin strip of a rather nondescript, umberish brown which seems to be holding all the rest in place.

Lucio Fontana

Born in Argentina in 1899 to Italian parents, Lucio Fontana was educated in Italy. Later he studied construction, architecture, physics, mathematics and mechanics at the Technical Institute in Milan. At the age of twenty-eight he enrolled in the Accademia di Belle Arti di Brera as a pupil of Adolfo Wildt, 'the great master of marble carving'. He worked as a monumental sculptor until 1949 when he made the first of his punctured canvases, known as *Buchi* or 'holes'.

Concetto Spaziale / Attesa

1959
Water-based paint on canvas, 91 x 1₂
Stedelijk Museum, Amsterdam

The earliest Tagli, the 'cuts', which Fontana referred to as *attese*, 'waitings', were made in 1958. The 'cut' was not a gesture against painting, but against what Fontana described as 'an over-weighted tradition'. He was looking to overcome painting's flatness, and the 'cut' allowed him to substitute real space for illusion. As he famously remarked, 'the "cut" bears witness to the potential limitlessness of the surface by opening up the space beyond'. But there is far more to these 'cut' paintings than Fontana's metaphysical elaboration suggests. They are very deliberate, spatial constructions, the products of a carefully managed, five-stage process: the stretching of the unprimed canvas so that the tension is just right; its saturation with emulsion paint of a consistency to ensure the 'cut' holds its shape when dry; the making of the 'cut' with a short-bladed knife at precisely the right moment in the drying process, while the canvas is still slightly damp; the gentle opening of the slit with the fingers before the final taping of the aperture behind with a heavy-duty, black gauze. The 'cuts' speak of bodily violence. They represent both a wounding and an invagination; they have both religious and sexual connotations. The link to surgery and the cutting of flesh is very strong, as is the reference to the stigmata and the piercing of Christ's body.

Ugo Mulas,
Photograph of Lucio Fontana making a cut,
1964

Concetto spaziale, 1962
Oil on canvas, 100 x 80 cm
Galerie Xavier Hufkens, Brussels

Spazialismo / The Spatialist Movement

The first 'Spatialist' manifesto, of which there were seven in all, was signed
by Lucio Fontana, the critic Giorgio Kaisserlian, the philosopher Beniamino
Joppolo and the novelist Milena Milani in December 1947. 'We refuse to think
of science and art as two distinct phenomena.... It is impossible for man not to
pass from canvas, to bronze, to plaster, to Plasticine, to the pure aerial image,
universal and suspended.' After the publication of the second manifesto, Fontana
began to use the term 'Concetto Spaziale' ('Spatial Concept') often with an
added qualifying word like 'Attese' or 'Natura' to distinguish the different
groups of works, rather than the traditional labels of painting, sculpture etc.
Ultimately, the Spatialists were seeking to establish an art that tied together
space and light as form and as architecture.

Frank Stella was born in 1936 in Malden, Massachusetts. He studied art at
the Phillips Academy in Andover before majoring in history at Princeton University, where
he met the painter Darby Bannard and the poet, art historian and critic Michael Fried.
He made his 'breakthrough' series of 'black' paintings, which included *Die Fahne Hoch!*,
in 1959. The curator Dorothy Miller selected four paintings from the series for
the seminal group exhibition 'Sixteen Americans' at the Museum of Modern Art
in 1959, and Stella was taken on by the Leo Castelli Gallery in the autumn of
the same year. He was still only twenty-three years old.

Die Fahne Hoch!

1959. Enamel paint on canvas, 308.6 x 185.4 cm
Whitney Museum of American Art, New York

Frank Stella's move from Princeton to New York towards the end of the 1950s provided
an important opportunity for reassessment. His first, rather painterly 'stripe' paintings,
clearly influenced by Hans Hofmann and Jasper Johns, came in 1958. But by the end
of the decade Stella had abandoned expressive brushwork and had already formulated
a new way of defining a painting, which he described as 'painting-as-object'. 'Flatness'
was the central tenet of this new approach, and Stella famously remarked that
'a painting is nothing more than a flat surface with paint on it'. Much later,
in the year 2000, Stella also declared: 'I like real art.... It's difficult to define 'real' but it is
the best word for describing what I like to get out of art and what the best art has.
It has the ability to convince you that it's present — that it's there.... You could
say it's authentic ... but real is actually a better word, broad as it may be.'
The black paintings of late 1958 and 1959 were the first manifestation of 'painting-as-
object' and in their deployment of basic geometric systems are regarded by many as the
true precursors of Minimalism. The paintings were made by marking equal subdivisions
(as far apart as the support was deep) along the sides, bottom and top edges of the canvas
and using these intervals to generate simple, symmetrical patterns comprising bands
of black enamel paint separated by thin lines of unpainted canvas. Stella gave the black
paintings morally provocative titles. *Die Fahne Hoch!* is named after the anthem of the
Hitler Youth (it was also the Führer's favourite marching song) and is one of several
paintings in the series that make direct reference to Nazism. By applying a hotly
emotive title to a studiedly 'cool' image, Stella's ironic purpose was that of destabilizing
the idea of meaning itself.

The Theory of 'Flatness' The term 'flat' as applied to Modernist painting is often
misrepresented and misunderstood. Arising in its most erudite form in Clement
Greenberg's writings of the late 1950s and early 60s, it is best understood as part of
the wider discussion of what he calls 'opticality'. Greenberg argues that this 'flatness'
can never be 'utter flatness'. While it may not permit *trompe-l'oeil*, perspectival or
sculptural illusion, it does allow forms of illusion that sensitively respect the optical
integrity of the picture plane. Greenberg put it very clearly in his essay 'Modernist
Painting' (1960): 'Where the Old Masters created an illusion of space into which
one could imagine oneself walking, the illusion created by a Modernist is one
into which one can look, can travel through, only with the eye.'

Castle, 1959
[Oil o]n canvas, 308 x 186 cm
[Hirshhor]n Museum and Sculpture
[Garden, S]mithsonian Institution,
[Washingt]on

Seward Park, 1958
Oil on canvas, 215.5 x 278 cm
Kunstmuseum Basel

Yves Klein

Anthropometry: Princess Helena

1960
Dry blue pigment in synthetic
resin on paper mounted on w
198 x 128.2 cm, The Museum
of Modern Art, New York

The idea of painting in a way that requires the direct intervention of the body first came to Klein while practising judo. He noticed the indentation left on the mat by the body of a contestant who had just taken a fall. In 1958 he arranged a performance in the apartment of Robert Godet, during which he used naked models to spread blue paint over large sheets of white paper stretched on the floor. He regarded this first attempt as a failure and it was two years before he tried again.

Klein finally embarked on his 'Anthropometries'—body paintings—in 1960. For some time he had encouraged nude models to wander about in his studio in the belief that the prese of their bare bodies would 'help stabilize the Monochromes'. The stability he was seeking was spiritual rather than material. As he wrote at the time, he wanted the Monochromes to be 'marked by the immediate ... through the resurrection of the body in the resurrecti of the flesh'. And so it is that the mystical reinvention of the Christian promise of 'resurrection'—echoed in the trace or imprint of a body that has 'risen'—is central to thes Klein's understanding of the human body was a detailed and particular one derived from his reading of Empedocles. Klein made a clear separation between the 'unthinking' and the instrumental or 'thought-driven' parts of the body. The 'unthinking'—'all-powerful'— comprised the trunk and thighs; the thinking parts were the head, the arms and the lowe legs, which he deemed to be mere intellectual articulations around the 'bulk of flesh whi is the true unthinking body'. This distinction is clearly visible in *Princess Helena*, as it is in all of Klein's 'Anthropometries' from 1960 and early 1961.

Klein, Empedocles and *Katharmoi*

Not only did Klein read Empedocles, he also identified with the latter's death by self-immolation. The philosopher is thought to have committed suicide by throwing himself into the fiery crater of Mount Etna. The work that is most pertinent to Klein's view of th body is the fragmentary poem *Katharmoi*, in which Empedocles describes an incorporea limbless and immortal version of the body: 'Its limbs are not fitted out with human head, nor do two branches spring from shoulders, nor feet, nor swift knees, nor hairy chest; but it is only a body and superhuman mind, darting with swift thoughts over the whole world.' This image corresponds almost exactly with Klein's 'unthinking and all-powerful body'.

ometry
ance
internationale
ntemporain,
960

ein and a
reating an
ometry
using a
ke cylinder
apartment,
960

ometry
), 1960
nent in
c resin on
canvas,
cm
collection

Morris Louis

Where

1960. Magna on (cotton duck) can
252.3 x 361.9 cm. Hirshhorn Museum
and Sculpture Garden, Smithsonian
Institution, Washington

Morris Louis was born Morris Louis Bernstein in Baltimore in 1912. He studied
at the Maryland Institute of Fine and Applied Arts from 1929 to 1933 but withdrew
shortly before the end of his course. Determined to become a painter, he supported
himself in these early years by undertaking casual work of various kinds. From 1936
to 1940 he lived in New York and worked on the WPA Federal Art Project. There
he met Arshile Gorky, David Alfaro Siqueiros and Jack Tworkov. In 1952 Louis
moved to Washington, where he became friendly with the young Kenneth Noland. In
1953 they travelled to New York together to visit the studio of Helen Frankenthaler,
where Louis saw one of her early 'stain' paintings, *Mountains and Sea* (1952).

Helen Frankenthaler
Mountains and Sea
1952. Oil on canvas
220.5 x 298 cm
National Gallery
of Art, Washington

On their return to Washington, they started to experiment
with new painting methods and by 1957, when Morris Louis
had the first major public showing of his work at the Martha
Jackson Gallery in New York, he had already evolved
the pouring technique of his mature work. He died in
Washington in 1962.

Most who knew Morris Louis speak of his utter seriousness
and his lifelong devotion to painting. However, this tends to
obscure the fact that he worked with great intensity and not
very much distinction for nearly twenty-five years and is only
now recognized as a significant artist for the work he produced in the last eight
years of his life. He was a secretive man, but it is clear in retrospect that this late
flowering started some time in 1954 when he painted his first series of Veil paintings.
These were made by diluting Magna colour and flooding it in layers — initially
across stretched canvases — so that the marks or forms overlapped, bled into, or
were seen through each other. As a paint medium, Magna possessed very particular
qualities. It delivered a significantly improved colour intensity and retained its
clarity of hue even when it was diluted. Most important of all from Morris Louis's
point of view, Magna colours were soluble in almost any volatile oil. This allowed
him to choose the most appropriate diluting agent for his purpose: one that would
soak, run and dry at the right speed. Louis was quick to realize that he could
abandon the brush altogether if he worked with unprimed and unstretched cotton
duck, hanging and draping it to make channels ready to receive the liquid paint.
As a result the marks or forms would look as if they had made themselves.
They would have something of the uniqueness and integrity of a spontaneous
event. By the time Morris Louis made *Where* in 1960, he had achieved a quite
extraordinary degree of control over this method — sufficient to lay a series
of strong colours next to each other such that they would work harmoniously
together yet still remain optically apart.

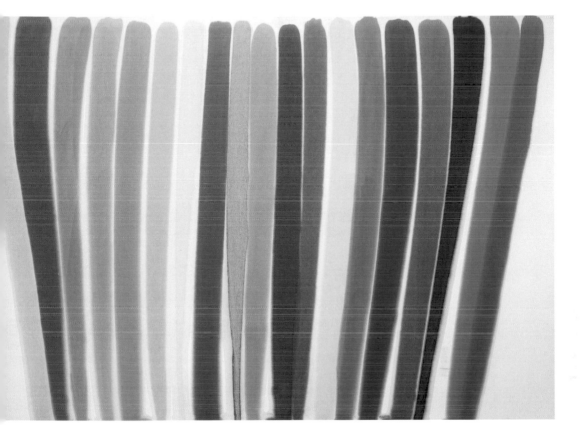

'Louis spills his paint on unsized and unprimed cotton duck canvas.... The fabric, being soaked in paint rather than merely covered by it, becomes paint in itself, colour in itself, like dyed cloth: the threadedness and wovenness are in the colour.'
Clement Greenberg

Iris, 1954. Acrylic on canvas, 205 x 271 cm. Private collection

Alberto Giacometti

was born in Borgonovo, Val Bregaglia, Switzerland, in 1901, but spent most of his childhood in the Italian border town of Stampa. He attended the School of Fine Arts in Geneva before moving to Paris, where he studied under the sculptor Antoine Bourdelle at the Académie de la Grande Chaumière. With lodgings in Montparnasse, he was soon mixing with the likes of André Breton, Max Ernst, Joan Miró and Pablo Picasso and making regular contributions to the journal *Le Surréalisme au Service de la Révolution*. Through Breton he quickly acquired a circle of literary friends, too, amongst them Samuel Beckett, Paul Eluard, Jean-Paul Sartre and, later on, Jean Genet. In the late 1920s and early 1930s Giacometti made some of the most important Surrealist sculptures, including *Reclining Woman Who Dreams* (1929) and *The Palace at 4 A.M.* (1932), but by 1935 he had turned towards a more perceptually base form of sculpture and painting, mostly working from the human head. His work thereafter became marked by the perceptual narrowing and elongation of heads and figures. Giacometti died in Chur, Switzerland, in 1966.

Annette

1961
Oil on canvas, 55 x 46.5 cm
Hirshhorn Museum and Sculpture Garden, Smithsonian Institution, Washington

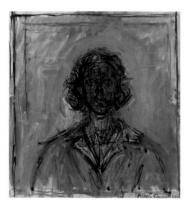

Annette, 1960
Oil on canvas
54 x 50 cm
Private
collection

Although he is sometimes described as an Existentialist artist, Alberto Giacometti started out as a Surrealist and it is arguable that, despite the dramatic change in the appearance of his work that took place in the mid-1930s, he in fact remained a Surrealist. He worked incessantly from the model but, like Cézanne, suffered chronic doubt over the possibility — in Giacometti's case even the desirability — of finding a true equivalent in clay or paint. For him the world was a place of sudden transformations, surprising expectations and uncertain presences: a place, as he said, of 'apparitions'. The most unstable elements were those of distance and size, which in turn rendered reality itself fugitive, and Giacometti once remarked: 'it is impossible to reproduce what one sees ... fixing the root of the nose is more than I can manage'. But what starts out as tentativeness in Giacometti's work ends up providing us with a vivid experience of a quest that reaches far beyond the confines of the painting itself, a quest that penetrates deep into the primordial condition of things. Giacometti's imagination has been described as 'anthropological' in its scope and depth, and Sartre famously remarked that, uniquely amongst his contemporaries, Giacometti had 'found a way of placing himself at the beginning of the world'.

One of the artist's favourite subjects for drawing and painting was his wife Annette who was required to sit for hours, days and weeks on end, while Giacometti laboured to fix her image on the canvas. This 1961 painting has all of the characteristics of his mature work, notably the frame within a frame that seems almost to suggest that Annette is seated in a glass vitrine, the slight narrowing and stretching of the neck and head, attributable to Giacometti's interest in the

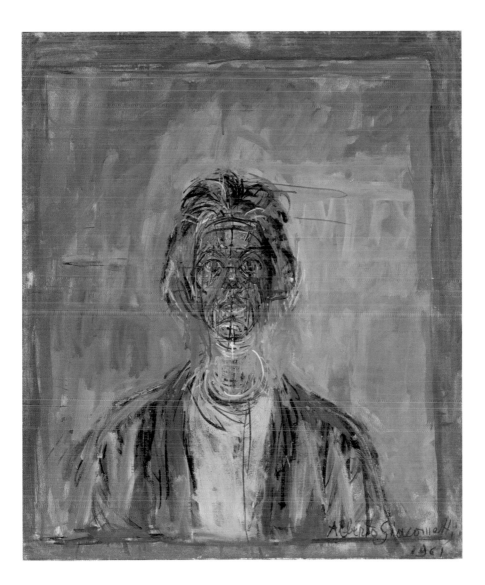

perceptual convergence that occurs in bi-optical vision, and the trans-
parency of forms arising out of the continual restating of the position,
size and shape of her features. A notable quality in all of Giacometti's
painting is the subdued colour range: admixtures of greys, browns, ochre,
black and white. This alone sets them very much apart from paintings that
seek to represent the real world and places them firmly within the realm
of metaphysics, where factors like shape and extension take precedent
over anything that might point to peculiarities of substance.

'The state of expectation is wonderful, no matter whether the expected
arrives or not. That was the subject of a long chat I had with my
friend Alberto Giacometti.' **André Breton**

Yves Klein
Untitled Fire Painting (F74)

1961. Charred paper on board, 139.5 x 102.3 cm
Musée National d'Art Moderne,
Centre Georges Pompidou, Paris

The first exhibition of Klein's work to include 'fire pieces' took place at Museum Haus Lange in Krefeld, Germany, in 1961. It was a survey of his work to date, and included a 'void' room and a vitrine with his proposals for water and fire architectures. With the assistance of the Krefeld Public Works and Gas Department, Klein was also able to install a 'Fire Wall' and two 'Fire Fountains' outside the museum, and he made his first group of 'Fire Paintings' by holding sheets of paper against them, lightly burning the surface. On his return to Paris from Krefeld, Klein enlisted the help of Gaz de France, who—quite exceptionally for the time—provided him with specialized facilities and expertise. In their Testing Centre he could use the giant gas torch with which he made the series of works that includes *Untitled Fire Painting (F74)*.

Although the technique is simple—involving the controlled application of water to the picture carrier so that certain areas resist the consuming energy of fire—it has profound implications. The 'primitive' elements of 'fire' and 'water' are brought together in one work: as destruction and resistance to destruction, life denying and life sustaining. Klein himself put it very simply when he said that these works 'are about life and death'. However, as one who was well versed in pre-Socratic thought, he also knew that the fire/water, death/life metaphor is by no means as uncomplicated as it may first appear. Both referents are all-sustaining both are all-consuming. When speaking about his 'Fire Paintings' Klein was fond of quoting an epigram by his favourite philosopher, Heraclitus of Ephesus: 'fire coming on will discern and catch up with all things'. Accordingly, the active principle of fire runs through everything. It is nothing less than a form of cosmic intelligence. It was a sentiment Klein found confirmed by another of his favourite writers, the celebrated French philosopher of science Gaston Bachelard, who, in his seminal book *The Psychoanalysis of Fire*, writes that 'fire is a privileged phenomenon, it can explain everything'.

**Fire Wall and Fire
Fountain**, 1961
Museum Haus Lange, Krefeld

Yves Klein creating fire paintings.
Testing Centre of Gaz de France,
Plaine Saint-Denis, 1961

**Untitled Fire Painting, with burn markings
from the Fire Wall at Krefeld (F45)**, 1961
Charred paper on wood, 72 x 103 cm
Private collection

Phenomena not Form

'I made the flames lick the surface of the painting in such a way that it recorded the spontaneous traces of the fire. But what is it that provokes in me this pursuit of the impression of fire? Why must I search for its traces? Because every work of creation, quite apart from its cosmic position, is the representation of a pure phenomenology — every phenomenon manifests itself of its own accord. This manifestation is always distinct from form, and is the essence of the immediate, the trace of the immediate.' Yves Klein — 'Manifeste de l'Hôtel Chelsea' (1961).

Jasper Johns

During the late 1950s, after his debut show at the Leo Castelli Gallery in New York, Jasper Johns stopped replicating simple heraldic forms such as targets and flags and began to use more conceptually demanding, although no less recognizable, visual material such as letter forms and numbers. The first of the Number Paintings came in 1955. These were followed by more aggressively worked, highly coloured paintings like *False Start* (1959) and, in 1960, by the first of the object sculptures, *Painted Bronze (Ballantine Ale)* and *Painted Bronze (Savarin)*. Johns made the first of his paintings that use the map of America in 1961, a year before *Slow Fields*.

Slow Fields

1962. Oil and objects on canvas, 181 x 90 cm
Moderna Museet, Stockholm

'Most of the power of painting comes through the manipulation of space.'
Jasper Johns

There is a striking difference between the feel and look of paintings made with encaustic and those made with oil paint. Although more textured, the overall feeling of an encaustic painting is one of an almost wall-like flatness and this perfectly suited Johns' early iconic works. However, by the 1960s he was aiming for a more spatially open and varied look to his paintings and this led him increasingly to the use of oil paint. The advantage of this more flexible medium is clearly visible in *Slow Fields*, which deploys a huge range of different kinds of brushmarks as well as alternating large and small areas of thick and thin paint in order to produce a highly complex condition of spatial flux. Marks and forms, moving forwards and backwards, seem to be endlessly reconfiguring themselves as different versions of the same 'field' or ground as the eye traverses the picture surface. The word 'slow' in the title suggests an image that is only allowed to clarify itself — to settle into visibility — gradually. It is an image, in other words, that checks and delays our comprehension as we peruse the painting. We recognize elements — letters, objects etc. — without being able to read them properly. It takes time, for example, to identify the vertical column of lettering and even longer to decipher it as a sequential use of the words 'red, yellow and blue'. This complexity is further compounded by Johns' use of real objects. Some are applied to the surface and then incorporated into the paint so that they lose definition; others, the small canvas and paintbrush hinged to the bottom right-hand corner of the painting, having been 'displaced', are then returned to the painting proper in the form of a drawn image.

Critical Irony, Jasper Johns and the New York Art Scene There is a combative side to Johns' work that is rarely discussed. He saw his work as standing in critical opposition to Abstract Expressionism and his rapid rise to prominence caused resentment amongst the old guard of Abstract Expressionists and the critics that supported them. Johns' response was typically cool. More often than not it involved the use of irony and in *Slow Fields* it is at its sharpest. The late 1950s and early 1960s marked the high point of Clement Greenberg's promotion of colour-field painting. Johns' pluralizing and implied slowing down of field recognition thus acquires a certain critical resonance. This is further intensified in the painting itself by the centred column of words — echoing the 'zips' of Barnett Newman — and the tachistic mark-making that seems to deliberately mimic the paintings of Clyfford Still.

...inting, 1963–64
...anvas with objects
...els), 183 x 93.5 cm
...n of the artist

...Bronze (Savarin)

...onze
...5 cm diameter
...n of the artist

271

Roy Lichtenstein

was born in New York in 1923. Educated at a private school, he had no formal art education until he enrolled for a summer school at the Art Students League in 1939. On leaving school, he went to Ohio State University where his fine arts studies were interrupted by the outbreak of the Second World War. He spent three years in the army, serving in Europe, before returning to complete his studies in 1946; he finally graduated in 1949. That same year Lichtenstein had his first one-person show at the Ten Thirty Gallery in Cleveland. It passed entirely unnoticed by the critics. Shortly afterwards he was appointed to teach at Rutgers University, where he came under the influence of Allan Kaprow and met Claes Oldenburg. He made his first large-scale painting using cartoon imagery, *Look Mickey*, in 1961. This, in turn, led to his first exhibition at the Leo Castelli Gallery in 1962. The show sold out in advance of the opening and he was able to resign from teaching. He died in New York in 1997.

Takka, Takka

1962. Magna colour on canvas, 173 x 143 cm. Museum Ludwig, Cologne

The story goes that Lichtenstein painted *Look Mickey* in response to a challenge from one of his sons, who one day pointed to a picture of Mickey Mouse and Donald Duck and said to his father, 'I bet you can't paint a picture as good as that.' The story may be apocryphal, but Lichtenstein never denied it, and certainly the break with his earlier work, when it came, was both sudden and radical. Painted only a year after *Look Mickey*, *Takka, Takka* belongs to the earliest phase of Lichtenstein's so-called comic-book paintings and still has the freshness and excitement of discovery about it. Arguably it was made before Lichtenstein's natural inclination to refine things had fully taken hold. He had just found the Benday dot screen, a flexible, evenly pierced sheet of metal,

that enabled him to produce a true equivalent in paint of a printed half-tone, and its use in *Takka, Takka* still has an immediacy and responsiveness about it that was lost in the later paintings. Moreover, there is a rawness and an energy about the drawn line that gave way, by the early 1970s, to a more precise and evenly accented approach. But the sense of discovery is not just attached to the look of the image, but to its content, too. Comic-books have an extraordinary propensity to throw up novel and highly pertinent juxtapositions of images and words. The United States had formally committed itself to the Vietnam conflict towards the close of 1961, and *Takka, Takka* quite brilliantly captures the idea of the war to come—as natural contagion—by setting a clattering image of guns firing through foliage alongside a caption that invokes the as yet invisible, insidiously corrosive presence of 'tropical fungus infections'.

Look Mickey
1961. Oil on canvas,
122 x 175.5 cm
National Gallery
of Art, Washington

'I'd rather use the term "dealing with" than "parody". I am sure there are certain aspects of irony ... but I think just to make parodies or to be ironic about something in the past is too much of a joke for that to carry your work as a work of art.'
Roy Lichtenstein

Giorgio Morandi
Still Life

1962
Oil on canvas, 30.5 x 30.5 cm
Scottish National Gallery
of Modern Art, Edinburgh

By far the greatest proportion of Giorgio Morandi's working life was spent painting still lifes using a small range of objects — vases, oil lamps, bottles and small ceramic beakers — that he kept on tables and shelves in his studio. Sometimes he painted small flower pictures from crudely made artificial flowers: twigs with crumpled bits of coloured paper tied to them.

The still lifes divide into three chronological groups that span the following periods from 1925 to 1939; from 1940 to the early 1950s; and from the early 1950s up until a year before the artist's death in 1964.

The paintings in the first group, which includes *Still Life* (1929), now in the Pinacoteca di Brera, have a strong feeling of immediacy about them. The objects seem to have been freshly formed. There is surprisingly little detail and a disturbing ambiguity about the size of the motifs, yet visually we feel very close to these compositions. The low eye level gives viewers a sense of having been recast as diminutive creatures let loose in a world of giant objects. Disconcertingly, in the pictures of this period it is the space in between things that counts the most.

In the second group of paintings, of which the Tate's *Still Life* of 1946 is a typical example, the objects are more reticent, quietly certain of their forms and, as a consequence, far less insistent. Morandi has also raised the viewing position slightly so that the volume of objects is more in evidence. We are now able to look down in them — appreciating their volume — and this, in turn, makes their proximity to each other and to us much less unsettling.

In the still lifes painted in the second half of the 1950s, Morandi's chief concern seems to be to find ways of 'abstracting' or ghosting the objects by folding them into the picture plane. In works such as the *Still Life* of 1956, now in the Museo Morandi, this is done by making the front surfaces of the objects nearest to the eye coincide with the picture plane and raising the eye level so as to push everything else upwards and forwards. In Edinburgh's ethereally beautiful, late picture from 1962, Morandi has adopted the opposite strategy, lowering the eye level to the point where the objects become optically thin and can only be seen as in front of or behind each other by small adjustments to their common baseline. Here, too, the usual ways of depicting volume have been abandoned and, with them, all references to weight and gravity. It is as if the objects were made and held in place by the density of the paint alone, and even that is frequently wraithlike and translucent.

Still Life, 1929
Oil on canvas, 57 x 55 cm
Pinacoteca di Brera, Milan

Still Life, 1946
Oil on canvas, 37.5 x 45.5 cm
Tate Collection, London

Still Life. 1956
Oil on canvas, 36 x 35.5 cm
Museo Morandi, Palazzo d'Accursio, Bologna

Antoni Tàpies

Pintura Bastida

1962
Mixed media, 162 x 130 cm
Antoni Tàpies Foundation,
Barcelona

Antoni Tàpies was born in Barcelona in 1923. He suffered a serious illness during his adolescent years, which also corresponded with the Spanish Civil War. In 1944 he started to study for a law degree at the University of Barcelona but dropped out after two years to pursue his growing interest in art. Tàpies chose not to attend art school but rather to learn through practice, and in 1948, with the Catalan poet Joan Brossa, he helped found the Blaus, a radical group of artists and writers who also published the review *Dau-al-Set*. His early work was influenced by Surrealism, especially the work of Paul Klee and his fellow Catalan artist Joan Miró. Later on his work developed more in the direction of Arte Povera. Tàpies was awarded the Golden Lion at the Venice Biennale of 1993. He lives and works in Barcelona.

Painters have always been fascinated by the space beyond the canvas, as well as with the enigma represented by the canvas itself. The problem is given succinct visual form in René Magritte's painting *The Alphabet of Revelation* (1928–29) in which the painting of the back of a canvas, with its stretcher exposed, is used to frame and then hold apart the language of inscription from that of the image. Magritte's point is clear. Where inscription — written language — asserts its meaning in a void — seen here as a dark, indeterminate space — images, as projected shadows from the same 'beyond' (seen here as a kit of instantly recognizable Magrittian cut-outs) need somewhere to exist, even if that somewhere is the blank canvas. Tàpies's *Pintura Bastida* carries this same argument a significant stage further by opposing the brute 'reality' of a well-used canvas support seen from the back — a renewable resource of one kind — against its potential as a vehicle for carrying images — as a

René Magritte
**The Alphabet
of Revelations**
1928–29
Oil on canvas,
54.5 x 73.5 cm
Private collection

renewable resource of an entirely different kind. He renders visible and open to the most meticulous scrutiny, the type of 'reality' that usually remains hidden, while the other 'reality' — the one upon which we would normally lavish all our attention — he renders invisible by placing the canvas face to the wall. We find this same strategy at work in an even more pointed form in Giulio Paolini's *Untitled* (1962–63) in which we are confronted by three reversed canvases set neatly one inside the other to produce a material model, almost a parody, of a recessional — perspectival — pictorial space. Painting's implicit illusionism is thus given concrete form by finding a new kind of purpose and a new meaning for the 'lost' space configured by the stretcher behind it.

lini
1962–63
id wood,
m
llection

Patrick Caulfield

was born in London in 1936 but grew up in the industrial town of Bolton in the north of England. He studied painting first at London's Chelsea School of Art and afterwards at the Royal College of Art, where his work was linked with the British Pop Art generation that included David Hockney, Peter Phillips and Allen Jones. This was an association with which he was never really comfortable. While he shared their interest in the banal imagery and commercial kitsch thrown up by popular culture, at heart he was very much a classical painter with exacting standards, in the model of the painter he admired above all others, the Spanish Cubist Juan Gris. Caulfield died in London in 2005.

Greece Expiring on the Ruins of Missolonghi (after Delacroix)

1963
Oil on board
152.4 x 121.9 cm
Tate Collection,
London

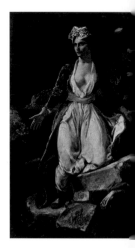

In his final year as a student at the Royal College of Art, Patrick Caulfield produced a series of paintings that were immediately noticed and instantly controversial. They were made using cheap household enamel paint. They were flat and shiny; almost unpleasantly so. A critic at the time described them as 'blatantly decorative', when the word 'decorative' carried mainly negative critical connotations. This group of works included Caulfield's *Portrait of Juan Gris* (1963) and his transcription after Eugène Delacroix's *Greece Expiring on the Ruins of Missolonghi* (1826). In fact th painting was Caulfield's response to an exercise set by one of his teachers: 'to mak a contemporary version of a historical work of art of the student's own choice'. It was to be expected that Caulfield would pick a great, iconic work, and typical of his gently satirical turn of mind that he should choose a work that he had never actually seen except in the form of a small black-and-white reproduction. It seems it was his intention to treat Delacroix's famous image with a degree of indifference as if it were a found object, and the process that he applied to it — on the surface a least — was bordering on the disrespectful. Nowadays, using projection to enlarge and transfer an image to canvas is a routine procedure. Ironically — given Caulfiel subsequent reputation as the most refined draughtsman of his generation — his us of this procedure was thought, in the early 1960s, to be the last resort of someone who could not draw. Besides demonstrating Caulfield's finely tuned, selective eye and his acute powers of interpretation, *Greece Expiring* also shows his subtly laconic manipulation of subject-matter. The painting refers the viewer to the wholesale destruction of the great classical tradition. But it does so indirectly — through a Romantic veil — thereby spicing its inbuilt nostalgia and profound sense of loss with a thoroughly contemporary dose of devil-may-care. In the end — gesturally speaking — its seeming 'open-handedness', allows the viewer to experience something of Caulfield's naughtiness, a slight frisson of illicit pleasure

Delacroix
Expiring
Ruins of
nghi

anvas,
4/ cm
les Beaux-
rdeaux

of Juan Gris

nvas,
2 cm
ollection

René Magritte

The Telescope

1963
Oil on canvas, 175.5 x 115.4 cm
The Menil Collection, Houston

In the 1950s and early 1960s Magritte took on a number of major mural commissions: in 1951 at the Théâtre Royal des Galeries Saint-Hubert in Brussels; in 1953 at the casino at Knokke-Heist; in 1957 at the Palais des Beaux-Arts in Charleroi; and finally, in 1961, for the Palais des Congrès in Brussels, which he was unable to complete for health reasons. By this time in his working life, even though his subject-matter remained mysterious, his style of representational painting had become extremely lucid and was matched by a painting method that was both direct and systematic. Magritte's health deteriorated during 1965 and 1966; he died in Brussels in 1967.

The transference of the landscape image onto the window-pane through which it is seen was a favourite device of Magritte's, appearing first in works from the early 1930s such as *The Key of the Fields* (1936). Here, fragments of shattered glass, bearing corresponding sections of the view outside, have fallen into the room, where they are in the process of reassembling themselves to make a parallel, alternative landscape to the one outside. Magritte used the same device again over fifteen years later in *The Domain of Arnheim* (1949), in this case leaving some of the shards of glass on the window-sill to link the space inside to the icy mountains of the 'real' landscape outside. But by far the most sophisticated example of this type of transference is found in *The Telescope*, painted in 1963, just four years before Magritte's death. One of the painter's starkest images, it is complex and disturbing. At first sight the transference seems to be quite straightforward: a simple exchange of day for night. A sunlit, slightly hazy image of sea and sky occupies a pair of vertical window-panes, one of which is opened from the centre to reveal darkness— night-time—beyond. However, closer examination reveals three details that, taken together, severely destabilize the reading of the image and give it a sinister twist. Firstly, Magritte has contrived a subtle point of coincidence between the leading edge of the image that occupies the glass of the open window and the frame into which it fits. This opens the way for a more telling ambiguity. Secondly, he has placed the horizon—the division between sea and sky— exactly at eye level so as to suggest a supposedly unproblematic spatial unity between the two halves of the landscape. And thirdly, at the top of the open window

The Key of the Fields, 1936
Oil on canvas,
80 x 60 cm
Museo Thyssen-Bornemisza,
Madrid

The Domain of Arnheim, 1949
Oil on canvas,
100 x 81 cm
Private collection

he has switched the allegiance of the image from the glass back to
the window-frame, thereby removing any possibility of a coherent reading and
putting into reverse the viewer's growing sense of visual certainty. The question
that remains, then, is no longer simply about the location of reality, but its
very dependability. Magritte seems to be suggesting that ultimately, even
the 'telescope' of his title is pointed into infinite darkness, that there really
is quite literally 'nothing' beyond the games that—as a painter—he is
condemned to play with appearances.

Michelangelo Pistoletto

was born in Biella in the Piedmont region of Italy in 1933. He spent his childhood in Turin. His mother was a painter and his father had a workshop for picture restoration and fresco painting. Pistoletto worked with his father from 1947 to 1958 and acquired considerable knowledge of traditional painting techniques in the process. He discovered the work of the Anglo-Irish painter Francis Bacon in the late 1950s and Bacon's influence was apparent in the work that he showed in his first solo exhibition, at the Galleria Galatea in Turin in 1960. The first of his groundbreaking mirror paintings came in 1962. When they were shown at the Galerie Sonnabend in Paris in 1964 they immediately established Pistoletto as an internationally important artist. It was Pistoletto's *Oggetti in meno* — the *Minus Objects* — started in 1965 and shown to a select audience in his studio in 1966 that paved the way for Arte Povera. He lives and works in Turin.

Three Girls on a Balcony

1962–63. Oil and graphite on tissue-paper mounted on mirror-polished stainless steel, 200 x 200 x 2.2 cm. The Walker Art Center, Minneapolis

The mirror paintings followed a period of almost fifteen years during which Pistoletto's attention had been focused on the genre of the self-portrait. In the early 1960s, when he was painting full-figure images on semi-reflective grounds, he suddenly realized that he could see his own imperfect reflection side by side with the painted image. The mirror paintings followed quite naturally from this perception. In one way, replacing the ground with a fully reflective surface was a simple move, but it proved to have profound conceptual implications. By placing the painted and the moving reflected image side by side in the same ambient space, the mirror brings together the past, the present and the future, and in the process, as Pistoletto has said, 'carries art to the edges of life in order to verify the entire system in which both of them function'. As can be seen very clearly in *Three Girls on a Balcony*, with its three part-printed, part-painted figures looking away from the viewer into the space beyond, it is the static nature of the silhouettes that provides the vital point of interface between the two. Through them we are made aware of two entirely different time frames. One belongs to art — is fixed and by implication eternal — the other, though it is contained, belongs to life — is entirely prey to social contingency and the passage of time.

More generally, the mirror paintings introduced the figure of the artist and of the viewer into the effective space of the work. It was this that led Pistoletto to make the earliest of the highly innovative series of *Minus Objects*: pieces such as *Lunch Painting* (1965) and *Structure for Talking While Standing* (1965–66).

Man in Shirt (The Present), 1961
Oil, acrylic and plastic varnish on canvas, 200 x 150 cm
Collection of the artist

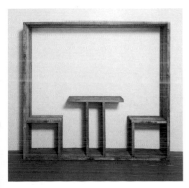

Lunch Painting (Minus Objects)
1965. Wood, 200 x 200 x 50 cm
Cittadellarte – Fondazione Pistoletto, Biella

Structure for Talking While Standing (Minus Objects)
1965–66. Iron and enamel. 120 x 200 x 200 cm
Cittadellarte – Fondazione Pistoletto, Biella

Ed Ruscha

was born in Omaha, Nebraska, in 1937. He lived for fifteen years in Oklahoma City before moving to Los Angeles in 1956. Having studied at the Chouinard Art Institute from 1956 to 1960, he found work as a graphic designer. In 1961 he turned his attention to painting, printmaking and photography, and artistic success soon followed. By the mid-1960s he was exhibiting in Los Angeles with the well-respected Ferus Gallery alongside such artists as Robert Irwin, Edward Moses, Ken Price and Edward Kienholz. From the outset, Ruscha sought to integrate the rhetorical forms and the graphic and typographic conventions he had learned in the design field into the language of painting. The challenge, as he saw it, was to replace the tired, painterly conventions of Abstract Expressionism with a visual language that was, idiomatically speaking, thoroughly contemporary. *Ace* belongs to this early, somewhat puritanical phase of Ruscha's work.

'The plastic being of the word
(by literal nominalism) differs from
the plastic being of any form.'
Marcel Duchamp

1962–63
Oil on canvas, 183 x 170 cm. Hirshhorn
Museum and Sculpture Garden,
Smithsonian Institution, Washington

Ace

No doubt it was Ruscha's design background that led him to search for ways of 'pictorializing' the written word. On the surface the formal devices for doing so are blatantly obvious. Firstly, the word has to be placed properly: in the case of a work like *Ace*, at the absolute, neutral centre of the canvas. And then it must be made to do work. It cannot be allowed just to sit there. In *Ace*, Ruscha has chosen to use a very ugly typeface in its capital, italic form. The heavy block serifs anchor the word, but also impart a rather clumsy, horizontal movement to it. This is reinforced — streamlined even — by the yellow flash with its horizontal violet streaks that enters from the middle of the left-hand frame and captures the 'A' and the 'C' before attaching itself to the downward stroke of the letter 'E'. The impression is of a word that has just arrived and has been brought to a halt at precisely the right pictorial moment, or one that is still in the process of passing through and has been caught in the blink of an eye.
The paradoxical aspect of the painting lies in the fact that a word has been treated as if it were a physical object, independent of anything it might mean. Ruscha's bathetic pretence is that a word can be made to speed into sight just like a car can be made to speed into sight and that, by doing so, it can attain a whole new level of significance. He plays a similar game, this time with the image, in the wickedly humorous painting based on an advertisement for Robin pencils, *Robin, Pencils* (1965). The insertion of the comma in the title removes the ambiguity of the original phrase, which could be read as a noun and verb, and turns it into a list of two nouns. Once again the image is placed more or less centrally but is made to register two contrary movements. The pencil appears to have made a sudden movement to the left thereby dislodging the robin, which is on the point of falling or taking off towards the right.

'encils, 1965
nvas, 170 x 126 cm
n Museum and Sculpture Garden, Washington

Philip Guston

The Light

1964
Oil on canvas, 175.3 x 198.1 cm
The Modern Art Museum of Fort Worth

Guston was never really happy with the idea of total or—as he called it—
'pure' abstraction. Even the paintings of the early 1950s—commonly referred
to as his 'abstract' phase—were strongly landscape in feeling, so much so that
unfriendly critics dubbed them 'Abstract Impressionism', the suggestion being that
they were without the kind of forceful autonomy required to qualify as full-blown
Abstract Expressionism. It is certainly true that although the works of the 1950s
and early 1960s were extremely beautiful—rich and sensuous in their brushwork,
seductively melodic in their use of colour harmonies and discords—they lacked the
iconic singularity of the works of painters such as Willem de Kooning and Robert
Motherwell. By contrast, Guston's paintings were quietly complex, gently multi-
vocal, almost miragelike images. They retained landscape characteristics but
also began to reconfigure collections of marks into discrete presences, illusionistic
spaces and atmospheres. In a 'school' of painting where the autonomy of the mark
was almost a religion, this seeming drift into non-specific figuration was seen
by many as a weakness. In fact, it was a sign of Guston's serious engagement
with painting as a progressive tradition. He had retained a political dimension
to his thinking from his early years in Los Angeles and still believed fervently
that painting had its origins in the mess and muddle of the social world rather
than in some rarefied, quasi-metaphysical other-place where forms existed
in and for themselves.

By the mid-1960s, when Guston painted a number of works similar to *The Light*,
his progress towards the more specific form of figuration of the early 1970s was
already under way. The canvas has started to figure as a unified space and forms
take on the character of specific 'things': still-life objects or heads. The role
that colour plays in these paintings has changed, too. Colours have become
more localized. They are used less impressionistically and seem to be much
more about the labelling of areas and/or things. Guston was a supremely technical
colourist, and in paintings such as *The Light* we see
him exercising this skill in its most pared-down and
elegant form. Only two basic colours are in operation:
a reddish crimson and a middle blue. Combined with
white, they generate spatially porous violets and
optical greys that lift the image away from the surface
combined with black, they solidify into an airy
colour-field populated with specific objects.

Beggar's Joys, 1954–55
Oil on canvas, 183 x 172.5 cm
Private collection

Close-Up III, 1961. Oil on canvas, 178 x 183 cm
The Museum of Modern Art, New York

When asked about the residual figuration in his paintings, Guston famously replied: 'There is something ridiculous and miserly in the myth we inherit from abstract art.... that painting is autonomous, pure and for itself — therefore we habitually analyse its ingredients and define its limits. But painting is "impure" and it is the adjustment of "impurities" which forces its continuity. We are "image-makers" and "image-ridden". There are no "wiggly or straight lines" (Guston is quoting Ad Reinhardt here) or any other "elements". You work until they vanish. The picture isn't finished if they are seen.'

David Hockney was born in Bradford, West Yorkshire, England, in 1937.

He studied at Bradford School of Art and afterwards at the Royal College of Art, London (RCA), where he was awarded the Gold Medal for Painting in the summer of 1962. At the RCA he was one of a very distinguished group of students who together formed the core of the British Pop Art movement: Derek Boshier, Patrick Caulfield, Allen Jones, Ron Kitaj and Peter Phillips. Initial public recognition came when he showed a series of four paintin under the collective title *Demonstrations of Versatility* at the 'Young Contemporaries' exhibition in 1962. His first solo exhibition at the Kasmin Gallery a year later brought him immediate international acclaim. Attracted by the sunlight, the young gay scene and its o of sexual freedom, Hockney went to live in Los Angeles in 1964 and he has mostly lived an worked between California and London ever since. He has also travelled extensively, as the changing subject-matter of his paintings clearly shows.

Man Taking a Shower in Beverly Hills

1964
Acrylic paint on canvas, 167 x 167 cm
Tate Collection, London

In 1963 David Hockney painted three pictures that he called 'domestic scenes'. Each was further qualified by the addition of a particular location. The last of these, *Domestic Scen Los Angeles*, was based on an image in *Physique Pictorial*, a gay soft-porn magazine pub lished in Los Angeles. The painting is not a slavish translation of the original, but combin elements of the photograph with items such as an armchair and a telephone taken from Hockney's own domestic life in London.

Domestic Scene in Beverly Hills, 1964. Acrylic on canvas, 167 x 167 cm. Tate Collection, London

More significant is the fact that it was painted several months be Hockney's first trip to Los Angeles and in this respect is at once projected idealization and a wish-fantasy. The artist moved to Lo Angeles in January 1964 and *Man Taking a Shower in Beverly H* was made later the same year. It, too, was based on a carefully staged photograph: one of a sequence of images (circulated by T Athletic Model Guild) that Hockney bought from *Physique Pictor* Like the earlier painting, it adapts the photographic image by usi some typical Hockney devices. The space of the shower cubicle, example, is shunted sideways to produce an isometric rather tha a perspectival space. This makes it easier for him to give an ove feeling of flatness to the image. And the shower curtain, which se to have just been swished open, is reminiscent of curtains in earl works, for instance the dark curtain that drops down and swings across the canvas to frame Ossie Clarke's head in *Domestic Sce Notting Hill*. The slight residual movement is suggestive of sudd exposure. Surprised thus, the man has turned his head towards viewer slightly quizzically as if inviting some kind of intimate ero exchange. Hockney admitted to having difficulty in painting the feet, which did not appear in the original photograph, and introd the plant in the foreground in order to solve the problem.

Ron Kitaj, **The Ohio Gang**, 1964. Oil on canvas, 183 x 183 cm
The Museum of Modern Art, New York, Philip Johnson Fund

d Hockney, R. B. Kitaj and the School of London

Initially labelled a Pop Artist, today Hockney is sometimes linked with the School of London, a term first used in the mid-1970s by the American painter Ron Kitaj to describe the remarkable range of figurative painting that had been going on in London since the late 1940s despite the international dominance of abstraction. Neither designation really fits. Even in the 1960s, Hockney was not entirely at ease with the label Pop Artist. His concerns were too personal and his approach too idiosyncratic for that. Nor has he ever shown the bullish concern for sweat and physical matter that characterizes the work of so many of the School of London painters. He does not belong in the same painterly universe as the likes of Francis Bacon, Lucian Freud or Frank Auerbach. His painting is at once more graphic and more particular: it is illustrative in the best sense of the word. Hockney and the slightly older Kitaj were students together at the RCA. Both were interested in literature and took a graphic approach to image-making. Although temperamentally very different, for a time they influenced each other. It was Kitaj who persuaded Hockney to persist with figurative painting at a moment when he was starting to experiment with a voguish, style-based and more abstract approach to painting.

Hans Hofmann

was born in Weissenburg in Bavaria in 1880. He first studied in the studio of Moritz Heymann, where he met Jules Pascin. Afterwards he worked with Wassily Kandinsky's teacher Anton Ažbe. In 1904, he went to Paris, where he met Henri Matisse, Pablo Picasso, Georges Braque and André Derain. Through his future wife 'Miz' (Maria Wolfegg), he developed a close relationship with Sonia and Robert Delaunay. He opened his first art school, the Hans Hofmann School of Fine

Arts, in Munich in 1915. In the summer of 1930 he undertook his first highly influential spell of teaching in America at the University of California at Berkeley. Hofmann finally left Germany for America in 1932 because of the Nazi suppression of artists and intellectuals. He settled in New York and opened his new School of Fine Arts, in Madison Avenue, a year later in 1933. He joined the Abstract Expressionist group the 'Irascibles' in 1950 to protest against the exclusion of avant-garde art from American museums. He stopped teaching in 1958 and died in New York in 1966.

Untitled (Portrait of Maria Wolfegg), c. 1901
Oil on academy board mounted on masonite, 70 x 49.5 cm
André Emmerich Gallery, New York

To Miz: Pax Vobiscum

1964
Oil on canvas,
196.5 x 212.4 cm
The Modern Art Museum
of Fort Worth

For most of his working life teaching was as important to Hofmann as painting. Indeed, he stopped painting for long periods in order to concentrate on his pedagogic pursuits. Even so, he can be counted as one of the most important, continuously inventive and influential painters of the first-generation New York School. Some have described him as the philosophical engine that powered Abstract Expressionism, and certainly he was close to Jackson Pollock, Willem de Kooning and Arshile Gorky at the most crucial stages in their development. Four strands of Modernism come together in Hofmann's thinking: the Russian mystical tradition of abstraction as represented by Kandinsky's 'Improvisations'; a post-Fauvist use

of pure colour to make form and space in the refined manner of Matisse and the Orphists; an insistence upon layered flatness derived from Cubism; and the 'will to form' springing from his earlier involvement with German Expressionism.

All four strands are present in the Cape Cod paintings, of which *To Miz: Pax Vobiscum* is a fine example. Here we see at work the two principles that Hofmann stressed in his teaching. What he call 'colour-forms' dominate the layout of the painting. For Hofmann, colours are measurable: area is set against visual weight. Accordingly, colour-forms, in terms of their size and combination, are designed to perfectly match the intensity of their hue.

Bacchanale, 1946. Oil on composition
board, 162.5 x 122 cm. Private collection

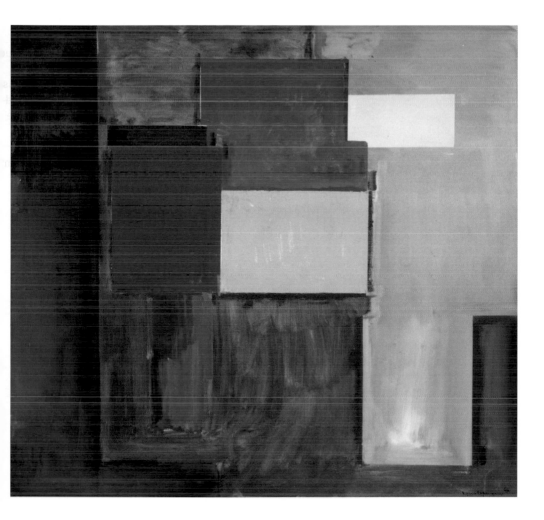

And the visual mechanism that brings the picture so vividly to life is
that of 'push and pull'. Blocks of intense colour seem to move with and
against each other, floating towards and away from the viewer, returning
to and emphasizing the picture plane at the same time as working in tension
with the material flatness of the painted support. Underlying Hofmann's
abstraction was an unshakeable belief in the importance of drawing from
nature (his life classes were legendary). He believed in art as a form of
holistic experience linking the self to the world's space, and in his view
drawing was the ideal instrument through which to discover and explore
this mysterious unity. It was a bone of contention with other Abstract
Expressionist painters, Jackson Pollock especially, who saw it as a throwback
to European ways of thinking.

Ad Reinhardt

was born in Buffalo, New York, in 1913. He studied art history under Meyer Schapiro at Columbia University and afterwards took courses in fine art at the American Artists School and the National Academy of Design. He worked on the WPA Federal Art Project from 1936 to 1939. Reinhardt had his first one-person show in 1943, and by 1946 was showing regularly at the Betty Parsons Gallery. That year he enrolled at the New York University Institute of Fine Arts, where he studied until 1951. It was about this time that he started working on canvases that use variations on a single colour. The 'red' and the 'blue' paintings appeared in 1952 and the first of the 'black' paintings, for which he is best known, in 1953. *Abstract Painting, No. 34* belongs to the long series of works that Reinhardt started in 1960 and continued with until he stopped working in 1966. He died in New York in 1967.

Abstract Painting, No. 34

1964
Oil on canvas, 153 x 152.6 cm
National Gallery of Art, Washington

Ad Reinhardt's black paintings remain amongst the most challenging works of the late 1950s and early 1960s. Controversial at the time, they seem to have retained something of their capacity to surprise and can still divide critical opinion. This is art stripped to the bare minimum, taken close to the edge of nothingness. In this respect they reflect a powerful streak of Puritanism within the American tradition. The numbered black paintings that Reinhardt made in his final phase all share the same format: nine equal squares stacked up in sets of three to form a larger square. Each of the component squares is painted a carefully modified black that is to say, a black with a tiny quantity of another colour added to it. The colour black absorbs light rather than reflecting it and this, coupled with an unusual evenness of tone, allows these small quantities of added colour to become active, almost subliminally. As we gaze at the painting, squares shaded with different colours seem to loom into sight only to disappear again. The effect is genuinely mysterious. What at first sight appears to be a rather sullen black square suddenly

acquires an uncanny luminosity. These paintings have none of the matter-of-factness that we associate with Minimalism proper, but are real objects of contemplation.

'The more uses, relations, "additions" a painting has, the less pure it is. The more stuff in it, the busier the work of art, the worse it is. More is less.' **Ad Reinhardt**

Abstract Painting, Blue, 1953
Oil on canvas, 127 x 71 cm
Whitney Museum of American Art, New York

Ad Reinhardt and the 'Reductive' Tendency in American Art

Reinhardt has been seen by some critics as epitomizing the drive to 'simplify' the outward appearance of the work of art that coloured so much American art after the Second World War. This tendency is commonly described as 'reductive', a term that is by no means as simple as it may seem at first. With the possible exception of the Minimalists, in almost all cases it reaches far beyond the question of appearances to touch upon the question of individual purpose, deep content and emotional affect. This is particularly true in Reinhardt's case. More than anything else he wanted to break with what he saw as the emotive excesses of Abstract Expressionism and 'return art to itself'. It was for this reason that the paintings of Mark Rothko were something of a *bête noire* to him. But he didn't want to reduce painting to a set of bare visual facts either. His interest in the Orientalism of Mark Tobey led him to retain some notion of a spiritual centre to his work.

Frank Stella

1964. Fluorescent alkyd on canvas, 198 x 198 cm
Albright-Knox Art Gallery, Buffalo

Fez

One of a series of twelve square paintings named after Moroccan towns, *Fez*
was first shown in the exhibition 'Eleven Artists' curated by the artist Dan Flavin
for the Kaymar Gallery, New York, in 1964. The show was fairly mixed, although
overall it was dominated by the Minimalists and their fellow travellers. In a review
for the *New York Times* in March 1964, Brian O'Doherty wrote that 'the outstanding
picture is a recent Frank Stella (Fez) that could, without any exaggeration,
be described as a masterpiece'.

By 1964 Minimalism had already begun to create a divide between the 'literalists'
and the 'opticalists': between those, such as Carl Andre, Dan Flavin and Donald
Judd, who wanted to stress the 'structured' integrity of the material object, stripped
of illusion, and those, such as Agnes Martin, Larry Poons and Ad Reinhardt,
who were keen to explore the potential of colouristic surface-effects for generating
spatial illusion, no matter how minimal. Stella's work after the 'black' paintings
—a series of great 'silver' slabs and metallic chevrons—had seemed to place him
firmly in the camp of the 'literalists', but with the Moroccan series he appeared
to have jumped ship and gone over to the other side. The most heated polemic in
American art in the mid-sixties took place between Clement Greenberg, champion
of the 'optical', and Donald Judd. While Greenberg staunchly defended the idea
that painting and sculpture were distinct, medium-specific visual languages, Judd
maintained that painting was dead, that it had been absorbed into a new aesthetic
of 'objectness'. Judd stated his position almost brutally in the opening sentence of
his important polemical essay 'Specific Objects' (published in 1965): 'half or more
of the best new work in the past few years has been neither painting nor sculpture'
and he went on to argue that 'real space' was both 'more powerful and specific'
than paint on a flat surface'. *Fez*, of course, is 'opticality' carried to an extreme.
It uses 'light-fortified' or fluorescent paint (for the first time) to create powerfully
inductive, optically vibrating contrasts of tone and hue, in a pattern of opposing
diagonals that push towards the centre, releasing a continuously changing
barrage of optical effects.

Opticality, not 'Op Art'

Asked by the critic Bruce Glaser about his relation to European
geometric painting or Op Art in an interview just after the first showing of *Fez*,
Stella made the following very telling distinction: 'The European geometric painter
really strive for what I call relational painting. The basis of their whole idea is

balance. You do something in one corner and you balance it with
something in the other corner. Now the "new painting" is being
characterized as symmetrical. Ken Noland has put things in the
centre and I'll use a symmetrical pattern, but we use symmetry in
a different way. It's non-relational. In the newer American painting
we strive to get the thing in the middle, and symmetrical, but
just to get a kind of force, just to get the thing on the canvas.
The balance factor isn't important. We are not trying to jockey
everything around.'

Marrakech, 1964
Fluorescent alkyd on canvas, 195 x 195 cm. Private collection

Dan Flavin
A Primary Picture
1964
Red, yellow and blue
fluorescent light
61 x 122 cm
Hermes Trust, UK,
Courtesy of
Francesco Pellizzi

Larry Poons
Orange Crush
1963
Acrylic on canvas
203 x 203 cm
Albright-Knox Art
Gallery, Buffalo

Daan van Golden

was born in Rotterdam in 1936. In his early teens he had painting lessons from a Jesuit priest and at sixteen took employment as a window dresser in a department store. He attended drawing classes at the Rotterdam Academy of Art and Technical Sciences, where he also studied graphic techniques. The late 1950s saw the beginning of his passion for travel and, typically perhaps, his first one-person show—at Amsterdam's Galerie 207 in 1961—opened in his absence Van Golden was away, travelling in Mexico and the United States. In 1962 Van Golden made a pavement drawing in Paris to mark the death of Yves Klein. During 1963 and 1964 he lived in Tokyo, where he had the first showing of his meticulously executed 'golden pattern' paintings at the Naiqua Gallery. His work was included in Documenta 4, the important show of international comtemporary art held every seven years in Kassel, West Germany, in 1968, but after that he did not show in public again until his exhibition at the Stedelijk Museum in Schiedam in 1978. Van Golden represented the Netherlands at the Venice Biennale in 1999. Today he lives and works in Schiedam, Holland.

Composition with Blue Square

1964. Gloss paint on canvas on panel, 70.5 x 70.5 cm. Stedelijk Museum, Ams

Van Golden lived in Tokyo from 1963 through to the end of 1964. He arrived there after travelling through Turkey, Iran, East Pakistan, Burma, Thailand, Malaysia, Singapore and Hong Kong. In Holland he had made large black-and-white Abstract Expressionist paintings. His time in Japan, which served to reinforce a long-standing interest in Zen Buddhism, changed him and his work beyond all recognition. In Tokyo, the idea of the work of art as an expression of 'self' emerging out of a spontaneous creative moment gave way to a more distanced attitude involving the careful choice of a simple motif and a sustained, intensely contemplative approach to the act of painting itself. In all, he made some twenty works that took as their starting point pre-existing visual sources like decorative and corporate wrapping papers, patterned fabrics, tea towels and handkerchiefs. These became known collectively as the *Golden Patterns*.

Composition with Blue Square is one of four works that were based on the complex cross-weaving of self-coloured threads found in gentlemen's pocket handkerchiefs. The ironic reference to the Dutch modern master Piet Mondrian is obvious from the title; less obvious is van Golden's fascination with the works of Ad Reinhardt and Yves Klein.

Fujiya, 1964
Gloss paint on canvas on panel, 70 x 60 cm. Museum Boijmans-Van Beuningen, Rotterdam

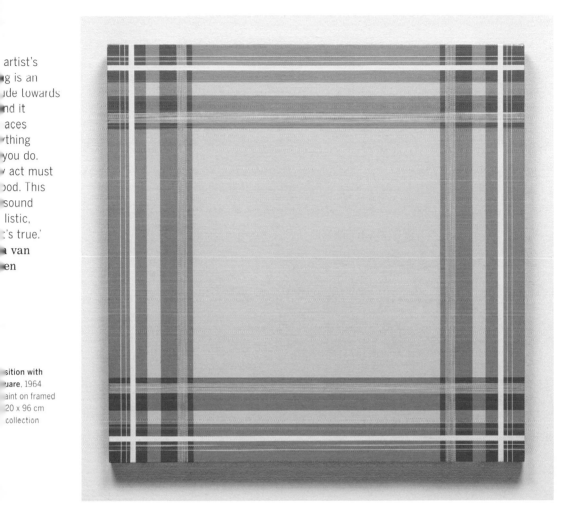

artist's
g is an
de towards
nd it
aces
thing
you do.
act must
od. This
sound
listic,
's true.'
van
en

sition with
uare, 1964
aint on framed
20 x 96 cm
collection

Object as Image

The emergence of Pop Art led artists to look to common everyday objects
for their potential as 'meaningful' images. While the conceptual impetus for
this tendency has its origin in Marcel Duchamp's denial of aesthetic quality
in the readymade, by the time it arrived in the hands of Jasper Johns, Claes
Oldenburg and Andy Warhol and others it had acquired an aesthetic baggage all
of its own. The objects of choice must possess nostalgic resonance — like Johns'
Painted Bronze (Ballantine Ale) (1960), which is a realistic representation of
two Ballantine Ale cans, or Warhol's *Brillo Box* (1964). They must also have real
potential as lifestyle indicators. Culturally speaking, Daan van Golden's careful
replication of household linen is more subtle than either of these alternatives.
His paintings have a gently quizzical air of tongue-in-cheek puritanism about
them that is unmistakably Dutch.

Georg Baselitz

Georg Baselitz was born Hans-Georg Kern in 1938 in the small town of Deutschbaselitz near Dresden in what was to become East Germany. He first studied painting at the Hochschule für Bildende und Angewandte Kunst in East Berlin, from where he was expelled in 1957, and afterwards at the Hochschule für Bildende Künste in West Berlin. By the beginning of the 1960s he had discovered the writings of Lautréamont and Antonin Artaud and had also shown some interest in the Abstract Expressionist painters Jackson Pollock, Willem de Kooning and Philip Guston. However, in 1961 he published his first public statement, *Pandämonium*, with Eugen Schönebeck, in which they argued for a complete and radical break with abstraction. Baselitz had his first one-person show at Gallery Werner & Katz in Berlin in 1963. The exhibition caused a public outcry. Several of the paintings were deemed to be obscene and were removed from public view. They were confiscated for a period of two years by the city authorities. In 1965 Baselitz spent some months studying Italian painting in Florence, where he discovered the work of the Italian Mannerists Agnolo Bronzino, Parmigianino and Pontormo.

Man in the Moon — Franz Pforr

1965
Oil on canvas,
161.9 x 129.8 cm
National Gallery
of Art, Washington

'I am a mannerist in the sense that I deform things. I'm brutal, naive and gothic.'
Georg Baselitz

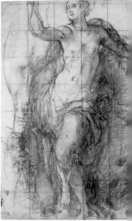

Man in the Moon—Franz Pforr was painted shortly after Baselitz returned from Florence and it shows something of what he had learnt and thought about during his time there. The loose, more aggressive style of painting that characterizes his Hand of God paintings from late 1964 and early 1965 has been replaced by a new, painterly lyricism and formal fluency. In this picture, the smallness of the head combines with the length and bulk of Pforr's body to produce a manneristic image very similar to that which we find in the drawings of Pontormo, most notably in his *Study of Venus* from the drawing collection of the Uffizi. Just as the Italian master bulks out and eroticizes the body of Venus by enveloping her in voluptuously flowing swathes of drapery, so, too, Baselitz wraps his 'hero' around with snakelike creatures that carry obviously phallic sexual overtones. Franz Pforr was a Romantic painter (one of the founding members of the early nineteenth-century German group the Nazarenes) who died of tuberculosis when he was just twenty-four years old. Baselitz included him in the series of paintings that he called New Types, such as *Rebel* (1965),

Rebel, 1965
Oil on canvas, 162 x 130 cm
Tate Collection, London

nd —
nd of God
55
canvas,
9 cm
useum

Pontormo
or a Venus

ed and white
on paper,
cm
degli Uffizi,
to degli Disegni
e, Florence

intended to call into existence a new brand of heroism joining spiritual force with
a true understanding of history. Like Anselm Kiefer, Baselitz had understood the
dangers involved in Germany's refusal to confront its recent history, but where
Kiefer chose to harness the symbolic and mythic forces of German legend,
Baselitz chose to depict a mixture of real historical figures, generic occupations
and social types. His admiration for Franz Pforr in all probability attached itself
to the lucidity of the young painter's style, which brings together something
of the 'nature symbolism' of Caspar David Friedrich with the structural clarity
of Italian Renaissance painting.

Helen Frankenthaler was born in New York in 1928.

In 1945 she graduated in painting from the Dalton School, where she
had been taught by the distinguished Mexican painter Rufino Tamayo.
In 1946 she returned to her studies again for one year at Bennington College
before enrolling at the Art Students League in New York in 1947 as a student of
Vaclav Vytlacil. In 1949 she attended graduate classes at Columbia University,
New York, with Meyer Schapiro. Frankenthaler met Clement Greenberg in 1950
and he introduced her to David Smith, Lee Krasner, Jackson Pollock, Willem
de Kooning, Franz Kline and Barnett Newman. The next year she had her
first one-person show at the Tibor de Nagy Gallery in New York. In 1966, with
Ellsworth Kelly, Roy Lichtenstein and Jules Olitski, she represented the United
States at the Venice Biennale. Frankenthaler still lives and works in New York.

Canyon

1965. Acrylic paint on canvas, 112 x 132 cm. The Phillips Collection, Washingto

Just a year before she made *Canyon*, Frankenthaler produced *Interior
Landscape* (1964), which was to be one of the most innovative paintings of
the 1960s. It used an acrylic resin-based paint modified by the incorporation
of a small quantity of detergent, the effect of which was to reduce the surface
tension of the liquid colour, thereby allowing it to soak immediately into
unprimed canvas. This comparatively simple technical development had
farreaching effects on the way paintings looked. Not only did it introduce a new
vocabulary of marks—later defined as Stain Painting—but it also generated
an entirely different look and feel to the painted surface. The tortuous surface,
the thick impasto and ridged accumulation of marks familiar from Abstract
Expressionist painting were replaced by an array of painted marks that seemed
almost to have formed themselves: softly exfoliating loops and large fluid
expanses of densely coloured paint, all holding themselves tight and flat against
the picture surface so that the grain of the canvas was still present to the eye.
Jackson Pollock introduced pouring and dripping into the painter's vocabulary.
Frankenthaler's introduction of staining techniques, as *Canyon* clearly

demonstrates, allowed the same
degree of informality to be extended
to the creation of large areas of
colour and even to the canvas
ground itself. What is also made
apparent by *Canyon* is that by
pouring and staining Frankenthaler
was able to return to some notion

Interior Landscape
1964. Acrylic on canvas,
266.5 x 253.5 cm
San Francisco Museum
of Modern Art

of shape in painting, a factor that had been largely eradicated by
Abstract Expressionism's insistence on the singularity of the mark.
In the case of *Canyon*, the location of the original pour of red paint
is still clearly visible in the density of colour left of centre, giving
the painting its powerfully ambiguous sense of volume and space.

Agnes Martin

was born in Maklin, Saskatchewan, Canada, in 1912. She was brought up in Vancouver, British Columbia. Having moved to the United States in 1932 and commenced pedagogic studies at Bellingham in 1934, she enrolled in the Art Department of the University of New Mexico in 1946. She gained her MA in Education at Columbia University and moved to live in Lower Manhattan, New York in 1957, where her neighbours included Robert Indiana and Ellsworth Kelly. Her first solo exhibition, out of the advocacy of Barnett Newman, took place at the Betty Parsons Gallery in 1958. Martin is sometimes thought of as one of the sources of American Geometric Minimalism, a connection that she refuted. Certainly her paintings are more inward looking, contemplative and emotionally driven than a strict adherence to the Minimalist aesthetic would permit. Her working life extended over four decades. She died in 2004 in her beloved adobe house in New Mexico at the age of 92.

Morning

1965. Acrylic paint and pencil on canvas, 182.6 x 181.9 cm. Tate Collection, London

From her student days onwards, Agnes Martin paid regular visits to New Mexico, attracted by the vast open spaces of its desert landscape. Not only did it suit her highly ascetic temperament, but its 'unpaintable character'—the miasma of time, space and light—linked to her interest in Taoism helped to form the spiritual impetus behind her notion of space in painting. The formative period of her mature style occurred between 1957 and 1961. The obsessive interest in the relationship between the rectangle and the square format that Martin was to work with for the rest of her life emerged at this time in paintings like *Window* (1957) and the DIA Art Foundation's *Untitled* of 1959. The first of the paintings that used a closely worked grid pattern came a year or so later in the shape of *White Flower* and *The Islands* painted in 1960 and *c.* 1961. By the mid-1960s, when *Morning* was painted, the main characteristics of her work were already in place: a square format with a carefully modulated, lightly tinted, transparent ground overlaid by a meticulously constructed and perfectly regular rectilinear grid of pencil lines. Viewed against the background of the philosophy of the 'field of Tao', Martin's paintings are empty and formless but capable of yielding up all forms: contained and yet, by implication, capable of infinite extension. Joseph Needham in his important exposition of Chinese physical science (*Science and Civilization in China*, vol. IV, 1962) argued that 'it is not "particulate" like Western science' but conceives of things as a perfectly continuous whole in which the opposing forces of *yin* and *yang* produce intrinsic rhythms that are integrated into the general harmony of the world. This statement could easily be a description of an Agnes Martin 'grid' painting. Though simple in construction, they are certainly not simple at the point of apprehension, but full of subtly shifting—appearing and disappearing—wavelike movements.

Kasimir Malevich, **White Square on White Ground**, 1918. Oil on canvas, 79.5 x 79.5 cm. The Museum of Modern Art, New York

Modernism and the Barely Visible
Ever since Kasimir Malevich painted *White Square on White Ground* and *White Cross* in 1918, there has existed a strand of modern painting concerned with exploring monochromy and shifts of colour at the very edge of visibility. The first category is exemplified in high modernism by such key figures as Yves Klein and Robert Ryman; the second by Ad Reinhardt and Agnes Martin. But where Ryman is looking at the absence of light—the point at which disappearance occurs—Martin is searching for the point at which light suffuses and dissolves everything into one, all-embracing condition of visibility—a transcendent evanescence within which all the elements are seen and recognized but only fleetingly.

Gerhard Richter

was born in Dresden in 1932. On leaving school he worked in advertising and as a stage-set painter until he was accepted at the Dresden Art Academy. A few months before the Berlin Wall was erected, he and his wife fled to Düsseldorf in West Germany. Richter then enrolled at the Staatliche Kunstakademie Düsseldorf where he studied under Karl Otto Gotz from 1961 to 1964. He had his first one-person exhibition at Galerie Schmela in Düsseldorf in 1964. Richter has held professorial posts at the Hochschule für bildende Künste in Hamburg, Nova Scotia College of Art and Design, and at the Kunstakademie in Düsseldorf. His reputation as one of the most important painters working today was powerfully reinforced by his third major retrospective, curated by Robert Storr for the Museum of Modern Art in New York in 2002. He lives and works in Cologne.

Woman Descending the Staircase

1965
Oil on canvas, 200.7 x 129.5
The Art Institute of Chicago

Gerhard Richter's paintings fall into two main categories: the photography-based, figurative paintings and the process-based abstract paintings. Despite this stylistic difference they share a common procedural principle in that they stress the importance of the painter's 'neutrality'. Richter's paintings in whatever style — both abstract and figurative — are not concerned with expression but with method. The photographic paintings are meant to be 'photograph-like'; to shift focus across the surface in a similar way. They are to be read in terms of their faithfulness to their source; the deftness and skill with which the painter has succeeded in translating photographic effects into brushwork. *Woman Descending the Staircase* is one of the most conceptually elaborate examples of this process. It is intended a a witty, even a tongue-in-cheek commentary on Marcel Duchamp's canonical modern masterpiece *Nude Descending a Staircase*, and the differences between the two works are of critical importance. Where the Duchamp is an unclothed male figure depicted in a non-perspectival space, Richter has chosen to present a clothed female figure in a fully recessional, photographic space. Where Duchamp's nude passes through the picture from left to right, in parallel with the picture surface, Richter's woman seems to threaten the integrity of the picture surface by advancing diagonally through the space of the picture towards the viewer. In this respect the Richter is doubly ironic. *Nude Descending* was Duchamp's last easel painting, his final dalliance with what he called the 'retinal' in painting — the play between mark making and surface to create spatial illusion. Using painting as his means, Richter substitutes the photographic image for the painted image by imitating the surface neutrality of the photograph.

Gerhard Richter, Sigmar Polke and German Pop Art: A Footnote

Polke and Richter's work of the mid- to late 1960s is often referred to as repres-entative of German Pop Art. Certainly both were interested in popular imagery, especially as it was manifest in journalistic photography. However, they were clearly not Pop artists in the openly 'celebratory' way that the same generation of American and British painters was. Firsthand experience of the Cold War through the partitioning of Germany had made them more culturally aware and more critical. They were not so interested in the image itself, but in the conceptual interface between the image and the material processes of painting.

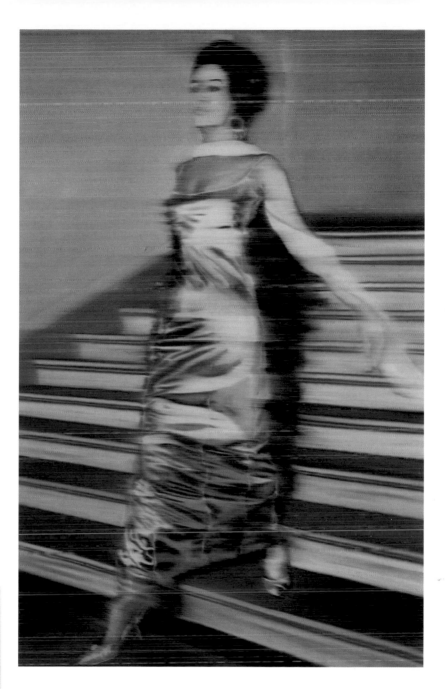

alura, 1900
nvas, 135 x 130 cm
ry of Ontario, Toronto

Helga Matura

Marcel Broodthaers

was born in Brussels in 1924. Having matriculated at university to study chemistry, he soon abandoned it for the more free-wheeling life of a book dealer. This bred in him a lifelong passion for writing and printing in all its forms — from fine typography to the graphic image. He had been fascinated with art history from his teenage years and for a time supplemented his income by giving lecture tours at the Musées royaux in Brussels. In 1957 he made the short film *La Clef de l'horloge* — a homage to Kurt Schwitters — that was shown at the experimental film festival in Knokke-le-Zoute. He also published his first book of poetry. It was at about this time that he met and became a close friend of Piero Manzoni. He saw the work of the American Pop artists for the first time at the Sonnabend Gallery in Paris in 1963 and he found it both exciting and disturbing. It is arguable that it was this experience, combined with his knowledge of Dada and Cubist collage, that paved the way for the assemblage and installation techniques that came to dominate his mature work. Broodthaers died in Cologne, Germany, in 1976.

Mussel Shells

1966
Resin, mussel shell and paint on panel, 116 x 122 x 14 cm
National Gallery of Art, Washington

Despite the fact that Marcel Broodthaers worked in a wide range of different media — from drawn and printed works to film and installation — his interest in painting remained with him throughout his working life. It was not, however, an unqualified or an uncritical interest. As the traditional site of bourgeois connoisseurship, painting raised real political issues for him. He wanted to preserve and celebrate its past but was weary of the way that it was being used and interpreted by those who controlled public institutions, especially art galleries and museums. For this reason his use of the painting format has a clear democratic intent. Broodthaers emphasizes its generic presence as an object hung on a wall for people to contemplate; at the same time, however, he also denies it its history of representation through craft-based skill.

Images are replaced by real things, graphic signs and handwritten names. *Mussel Shells* is one of a number of works from 1965–66 in which this democratizing strategy appears in its starkest form. Consisting of a square panel crowded with mussel shells held in place by transparent, blue-tinted resin, the title is entirely tautological. However, the work is not as simple as it may first appear, depending as it does on Broodthaers's favourite punning of the French '*une moule*' (feminine), meaning a mussel, and '*un moule*' (masculine), meaning a mould. There are several different layers of meaning to Broodthaers's pun. In general it

Mussel Pot, 1968. Casserole, mussel shells
int, 25 x 25 x 18.5 cm. Private collection

proposes a model of society comprising individuals that give it its shape
as much as they are shaped by it. This theme is given a further mildly
sardonic twist in several other works in which mussels are seen pushing
up the lids of the ubiquitous Belgian casserole. More specifically, it points
to the necessity underlying reproduction and the inevitability (sociologically
as well as industrially) of replication, a suggestion that is given even
sharper focus in the slightly later *Roule Moule* (1967).

Marcel Duchamp

Étant donnés: 1. la chute d'eau, 2. le gaz d'éclairage

(Given: 1. The Waterfall, 2. The Illuminating Gas)

1946–66
Installation using various objects and materials including old wooden door, bricks, velvet, cotton, wood, leather, twigs, metals, glass, Plexiglas, linoleum, electric lights, gas lamp, electric motor. Approx. overall visible, 242.5 x 177.8 cm
Philadelphia Museum of Art

Duchamp's last work, *Étant donnés* was made in secrecy over a twenty-year period, during which it was widely assumed that he had stopped working. He started work on it in February 1946, and when he visited the town of Chexbres in Switzerland later in the same year, he took photographs of an 'absurdly photogenic waterfall' that ended up as part of the landscape background of the finished work. By 1948 he had found his model for the naked female figure, 'woman with open pussy', which was to be at the centre of the work: Maria Martins, a sculptor and the wife of Brazil's ambassador to the United States. Duchamp's letters to Maria during 1949 describe the progress of work on her life-size model. After that, very little is known about the making of *Étant donnés* until its completion in 1965–66. Shortly before his death in 1968, Duchamp showed it to his friend, the artist and collector William Copley. *Étant donnés* was installed posthumously, exactly as he had stipulated, in the Philadelphia Museum of Art in 1969.

The point is often made that *Étant donnés* shows Duchamp returning to the thematic material of *The Large Glass* but in a more pictorial form. Certainly there is a marked degree of overlap as his choice of title suggests. *Étant donnés: 1. la chute d'eau, 2. le gaz d'éclairage* is the prefacing note to *The Large Glass* as it appears in *The Green Box* of 1934. Duchamp gave no clues as to how to read or understand either the work or its title, which, philosophically speaking, is both technical and tautological. In philosophy a 'given' is said to be 'axiomatic'. It is self-evidently true and as such provides an appropriate starting point for speculation. But what—precisely—should we take as 'given' in this case? The spectator can only see the work in an interrupted form by peeping through two small holes that Duchamp made at eye level in an old door he had shipped from

Handmade Stereopticon Slide. 1918–19
Rectified readymade: pencil over photographic stereopticon slide, each image 5.5 x 5.5 cm, in cardboard mount, 7 x 17 cm
The Museum of Modern Art, New York

Wedge of Chastity, 1954
Sculpture in two interlocking parts: galvanised plaster
for the wedge and dental plastic for the base, 5.5 x 8.5 x 4 cm
Private collection

Spain especially for the purpose. Beyond the door is a second aperture that seems to have been knocked through a solid brick wall, and beyond that again we see a 'coldly' erotic tableau. What is 'given', then, is a stereoscopic experience of a scene that has been staged especially for the individual spectator and can be approached or read in no other way.

Duchamp had already experimented with stereoscopy as early as 1918 when he made the assisted readymade *Handmade Stereopticon Slide*, consisting of two identical photographs side by side, each identically overlaid with two pyramids (one standing on the upturned base of the other) drawn in perspective. This was followed two years later by a crude attempt to make a stereoscopic movie using two cameras, and Duchamp continued experimenting with mechanically induced 'double vision', as in his *Rotoreliefs*, up until 1935.

It is arguable that in the end this long-standing fascination with stereoscopy finds its fullest expression in *Étant donnés*. The effect, peering into the inner space of the work, is of a diorama with foreground, middle distance and background sharply delineated. Most startling of all is the way in which the visual elements appear to exist in deep space.

The reclining nude in *Étant donnés* delivers herself to the spectator's voyeuristic gaze with her left leg pulled sharply back to fully expose her sex and her arm extended to bring the gas lamp she is holding in her left hand into close, visual proximity with the distant waterfall. Blonde hair falls across her right shoulder, shading her armpits and her pubic area. Duchamp made a preliminary study for the figure: a small version in plaster covered with vellum, contained by a green-velvet mount, which he gifted to the woman who modelled for it, Maria Martins. However, the blonde hair in *Étant donnés* seems more to suggest an apotheosis of his wife Teeny, the recipient, on her wedding day in 1954, of his sculpture *The Wedge of Chastity*, on the back of which Duchamp had written the enigmatic, French/English aural pun 'pour Teeny'.

It has been suggested that there is a deathly quality to the figure in *Étant donnés*, an implication of necrophilia even. But it is more appropriate to the content of the work to think of it as pointing to an imminent resurrection: the translation of the 'virgin'. The combination of water and gas, which appears repeatedly in Duchamp's work after 1914, signals the coming into being of the 'bride'. Whereas the water and gas are invisible in *The Large Glass* and do their

Given the Illuminating Glass and the Waterfall, 1948–49
Painted leather over plaster relief, mounted on velvet, 50 x 31 cm
Moderna Museet, Stockholm

work 'in darkness', as Duchamp writes in the notes in
The Green Box, in *Étant donnés* they are visibly present
and waiting to 'energize' the 'bride' as 'an allegorical
appearance like an extra rapid [photographic] exposure'.
The lamp flickers, the waterfall glistens with reflected
light and the spectator's gaze seems compelled to travel
the triangle between the waterfall and lake (a mirage
of masculine sexual affect and feminine receptivity),
the female pudenda (more cutlike than vaginal),
and the phallic lamp that seems fated to burn endlessly,
perhaps to very little effect. In this respect, *Étant
donnés* has a certain affinity with a video loop.

Why Discuss *Étant donnés* — an Installation — in a Book on Painting?

Duchamp's work after 1914 constitutes a powerful critical attack on 'retinal'
painting and on modern painting in general. He deplored the realist inheritance:
Impressionism, Cubism and Futurism. He had no time for the formalist agenda
either. He distrusted the repetitive visual rhetoric of European abstraction
and Constructivism, and remained entirely unimpressed by the more lyrical
abstraction of the New York School. His preference throughout his working life
remained with Surrealism, which, he argued, had survived because 'it wasn't
a school of painting. It wasn't a school of visual art, like the others. It wasn't an
ordinary "ism", because it goes as far as philosophy, sociology, literature, etc.'
We can see from this that Duchamp was in favour of a type of art—and this
includes paintings by certain individuals (he cites Seurat, Matisse, Max Ernst
and De Chirico)—that is conceptually based, embraces deep content and refuses
to reveal itself immediately or in total. For Duchamp, there is a place that might
properly be called the artist's domain (epitomized here by *Étant donnés*) that
even the most assiduous art lover cannot enter. There are things that the artist
thinks and does that cannot be directly retrieved by a viewer and resonate
for only a few, exceptional individuals. In this respect, the experience
of art has 'some analogy with a religious faith or a sexual attraction
—an aesthetic echo'.

Frank Stella

Wolfeboro I

1966
Fluorescent alkyd and epoxy
on canvas, 407.9 x 253.4 cm
San Francisco Museum of Modern Art

In 1966, Frank Stella took the art world in New York completely by surprise when he showed a series of paintings that later became known as 'Irregular Polygons' at the Leo Castelli Gallery. They were difficult and, in certain respects, visually uncomfortable works and received a mixed reception from fellow artists and critics alike. By now they are widely recognized as a characteristically intelligent and radical approach to the problem of painting at a crucial moment in the history of Modernism.

By continuing to use the 'stripe' since his breakthrough in 1959, Stella had so far managed to avoid the question of 'shape' in painting. This state of affairs was dramatically reversed in the Irregular Polygons, which might be said to be all 'shape'. While the 'stripe' paintings had derived pictorial tension through the creation of spatial illusions (a forwards-and-backwards 'optical' movement) and by forcing these energies to converge on the median lines or at the centres of the canvases, the Irregular Polygons—in effect—are without centres. They are all about chasing edges in order to discover form. Scale is also a crucial factor in the reading of Stella's Irregular Polygons. The two versions of *Wolfeboro*, for example, are more than twice human height and quite difficult to take in all at once.

It is as though Stella intends the forms to be read as a succession of segments, the purpose of which is to complicate the relationship between inside and outside. In *Wolfeboro I*, the symmetry of the tonally unified blue and grey trapezoid that forms the base of the painting is used to launch a zigzagging black line that suddenly terminates in space, framing an emptied-out area that allows the whiteness of the wall to rush in. In *Wolfeboro II* the same trapezoid form has a void at its centre, a darkish green-blue is edged with yellow, and the zigzag line—this time painted orange—is held firmly in place by a slab of brilliant red. Stella made three versions of each painting in the series so that he was free to abandon the ones that he felt were less successful.

Wolfeboro II, 1966
Fluorescent alkyd and epoxy on canvas, 406.5 x 354 cm
The Dayton Art Institute

Michael Fried on Two Kinds of Shape (1966)

'Frank Stella's new paintings [the Irregular Polygons] investigate the viability
of shape as such. By "shape as such" I mean not merely the silhouette of the support
(which I shall call literal shape), not even the outline of the elements in a given picture
(which I shall call depicted shape), but shape as a medium within which choices
about both literal and depicted shapes are made, and made mutually responsive.
And by the viability of shape I mean its power to hold, to stamp itself out
[thereby] compelling conviction.'

Francis Bacon

was born of English parents in Dublin in 1909. His father, a retired officer from the Hussars, was a racehorse trainer. Bacon was a severely asthmatic child who was violently allergic to dogs and horses. He was also effeminate and liked dressing up, for which he was frequently beaten. The family moved to England in 1914, initiating a succession of shifts between England and Ireland, and Bacon was sent to school for two years — his only experience of formal education. In 1927 he went to Berlin, where he stayed for two months before moving to Paris. There he learned French and fell under the spell of Nicolas Poussin's *Massacre of the Innocents* (*c.* 1630) a painting that Bacon often referred back to throughout his working life. On his return to London he worked as an interior designer. His reputation as a painter began to take off in 1933 when his *Crucifixion* was reproduced in Herbert Read's book *Art Now*. Bacon's first one-person exhibition followed a year later. This show attracted some important collectors and in 1937 he was included in the seminal 'Young British Painters' show at Thomas Agnew's in the company of Graham Sutherland, John Piper, Victor Pasmore, Ivon Hitchens and Ceri Richards. This established him as one of the most important British artists, a reputation that was greatly enhanced in the period following the Second World War.

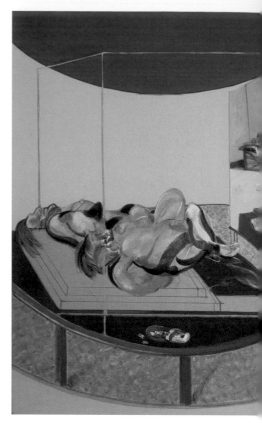

1967
Oil on canvas, three panels: (a) 198.8 x 148.3 cm
(b) 198.8 x 148 cm and (c) 200.3 x 148 cm.
Hirshhorn Museum and Sculpture Garden,
Smithsonian Institution, Washington

Triptych Inspired by T. S. Eliot's 'Sweeney Agonistes'

At the beginning of 'Sweeney Agonistes', T. S. Eliot — a Catholic — quotes from St John of the Cross: 'Hence the soul cannot be possessed by the divine union, until it has divested itself of the love of created beings.' The irony is made obvious by what follows, a dialogue between Sweeney — a representative of 'sensual, secular and debased and debauched humanity' — and a group of named but otherwise anonymous people whose existence is spent debating the relative 'social' merits of created beings. 'Well some men don't,' Eliot writes, 'and some men do ... some men don't and you know who.' This lilting piece of innuendo echoes a popular

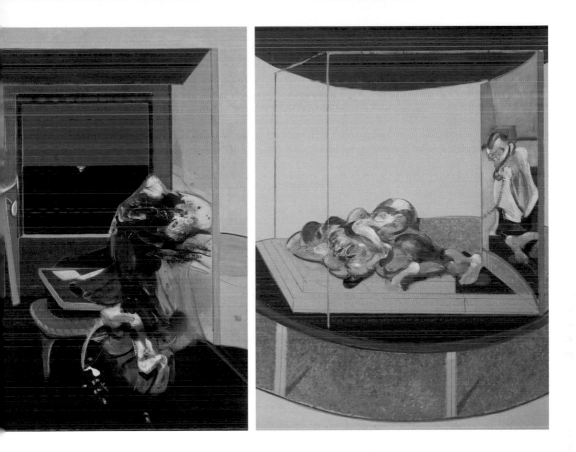

music-hall song of the 1930s, usually sung by a woman about other women whose morals were thought to be not quite what they should be. Autobiographically, Bacon's triptych looks back to the time when he was living in a stressful triangular relationship with the painter Roy de Maistre (who had introduced Bacon to Eliot's poetry) and the writer Patrick White. In the left-hand panel, the male lovers seem oblivious to a third party who is just leaving from the right side of the picture. In the right-hand panel—a contrived reversal in the passage of time—the same third party is looking on, scrutinizing the sexual act at the same time as speaking to someone on the telephone, as Eliot's verse drama suggests, 'speaking of birth, copulation and death'. In the centre panel, the bloodied figure of Sweeney staggers around in an enclosed space, divesting himself of articles of clothing as he goes. As Eliot, echoing John Milton's 'Samson Agonistes', writes, 'when you're alone like he was alone, you're either or neither' alive or dead.

Crucifixion, 1933
Oil on canvas, 60.5 x 47 cm. Private collection

Barnett Newman

Born in New York in 1905 to Russian-Jewish immigrant parents, Barnett Newman studied at the Art Students League from 1922 to 1926 while also studying philosophy at the City College of New York, from where he graduated in 1927. In the 1930s he worked in his father's clothing business and as a substitute art teacher in high schools. In 1939–40, profoundly unhappy with his own practice and the current state of art, he stopped painting and destroyed most of his work. When he started to paint again, he set about trying to recover something of the spirit of the sublime, which he believed was possible as long as he cou find a way of painting 'as if painting had never existed before'. Newman had his fir solo exhibition at the Betty Parsons Gallery, New York, in 1950, and his second a year later. His work was not well received by the critics so he simply withdrew it, declaring that he would never again exhibit his work in a commercial gallery. Although he was a key figure in the New York art scene just as Abstract Expressionism was in the ascendant in the early 1950s, it was not until he was nearly sixty that he began to be recognized as one of America's leading artists. He died in New York in 1970.

Voice of Fire

1967. Acrylic paint on canvas, 543.6 x 243.8 cm
National Gallery of Canada, Ottawa

As a thinker, Newman was a curious mixture of political philosopher and mystic. He argued the case for an 'individualistic' brand of anarchism not dissimilar to tha espoused by the Russians Mikhail Bakunin and Peter Kropotkin and — closer to home — the American nineteenth-century political philosopher Benjamin Tucker. He was also fascinated by native Amercan culture, especially tribes like the Kwakiutl Indians of the north-west coast of British Columbia, who believed that simple shapes could convey feelings directly without reference to the visible world. Most important was his interest in the Jewish cabalistic tradition and the way that it conflates notions of boundless space with divine light — cosmic consciousness — in the concept of Makom — a sacred (and erotic) site. Newman's invention of the 'zip', a strip of colour reaching fron the top to the bottom of the canvas, is closely related to this way o thinking about space and place. In *Voice of Fire*, the 'zip' is red on blue, the tones are close and the sense of emanating light and hea is generated through colour contrast, with the blue feeding energy into the broad strip of red. In a work such as *Profile of Light*, painted in the same year, where the 'zip' is white over dark blue, the quality of illumination is generated through tonal contrast: the darkness of the blue feeds brightness into the white. Seen 'in the flesh', Newman's paintings are much rougher and tougher thar they appear in reproduction. They are restated and worked over and this gives them real physical presence. For this reason, although he is considered one of the forerunners of colour-field painting, Newman's coloured areas have none of the neutrality or visual passivity required by the notion of 'field'.

White Fire IV
1968
Acrylic and oil
on canvas,
355 x 127 cm
Kunstmuseum
Basel

Untitled
1970
Acrylic on
canvas,
197 x 152.5 cm
San Francisco
Museum of
Modern Art

316

Andy Warhol was born Andrew Warhola in 1928 in Pittsburgh, Pennsylvania, to immigrant Czechoslovakian parents. His father was a construction worker. His mother made and sold (door-to-door during the Depression) hand-crafted, decorative items such as painted eggs and paper flowers. Warhol studied pictorial design at the Carnegie Institute of Technology from 1945 to 1949.

Big Electric Chair

1967. Silk-screen ink on synthetic polymer paint on canvas, 137 x 185.4 cm. Moderna Museet, Stockholm

Robert Rauschenberg and Andy Warhol began to use silk-screen printing on canvas in the same year, 1962. In Rauschenberg's case, it was added to an already extensive array of technique-based visual effects; in Warhol's it was a means of capturing and manipulating single images. Large-format screen-printing combined with photo-processing enabled him to do things that would otherwise have been all but impossible. It allowed him to deploy the photographic image very directly, as a 'readymade'. Having made the screen, he could multiply and repeat the image at will, with only slight, accidental variations. It was easy to make different colour versions, or to make rapid changes by using paper masks. But printing also imposes its own mechanical limitations and it was this that most charmed Warhol. He was greatly attracted by the idea of a 'hands-off', emotionally distanced approach to his work. As he himself said: 'I find it easier to use a screen. This way I don't have to work on my objects at all. One of my assistants or anyone else, for that matter, can reproduce the design as well as I could.'

The Stockholm *Big Electric Chair* is one of a group of works, that Warhol started to make in 1963 from an American Press Association photograph of an electric chair. Where the earlier works had used smallish, repeated images screened over a single colour and were named according to the colour of the ground—*Red Disaster*, *Silver Disaster* and so on—the later pictures, which were cropped so that the chair is now left of centre, were large-scale, multi-coloured, single images that deployed a whole range of printed effects.

The use of a discordant, yellow-green, overlaid, negative image of the electric chair, slightly out of register so that it overprints the red-orange ground, gives the feeling of a strangely floating, insubstantial world. The abrupt intervention of the blue slicing at an angle down the left-hand side of the painting creates

something akin to a void, with the result that the electric chair seems to be poised rather ominously between life and death—on the very edge of reality.

Lavender Disaster, 1963. Silk-screen ink on synthetic polymer paint on canvas, 269 x 208 cm. The Menil Collection, Houston

as. **Andy Warhol in his studio, New York**, *c.* 1964–65

Blinky Palermo

was born Peter Schwarze in Leipzig, Germany, in 1943. Shortly after his birth he and his twin brother were adopted by a family named Heisterkamp. Having first studied at the School of Arts and Crafts in Münster, Peter Heisterkamp then enrolled at the Art Academy in Düsseldorf, where he was a contemporary of Sigmar Polke and Gerhard Richter. In 1964 he joined the class of Joseph Beuys, where he worked alongside Anatol (Karl-Heinz Herzfeld), Bernd Lohaus and Reiner Ruthenbeck. Anatol decided to rename him Blinky Palermo after seeing a newspaper photograph of Sonny Liston's gangster boxing manager, Frank 'Blinky' Palermo. Palermo exhibited under this pseudonym for the first time in 1965 in the group exhibition 'Weiss-Weiss' at the Galerie Alfred Schmela in Düsseldorf. After a short but meteoric career Blinky Palermo died of a heart attack in 1977.

Butterfly II

1969. Oil on canvas-covered wood and fibreboard, two parts, overall size 303.5 x 93 x 4.5 cm. Museum für Moderne Kunst, Frankfurt am M

Almost thirty years after his death Palermo's extraordinarily varied work is still not widel known outside the professional art world. Concerned mainly with the very contemporary question of painting's identity, his work includes a large number of watercolours and gouaches, oil and acrylic paintings on canvas and metal plate, fabric works (*Stoffbilder*), prints, objects (*Bildobjekte*), site-specific murals and installations. *Butterfly II* is properly classified as a *Bildobjekt* and is fairly typical of the two-part works that Palermo made under that heading, many of which set a tall, thin, vertical element alongside a flattish, irregular or roundish form.

Most of Palermo's work asks questions about the relation of 'the painting' to the wall behind it. In *Composition with Eight Red Rectangles* (1964), a fairly conventional piece in terms of its format, the problem is posed by making one of the red rectangles contiguous with the top left-hand corner of the canvas. In other words, this rectangle is held in place partly by the wall and partly by the broken white ground, with the two acting together as single optical field. In the *Bildobjekte*, Palermo dispenses with the traditional rectangular canvas altogether and treats painterly gestures and forms as separate material elements In *Butterfly II* the vertical green-black component, edged with orange and yellow to lift it and twist it in space, has all the expressive force of a single brushstroke, while the semi-geometric butterfly shape (apparently a found object repainted by Palermo), placed high up just to the left, strongly suggests both direction and rectilinear extension. The idea of a ghosted rectangle is carried much further in later two-part *Bildobjekte* like

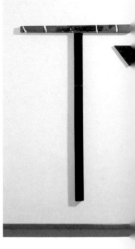

Untitled (For Kristin) from 1973, in which the downward thrust of the arrow suggests an invisible vertical coinciding with the right-hand arm of the main T-shaped element.

Untitled (Composition with Eight Red Rectangles), 1964. Oil and pencil on canvas, 95.5 x 111 cm. Kunstmuseum Bonn

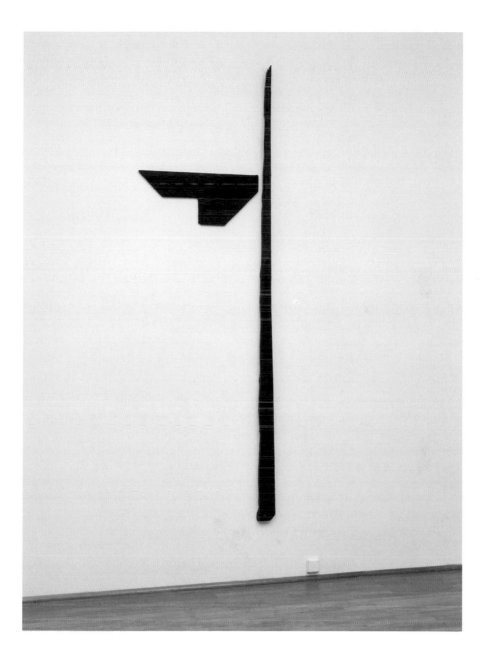

(For Kristin)
ein on wood
n on plywood;
art 184 x 8.5 x 5 cm,
4.5 cm. 31.5 x 3 x 26.5 cm
Kunst Palast, Düsseldorf

Palermo and Beuys

Blinky Palermo, then named Peter Heisterkamp,
was a student in Düsseldorf when Joseph Beuys's
teaching was at its most intense. Beuys is reputed
to have put only one question to Palermo when he asked
to join his student group: 'Can you see things differently?'
Palermo is said to have answered in the affirmative. Later
Beuys described him as 'the best of all of his students'.

Ellsworth Kelly

was born in Newburgh, New York, in 1923. Having studied at the Pratt Institute from 1941 to 1943, and having served with the military from 1943 to 1945, he continued his studies at the School of the Museum of Fine Arts in Boston from where he graduated in 1947. In 1948 he went to live in Paris and enrolled as a student at the École des Beaux-Arts, although his attendance was rather sporadic. In Paris, besides studying the art of the remote past, he discovered the Surrealists and the Neo-Plasticists, Piet Mondrian and Theo van Doesburg. While in France, he also met Constantin Brancusi, Francis Picabia and Georges Vantongerloo. He had his first one-person show in Paris at the Galerie Arnaud in 1951. Kelly returned to New York in 1954 and found himself living near Robert Indiana and Agnes Martin. He had his first solo exhibition in the United States at the Betty Parsons Gallery in 1956. His first retrospective exhibition took place at the Museum of Modern Art, New York, in 1973. He lives in Spencertown, in upstate New York.

Two Panels: Yellow with Large Blue

1970
Oil on canvas, 261.6 x 276.9 cm
The Museum of Contemporary Art,
Los Angeles

At first sight Kelly's paintings appear to be strictly non-figurative, but this belies their origin in the painter's day-to-day experience. As his notebooks show, they mostly begin with something seen—'a motif to be copied or otherwise transferred' —an out-of-focus glimpse of a coloured interior, the painted hulls of fishing boats passing each other in a harbour, architectural features such as painted garage doors and colour-washed walls set against each other. At the same time, his refusal to engage with representation, is absolute. For Kelly, his paintings are abstract translations in which, linguistically speaking, the components of the original visual experience have been thoroughly transformed. The movement is from a transient and contingent reality into one that captures a sense of immanence and timelessness. It is for this reason that Kelly places so much emphasis on unitary colour. The separate panels allow him to treat each colour as if it were an object—a 'thing in itself'—imbued with its own very special qualities. 'Relationship'—the way that colours fit together and interact with each other—is no longer determined by a unifying boundary or picture edge, nor is it generated by placing coloured forms against a field or ground. And in this particular case, where a small, very luminous panel of bright yellow is juxtaposed with a larger, visually much heavier panel of intense blue, it is the result of a measured and very carefully weighted act of placement in 'relationship' to the wall and beyond that to the space of the architecture.

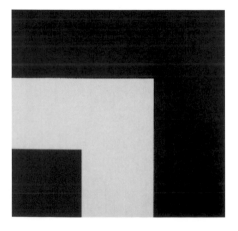

Red, Yellow, Blue I, 1963
Acrylic on canvas, three joined panels, 231 x 231 cm overall
Fondation Maeght, Saint-Paul

'The form of my painting is the content. My work is made of single or multiple panels.... I am less interested in marks on the panels than the presence of the panels themselves.

In *Red, Yellow, Blue* the square panels present colour. It was made to exist forever in the present; it is an idea and can be repeated anytime in the future.'
Ellsworth Kelly

Installation of Red, Yellow, Blue II, 1965, and Piet Mondrian's **Trafalgar Square**, 1939–43, in the exhibition **Classic Modernism: Six Generations**, at Sidney Janis Gallery, New York, 1990

Mark Rothko

Untitled (Black on Grey)

1969–70
Acrylic on canvas, 204 x 175.5 cm
Solomon R. Guggenheim Museum, Ne█

Rothko always argued that his paintings were concerned with tragedy, not as narrative but in the grand, Nietzschean sense. For Friedrich Nietzsche, tragedy was allied to the Dionysian, which he regarded as 'an affirmation of life even in its strangest and sternest problems' … '[the] bridge to the psychology of the tragic poet'. At times Rothko himself talked of painting in terms of violently opposing forces: the vertical against the horizontal; light against dark; hot colours against cold. And this Nietzschean vision of painting as a kind of elemental warfare appears in its bleakest form in the 'black and grey' paintings made in the year before his suicide.

Rothko made most of the predominantly dark, almost entirely 'black', paintings after 1964. Built up in thin, translucent layers of differently shaded blacks, they were, perhaps surprisingly, luminous and warm: not at all forbidding. The overall effect was strangely ambiguous, neither space nor substance, and Rothko himself described them as touching upon the 'historical sublime'. Most notable amongst them is *Untitled 1968*. This painting is sonorously enigmatic. A block of yellowish purple-black is held in place from below by a horizontal lozenge of red-black, and from above by a similar area of greenish black. The closeness of tone produces an unnerving oscillation between 'presence' and 'nothingness'; the forms coalesce, disappear, and reappear only to lose themselves to the ground once more.

Rothko suffered an aortic aneurysm in mid-1968 and during his recuperation he was able only to work on stretched paper. This led to the first of the 'black and grey' paintings that immediately in-troduced new formal elements into Rothko's painterly language. Firstly, the new paintings were in two parts, above and below a sing█ dividing line. Secondly, this division ran right across the image, fron█ one edge to the other like a horizon line. And thirdly, the painted are█ was framed with a band of white just over a centimetre wide. In the first instance, the white edge came from the technique used to stretc█ the paper. The edges were secured using a gummed tape that left a margin of bare paper when it was removed. Later on, Rothko taped the edges of his canvases before painting, so as to produce the same effect.

Untitled (Violet, Black, Orange, Yellow on White and Red)
1949. Oil on canvas, 207 x 167.5 cm
Solomon R. Guggenheim Museum, New York

Night Poetry: Rothko and Novalis

It is arguable that the 'grey and black' paintings represent a turning away from abstraction on Rothko's part, and a return to some kind of content. When asked about them, he said, quite simply, that they were about death. However, it is important to try to understand in what sense. Certainly they are desolate, empty images, but they als█ afford a richly ambiguous visual experience. Strangely, too, Rothko

Untitled. 1968
Oil on canvas, 233 x 175 cm. Private collection

sought to deny their landscapelike qualities, saying that he had put the black at the top to stop them being read as such. If this was indeed his aim, it was singularly ineffective. The paintings are even more landscapelike with the black at the top — an Arctic wasteland under a vast and empty sky — and at the same time more deathlike. As one familiar with the poetry of the German writer Novalis (1772–1801), Rothko would have known Novalis's *Hymns to the Night* and the image that the poet creates of a transworldly, transfigured 'oneness' wherein night is finally reconciled with day at the moment of death.

Francis Bacon

Triptych in Memory of George Dyer

1971. Oil on canvas, each panel 198 x 147.5 cm
Fondation Beyeler, Riehen

This is the first of several three-part works in which Bacon treats the death of George Dyer, his companion and sexual partner from 1964 to 1971. Dyer, a good-looking, small-time crook, died alone from a drugs overdose, stoked by alcohol, in their room in a Paris hotel while Bacon was attending the party given for the opening of his 1971 retrospective at the Grand Palais.

Taken overall, *Triptych 1971* is a disturbing commentary on human sexuality, particularly on homosexual desire, which, in Bacon's words, 'worked the trajectory between lust and self-loathing'. Here this polarity seems to be operating in reverse. The left-hand panel shows Dyer in boxing shorts and boots, sprawling across a curved, red padded couch seen against a powdery pink background: a vivid image of 'monstrous' flesh; a writhing, contorted mess of muscle and flexing limbs made slick with sweat and pushing forwards to engulf the viewer. The right-hand panel shows Dyer seated on the same couch. This time he is well groomed, his head turning away, as in the photograph of Dyer by John Deakin that Bacon possessed. His reflection, inverted and reversed, seems to topple forwards to find itself in the shiny surface of the bar-table that stands in front of him. This reversal of the

reflection makes Dyer a Narcissus and an Echo in one. The central panel shows a half-landing in a stairwell. The (for Bacon) unusually precise spatial geography of the image probably references the Paris hotel in which Dyer died. The image is full of those little existential asides that Bacon was so fond of—ominous dark spaces glimpsed through windows and doorways, a bare, dully glowing light bulb, a blind-pull that taps against the window. The ungainly, possibly drunken, figure of George Dyer stands front-right, trying to put a key into the lock, beating on the door with his other hand.

John Deakin, **Portrait of George Dyer**, 1960s
Copy of photograph from Francis Bacon's studio. The Francis Bacon Estate

Francis Bacon and T. S. Eliot's *The Waste Land*

Interviewed by David Sylvester in 1979, Bacon stated that he had 'always been influenced by Eliot... *The Waste Land* especially and the poems before it have always affected me very much'. *Triptych 1971* is a clear example of this, bringing to mind the lines: 'I have heard the key / Turn in the door once and once only / We think of the key, each in his prison / Thinking of the key, each confirms a prison / Only at nightfall; and equally pertinent, from the same section of the poem: 'He who was living is now dead / We who are living are now dying / With a little patience.'

Eliot, in his own notes to *The Waste Land*, refers the reader to a passage from *Appearance and Reality* (1893) by the English monist philosopher Francis Herbert Bradley: 'My external sensations are no less private to myself than are my thoughts or my feelings. In either case my experience falls within my own circle, a circle closed on the outside; and, with all its elements alike, every sphere is opaque to the others which surround it.... In brief, regarded as an existence which appears in a soul, the whole world for each is peculiar and private to that soul.'

Leon Kossoff

was born in London in 1926 to Russian-Jewish parents. From 1945 to 1948 he saw military service in Belgium, France, Germany and Holland. In 1949 he enrolled as an art student at St Martin's School of Art, where he met Frank Auerbach, with whom he attended the drawing classes of David Bomberg at Borough Polytechnic. Afterwards both went on to study painting at the Royal College of Art in London. Like Bomberg, his philosophical mentor, Kossoff has been a dedicated teacher for much of his professional life. Bomberg taught the importance of drawing as the foundation of good painting. His idea of drawing included feelings and emotions as well as perceptual analysis, and Kossoff carried this approach forward in his own teaching. For Kossoff the notion of good painting tends to be canonic: the Old Masters are the essential gold standard.
He is counted amongst the senior figures in the School of London.

Children's Swimming Pool, Autumn Afternoon

1971
Oil on board, 168 x 214 cm
Tate Collection, London

Leon Kossoff started to paint London in the 1950s. These were grim times: a period of continued austerity and intensive physical reconstruction in the aftermath of the Second World War, and in some ways this has continued to shade his view of the city and the life of its people. For this reason Kossoff's is certainly not an optimistic vision, but it is not entirely pessimistic either. At its centre are those close to him — family and friends — and more publicly, ordinary men and women going about their daily lives. But what starts out as a fairly narrow vision of life greyed over by the poor of London and their struggle to survive, ends up as a homage to, and a picture of, the harsh end of urban life the world over; gritty and profoundly melancholic. The five paintings of the children's swimming pool in Willesden, north London, where the painter took his son to teach him to swim, were made between 1969 and 1972 after almost two years of drawing on site and in the studio. The titles point to the painter's immediate interest in the quality and temperature of the light, at a particular time of day and season of the year: *Children's Swimming Pool, Eleven O'Clock Saturday Morning, August,* or *Children's Swimming Pool, Twelve O'Clock Sunday Morning, September* and so on. But beyond that, these paintings depict the turbulent, unselfconscious life-force of children and young people at play and experiencing, in the process, some kind of elemental, social and spiritual catharsis —

an emptying out and a release from superficial, passing cares and anxieties, similar to that which Kossoff claims for his own working process. The technique alternates the rapid accumulation of thick paint with scraping back — statement and restatement — always working across the whole image.

Children's Swimming Pool, Eleven O'Clock
Saturday Morning, August, 1969
Oil on board, 183 x 213.5 cm. The Saatchi Gallery, London

The Legacy of David Bomberg and the School of London

While the term 'School of London' (originally coined by Ron Kitaj) describes a number of painters who, taken together, do not have the coherence usually associated with the idea of a 'school', within it there is a group who certainly do: those who, either directly or indirectly, follow on from the teaching of David Bomberg (1890–1957). The best known are Leon Kossoff and Frank Auerbach (born 1931), but over the years many more have taken his teaching as their starting point. Bomberg was a committed modern painter but a lapsed Modernist. As a Vorticist (although never a full member of the group), he saw Modernism as a progressive force, but abandoned this view in the late 1920s and turned instead to an expressionistic form of figuration. Bomberg was a deeply serious man who, as a teacher, adopted a high moral tone, passing on to many of his students his conviction that painting is not something to be undertaken lightly and that it carries with it profound social and cultural responsibilities.

Bridget Riley

Punjab

1971
Acrylic on canvas, 143 x 365 cm
Glasgow City Council Museums

Bridget Riley was born in London in 1931. She studied drawing
and painting at Goldsmiths College under the renowned drawing
teacher Sam Rabin. She went from there to the Royal College
of Art, from where she graduated in 1955. Her contemporaries at
the RCA included Dick Smith and Joe Tilson. Riley had her first
one-person show at Victor Musgrave's Gallery One in 1962.
Her involvement with optical painting — Op Art — dates from
that time. In the early 1960s her black-and-white paintings were
greeted with almost immediate international acclaim, but by 1966
she had turned her attention to the more fascinating optical
problems that arise with the use of colour. Riley was awarded
the International Prize for Painting at the Venice Biennale in 1968.
Today she has studios in London, Cornwall and Provence.

Bridget Riley's interest in optical colour started in
her student days, when she discovered the Pointillism
of Georges Seurat. She was immediately intrigued by
the fact that, in the multi-hued context of a painting,
a colour would appear entirely different in the eye from
the way that it appeared on the palette, or even that
colours could appear optically where no such colour
existed. It was this last insight that in part led to the black-and-white paintings.
In works like *Suspension* from 1964, for example, optical shades of magenta and
green appear in the whites caused by the scanning movement of the eye as it
traverses adjacent, parallel bands of extreme tonal contrast. Riley has argued
that it is the combination of the moving and the static eye that lies at the heart
of painting's power to fascinate and compel human attention. Certainly frontally
oriented, bi-optical vision brings with it a different, more psychologically complex,
often more perplexing experience of the world. It makes human beings powerfully
aware of the world's capacity to generate illusions, visual tricks and contradictions.
In Riley's later paintings, in which she uses strong, equally weighted colours
— in the case of *Punjab*, red, blue and green — the movement of the eye across
the surface of the painting becomes the all-important factor in the experience of
viewing. *Punjab* is unusual in that the main elements are presented horizontally,
thereby creating a fast, smooth movement from left to right and vice versa. By
contrast, the optical dynamic of the painting occurs vertically. There is an implied,
graduated recession: red elements diminish in width systematically from the bottom
to the top of the painting. These are lined on either side with blue and green so as
to generate a vertical 'flicker' of optical yellow that gains in intensity progressively
as the eye travels up the painting.

Philip Guston

Painting, Smoking, Eating

1973
Oil on canvas, 195.7 x 261.7 cm
Stedelijk Museum, Amsterdam

Between 1965 and the early 1970s Philip Guston's work seemed to undergo a dramatic change. The painterly but vague figuration of works such as *The Light* (1964) was replaced by a harder, more graphic style that owed much to Guston's interest in political caricature and comic-books. He had first copied a George Herriman *Krazy Kat* cartoon when still in his teens and much later returned to the same, dramatic spatial images in paintings such as *Door* (1978). In the 1970s he also discovered the cartoon drawings of Robert Crumb. The change in Guston's work was thus neither sudden nor unheralded. Close examination of his work overall shows a drift into figuration that started as early as 1956, but the process was greatly accelerated when, in the 1960s, Guston began to look again at the work of the German Expressionist Max Beckmann, who rekindled his interest in the drawn line as a means of giving specificity of shape to identifiable things. There was much more to Guston's new, conspicuously figurative approach to painting than the assertion of a new painterly identity. As the painter himself would later recall, it coincided with a truly apocalyptic time in modern American history. The election year of 1968 saw the assassination of Robert Kennedy and America's last desperate throw in the Vietnam War. Set in train by the Tet Offensive, nearly 15,000 troops were killed in one year. In paintings such as *The Studio* of 1969, Guston began to use — to dress himself in — the guise of a Ku Klux Klansman. Although only a shadow of what it had been in the 1930s, the Klan remained a potent symbol of the worst aspects of American conservatism and Guston used it to point to the shifting moral sands and political decline brought about by the country's ongoing imperialistic adventure in South-East Asia.

The Studio, 1969
Oil on canvas, 122 x 106.5 cm
Private collection

Sleeping, 1977
Oil on canvas, 216 x 178 cm
Private collection

Robert Crumb
Weirdo Number 7
back cover, 1983

If Guston himself is to be believed, painting, smoking and eating were his favourite activities. The painter's alter ego, a squat, one-eyed, puffy-cheeked little man who appears for the first time in Guston's paintings of the early 1970s, usually has a burning cigarette pinched between his lips — whether he is awake or sleeping — and, close at hand, paint brushes and a pile of food. In *Painting, Smoking, Eating* the artist is shown lying in bed amidst the imaginary squalor of his studio. The symbols that are preoccupying him are stacked in an untidy heap in the background, as he lies significantly disposed between illumination — the light bulb on the left-hand side of the picture — and the possibility of self-imposed oblivion, represented by the electric pull-switch that hangs down on the right.

'So when the 1960s came along I was feeling split, schizophrenic. The war, what was happening to America, the brutality of the world. What kind of man was I, sitting at home, reading magazines, going into a frustrated fury about everything and then going to the studio to adjust a red to a blue.... I wanted to be complete again, as I was when I was a kid. I wanted to be whole between what I thought and what I felt.' Philip Guston

Kenneth Noland

was born in Asheville, North Carolina, in 1924.
In his early twenties he attended the famous
Black Mountain College. He spent 1948 and 1949
in Paris working with the sculptor Ossip Zadkine.
When he returned to the United States he met
Morris Louis at the Washington Workshop Center
of the Arts and they became close friends. It was
about this time, too, after a visit to the studio
of Helen Frankenthaler, that Noland and Louis
started to experiment with a new form of acrylic
paint—Magna colour—and a new painting
technique. They used intense liquid colour,
chemically modified so that it would soak directly
into the weft and warp of unprimed canvas and
become one with it. Noland was an intimate of
the circle of artists, including such figures as Jules
Olitski, Jack Bush and Anthony Caro, that was
championed by the critic Clement Greenberg.
He still lives and works in Washington.

Oakum

1973. Synthetic polymer paint on canvas, 226.3 x 610 cm. National Gallery of Australia, Canberra

Noland has always been fascinated by the 'formal' or 'phenomenal' life of painting.
Over the years he has paid particular attention to the problem posed by the
painting's edge, trying to answer the question of what 'edge' might mean, in formal
and spatial terms, once the picture frame—as window onto the world—has been
taken away. He first tried to solve this problem in the Target Paintings (1958–62)
by centring and isolating concentric circles of colour, and allowing them to float
'optically' forwards and backwards against each other. He followed this in the
mid-1960s with the Chevron Paintings in which he used bilateral symmetry to
act directly on the painting's edge, warping and twisting its spatial presence.

By far the most radical approach to the problem
came with the Stripe Paintings he made between 1967
and 1973, of which *Oakum* is an extreme example.
Reminiscent of Monet's large-scale Water Lily
paintings, Noland's extending, even elongated 'stripes'
force the viewer to recognize—very directly and in
a highly succinct form—the real, phenomenological
difference between our experience of the vertical as

That, 1958–59
Acrylic on canvas, 206.5 x 207.5 cm. Private collection

opposed to the horizontal dimension. *Oakum* is over six metres long. Its length can never be taken in all at once; it can only be scanned—left to right and vice versa—in 'smooth' concert with the top and bottom of the painting and the brightly coloured horizontal bands of colour that zip across its surface. By comparison, trying to scan its vertical dimension is a stuttering affair, subject to repeated interruptions that remind us of its horizontal character. Viewed in this context, the sides of the painting assume the character and presence of starting and ending points—origin and terminus.

'Purely formal characteristics [in painting] exercise the senses as do string quartets, piano concertos, Dixieland. Because of this, the representation I am interested in is of those things only the eye can touch. I think of painting without subject matter as music without words. It effects our innermost being as space, spaces, air.'
Kenneth Noland

Saturday Night, 1965
Acrylic on canvas, 152 x 152 cm. Private collection

David Hockney

Kerby (after Hogarth) Useful Knowledge

1975
Oil on canvas, 183 x 153 cm
The Museum of Modern Art, New York

In the years before David Hockney painted *Kerby* in 1975, two of the main formative influences on his work were his relationship with Peter Schlesinger and his growing reputation as a set designer following the success of his designs for *Ubu Roi* at London's Royal Court Theatre. Hockney met Peter Schlesinger at the University of California in Los Angeles in 1966 and they became lovers and companions in a relationship that lasted until 1971. It put an end to Hockney's 'promiscuous' phase, but more importantly, it changed both the mood and content of his work. His drawings of Peter Schlesinger from 1966 have an almost breathless intimacy about them. They show an empathy for their subject that is almost entirely absent in previous work. Furthermore, this deeper level of engagement permeated the rest of Hockney's work, as the three double portraits painted at the same time clearly show. In the summer of 1974, three years after the break-up with Peter Schlesinger, Hockney was asked to design the set for Stravinsky's opera *The Rake's Progress* to be staged at Glyndebourne, England, in 1975. He was still trying to lose himself in work and was attracted to the project because he liked Stravinsky's score and was amused by W. H. Auden and Chester Kallman's rather wayward libretto. Most intriguing of all, though, was the opportunity it gave him to immerse himself once more in the graphic works of the great eighteenth-century English painter and engraver William Hogarth. *Kerby (after Hogarth) Useful Knowledge* arose out of this period of intense research.

This painting is based on a Hogarth design for an engraving that was used by his friend Joshua Kirby (not Kerby) as the frontispiece for Dr Brook Taylor's *Method of Perspective Made Easy*, published in 1754. The print shows some of the stupidities, confusions, inconsistencies and errors that might occur if an artist either does not know, does not understand or fails to deploy the rules of perspective properly. Hockney's version is greatly simplified but it uses the same overall topography and delights in a similar range of spatial absurdities. However, it differs markedly from the original in its overall sense of purpose. Where Hogarth is holding up a warning hand to the ill-informed and careless artist, Hockney seizes on it as the perfect opportunity to demonstrate the sheer visual intoxication that can ensue from a lack of pictorial consistency. A past master at manipulating conventional systems for rendering pictorial space, Hockney had long argued for a version of spatial consistency that was not rule-based but arose in the act of painting out of the search for a convincing 'picture'. In *Kerby (after Hogarth) Useful Knowledge* — alongside other concerns — he set out to prove his case. Robbed of the fully rounded illusionism of the original Hogarth print, the picture teeters on the verge of visual chaos. Spatial devices collide and contradict each other; convexities are turned into concavities; planes flip over and advance when they should recede;

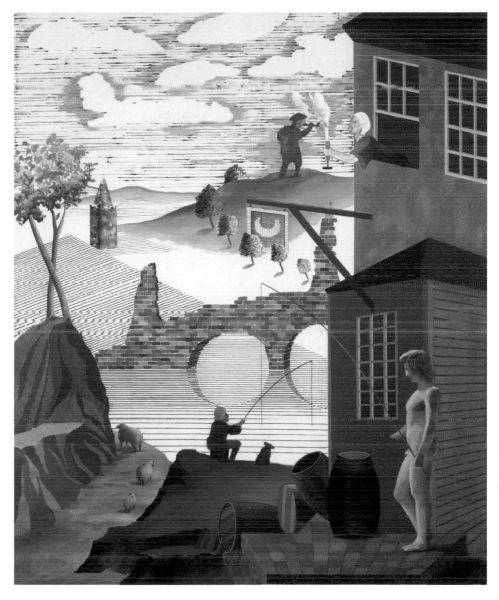

grounded forms are suddenly made airborne, and still—miraculously almost—the picture holds together. But beyond the technical virtuosity of *Kerby* there is an altogether different reading. Hockney was emerging from a period when he had experienced bouts of intense loneliness that had sometimes brought him close to despair. Viewed from this standpoint, the painting has, despite its intellectual playfulness, a certain chill about it. The figure standing in profile to the right in the painting — ostensibly a statue—reads more like a ghost, a shadow or a shade—an absence even— and although it is not exactly the same pose it resembles that of Peter Schlesinger in the last of Hockney's paintings for which he was the model, *Portrait of an Artist (Pool with Two Figures)* of 1971.

Brice Marden was born in Bronxville, New York, in 1938. He spent two years

at Florida Southern College on a liberal arts course before transferring in 1958
to Boston University School of Fine and Applied Arts to study painting. In 1961,
after attending a Yale summer school for music and art, he enrolled for a Master's
in Fine Art at Yale University. He graduated in 1963. That same year he moved to
New York and found work as an attendant in the Jewish Museum, where he had
the opportunity to study the work of Jasper Johns at close quarters. He made
his first monochrome paintings in 1964 and his first one-person exhibition in
New York took place at the Bykert Gallery in 1966. Between 1969 and 1974
he taught painting at New York's School of Visual Arts. Today he lives
and works between New York and the Greek island of Hydra.

Grove Group I, 1972. Oil and wax on canvas, 183 x 274 cm
The Museum of Modern Art, New York

Grove Group III, 1973. Oil and wax on canvas, 183 x 274 cm
Matthew Marks Gallery, New York

Grove Group IV

1976. Oil and wax on canvas, two panels, each 183 x 274.5 cm
Solomon R. Guggenheim Museum, New York

Even though Josef Albers had stopped teaching at Yale by the time Marden arrived
there in 1961, his systematic approach to colour was still a dominant influence on
staff and students alike. However, Marden found Albers's 'interactive' theory of col
prescriptive and unsympathetic, preferring a material-based, intuitive approach.
Marden thought of colour as the emotionally nuanced, sensual aspect of visual
language, rather than a focus for technical know-how. But his more poetic and ope
ended approach only gathered real force when, in the late 1960s, he started to wor
with a wax-and-oil emulsion (on canvas) and with separate colour panels, as in the
series of five *Grove* paintings. Wax has a number of important advantages over oil
paint for the colour painter. As well as being able to produce a smooth, even and
uniformly matt surface, it also carries pigment very well. What you see when you r
a colour is what you get when you put it on the canvas. Moreover, it is not subject
dichromatic blurring or change of hue during the drying process. It also generates
a much greater degree of luminosity than oil. The prime objective behind Marden's

paintings is to elicit an emotional response from the viewer by setting a very particular colour mood. As his titles suggest, these moods, in many cases, subtly recall the artist's experience of the natural landscape. He has said of *Grove Group IV*, for instance, that its two separate colour panels are a response to the shift between the khaki-green undersides and lighter, silvery-grey topsides of the leaves of the olive trees on Hydra as they are combed this way and that by the breeze. Clearly, this is not intended as a guide to the reading of the painting, which is strictly non-figurative, but to show how factors of place, colour and illumination can come together to determine the presence and atmosphere of a given work.

'When I started to get involved with colour — the colour started to get subtle — I had to get rid of the shiny stuff and I asked around, "How do you make a matt painting?" Harvey Kleighton said try wax and gave me a couple of formulas.... I tried it and it worked from the beginning. I've been using it ever since.'
Brice Marden

Richard Diebenkorn was born in Portland, Oregon, in 1922.

He moved with his family to San Francisco when he was still a very small child.
He studied fine art at Stanford University. Having achieved a measure of
professional recognition quite quickly, Diebenkorn lived an outwardly uneventful,
rather scholarly existence, spending his time between the Bay Area of
the city and his home in Santa Monica. He died in San Francisco in 1993.

Ocean Park No. 96

1977. Oil on canvas, 236 x 216 cm
Solomon R. Guggenheim Museum, New Yc

Over the years, Diebenkorn wore his painterly influences — his loyalties and his
passions — very much on his sleeve. The more figurative paintings of the 1960s,
works such as *Cityscape I* (1963), show his keen interest in the work of Henri
Matisse. But they also show a Hopper-like approach to light and shade, and it is
this that he uses in the early work to carve out and give shape to the landscape
of southern California. The story goes that Diebenkorn spent many hours in the
Phillips Collection in Washington, DC, looking at Matisse's *Studio Quai Saint-
Michel* (1916), but his use of geometry and line, especially in the more abstract
works painted after 1972, seems to tie him more to the Matisse of the Moroccan
Period (1912–14). *Entrance to the Kasbah*, painted by Matisse in 1912–13, for

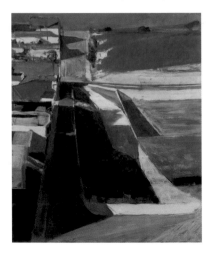

example, has much of the lightness, transparency and
purity of hue that we increasingly find in Diebenkorn's
great Ocean Park series, which eventually ran to some
150 canvases. The key to understanding these late
paintings is to bear in mind, as one observes them,
the play of light on things in the world — buildings,
sidewalks and driveways, the Californian beaches,
sea and sky — and how even bright colour is rendered
translucent and slightly fugitive in bright sunlight.
Diebenkorn's *Ocean Park No. 96* is redolent with
this kind of experience, wherein colour is no longer
simply optical, but gives rise in the muscular memory
to sensations of floating
and lingering warmth.
Underlying it all are the
traces of the painter's

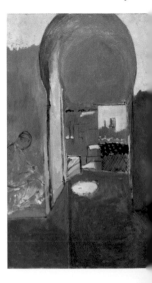

obsession with a pictorial geometry that, unlike in
the unfinished paintings of Mondrian — another
painter whom Diebenkorn greatly admired — is not
the result of a search for the proper location of things,
but a device for showing the forces of orderliness
and transience working with and against each other.

Cityscape I, 1963
Oil on canvas, 153 x 128.5 cm
San Francisco Museum of Modern Art

atisse
e to the Kasbah, 1912–13
nvas, 116 x 80 cm
Museum of Fine Arts, Moscow

Luciano Fabro

Attaccapanni (di Napoli)

1976–77. Bronze, handwoven linen, acrylic, white cotton thread for crochet. Five elements: 199 x 143 x 45 cm; 213 x 114 278 x 118 x 42 cm; 175 x 125 x 33 cm; 180 Castello di Rivoli, Museo d'Arte Contempor

Luciano Fabro was born in Turin in 1936. He spent his childhood in Friuli. When he was twenty-three years old he moved to Milan, where he began to mix with the artistic community. Here he discovered and came under the influence of such major figures as Lucio Fontana, Yves Klein and Piero Manzoni. His first solo exhibition, which combined mirror pieces with tubular metal, took place at the Galleria Vismara in Milan in 1965. Fabro has been a part of the Arte Povera movement since it first emerged (and was named by Germano Celant) in 1967. He lives and works in Milan.

Fabro's series of *Piedi di marmo* — 'marble feet' — were shown at the Galleria Borgogna in Milan in 1971. They represented a new approach to the identity of the work of art. Each was a new proposition about its form and its anthropological character. They were followed a year later by the *Piedi di vetro* — 'glass feet'.
Fabro made these five *Attaccapanni* — 'clothes hangers' — in part as a re-reading of the myth of Apollo and Daphne. Apollo, struck by Cupid's arrow, falls helplessly in love with Daphne, daughter of the Arcadian river deity Ladon. Daphne flees from him, but he pursues her relentlessly. The story is all about visibility — of what can be seen and what must remain out of sight — a fleeting vision of the clothed and the unclothed body. Of course, the *Attaccapanni* are not literal representations of the myth, but poetic analogies. More specifically, they are the product of Fabro's approach to material, and his conviction that the role of the artist is to assist matter to find its own space and place from which it will then derive its meaning. The curtainlike hangings with their vertical fluid bands of luminous colour create a highly complex spatial reading, within themselves and between each other. Fabro is a devoted student of the history of art — of painting in particular — and these hangings seem to reference the treatment of drapery in the great Mannerist tradition of Italian painting, in which a pink cloth can turn a vivid green in its shaded parts; a yellow cloth, aquamarine blue or a pale pinkish-violet. Each cloth is 'crowned' with a vegetal bronze rail — snaking stem and leaves — reminding the viewer of Daphne's final transformation into a laurel tree.

Lucian Freud

was born in Berlin in 1922. He is the grandson of the founder of psychoanalysis, Sigmund Freud. The family moved to England in 1933. He studied with the artist Cedric Morris at his East Anglian School of Painting and Drawing in Dedham, and afterwards at Goldsmiths College. His early paintings owe much to German realism, in particular the 'Neue Sachlichkeit' of artists such as Otto Dix and Christian Schad. His more recent work, while it adheres to a realist view of things, is much more observational in its method. He works very slowly and exhibits only occasionally. A leading member of the School of London, he lives and works in the west of the city.

Naked Man with Rat

1977. Oil on canvas, 91.5 x 91.5 cm
Art Gallery of Western Australia, Perth

Lucian Freud describes his unclothed subjects as 'naked' rather than 'nude'. The distinction is an important one, in that it makes clear the painter's observational intentions: his comprehensive approach to the human body as living flesh. In this respect, the paintings are whole-body portraits rather than examples of 'the nude' as a historical painting genre. Some observers have described Freud's

depiction of flesh as 'raw', 'skinless' or 'flayed', and certainly there is a feeling of heightened sensitivity, a precarious quickness, even a bruisable vulnerability about it. The skin is made slick and semi-transparent so as to reveal the blue-purple, pink and ochre of the muscle and fat that lies beneath. *Naked Man with Rat* is one of a small number of paintings dating from the late 1970s that picture the same male model, sometimes alone and sometimes as a participant in a double portrait, the best known of which is *Naked Man with His Friend* (1978–80). As well as being a meticulous observer of his subjects, Freud packs his pictures with humorous asides, visual puns and sexual innuendo. In *Naked Man with Rat*, the rat, with its pointed pink nose, puns the man's flaccid penis, possibly suggesting that it shares its predilection for burying itself in hidden places. In *Naked Man with His Friend*, the interlocking of the legs suggest mutual phallic arousal, while in the painting *Naked Portrait with Reflection* (1980), in which the female model occupies the same broken-down old couch, the reflection of the artist's feet in the top right-hand corner of the picture strikes an entirely predatory note. It is as if Freud were sneaking up on his subject for sexual purposes.

Naked Man with His Friend, 1978–80
Oil on canvas, 90 x 105.5 cm
Private collection

344

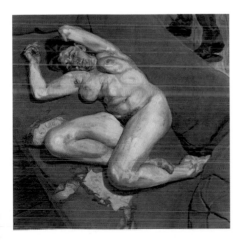

Naked Portrait with Reflection, 1980
Oil on canvas, 90.5 x 90.5 cm
Private collection

Howard Hodgkin

The Hopes at Home

1973–77
Oil on plywood panel,
91.3 x 106.7 cm. Manchester
Art Gallery, Manchester

Howard Hodgkin was born in London in 1932. He studied at Camberwell School of Art and later at the Bath Academy of Art, Corsham. He had his first one-person show at Arthur Tooth and Sons, London, in 1962. He became interested in Indian art as a teenager and visited India for the first time in 1964. The experience of the country itself had a profound influence on him and he returned there a number of times during the late 1960s and early 1970s, becoming an avid collector of Indian painting. He served as a trustee of the Tate Gallery and the National Gallery, and represented Britain at the Venice Biennale in 1984. He was made a Commander of the British Empire for his services to art in 1977 and was knighted in 1992. Sir Howard Hodgkin lives and works in London.

The presence of Indian painting hangs over Hodgkin's work like an entelechy—a life-giving force—and yet his very considerable knowledge of Indian painting has been so thoroughly absorbed that it is hard to cite precise points of reference. He,

Bombay Sunset
1972–73
Oil on wood,
85 x 92 cm
Private collection

In the Bay of Naples, 1980–82
Oil on wood,
137 x 152.5 cm
Private collection

himself, readily admits to a certain connection, but only as one of a number of influences, including Cubism, the paintings of Vuillard—with whom Hodgkin has found a particular affinity over the years—and Matisse. The feature that seems to bring his painting closest to Indian art is his use of strong colour as a framing device, such as the red in *Bombay Sunset* (1972–73), for example—the painting that Hodgkin has cited as the most obviously Indian of all of his works. Usually the paintings take as their starting point a particular event, social occasion or travel experience—the intimate encounters between himself and others that occur during dinner parties or weekend house visits, while travelling to exotic locations, in hotel lounges, bathrooms and bedrooms. The painting process is usually a lengthy one

and involves a gradual distillation of everything that makes a scene memorable: mood and atmosphere, feelings and emotions, bodily sensation and state of mind. All have to be brought together and effectively 're-framed' as part of a conspicuously visual experience. In *The Hopes at Home*, the black frame serves to condense and concentrate our attention on the image in the same way that the darkness in the cinema focuses attention on the screen. In the centre, the abstracted image of the Hopes—friends of the artist—is jewel-like and vivid. There is a strong feeling that as well as framing the image, the black is also editing it, a feeling that is reinforced by the way colour spills from behind the black at the painting's edges.

David Hockney

1979. Acrylic on canvas, 153 x 153 c▮
Carnegie Museum of Art, Pittsburgh

Divine

In 1977 David Hockney accepted a commission to design a new production of Mozart's *Magic Flute* for Glyndebourne, England, and decided to work on the project between New York and London. It took him almost a year to complete, during which time he painted very little. With the *Magic Flute* up and running, he returned to Los Angeles in 1978 and plunged immediately into an intense period of work. Among the paintings he made at this time was a huge painting called *Santa Monica Boulevard*, which he abandoned and later destroyed. Work on the *Magic Flute* had proved a liberation but he was still casting around for a new direction in his painting. He wanted to paint more speedily, more directly, and to use stronger colour. A long-time admirer of Henri Matisse, more recently Hockney had started to look more carefully at the work of Raoul Dufy, and it is Dufy's influence that seems to come to the fore in the paintings and drawings from 1979 and 1980.

David Hockney's portrait of the larger-than-life transvestite and drag queen, star of John Waters' cult underground movies *Pink Flamingos* (1972), *Female Trouble* (1974) and *Hairspray* (1988), was painted nine years before the actor's death in 1988 at the age of forty-two. Divine, whose real name was Harris Glenn Milstead, was at the peak of his fame and Hockney succeeds in catching something of his outrageous vulgarity and daring opulence. The pose is studiedly relaxed and this is matched by Hockney's use of paint. His brushwork throughout has an elegant ease about it. In fact, the emergence of Hockney as a great colourist starts with the paintings made between 1978 and 1980. Modestly, the painter put this down to his discovery of a new kind of high-saturation acrylic paint. But a painting like *Divine* shows that by the end of that period he had reached an entirely new level of understanding of the thematic orchestration of colour. Green, blue and violet dominate with complementary accents of ochre, orange and red. The painting of the head is master▮ with the purple and red spreading upwards and across to give it its form. In earlier work Hockney had stayed very close to the local colour of things, modelling forms by changes of tone rather than changes of colour. It was this tonal control applied to the use of colour that had for a long time underpinned his 'naturalism' and it was this that he was determined to break with on his return to Los Angeles. The struggle to achieve a new way of ordering colour relationships can be seen very clearly in a work like *Canyon Painting* from 1979. In this rather crude painting the intensity of the colour tends to fragment the picture surface, thereby vanquishing the unitary nature of the painting altogether. In *Mulholland Drive: The Road to the Studio*, painted just two years later, an equally strong and diverse range of colours are made to work together to reinforce the picture plane and to create a strong pictorial unity.

Canyon Painting, 1979
Acrylic on canvas, 152.5 x 152.5 cm. Private collection

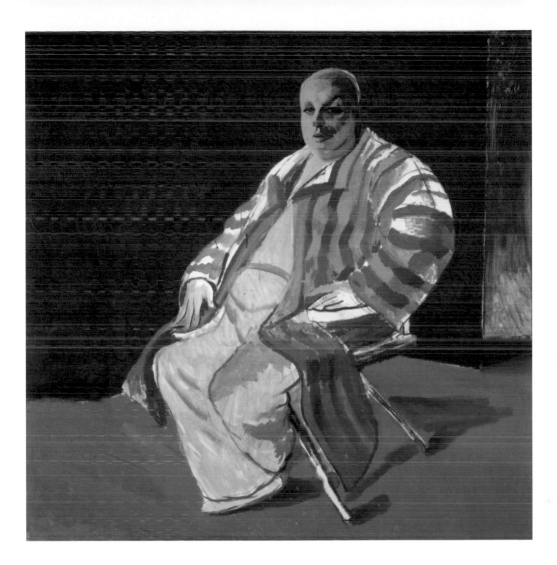

'Divine was an uncommonly sweet man, albeit cursed with an inordinate interest
in marijuana and fancy clothes. You can almost hear her talking from across a Formica
breakfast table somewhere in suburban Baltimore, coffee and cigarettes at the ready.'
Matthew Kennedy

Mulholland Drive: The Road to the Studio, 1980
Acrylic on canvas, 218 x 617 cm, Los Angeles County Museum of Art

Mario Merz

The son of an engineer inventor, Mario Merz was born in Milan in 1925. He spent his childhood in Turin and studied medicine for two years at the Università degli Studi di Torino. During the Second World War he became a member of the anti-Fascist group Giustizia e Libertà, for which he was imprisoned in 1945. He started to paint in the early 1950s and had his first one-person show at Galleria La Bussola in Turin in 1954. In the late 1960s he became associated with the Arte Povera movement. His concern for human and environmental issues surfaced with the 'igloo' works in 1968 and was reinforced in the early 1970s when he started to use the mathematical Fibonacci sequence as a way of encoding a natural order into his work. By 1972 he had begun to include pictures of wild animals, often pierced through with neon tubes. Mario Merz died in Turin in 2003.

Crocodile in the Night

1979. Oil paint, metallic paint, charcoal on unstretched canvas with neon light tubes and electric elements, 270 x 435 cm. Art Gallery of Ontario, Toronto

Despite the years during which Mario Merz seemed to concentrate almost entirely on large-scale installation works, he always considered himself to be a painter and when, in the late 1970s, a new group of young Italian easel painters came on the scene—Sandro Chia, Francesco Clemente, Enzo Cucchi and Mimmo Paladino (the Transavanguardia)—under the critical patronage of Achille Bonito Oliva, Merz returned to painting with renewed energy. Between 1978 and 1980, working on large sheets of polythene or roughly cut pieces of unstretched canvas, he made a series of memorable, partly real and partly imaginary images of primitive animals each one pierced through with what he called a 'neon lance'. The idea of these images was to move through and across history, linking prehistoric times to the present day. It was for this reason that he chose animals that still have something of the primordial moment about them, creatures such as the snail, the lizard, the crocodile and the rhinoceros. Because Merz uses the device of a frame within a frame, *Crocodile in the Night* functions as a double image. The crocodile of the title is spread-eagled against the central frame, almost like a biological specimen, while similarly amphibious creatures thrash about in the space outside. The image is 'energized' by two 'neon lances': a blue one, substituting for the crocodile's spine, and a red one cutting diagonally through the space of the image, pinning and holding its inner and outer regions together. For Merz, neon light came to represent the life force: an invisible metaphysical energy made spectacularly visible as colour, line and direction. It was endowed with almost supernatural powers. It was able not only to bring the creatures he imagined and drew to life, but also to grant a supra-sensible, almost talismanic value to the image itself.

...ll of the House of Usher, 1979
...tallic paint and charcoal with neon lance, 300 x 400 cm
...collection

Rhinoceros, 1979
Oil, metallic paint and charcoal with neon lance, 300 x 400 cm
Private collection

Susan Rothenberg

Red Banner

1979
Acrylic paint on canvas,
228.6 x 314.6 cm
The Museum of Fine Art,
Houston

Susan Rothenberg was born in Buffalo, New York, in 1945.
She studied fine art at Cornell University, where she initially
concentrated on sculpture before turning to painting. Afterwards,
in 1967, she enrolled, but did not take up her place, at the Corcoran
School of Art in Washington, preferring instead to move to New
York, where she studied dance with Deborah Hay and Joan Jonas.
At this time she was working collaboratively with a cross-disciplinary
group of artists, as well as making 'patterned' paintings influenced
by Minimalism. She made the first of her Horse paintings in 1972–73,
and her first one-person show followed two years later at New York's
Greene Street Gallery. Rothenberg moved to live and work in
New Mexico in 1990.

What led Susan Rothenberg to continue to paint images of horses
— over a period of eight years she made some forty of them in all —
seems to have been unclear even to her. She started, as she has
said, as a way of not painting people. Afterwards the image of
the horse appears to have gained a real hold on her imagination,
increasing in psychological intensity from painting to painting.
Psychoanalytically speaking, the horse is a profoundly ambivalent
symbol. On the positive side of the equation it means energy under
the control of intuition, passions that are properly directed and
likely to achieve their objective. On the negative side, it represents
a destructive animality, or the dark side of human consciousness
out of control, or is the swift-footed creature that bears aloft
the skeletal figure of death. In the earliest
of Rothenberg's Horse paintings it is
the positive symbolic aspect that has
the upper hand. The horses are seen in
profile — standing or at a gallop — and
framed geometrically. By the end of the
1970s, when she painted *Red Banner*
and the even more sinister *Hulk* (1979),
it seems that it was the darker aspect of
the horse symbol that had gained the upper
hand. In *Red Banner* the horse is seen
head-on, alongside the whited bones of
a horse skeleton, both of them set against
a ground that is the colour of dried blood.

In *The Hulk* the bleached bones are embedded in a cloaklike, modulated
black form that is the shape of a horse's shoulders and chest viewed from
the front. In both cases, the image suggests the presence of death in life.

Fever, 1976
and tempera on
170 x 213 cm
dern Art
, Fort Worth

'Sometimes the painting starts to relate very directly to either sights seen or experiences felt, other times it goes off on a tangent that you really can't articulate.'
Susan Rothenberg

Wishbone, 1979. Acrylic and flashe on canvas, 259 x 193 cm, Private collection

Francesco Clemente was born in Naples in 1952. He embarked on a
degree in architecture in Rome but left before graduating. He turned his attention
to art—figurative drawing and painting—and had his first one-person exhibition
in 1971 at the Galleria Valle Giulia in Rome. Clemente made his first visit to India
in 1973 and afterwards returned there each summer. Between 1976 and 1977 he
spent time studying comparative religion in the library of the Theosophical Society
of Madras. By the end of the 1970s he had mapped out his main area of subject-
matter: the human form in all its manifestations; his own appearance and sexuality;
Oriental symbolisms, mythologies and religions. In 1980 his paintings were shown
in the Venice Biennale and he was acclaimed one of the new generation of Italian
artists, labelled the Transavanguardia by the critic Achille Bonito Oliva. He moved
to New York with his family in 1981, and although he continues to travel widely,
his New York loft is still his main base for living and working.

Water and Wine

1981. Gouache on paper, 243 x 248 cm
Art Gallery of New South Wales, Sydney

Clemente likes to describe his paintings as ideograms: readable sign systems that
point to a subject without actually representing it. In *Water and Wine*, for example,
the underlying theme is sacrifice and renewal, and Clemente gives this theme
conceptual circularity by overlaying the Christian mythology of death and
resurrection with Hindu symbolism. The picture shows Clemente himself just
after beheading a pure white cow. He holds its head, still dripping blood, in his right
hand while making the Hindu sign to ward off evil with his left. Underneath the cow
a female lookalike drinks milk directly from the cow's udder, making Clemente
both the instrument and beneficiary of the sacrificial act. The whole image is
raised above the ground—the cow tethered to Heaven—as if to make clear the
separation between the real world and that of mythology. In Hinduism, the cow,
Aghanya—that which cannot be slaughtered—is a matriarchal symbol of
abundance and comes under the protection of Krishna, the *bala-gopal* or 'the child
who protects the cows'. Historically, Krishna's protection could be set aside only
through the intervention of a Brahman priest. In this picture, Clemente presents
himself as the instrument of the cow's sacrificial death, but also as the means
of its resurrection. His body joins with that of the headless cow to form the image
of a new hybrid creature: male yet female, half human yet half animal.

Self-portrait, 1980
Oil on linen, 40.5 x 45 cm
The Brant Foundation,
Greenwich

Transavanguardia: Painting and Postmodernism

The Italian critic Achille Bonito Oliva invented the term Transavanguardia
to describe the work of a new generation of Italian figurative painters who
were reacting against Arte Povera, post-Minimalism and the formalistic
preoccupations of late transatlantic Modernism. Broadly speaking,
Transavanguardia is a part of the Postmodern tendency. It accepts 'uncertainty'
as the precondition of contemporary ways of knowing and living. It recognizes
the impact of globalization in cultural as well as economic matters and seeks
to ameliorate the worst effects of these forces by returning the human subject
to the centre of art and cultural life. This is most apparent in the paintings
of Sandro Chia and Francesco Clemente, where human beings are shown,
on the one hand, in their most animalistic state, performing their bodily
functions and, on the other, as noble, even seerlike creatures, possessed
of an almost mystical connection with the world, through their closeness
to the land, the sea and the sky.

1980
on paper,
cm
collection

Martin Kippenberger

was born in Dortmund in 1953. After a number of attempts to find gainful employment and thoughts of becoming a dancer or a musician, he enrolled at the Hamburg Art Academy in 1972. He abandoned his studies in 1976, claiming that he had learned nothing. In the same year he moved to Florence, where he planned to find work as an actor. It was there that he began to take his future as an artist seriously, painting the series of works called

The S.O.36 Bar in Berlin-Kreuzberg, 1979

Uno di voi, un tedesco in Firenze that were shown at the Galerie Petersen in Hamburg in 1977. A year later he went to live in Berlin where he set up *Kippenbergers Büro* and became manager of S.O.36, a performance space that he turned into the most famous punk rock venue in West Germany.

Self-Portrait

1982. Mixed media on canvas, 170 x 170 cm. Galerie Gisela Capitain, Colog

This early self-portrait was painted following Kippenberger's time at S.O.36 and it vividly demonstrates the socio-political conflict he experienced there. Politically, he was in tune with the 'smarter', fast-living, ambitious new left, but he was running a club for young people who, for the most part, were nihilistic anarchists. Like them, he rejected the values of his parents' generation, but he did not share their urge to self-destruct. The punks embraced indiscriminate violence, sexual freedom and the drugs culture as an antidote to West Germany's crudely meritocratic society and what they saw as its 'decaying vitality'. Kippenberger, by contrast, was an idealist pursuing his dream of comprehensive social freedom at the same time as trying to be a 'success'. This conflict of values came to a head when he was attacked and beaten up by punks from his own club—dissatisfied with the night's entertainment—and had to be admitted to hospital. The *Self-Portrait* of 1982 was made from photographs taken by friends after his release from hospital.

Typically, Kippenberger turned this very traumatic event to critical advantage in 1981 by staging an exhibition at the Achim Kubinski Gallery in Stuttgart with the ironic title 'Dialogue with the Young'. The photograph that formed the basis of this self-portrait—a rough and toughly painted, almost Cubist reconstruction of the artist's damaged face—appeared on the invitation cards for the opening of the exhibition. The painting shows many of the rhetorical devices that were to become characteristic of Kippenberger's painting thereafter: the almost random layering into the image of graphic signs, the fierce painterly attack, the uncompromising way in which he pushes the tonal range to breaking point. But this painting has a darkly frightened and frightening aspect unusual in Kippenberger's work. In some respects it is more like the work of the so-called 'Wild' painters—artists like Walter Dahn and Jiři Dokoupil—with whom he was friendly at the time.

Invitation to the exhibition 'Dialogue with the Young', 1981
Achim Kubinski Gallery, Stuttgart

Kippenberger on Success
'Success?... that the business (S.O.36)
which was housed in what used to be
a supermarket of no special architectural
value, is now a historic building.
For me, that is success. That's what
I was working towards.'

Sigmar Polke

Sigmar Polke was born in Oels in Silesia (once in East Germany, now Oleśnica in Poland) in 1941. The family moved to Willich near Mönchen-Gladbach in West Germany in 1953. He started to visit art galleries and exhibitions in his early teens and enrolled to study glass painting in Düsseldorf-Kaiserwerth before transferring to the Kunstakademie in Düsseldorf in 1961. In 1963, along with fellow student Konrad Fischer (also known as Konrad Lueg) and Gerhard Richter, Polke launched Capitalist Realism (an ironic reference to Socialist Realism) in part as a critical response to American Pop Art. Polke travelled widely throughout the 1970s — visiting countries such as Pakistan, Mexico, Afghanistan and Brazil — before settling down to live and work in Cologne.

Polke's fascination with the 'appropriated' image showed itself first of all in works such as *Bunnies* (1966), painted during his Pop or Capitalist Realist period. At this early stage, his borrowings, like those of his transatlantic counterparts, came mostly from newspapers, magazines and the commercial advertising current at the time. However, by the end of the 1970s, unlike the Americans who remained wedded to the idea of referencing contemporary life, Polke had expanded the range of his sources to include every type of graphic image old and new. This collapsing of the idea of art as historical progression and rejection of the notion of an emblematic modernity like that of painters like James Rosenquist and Tom Wesselmann, makes Polke the true forerunner of the tendency in contemporary art that later came to be known as Postmodernism.

The Copyist

1982
Oil, synthetic resin and chemical varni on canvas, 260 x 200 cm. The Watari Private Collection

The Copyist, along with other works produced at the same time — paintings such as the deliberately Turneresque *Hannibal with his Armoured Elephants* (1982) — provides a useful key to understanding something of the conceptual ground upon which Polke's later work stands. The main image in *The Copyist* is a reproduction of a reproduction: a technology-assisted, hand-made blow-up, taken from a reproduction of a Rembrandt-style hand-done drawing. Not only does it collapse the past into the present, it also seeks to redraw the boundary between what might loosely be described as the 'fake' and the original. The key question here is about authenticity. By flaunting the idea of the work of art as a product of artifice — a lie, a deception, a very particular kind of untruth — *The Copyist* serves as a powerful critique of the notion

Hannibal with his Armoured Elephan
1982. Artificial resin on canvas,
260 x 200 cm. Private collection

ies, 1966
etic polymer
nvas, 150 x 100 cm
horn Museum
Sculpture Garden,
ington

of unique authorship. The underlying proposition is that the artist—Polke
himself—is inevitably one who steals images, from nature and from the rest
of the man-made visual world, including the past of art. The poured, glutinous
blob of coloured resin occupying the centre of the left-hand side of the picture
is there to remind us that art's uniqueness—if there is such a thing—lies
in its approach to materials and its use of material transformation.

Richard Hamilton

The Citizen

1981–83
Oil on canvas, two canvases
each 200 x 100 cm
Tate Collection, London

The image that provided the impetus for *The Citizen* arose from Richard
Hamilton's habit of setting up a still camera in front of the television screen
in order to record the unexpected. 'By chance, in 1980, I was struck by a scene
in a TV documentary about republican prisoners in the H blocks ... [a] film was
shown of men "on the blanket".... It was a strange image of human dignity in
the midst of self-created squalor and it was endowed with the mythic power
most often associated with art. It manifested the noble spirit of Irish patriotism
having retreated (or was it pushed) into its own excreta.'

Despite the simplicity of Hamilton's initial response to his chosen image, it
acquired many new layers of meaning as the work progressed. Most importantly
it made new links with referential material already present in his work. Hamilton
had long been fascinated by Irish history and with the complex, figural way
in which it is woven into the fabric of James Joyce's 'modern' Homeric novel
Ulysses. He had first conceived of making paintings after *Ulysses* in 1947 and
made a number of drawings with this objective in mind. One such study, which
he described as entirely unsatisfactory, was of the 'Horne's House' episode;
he returned to this same subject in a pen-and-wash drawing of 1981, with
the centenary of Joyce's birth only a year away.

The first Christ-like figure, reminiscent of the Citizen, occurs in these drawings.
It is a reference to Finn MacCool, the part-legendary poet and patriotic leader of
the Fianna, the band of Irish warriors which gave its name to the Fenian Society,
or the IRB (Irish Republican Brotherhood), a secret organization dedicated to
achieving a united Ireland by violent and/or revolutionary means. But Hamilton's
reference is by no means as one-sided as it first appears. MacCool figures in the
'Cyclops' episode of *Ulysses* as the loud-mouthed, monocular giant nicknamed
'The Citizen', whose 'one-eyed crudity' disturbs the gentle, peace-loving Bloom
in Barny Kiernan's bar. It is clear, then, that Hamilton's portrayal of 'The Citizen'
intends even-handedness by balancing the mythologically charged, MacCool-like
image of the 'blanket protester' and hunger striker,
Hugh Rooney, with a heavy dose of Joycian obliquity.
Typically, Hamilton had fastened onto an image that
had enormous power in straightforward human as well
as in propaganda terms, and his technical approach
was characteristically thorough. The initial studies
were made from Cibachrome blow-ups of the original
film footage that he cut and pasted together in several
different versions before deciding how to proceed.
On a formal level he wanted to make a clear separation
between the two vertical panels. They were to sit
together comfortably, but to speak to different orders
of visual language: abstraction and figuration.

MacCool
Heliogravure,
nt and engraving
er, 53.5 x 39.8 cm
ollection, London

Frank Auerbach

was born in Berlin in 1931. In 1939 his parents sent him to school in England to escape the political situation in Germany, and he never saw or heard from them again. After the Second World War he found casual employment as a bit-part actor in London theatres before starting to attend drawing classes with David Bomberg at Borough Polytechnic. He studied at St Martin's School of Art and the Royal College of Art from 1948 to 1955. His contemporaries at the Royal College included Joe Tilson, Bridget Riley and Leon Kossoff. His first one-person show took place at the Beaux-Arts Gallery, London, in 1956. He was awarded the Golden Lion with Sigmar Polke at the Venice Biennale of 1986. A notable member of the School of London, today he lives and works in the Camden Town district of London.

Primrose Hill: Autumn

1984. Oil on canvas, 121.9 x 121.9 cm
Art Gallery of New South Wales, Sydney

Frank Auerbach is a painter who, over the years, has remained entirely faithful to his subjects: the individuals whose portraits he paints, the painters he admires and chooses to copy, and a small number of landscape locations — including Euston Steps, Mornington Crescent and, judging by the number of times he has painted it, his favourite site, Primrose Hill. An elevated, sloping, grassy open space dotted with trees and criss-crossed by footpaths, close to where he lives in north London, Primrose Hill has provided Auerbach with the opportunity — unusual in a densely built-up urban space — to explore high and low horizons as a means of giving character and expressive force to the city landscape. In this respect, many of the Primrose Hill pictures from 1981 and 1982 reconnect with the formal concerns of Auerbach's earlier building-site paintings, works such as *The Shell Building Construction Site* (1959), in which he adopts a high viewpoint in order to clear the space in the centre of the painting and push the detail towards its edges. The slightly later Primrose Hill paintings, including *Primrose Hill: Autumn* (1984), seem less concerned with topography than with discovering an effective and 'expressive' visual language. Here, starting from what looks like an open

Primrose Hill, Winter, 1981–82
Oil on canvas, 122 x 152.5 cm. Private collection

The Shell Construction Site, 1959
Oil on canvas, 152.5 x 122 cm. Museo Thyssen-Bornemisza, Madrid

bandstand in the right-centre foreground of the painting, the brushmarks climb forcefully upwards, taking possession of the trees beyond and invading the space of the sky above. Auerbach's chief concern here is one that is fundamental to landscape painting (and to figurative painting in general), namely to find a language of marks that can move purposefully between earth and sky and that can describe things as effectively as it describes spaces.

Auerbach's paintings often appear to be teetering on the edge of total abstraction, flirting with the idea of losing contact with the motif altogether for the sake of achieving a thoroughly unified visual language. But nothing could be further from the painter's mind. These are hard-won images that start from the subject and, throughout the process of painting, stay absolutely with that subject. The degree of abstraction that occurs in the process is integral to this engagement.

Georg Baselitz
The Head of Abgar

1984
Oil on canvas, 250 x 200 cm
Louisiana Museum for
Moderne Kunst, Humlebæk

In 1966 Georg Baselitz moved to Osthofen near Worms, where he painted his 'fracture' paintings (works such as *Drei Streifen—der Maler im Mantel* and *Zwei geteilte Kuhe II*) and the first of his 'inverted' images such as *Adler* (1972) and *Männlicher Akt* (1973). Baselitz moved again in 1975, this time to Derneburg near Hildesheim in Lower Saxony. In 1976 he established a working studio in Florence and began to work between Germany and Italy. Together with Anselm Kiefer, he represented Germany at the Venice Biennale in 1980.

The Head of Abgar is something of an oddity when viewed in the context of Baselitz's oeuvre as a whole. Despite its title, it is the only one of his paintings where the face, as opposed to the head, seems to be the subject. And it is the only painting in which a solitary head is allowed to spill out beyond the confines of the picture, thereby placing the main pictorial emphasis on the face as mask. Even without reference to the title, this scarred face is unquestionably the picture of a deeply troubled man.

Besides proposing a very particular subject, the title also focuses the quest for

meaning decisively in the domain of speculative theology and could be seen as something of a provocation. In biblical scholarship, Abgar was the grievously sick king of the small city-state of Edessa in Mesopotamia who wrote to Christ—shortly before his final entry into Jerusalem — asking to be cured. According to the legend, Christ dictated his response directly to Abgar's messenger, in the process predicting his own death and ascent into Heaven. The subplot to this story, almost certainly the focus of Baselitz's interest, is that Abgar chose as his messenger the court scribe and painter Hannan, whom he also charged with the task of painting Christ's portrait—a task that Christ involuntarily pre-empted by taking hold of the canvas and using it to wipe the perspiration from his face, thereby printing his own image on it. This *acheiropoietos* (a painting not made by a human hand) subsequently became known as The Holy Face of Edessa.

Viewed in the light of this legend, Baselitz's inverted image of Abgar takes on Christ-like properties, most particularly through the stitched lines that traverse the forehead and that are powerfully reminiscent of a crown of thorns. The blackness of the face adds another kind of inversion. It brings to the image something of the visual quality of a photographic negative.

Two Split Cows, 1966
Oil on canvas, 162 x 130 cm. Private collection

Fingerpainting I — Eagle — à la, 1971–72
Oil on canvas, 200 x 130 cm. Staatliche Museen, Neue Galerie, Kassel

René Daniëls

was born in 1950 in the southern Dutch town of Eindhoven close to the Belgian border. He started to exhibit in the late 1970s and worked for less than a decade. His active life as a painter was cut short by a severe stroke in 1987 when he was still only thirty-seven years old. Although he is still alive and struggles to draw from time to time, his oeuvre is considered to be complete.

A Hot Day in the Lighthouse

1984. Oil on canvas, 130 x 170 cm
Collection Paul Andriese, on loan to De Pont
Museum voor hedendaagse Kunst, Tilburg

René Daniëls's paintings belong more to the Franco-Belgian tradition than to the Dutch. Their conceptual lineage sits more comfortably with Dada and Surrealism (especially the Belgian version) than with either De Stijl or Cobra, while their spiritual precursors seem to be entirely Belgian: René Magritte and, most particularly, the combining of word and image, poetry and object, language and art that we find in the work of Marcel Broodthaers. Broodthaers declared the 'word paintings of Magritte' to be the root and centre of his art, and Daniëls — picking up on the synthesis made by his predecessor — claimed as his inherited territory 'the former [that is, before Broodthaers] no-man's-land between literature, the visual arts and life'. Daniëls's paintings range from Picabia-like, almost casually made, slightly wayward images, such as *Cocoanuts* (1982), to sharp commentaries on the consumerist politics of the museum space in works such as *Missing Painting* (1985). Daniëls is clearly fascinated by words and the way they hook themselves onto images to produce portmanteau metaphors. His brilliantly ironic invention, the perspectival 'bow tie' is perhaps the most telling example of this. Simultaneously an item of formal clothing, a schematic living space or an art museum, he uses it not only to symbolize bourgeois conformity — a way of thinking, a value system, an order of social relations — but also to argue the long-gone impossibility of painterly representation beyond the institutional rules that sustain it. For Daniëls, then, the art museum is as much the subject of painting as paintings are the subject of the art museum. *A Hot Day in the Lighthouse* belongs to the later architectural works. Like a number of the paintings Daniëls made between 1983 and 1987, its theme is windows and the link they make — the orientation they give from the inside — with the outside world. The use of a strong red ground in concert with the yellow halations around the edges of the four rhomboids gives a strong feeling of being inside looking out, and their implied perspective suggests a panoramic sweep from left to right and right to left. The three sky-blue windows to one white one strikes a typical note of humour by suggesting a possible change in the prevailing weather conditions as time passes.

Cocoanuts, 1982
Oil on canvas, 200 x 140 cm
Städtische Galerie, Karlsruhe

...ouse, 1986
...canvas, 190 x 130 cm
...bemuseum, Eindhoven

The Return of the Performance, 1987
Oil on canvas, 190 x 130 cm
Private collection

Anselm Kiefer

Seraphim

1983–84
Oil, straw, emulsion paint and
shellac on canvas, 320 x 330 cm
Solomon R. Guggenheim Museum, New

Anselm Kiefer was born in Donaueschingen, Germany, in 1945. After leaving school
he spent three years travelling before enrolling as a student to study law and
Romance languages at Freiburg University, which he pursued from 1965 to 1966.
Having started his studies in painting with Peter Dreher in Freiburg in 1966, he
went to the Akademie der Bildenden Künste in Karlsruhe in 1969 to study with
Horst Antes, and transferred a year later to the Kunstakademie in Düsseldorf,
where he encountered Joseph Beuys. Kiefer first came to public notice in 1969 when
he exhibited a series of photographs that he called *Occupations*. These showed him
dressed in riding breeches giving the Nazi salute in different identifiable locations
in Europe. He now lives and works in Barjac in the south of France.

Throughout the 1970s and early 1980s, German cultural history remained the
constant underlying theme of Kiefer's painting. As a child, he had experienced the
aftermath of modern warfare very directly, including the partitioning of Germany.
Growing up and being educated at that critical moment, he was also a living witness
to the denial of cultural and historical responsibility that had accompanied the
struggle for national renewal. Now, as a working painter, he wanted to open up
the conflict-ridden mythological territory that underpinned the German idea of
nationhood and that, in the recent past, had given such aggressive shape to her
institutions. His first major works to tackle these questions head-on were the
so-called *Panelled Room* paintings of the early 1970s. In works like *Quaternity*
(referencing the fourfold nature of the Godhead) from 1973, Kiefer shows the
planked floor of a large, roughly constructed hutlike interior—the space of
Germany's mythological forest-dwellers—as the site of a ritual conflict between
the powers of Good and Evil. For the first time in Kiefer's paintings Evil appears
in the form of a serpent symbolizing Lucifer, the fallen angel, shown here entering
the four-sided space of trial by fire. Kiefer returned to this powerful symbolic
configuration again in the *Angel* paintings of the 1980s, of which *Seraphim* is
the most notable example. Here the German earth is shown as a wasted, burnt
and blasted landscape. Kiefer has used a blowtorch to char, blacken and break

up the surface of the painting and to blur
the distinction between land and sky.
In the centre of the painting the ladder,
a rickety, perilously fragile symbol of hope
and resurrection, reaches upwards from
the ground—unsupported—only to fade
and disappear into the clouds above.
At its foot, the Earth-bound serpent
—the persistent presence of Evil on
Earth—slowly uncoils its body.

Quaternity, 1973. Charcoal and oil on burlap,
300 x 435 cm. The Modern Art Museum of Fort Worth

Per Kirkeby

was born in Copenhagen in 1938. He studied natural history, specializing in geology, at the University of Copenhagen from 1957 and graduated in 1964. Between 1958 and 1972 he worked off and on in Greenland as a geologist. He also enrolled at the Eksperimenterende Kunstskole in Copenhagen in 1962, where he involved himself mostly with painting and performance work. Afterwards he became affiliated for a short time with the Fluxus movement. He had his first one-person show in Copenhagen in 1964. Today he is Professor of Fine Art at the Städelschule in Frankfurt.

Sunset

1983–84. Oil on canvas, 200 x 250 cm
Castello di Rivoli Museo d'Arte Contemporanea, Rivoli

Per Kirkeby has many different ways of working: painting, plaster and bronze sculpture, printing techniques of different kinds, free-standing brick-built sculptures and environments. They are linked by his abiding interest in natural history and architecture and fascination with the related Nordic traditions of landscape and narrative painting. Although reference to the land and the forces that shape it remains central to Kirkeby's practice, he does not like to be thought of simply as a landscape painter. 'Landscape' as a motif is both too particular and too limiting for him. It requires the intervention of human memory and an awareness of the historical processes of culturalization for it to become enriched, fully fledged subject-matter. For this reason the motif in a Kirkeby painting is usually subjected to the twin processes of fragmentation and layering which, in their turn, greatly complicate its spatial reading. Indeed, there is no such thing as a straightforward recessional space in a Kirkeby painting. Always the most distant atmospheric regions of the image are picked up and brought back to—or are made to seem optically in advance of—the picture surface. This process is particularly apparent in *Sunset*. The vertical brown and blue-black area that occupies the left-hand side of the painting seems to be sitting very firmly on the picture surface, rendering the space beyond it almost entirely fugitive. Meanwhile, the patch of yellowish dove-grey that occupies the middle area between top and bottom at the right-hand side of the painting, obscuring the drawn, vertical silhouette, so reminiscent of Kirkeby's favourite brick building—the Domkirke in Copenhagen—seems almost to be breaking free and floating in front of the picture surface.
But there is another way of reading Kirkeby's paintings that relates to his long-standing interest in poetics. It is rewarding to view them as a series of metaphoric shifts across different visual languages. In *Sunset*, for example, the evidence of physical force—the energy of Kirkeby's mark-making—is quickly translated into an image of a spiritual energy that gathers momentum as you look from right to left. It is inescapably a journey from light into darkness. And this impression is further underlined by his use of subtle, vertical, semi-architectural references.

The Taking Down, 1985. Oil on canvas, 290 x 350 cm
Michael Werner Gallery, New York

Jean-Michel Basquiat

was born in Brooklyn, New York, in 1960, the first child of mixed Haitian and Puerto Rican parents. He showed great talent for writing, music and drawing while still very young. He attended the experimental City-As-School for gifted children, where he met the young graffiti artist Al Diaz. Together they invented the graffiti character SAMO (an abbreviation of SAME OLD SHIT), who for several years covered the walls of New York play areas, derelict buildings and tenements with politically provocative slogans. Basquiat parted ways with Diaz in 1978; that same year he briefly met the critic and curator Henry Geldzahler and the painter Andy Warhol, who would both befriend him a few years later. By the early 1980s he was an important figure on the New York art scene and was enjoying a rapidly expanding international reputation. The pressures of celebrity and a burgeoning drug habit led to his early death from an overdose in 1988. He was just twenty-seven years old.

Andy Warhol, **Portrait of Basquiat**, 1982
Copper paint, silk-screen and urine on canvas,
101.6 x 101.6 cm
The Andy Warhol Museum, Pittsburgh

Self-Portrait

1986
Acrylic paint on canvas,
180 x 260 cm
Museu d'Art Contemporani de Barcelona

The Barcelona *Self-Portrait*, painted two years before Basquiat's death, contains a number of signs and symbols familiar from his earlier work, the difference being that here they have been put together in a less graphic, more painterly way. A silhouette of the artist occupies the centre of the canvas. His head is skull-like, his face a mask with square-slotted mouth showing white teeth and narrow slits for eyes. His hair is a spiky halo of stiff-standing dreadlocks. Viewed in one way, Basquiat seems to be presenting himself as an angry, aggressive — even vengeful — figure; from another, as a damaged and broken man.

One of the artist's most prized possessions was his copy of the medical source-book *Gray's Anatomy*. It was a gift from his mother when, at age seven, he was hospitalized after a road accident. Anatomical references played an important part in Basquiat's work from his teenage years onwards. In this painting, he has one foot turned awkwardly inwards and a wasted leg, truncated below the knee. This way of conveying a sense of his own physical precariousness occurs in several earlier paintings, notably in *Self-Portrait as a Heel* from 1982 and *Figure 3A* from 1984, and in the self-portrait drawing of 1985 in which he savagely crossed out his right foot using red crayon. The colour red is often used by Basquiat to symbolize blood or the onset of physical violence. Here a bloody cascade of it falls from the top almost to the bottom of the canvas to the left of the figure, while to his right an ominously black, voided canvas hangs somewhat lopsidedly from a single nail.

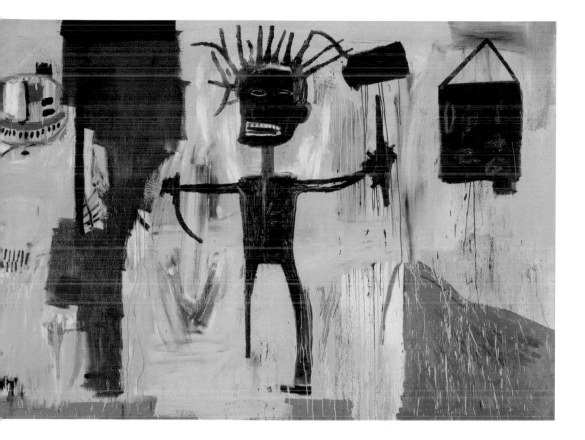

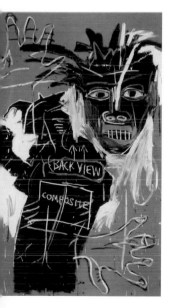

'In many of the paintings and also in the drawings, the body is torn apart and grimacing: a lesson in anatomy, a real medical dictionary that, as we know, he always had on him.... Death is disguised, ecstatic.'
Bernard Blistène

Basquiat's Use of Words

Something of a secret intellectual, Basquiat read a great deal more than he would ever let on. He had a particular interest in arcane subjects like alchemy and the cabala; he believed that colours and words were interchangeable and could be used abstractly like musical notation.

Self-Portrait as a Heel, 1982. Acrylic and oil paintstick on canvas, 243.8 x 156.2 cm. Private collection

Gerhard Richter
AB, Mediation

1986
Oil on canvas, 320 x 400 cm
The Museum of Fine Arts,
Montreal

After his so-called Pop Art phase in the 1960s, Richter's interest in the photographic image has continued unabated. Indeed, it has formed the basis for a long-term examination of the relationship between image and painting as process. Furthermore, the influence of photography shows itself even in his abstract works (the Abstract Paintings), which have continued to preoccupy him alongside his figurative paintings.

Richter's Abstract Paintings from the mid-1980s have a very distinctive look to them. In 1983 when he painted *Marian* he was still mostly using a brush, but by 1986, when he was producing works such as *AB, Mediation*, he had turned to the use of a large silk-screen squeegee to apply the paint, building the paintings up in layers and often applying wet paint onto wet. The resulting visual language moves between slickly modelled, smooth colour transitions that have an out-of-focus feel to them (mostly at the edges of the paintings) and heavily textured, brittle, crumbling impasto surfaces that pick up and fragment both colour and light in an almost granular way. Their colour is uncompromising in its range, utilizing the whole spectrum from dark purple-blue to a screaming, high-pitched cadmium yellow and taking in every variant of red, orange and green along the way. Methodologically speaking, these paintings are extreme in every sense, and yet they have a feeling of spontaneous ease about them, as if they are the result of a natural occurrence of a certain kind. The American avant-garde composer John Cage famously argued that while it is not appropriate to seek to imitate the appearance of nature, it is absolutely appropriate — perhaps even desirable — for the artist to look to find operational equivalents for the way that nature works. This would seem to be precisely what Richter achieved in the Abstract Paintings after 1985. A work like *AB, Mediation* is entirely the outcome of a working process. It could not have been predicted by the artist in anything other than the most general terms, and yet it has the most extraordinary feeling of precision about it. The fact that this precision arises entirely through the application of method, makes it very different from other more-or-less 'informal' approaches to the making of the painted image. For example, it is the very opposite of Abstract

Marian, 1983
Oil on canvas, 200 x 200 cm. Private collection

Expressionist painting, where the business of mark-making — as a procedure —
is both more deliberate and intentionally (self)expressive. There is also a
crucial point of convergence here between Richter's Abstract Paintings and his
photography based figurative paintings. His strategy of playing down the artist's
direct responsibility for determining the detail of the abstract images is not
at all dissimilar to his acceptance of the ultimate authority of the photographic
image to determine the final outcome of his figurative works.

375

Andy Warhol
Camouflage Self-Portrait

1986
Silk-screen ink on synthetic polymer
paint on canvas, 208.3 x 208.3 cm
The Metropolitan Museum of Art, New Yo

During the course of his working life, Andy Warhol returned time and time again to the subject of his own facial appearance. In 1964 he made a series of small-format, silk-screened self-portraits with coloured backgrounds on canvas, to be shown together in sets of two and four. Three years later, in 1967, there came the celebrated series of large-scale, single and double self-portraits, printed with commercial enamel paint on a synthetic polymer ground. Warhol returned to the same subject again in 1978 with a disturbing series of death-obsessed paintings that included the strangulation image *Self-Portrait with Hands around Neck*. New sets of printed and photographic images followed in 1978, 1979 and 1981; the last, extensive series of self-portraits, which included the *Camouflage Self-Portrait*, appeared just a year before Warhol's death in February 1987. In the late 1970s Warhol made a set of celebrity portraits with images of figures such as Mick Jagger, Truman Capote and Liza Minnelli. By this time he no longer needed to use agency photographs for his portraits: his own fame was such that other celebrities were prepared to pose for him and to subject themselves to

a lengthy pre-photographic preparation, including the application of a heavy-duty, white make-up intended to hide wrinkles and to 'light up' the face in the eye of the camera. In the final series of self-portraits, Warhol applied this treatment to himself. He had worn a hair-piece or a full wig since his mid-thirties. Now he chose an ash-blond, tousled wig which, together with his white face and carefully pencilled, eye make-up gives his face an ageless quality and adds a disconcerting intensity to a gaze that seems almost to transfix the viewer. In the finished *Camouflage Self-Portrait*, the enlarged image is printed in black over a patterned ground copied from a piece of the camouflage fabric in popular use on the streets of New York in the 1980s. Warhol liked it because it was both abstract and masculine with a distinctly militaristic edge.

Self-Portrait, 1967
Silk-screen ink on synthetic polymer paint on canvas, 183 x 183 cm
Tate Collection, London

Self-Portrait with Hands around Neck, 1978
Silk-screen ink on synthetic polymer paint on canvas, 40.5 x 33 cm
Estate of Andy Warhol

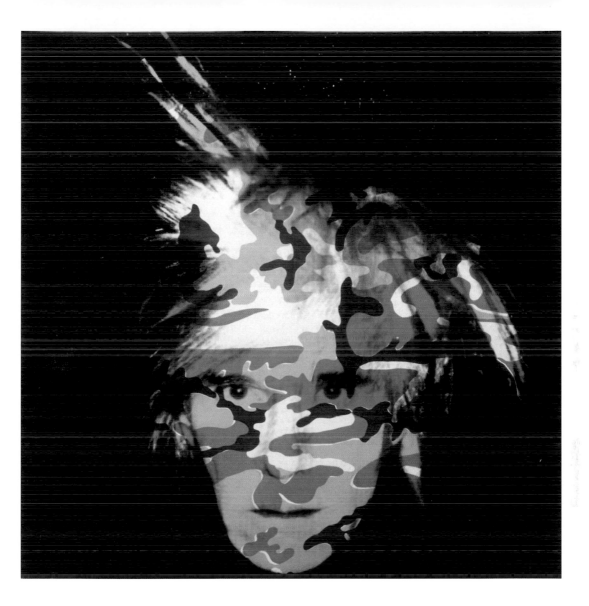

Warhol and Fame

Warhol started to collect Hollywood ephemera, especially promotional photographs for movie stars, when he was only six years old. It was a fascination that never left him. His high school graduation photograph (1945) is clearly aping the genre, and a number of photographs taken in the 1950s show Warhol posing as one or other of his celebrity heroes, amongst them Truman Capote and Greta Garbo. There are many accounts by friends of visiting Warhol in the Factory and finding the floor covered in fanzines and movie magazines. In fact he built and cultivated his public image assiduously and was careful to maintain a strict separation between that and his domestic life, which he lived mostly behind closed doors. Although he courted fame and the famous, underneath the glamorous exterior he was a remarkably shy person.

Selected bibliography

Janet Abramowicz, **Giorgio Morandi: The Art of Silence**, New Haven, Yale University Press, 2004.

Dore Ashton, **The Unknown Shore: A View of Contemporary Art**, London, Studio Vista, 1962.

Stephen Bann, **Experimental Painting: Construction, Abstraction, Destruction, Reduction**, London, Studio Vista, 1970.

Stephanie Barron, **Degenerate Art: The Fate of the Avant-Garde in Nazi Germany**, New York, Harry N. Abrams, 1991.

André Breton, **Manifestoes of Surrealism** (trans. Sever and Lane), Ann Arbor, University of Michigan Press, 1969.

André Breton, **Surrealism and Painting** (trans. Simon Watson-Taylor), London, MFA Publications, 2002.

Andrew Brighton, **Francis Bacon**, London, Tate Gallery Publishing, 2001.

Pierre Cabanne, **Dialogues with Marcel Duchamp**, London, Thames & Hudson, 1971.

Germano Celant (ed.), **Italian Art in the 20th Century**, London, Prestel and the Royal Academy of Arts, 1989.

Carolyn Christov-Bakargiev (ed.), **Arte Povera**, London, Phaidon Press, 1999.

Umberto Eco, **The Open Work** (trans. Anna Cancogni), London, Hutchinson Radius Books, 1989.

Dietmar Elger, **Expressionism**, Cologne, Taschen, 2002.

Michel Foucault, **This is not a Pipe**, Berkeley, University of California Press, 1982.

Michael Fried, **Art and Objecthood. Essays and Reviews**, Chicago, University of Chicago Press, 1998.

Matthew Gale, **Dada and Surrealism: Art and Ideas**, London, Phaidon Press, 1997.

Christopher Gray, **Cubist Aesthetic Theories**, Baltimore, John Hopkins University Press, 1953.

Clement Greenberg, **Art and Culture: Critical Essays**, Boston, Beacon Press, 1961.

Clement Greenberg, **Modernist Painting** (1961) in **Art in Theory 1900–1990: An Anthology of Changing Ideas** (Charles Harrison, Paul Wood, eds), Oxford and Cambridge, Blackwell, 1992.

Richard Gregory, **Eye and Brain: The Psychology of Seeing**, Princeton, Princeton Science Library, 1997.

George Heard Hamilton, **Manet and his Critics**, New Haven, Yale University Press, 1955.

Keith Hartley (ed.), **The Romantic Spirit in German Art 1790–1990**, Edinburgh and London, Scottish National Gallery of Modern Art and the Hayward Gallery, 1994.

Alistair Hicks, **The School of London: The Resurgence of Contemporary Painting**, London, Phaidon Press, 1990

Timothy Hilton, **Picasso**, London, Thames & Hudson, 1975.

Robert Hughes, **American Visions: The Epic History of Art in America**, New York, Alfred A. Knopf (Random House), 1998.

Wassily Kandinsky, **Concerning the Spiritual in Art**, New York, George Wittenborn, 1964.

Wassily Kandinsky and Marc Franz, **The Blaue Reiter Almanac**, London, Thames & Hudson, 1977.

Paul Klee, **On Modern Art**, London, Faber & Faber, 1954.

Paul Klee, **Paul Klee Notebooks, Vol I: The Thinking Eye**, London, Lund Humphries, 1961.

Paul Klee, **Paul Klee Notebooks, Vol II: The Nature of Nature**, London, Lund Humphries, 1973.

Lucy Lippard, **Pop Art**, London, Thames & Hudson, 1967.

Lucy Lippard, **Six Years: The Dematerialization of the Art Object from 1966 to 1972**, Berkeley, University of California Press, 1997.

Lucy Lippard, **Changing: Essays in Art Criticism**, New York, Dutton, 1971.

Marco Livingstone, **David Hockney**, London, Thames & Hudson, 1981.

Katharine Lochnan, **Turner, Whistler, Monet**, London, Tate Gallery Publications, 2005.

Kasimir Malevich, **The Non-Objective World: The Manifesto of Suprematism**, New York and London, Courier Dover Publications, 2002.

Filippo Tommaso Marinetti, **Marinetti: Selected Writings** (Flint ed.), London, Secker and Warburg, 1972.

James Meyer, **Minimalism: Art and Polemics in the Sixties**, New Haven, Yale University Press, 2001.

Linda Nochlin, **Realism: Style and Civilization**, London, Penguin Books, 1991.

John Rewald, **The History of Impressionism**, New York, Museum of Modern Art, 1946.

John Rewald, **Post-Impressionism: From Van Gogh to Gauguin**, New York, Simon and Schuster , 1956.

John Rewald (ed.), **Paul Cézanne: Letters**, Oxford, Bruno Cassirer, 1976.

Harold Rosenberg, **The Tradition of the New**, London, Thames & Hudson, 1962.

Harold Rosenberg, **Art-Works and Packages**, London, Thames & Hudson, 1969.

Irving Sandler, **The Triumph of American Painting: A History of Abstract Expressionism**, New York, Praeger, 1970.

Irving Sandler, **The New York School**, New York, Harper and Row, 1978.

Meyer Schapiro, **Modern Art: 19th and 20th Centuries**, New York, Braziller, 1979.

Howard Singerman, **Individuals: A Selected History of Contemporary Art 1945–86**, Los Angeles, Museum of Contemporary Art, 1986.

Leo Steinberg, **Other Criteria: Confrontations with 20th Century Art**, London, Oxford University Press, 1975.

Frank Stella, **Working Space (The Charles Elliot Norton Lectures)**, Cambridge, Mass., Harvard University Press, 1986.

David Sylvester, **Interviews with Francis Bacon 1962–1979**, London, Thames & Hudson, 1997.

David Sylvester, **About Modern Art: Critical Essays 1948–97**, New York and London, Henry Holt & Co., 1997.

David Sylvester, **Interviews with American Artists**, New Haven, Yale University Press, 2002.

Belinda Thomson, **Impressionism: Origins, Practice, Reception**, London, Thames & Hudson, 2000.

Kirk Varnedoe, **Jasper Johns: Writings, Sketchbook Notes, Interviews**, New York, Museum of Modern Art, 1996.

Andy Warhol, **The Philosophy of Andy Warhol (From A to B and Back Again)**, New York, Harcourt Brace Jovanovich, 1975.

Richard Wollheim, **Painting as an Art**, Princeton, Princeton University Press, 1987.

List of collections

Amsterdam, Stedelijk Museum
Lucio Fontana, **Concetto Spaziale / Attesa**, 1959. 258
Philip Guston, **Painting, Smoking, Eating**, 1973. 332
Daan van Golden, **Composition with Blue Square**, 1964. 296

Baltimore, The Baltimore Museum of Art
Chaïm Soutine, **View of Céret**, 1922. 164

Barcelona, Antoni Tàpies Foundation
Antoni Tàpies, **Pintura Bastida**, 1962. 276

Barcelona, Museu d'Art Contemporani
Jean-Michel Basquiat, **Self-Portrait**, 1986. 372

Basel, Kunstmuseum Basel
Paul Cézanne, **Mont Sainte-Victoire from Les Lauves**, 1904–06. 92
Pablo Picasso, **Two Brothers**, 1906. 88

Berlin, Brücke Museum
Emil Nolde, **Mocking of Christ**, 1909. 100

Berlin, Staatliche Museen zu Berlin, Alte Nationalgalerie
Arnold Böcklin, **The Isle of the Dead**, 1883. 46

Berlin, Staatliche Museen zu Berlin, Neue Nationalgalerie
Jean Dubuffet, **L'Oursonne (Corps de dame)**, 1950. 232

Boston, Museum of Fine Arts
Winslow Homer, **Driftwood**, 1909. 98

Buffalo, Albright-Knox Art Gallery
Paul Gauguin, **The Yellow Christ**, 1889. 60
Frank Stella, **Fez**, 1964 294

Canberra, National Gallery of Australia
Joan Miró, **Landscape**, 1927. 176
Kenneth Noland, **Oakum**, 1973. 334

Cardiff, National Museum of Wales
Jean-François Millet, **The Gust of Wind**, 1871–73. 28
Claude Monet, **Rouen Cathedral, Symphony in Grey and Rose**, 1892–94 68

Chicago, The Art Institute of Chicago
Willem de Kooning, **Excavation**, 1950. 230
Edward Hopper, **Nighthawks**, 1942. 208
Wassily Kandinsky, **Painting with Green Centre**, 1913. 130
Pablo Picasso, **Daniel-Henry Kahnweiler**, 1910. 110
Gerhard Richter, **Woman Descending the Staircase**, 1965. 304
Georges Seurat, **A Sunday on La Grande Jatte**, 1884–86. 50

Cleveland, The Cleveland Museum of Art
Pablo Picasso, **La Vie**, 1903. 80

Cologne, Galerie Gisela Capitain
Martin Kippenberger, **Self-Portrait**, 1982. 356

Cologne, Museum Ludwig
Roy Lichtenstein, **Takka Takka**, 1962. 272

Cortina d'Ampezzo, Museo d'Arte Moderna Mario Rimoldi
Alberto Savinio, **The Isle of Charms**, 1928. 182

Detroit, The Detroit Institute of Arts
Frederic Edwin Church, **Cotopaxi**, 1862. 12
James Abbott McNeill Whistler, **Nocturne in Black and Gold: The Falling Rocket**, 1875. 38

Düsseldorf, Kunstsammlung Nordrhein-Westfalen
Max Beckmann, **Night**, 1918–19. 152
René Magritte, **The Empty Mask**, 1928. 178

Edinburgh, Scottish National Gallery of Modern Art
Giorgio Morandi, **Still Life**, 1962. 274

Essen, Folkwang Museum
Franz Marc, **Horse in a Landscape**, 1910. 106

Fort Worth, Amon Carter Museum
Thomas Eakins, **Swimming (The Swimming Hole)**, 1885. 48

Fort Worth, The Modern Art Museum of Fort Worth
Philip Guston, **The Light**, 1964. 286
Hans Hofmann, **To Miz: Pax Vobiscum**, 1964. 290

Frankfurt am Main, Museum für Moderne Kunst
 Blinky Palermo, **Butterfly II**, 1969. 320

Glasgow, Glasgow City Council Museums
 Bridget Riley, **Punjab**, 1971. 330

Grenoble, Musée de Grenoble
 Claude Monet, **Water Lily Pond at Giverny**, 1917. 150

Hamburg, Hamburger Kunsthalle
 Robert Delaunay, **Window into Town**, 1912. 122

Hannover, Niedersächsisches Landesmuseum
 Claude Monet, **Saint-Lazare Station, Exterior (The Signal)**, 1877. 42

Hannover, Sprengel Museum
 Karl Schmidt-Rottluff, **Four Bathers on the Beach**, 1913. 132

Houston, The Menil Collection
 René Magritte, **The Telescope**, 1963. 280

Houston, The Museum of Fine Arts
 Susan Rothenberg, **Red Banner**, 1979. 352

Humlebæk, Louisiana Museum for Moderne Kunst
 Georg Baselitz, **The Head of Abgar**, 1984. 364

Jabbeke, Provinciaal Museum Constant Permeke
 Constant Permeke, **The Potato Digger**, 1929. 188

London, Courtauld Institute of Art Gallery
 Paul Cézanne, **Still Life with Plaster Cupid**, c. 1895. 70
 Édouard Manet, **A Bar at the Folies-Bergère**, 1881–82. 44

London, The National Gallery
 Paul Cézanne, **The Grounds of the Château Noir**, c. 1900–06. 82
 Edgar Degas, **Young Spartans Exercising**, c. 1860–62. 14

London, Tate Collection
Balthus (Balthasar Klossowski de Rola), **Sleeping Girl**, 1943. 210
Patrick Caulfield, **Greece Expiring on the Ruins of Missolonghi (after Delacroix)**, 1963. 278
Salvador Dalí, **Mountain Lake: Beach with Telephone**, 1938. 204
Richard Hamilton, **The Citizen**, 1981–83. 360
David Hockney, **Man Taking a Shower in Beverly Hills**, 1964. 288
Leon Kossoff, **Children's Swimming Pool, Autumn Afternoon**, 1971. 328
Agnes Martin, **Morning**, 1965. 302
Stanley Spencer, **Double Nude Portrait: The Artist and His Second Wife**, 1937. 202
Clyfford Still, **Untitled 1953**, 1953. 240
James Abbott McNeill Whistler, **Nocturne: Blue and Silver – Chelsea**, 1871. 26

Los Angeles, The J. Paul Getty Museum
James Ensor, **Christ's Entry into Brussels in 1889**, 1888. 54

Los Angeles, The Museum of Contemporary Art
Ellsworth Kelly, **Two Panels: Yellow with Large Blue**, 1970. 322

Madrid, Museo Nacional Centro de Arte Reina Sofía
Pablo Picasso, **Guernica**, 1937. 198

Madrid, Museo Thyssen-Bornemisza
Otto Dix, **Hugo Erfurth with his Dog**, 1926. 172
Paul Gauguin, **Mata Mua (In Olden Times)**, 1892. 66
George Grosz, **Metropolis**, 1916–17. 148
Edward Hopper, **Hotel Room**, 1931. 190
Christian Schad, **Portrait of Dr Haustein**, 1928. 184
Kurt Schwitters, **Merzbild Kijkduin**, 1923. 166

Mamiano di Traversetolo, Fondazione Magnani Rocca
Giorgio Morandi, **The Courtyard of the Via Fondazza**, 1954. 244

Manchester, Manchester Art Gallery
Howard Hodgkin, **The Hopes at Home**, 1973–77. 346

Merion, The Barnes Foundation
Henri Matisse, **The Joy of Life**, 1905–06. 86

Mexico City, Museo Dolores Olmedo Patiño
Frida Kahlo, **Henry Ford Hospital**, 1932. 192

Mexico City, Museo Tamayo Arte Contemporáneo
Matta, **Pecador Justificado (Justified Sinner)**, 1952. 236

Middlebury, The Middlebury College Museum of Art
 Théodore Rousseau, **The Gorges d'Apremont at Midday**, 1857. 10

Milan, Civico Museo d'Arte Contemporanea
 Umberto Boccioni, **States of Mind I: Those Who Go**, 1911. 112

Milan, The Gianni Mattioli Collection
 Gino Severini, **The Blue Dancer**, 1912. 124

Milan, Pinacoteca di Brera
 Giorgio Morandi, **Still Life**, 1919. 156
 Mario Sironi, **Urban Landscape with Chimneys**, 1921. 162

Minneapolis, The Walker Art Center
 Piero Manzoni, **Achrome**, *c.* 1958. 254
 Michelangelo Pistoletto, **Three Girls on a Balcony**, 1962–63. 282

Montreal, The Museum of Fine Arts
 Gerhard Richter, **AB, Mediation**, 1986. 374

Moscow, State Tretyakov Gallery
 Kasimir Malevich, **Black Square**, 1915. 140

New Haven, Yale University Art Gallery
 Vincent van Gogh, **The Night Café**, 1888. 58

New York, The Metropolitan Museum of Art
 Marsden Hartley, **Portrait of a German Officer**, 1914. 136
 Amedeo Modigliani, **Portrait of Jeanne Hébuterne**, 1918–19. 154
 Georgia O'Keeffe, **Black Iris**, 1926. 174
 Andy Warhol, **Camouflage Self-Portrait**, 1986. 376

New York, The Museum of Modern Art
 Milton Avery, **Sea Grasses and Blue Sea**, 1958. 252
 Willem de Kooning, **Woman I**, 1950–52. 234
 Philip Guston, **Painting**, 1954. 242
 David Hockney, **Kerby (after Hogarth) Useful Knowledge**, 1975. 336
 Yves Klein, **Anthropometry: Princess Helena**, 1960. 262
 Fernand Léger, **Three Women (Le Grand Déjeuner)**, 1921. 160
 André Masson, **The Kill**, 1944. 214
 Piet Mondrian, **Composition C (Composition with Red, Blue, Black and Yellow-Green)**, 1920. 158
 Pablo Picasso, **Les Demoiselles d'Avignon**, 1907. 96
 Larry Rivers, **Washington Crossing the Delaware**, 1953. 238
 Henri ('Le Douanier') Rousseau, **The Sleeping Gypsy**, 1897. 72

New York, Solomon R. Guggenheim Museum
 Richard Diebenkorn, **Ocean Park No. 96**, 1977. 340
 Wassily Kandinsky, **Study for Composition II**, 1909–10. 102
 Anselm Kiefer, **Seraphim**, 1983–84. 368
 Brice Marden, **Grove Group IV**, 1976. 338
 Mark Rothko, **Untitled (Black on Grey)**, 1969–70. 324

New York, Whitney Museum of American Art
 Arshile Gorky, **The Betrothal II**, 1947. 220
 Mark Rothko, **Four Darks in Red**, 1958. 256
 Frank Stella, **Die Fahne Hoch!**, 1959. 260

Niigata, Niigata City Art Museum
 Pierre Bonnard, **Woman Bending Over**, 1907. 94

Nottingham, City of Nottingham Museums, Castle Museum and Art Gallery
 Walter Richard Sickert, **Noctes Ambrosianae**, 1906. 90

Oslo, Nasjonalgalleriet
 Edvard Munch, **The Dance of Life**, 1899–1900. 74

Ottawa, National Gallery of Canada
 Barnett Newman, **Voice of Fire**, 1967. 316

Otterlo, Kröller-Müller Museum
 Vincent van Gogh, **Road with Men Walking, Carriage, Cypress, Star, and Crescent Moon**, 1890.

Paris, Musée d'Orsay
 Gustave Courbet, **The Artist's Studio**, 1855. 8
 Gustave Courbet, **The Origin of the World**, 1866. 22
 Edgar Degas, **In a Café (Absinthe)**, 1875–76. 40
 André Derain, **Charing Cross Bridge**, 1906. 84
 Édouard Manet, **Olympia**, 1863. 16
 Gustave Moreau, **Young Girl Carrying the Head of Orpheus**, 1865. 18
 Odilon Redon, **Joan of Arc**, 1900. 76
 Paul Sérusier, **The Talisman (Landscape in the Bois d'Amour)**, 1888. 56
 Georges Seurat, **Circus**, 1890–91. 64

Paris, Musée du Petit Palais
 Alfred Sisley, **Avenue of Chestnut Trees at La Celle-Saint-Cloud**, 1865. 20

Paris, Musée Marmottan
 Claude Monet, **Impression, Sunrise**, 1872–73. 30

Paris, Musée National d'Art Moderne, Centre Georges Pompidou
Pierre Bonnard, **Portrait of the Artist in the Bathroom Mirror (Self-Portrait)**, 1943–45. 216
Yves Klein, **Untitled Fire Painting (F74)**, 1961. 268

Perth, Art Gallery of Western Australia
Lucian Freud, **Naked Man with Rat**, 1977. 344

Philadelphia, Jefferson Medical College, Thomas Jefferson University
Thomas Eakins, **The Gross Clinic**, 1875. 36

Philadelphia, Philadelphia Museum of Art
Marcel Duchamp, **Nude Descending a Staircase, No 2**, 1912. 120
Marcel Duchamp, **Bride**, 1912. 126
Marcel Duchamp, **Étant donnés: 1. la chute d'eau, 2. le gaz d'éclairage**, 1946–66. 308

Pittsburgh, Carnegie Museum of Art
David Hockney, **Divine**, 1979. 348

Riehen, Fondation Beyeler
Francis Bacon, **Triptych in Memory of George Dyer**, 1971. 326

Rivoli, Castello di Rivoli, Museo d'Arte Contemporanea
Luciano Fabro, **Attaccapanni (di Napoli)**, 1976–77. 342
Per Kirkeby, **Sunset**, 1983–84. 370

Rouen, Musée des Beaux-Arts
Jean-Baptiste Camille Corot, **The Ponds at Ville-d'Avray**, 1868. 24

San Francisco, San Francisco Museum of Modern Art
Jackson Pollock, **Guardians of the Secret**, 1943. 212
Frank Stella, **Wolfeboro I**, 1966. 312

Santa Barbara, Santa Barbara Museum of Art
Berthe Morisot, **View of Paris from the Trocadéro**, c. 1871–73. 32

St Petersburg, State Hermitage Museum
Edgar Degas, **Place de la Concorde**, 1875. 34
Henri Matisse, **Music**, 1910. 108

Stockholm, Moderna Museet
Jasper Johns, **Slow Fields**, 1962. 270
Ernst Ludwig Kirchner, **Marcella**, 1909–10. 104
Andy Warhol, **Big Electric Chair**, 1967. 318

Stuttgart, Staatsgalerie
Giorgio De Chirico, **Metaphysical Interior with Large Factory**, 1916–17. 146
Yves Klein, **Untitled Blue Monochrome (IKB 219)**, 1956. 250

Sydney, Art Gallery of New South Wales
Frank Auerbach, **Primrose Hill, Autumn**, 1984. 362
Francesco Clemente, **Water and Wine**, 1981. 354

Tilburg, De Pont Museum voor Hedendaagse Kunst
René Daniëls, **A Hot Day in the Lighthouse**, 1984. 366

Tokyo, The Watari Museum of Contemporary Art
Sigmar Polke, **The Copyist**, 1982. 358

Toronto, Art Gallery of Ontario
Mario Merz, **Crocodile in the Night**, 1979. 350

Trieste, Museo Revoltella
Mario Sironi, **Shepherd**, 1932. 194

Troyes, Musée d'Art Moderne
André Derain, **Still Life on a Black Ground**, 1945. 218

Tübingen, Kunsthalle Tübingen
Richard Hamilton, **Just what is it that makes today's homes so different, so appealing?**, 1956.

Turin, Galleria Civica d'Arte Moderna e Contemporanea
Felice Casorati, **Portrait of Hena Rigotti**, 1924. 170

Venice, Peggy Guggenheim Collection
Giacomo Balla, **Abstract Speed + Sound**, 1913–14. 134
Giorgio De Chirico, **The Red Tower**, 1913. 128
Marcel Duchamp, **Sad Young Man on a Train**, 1911. 116
Max Ernst, **Attirement of the Bride**, 1940. 206
Joan Miró, **Dutch Interior II**, 1928. 180
Francis Picabia, **Very Rare Picture on the Earth**, 1915. 142
Jackson Pollock, **Enchanted Forest**, 1947. 226

Vienna, Leopold Museum
Gustav Klimt, **The Large Poplar II (The Gathering Storm)**, 1903. 78
Egon Schiele, **Black-Haired Girl with Skirt Turned up**, 1911. 114
Egon Schiele, **Cardinal and Nun (Caress)**, 1912. 118

Washington, Hirshhorn Museum and Sculpture Garden, Smithsonian Institution
Francis Bacon, **Triptych Inspired by T. S. Eliot's 'Sweeney Agonistes'**, 1967. 314
Alberto Giacometti, **Annette**, 1961. 266
Morris Louis, **Where**, 1960. 264
Piet Mondrian, **Composition with Blue and Yellow**, 1935. 196
Ed Ruscha, **Ace**, 1962–63. 204

Washington, National Gallery of Art
Georg Baselitz, **Man in the Moon – Franz Pforr**, 1965. 298
Georges Braque, **Still Life: Le Jour**, 1929. 186
Max Beckmann, **The Argonauts**, 1949–50. 228
Marcel Broodthaers, **Mussel Shells**, 1966. 306
Ad Reinhardt, **Abstract Painting, No. 34**, 1964. 292

Washington, The Phillips Collection
Helen Frankenthaler, **Canyon**, 1965. 300
Juan Gris, **Still Life with Newspaper**, 1916. 144

Zürich, Kunsthaus Zürich
Oskar Kokoschka, **Still Life with Cupid and Rabbit**, 1913–14. 138

Private collections
Jasper Johns, **Target with Plaster Casts**, 1955. 246
René Magritte, **The Pictorial Contents**, 1947. 224

Index

Artists' names in **bold** and page numbers in **underlined bold** refer to the main entries.
Underlined page numbers refer to secondary images.

Agnew, Thomas 39, 314
Albers, Josef 69, 338
Alloway, Lawrence 243
Anatol 320
Andre, Carl 294
Andrée, Ellen 40
Antes, Horst 368
Apollinaire, Guillaume 122, 127, 142, 206
Arp, Jean 166, 178, 206
Artaud, Antonin 218, 298
Auden, Wystan Hugh 336
Auerbach, Frank 165, 289, 328, 329, **362**
Avery, Milton 109, **252**, 256
Ažbe, Anton 290
Bachardy, Don 336
Bachelard, Gaston 268
Bacon, Francis 282, 289, **314**, **326**
Baj, Enrico 245
Baker, Josephine 192
Bakunin, Mikhail 124, 316
Balla, Giacomo 112, **134**, 162
Balthus (Balthasar Klossowski de Rola) **210**
Bannard, Darby 260
Barnes, Albert C. 165
Bartolini, Luigi 157
Baselitz, Georg **298**, **364**
Basquiat, Jean-Michel **372**
Baudelaire, Charles 8, 76, 212
Bazille, Frédéric 20, 30
Baziotes, William 238
Beckett, Samuel 266
Beckmann, Max **152**, 184, **228**, 230, 332
Beethoven, Ludwig van 78
Bellows, George 208
Benton, Thomas Hart 212
Bernard, Émile 18, 58, 60, _60_
Bernheim, Jacques 182
Bertin, Jean Victor 24
Beuys, Joseph 320, 321, 368
Bey, Khalil 22
Blavatsky, Helena Petrovna 130
Bleyl, Fritz 104

Blistène, Bernard 373
Boccioni, Umberto _112_, 124, 134, 162, 194, _194_
Böcklin, Arnold _46_, 128, 182
Böcklin, Maria 46
Bomberg, David 166, 202, 328, _329_, 362
Bonito Oliva, Achille 350, 354, 355
Bonnard, Pierre 56, _94_, 210, **216**
Bosch, Hieronymus 148
Boshier, Derek 249, 288
Bottai, Giuseppe 194
Botticelli, Sandro 14
Boudin, Eugène 30
Bouguereau, Adolphe-William 86
Bourdelle, Antoine 266
Bourgeois, Pierre 178
Bourgeois, Victor 178
Boursin, Maria 94, 217, 218
Bradley, Francis Herbert 327
Brancusi, Constantin 154, 322
Braque, Georges 25, 82, _83_, 84, 92, 120, 132, 144, 158, **186**, 290
Bresdin, Rodolphe 76
Breton, André 176, 178, 214, 232, 236, 266, 267
Bronzino, Agnolo 170, 298
Broodthaers, Marcel **306**, 366
Brossa, Joan 276
Browner, Juliet 206
Buffet-Picabia, Gabrielle 117, 127
Buñuel, Luis 204
Burri, Alberto 254
Bush, Jack 334
Cage, John 246, 374
Capote, Truman 376, 377
Carline, Hilda 202
Carlo Alberto, King 129
Caro, Anthony 334
Carrà, Carlo 124, _124_, 125
Casagemas, Carlos 80
Casorati, Felice **170**
Cassirer, Paul 138
Castellani, Enrico 255
Castelli, Leo 260, 270, 272, 313

Caulfield, Patrick 109, **278**, 288
Cenni, Silvana 170
Cézanne, Paul 70, 72, **82**, 86, **92**, 96, 110,
 122, 156, 244, 244, 266
Chagall, Marc 164
Chamberlain, Neville 204
Champfleury, Jules 9
Chase, William Merritt 136, 190
Chevreul, Michel-Eugène 50, 52, 52, 59, 64, 122, 162
Chia, Sandro 350, 355
Chirico, Andrea De *see* Savinio, Alberto
Chirico, Giorgio De 47, 47, **128**, **146**, 182, 183,
 206, 210, 311
Church, Frederic Edwin 12, 36
Clarke, Ossie 288
Clemente, Francesco 350, **354**
Cocteau, Jean 154, 210
Cole, Thomas 12
Constable, John 10, 10, 11
Copley, William 308
Cordell, Magda 248
Corinth, Lovis 79, 152
Cormon, Fernand 58, 142, 164
Corot, Jean-Baptiste Camille 10, 20, 20,
 24, 28, 29, 32, 32
Corso, Gregory 238, 239
Courbet, Gustave 8, 16, 17, 20, **22**, 25, 36
Couture, Thomas 16
Cranach the Elder, Lucas 206, 206
Crosby, Theo 248
Crumb, Robert 332, 332
Cucchi, Enzo 350
Cunningham, Merce 246
Dahn, Walter 356
Dalí, Gala 204
Dalí, Salvador 178, **204**
Daniëls, René 366
Daubigny, Charles-François 11
Daumier, Honoré 90
David, Jacques-Louis 14, 238, 239
Davis, Stuart 220
Deakin, John 326, 326
Degas, Edgar 14, 16, **34**, **40**, 43, 45, 60, 90, 95
Delacroix, Eugène 10, 278, 279
Delaunay, Robert 122, 131, 160, 206, 290

Delaunay, Sonia 122, 290
Denis, Maurice 56, 94
Depero, Fortunato 134
Derain, André 84, 86, 108, 154, **218**, 290
Desboutin, Marcellin 40
Diaghilev, Sergei 122, 144
Diaz de la Peña, Narcisse 10, 10, 20
Diaz, Al 372
Diebenkorn, Richard 340
Divine 348, 349
Dix, Otto 148, 152, **172**, 184, 344
Doesburg, Theo Van 158, 196, 196, 322
Dokoupil, Jiři 356
Dove, Arthur 136
Dow, Arthur 174, 175
Dreher, Peter 368
Dubuffet, Jean 232, 234
Duccio di Buoninsegna 154
Duchamp, Alexina 'Teeny' 310
Duchamp, Marcel 23, 23, **116**, **120**, **126**, 142,
 160, 236, 246, 297, 304, **308**
Duchamp, Suzanne 116
Duchamp-Villon, Raymond 116
Dufy, Raoul 232, 348
Durand-Ruel, Paul 66
Dürer, Albrecht 76
Dyer, George 326
Eakins, Thomas 36, **48**
Ekster, Aleksandra 140
Eliot, Thomas Stearns 314, 315, 327
Eluard, Paul 178, 266
Empedocles 262
Ensor, James 54
Erfurth, Hugo 172
Ernst, Max 148, 176, **206**, 266, 311
Fabro, Luciano 342
Fautrier, Jean 254
Feininger, Lyonel 102
Feuerbach, Anselm 47
Figgis, Mike 191
Fischer, Konrad 358
Flaubert, Gustave 76
Flavin, Dan 294, 295
Flouquet, Pierre-Louis 178
Fontana, Lucio 244, 254, **258**, 342

Francesca, Piero della 156, 170, 210
Franco, Francisco 198, 200, 201, 204
Frank, Robert 239
Frankenthaler, Helen 264, 264, **300**, 334
Freud, Lucian 289, **344**
Freud, Sigmund 128, 138, 184, 344
Freyburg, Karl von 136, 137
Fried, Michael 260, 313
Friedrich, Caspar David 47, 299
Funi, Achille 170, 194
Gachet, Paul 62
Galí, Francesc 176
Garbo, Greta 377
Garcia Lorca, Federico 204
Gauguin, Paul 25, 56, 57, 58, 58, **60**, 62,
 66, 86, 95, 100, 106, 109, 131
Gautier, Théophile 10
Geldzahler, Henry 372
Genet, Jean 266
Geoffroy, Gustave 150
Gérôme, Jean-Léon 36, 76
Giacometti, Alberto 244, **266**
Giacometti, Annette 266
Gide, André 210
Ginsberg, Allen 238, 239
Giotto di Bondone 156
Glaser, Bruce 294
Gleizes, Albert 116
Gleyre, Charles 20, 26, 30
Gloeden, Wilhelm von 49
Gödel, Kurt 120
Godet, Robert 262
Goethe, Johann Wolfgang von 52
Gogh, Theo van 58
Gogh, Vincent van 29, 55, **58**, 60, **62**, 67,
 84, 86, 100, 101, 104, 104, 106, 188
Golden, Daan van 296
Gorky, Arshile 215, **220**, 230, 237, 237, 264, 290
Gottlieb, Adolph 252, 256
Gotz, Karl Otto 304
Greenberg, Clement 150, 230, 241, 260,
 265, 270, 294, 300, 334
Greuze, Jean-Baptiste 16
Gris, Juan 25, 72, 72, **144**, 186, 278, 279
Gropius, Walter 102

Gross, Samuel David 36
Grosz, George **148**, 152, 172, 184
Grünwald, Altred 206
Guggenheim, Peggy 206, 226, 256
Guillemot, Maurice 30
Guston, Philip 92, 237, **242**, **286**, 298, **332**
Hamilton, Richard **248**, **360**
Hamilton, Terry 248
Hannibal 358
Hansen, Emil 100
Hartley, Marsden **136**, 252
Hausmann, Raoul 166
Haussmann, Georges-Eugène 42
Haustein, Hans 184
Hay, Deborah 352
Heartfield, John 148
Hébuterne, Jeanne, 154, 155
Heckel, Erich 104, 105
Heindel, Max 250, 251
Heisterkamp, Peter see Palermo, Blinky
Henderson, Nigel 248
Henri, Robert 190, 191, 208
Hepworth, Dorothy 202
Heraclitus of Ephesus 268
Herriman, George 332
Herzfeld, Karl-Heinz 320
Heymann, Moritz 290
Hiffernan, Joanna 27
Hindemith, Paul 138
Hiroshige, Ando 94
Hitchcock, Alfred 191
Hitchens, Ivon 314
Hitler, Adolf 152, 157, 204, 260
Hockney, David 109, 249, 278, **288**, **336**, **348**
Hodgkin, Howard 109, **346**
Hofmann, Hans 56, 57, 238, 260, **290**
Hofmann, Werner 78
Hogarth, William 336, 337
Homer, Winslow **98**
Hopper, Edward **190**, **208**, 340
Hughes, Robert 12
Humbert, Ferdinand 142
Humboldt, Alexander von 12
Huston, John 190, 191
Huysmans, Joris-Karl 18, 76

Ibels, Henri-Gabriel 56, 94
Ibsen, Henrik 132
Indiana, Robert 302, 322
Ingres, Jean Auguste Dominique 14, 50, 155, <u>155</u>
Irwin, Robert 284
Isherwood, Christopher 336
Jackson, Martha 264
Jacob, Max 232
Jaeger, Hans 74
Jagger, Mick 376
Janis, Carroll 120
Janis, Harriet 120
Janis, Sidney 120, 234, 323
Jarry, Alfred 94
Jawlensky, Alexei 69, 106
Johns, Jasper 122, 234, **<u>246</u>**, 249, 260, **<u>270</u>**, 297, 338
Jonas, Joan 352
Jones, Allen 249, 278, 288
Jongkind, Johan Barthold 30
Joppolo, Beniamino 259
Jorn, Asger 245
Joyce, James 360
Judd, Donald 294
Jung, Carl 212, 213
Kahlo, Frida <u>192</u>
Kahnweiler, Daniel-Henry 110, 186, 198, 214
Kaisserlian, Giorgio 259
Kallman, Chester 336
Kandinsky, Wassily <u>102</u>, 106, 122, **<u>130</u>**, 136, 290
Kant, Immanuel 39, 93
Kaprow, Allen 272
Kazan, Elia 191
Kelly, Ellsworth 300, 302, **<u>322</u>**
Kennedy, Matthew 349
Kennedy, Robert 332
Kerouac, Jack 238, 239
Khnopff, Fernand 54
Kiefer, Anselm 299, 364, **<u>368</u>**
Kienholz, Edward 284
Kiernan, Barny 360
Kippenberger, Martin <u>356</u>
Kirby, Joshua 336
Kirchner, Ernst Ludwig <u>104</u>, 132, 133
Kirkeby, Per <u>370</u>
Kisling, Moïse 154

Kitaj, Ron 249, 288, **<u>288</u>**, 289, 329
Klee, Paul 100, 102, 136, 206, 276
Kleighton, Harvey 339
Klein, Yves <u>250</u>, 254, **<u>262</u>**, **<u>268</u>**, 296, 303, 342
Klimt, Gustav <u>78</u>, 114, 118, <u>119</u>
Kline, Franz 300
Klinger, Max 47, 128
Knobloch, Madeleine 64
Koffka, Kurt 197
Kokoschka, Oskar 79, **<u>138</u>**, 165
König, Kasper 225
Kooning, Willem de 215, 220, 223, **<u>230</u>**, **<u>234</u>**, 237, 238, 286, 290, 298, 300
Kossoff, Leon 165, **<u>328</u>**, 362
Krasner, Lee 300
Kraus, Karl 78
Krohg, Christian 74
Kropotkin, Peter 316
Kubinski, Achim 356, 357
Kunisada, Utagawa 94
Kuniyoshi, Utagawa 94, <u>95</u>
Kupka, Frantisek 131
Lacan, Jacques 22
Lamothe, Louis 14
Laurencin, Marie 186
Lautréamont, Comte de 298
Le Corbusier 236
Leck, Bart van der 158
Léger, Fernand 116, 144, **<u>160</u>**, 164
Lenin, Vladimir 148
Leonardo da Vinci 18
Lepic, Ludovic-Napoléon 34
Leroy, Louis 31
Leslie, Alfred 239
Leutze, Emanuel 238, <u>238</u>
Lichtenstein, Roy 249, **<u>272</u>**, 300
Liebermann, Max 79, 152
Lipchitz, Jacques 154
Liston, Sonny 320
Lohaus, Bernd 320
Lombroso, Cesare 134
Loos, Adolf 138
Louis, Morris 69, **<u>264</u>**, 334
Lugné-Poë, Aurélien 94
Maar, Dora 200

MacCool, Finn 360, 361
Mack, Heinz 255
Macke, August 106, 107
Magritte, René 178, **224**, 276, **280**, 366
Mahler, Alma 138
Mahler, Gustav 138
Maistre, Roy de 315
Malevich, Kasimir 131, **140**, 302, 303
Mallarmé, Stéphane 76
Malraux, André 210
Manet, Édouard 16, 25, 32, 34, 35, 36, 42, **44**
Mantegna, Andrea 14
Manzoni, Piero 244, **254**, 306, 342
Marc, Franz 102, **106**, 136
Marden, Brice 338
Marées, Hans von 47, 228, 229
Marey, Étienne-Jules 116, 120, 120
Marin, John 136
Marin, Louis 227
Marinetti, Filippo Tommaso 112, 162
Martin, Agnes 294, **302**, 322
Martin, John 12, 13
Martini, Arturo 170
Martini, Simone 154
Martins, Maria 308, 310
Marx, Karl 9, 124
Mascagni, Pietro 182
Massine, Leonide 122
Masson, André 22, 176, **214**, 223, 226
Matisse, Henri 18, 84, **86**, 106, **108**, 136, 144, 252, 256, 290, 311, 340, 341, 346, 348
Matta Echaurren, Roberto Sabastien 236
Matura, Helga 305
Mauve, Anton 58
McHale, John 248
Méligny, Marthe de *see* Boursin, Maria
Merleau-Ponty, Maurice 254
Merz, Mario 350
Metzinger, Jean 116
Meurent, Victorine 16, 17, 44
Michelangelo Buonarroti 70
Micheli, Guglielmo 154
Milani, Milena 259
Miller, Dorothy 260
Millet, Jean-François 10, **28**

Milton, John 315
Minnelli, Liza 376
Miró, Joan 176, 178, **180**, 222, 223, 266, 276
Mistead, Harris Glen 348
Moa 114, 115
Modigliani, Amedeo 154, 164
Moitessier, Madame Paul-Sigisbert 155
Moll, Carl 79
Mondrian, Piet 69, 131, **158**, **196**, 242, 243, 296, 322, 340
Monet, Claude 16, 20, 21, 25, 25, **30**, 32, 32, 33, 33, 34, 35, **42**, **68**, 84, **150**, 242, 334
Morandi, Giorgio 156, **244**, **274**
More, Thomas 227
Moreau, Gustave 18, 86, 206, 206
Moreno Carbonero, José 144
Morisot, Berthe 32
Morris, Cedric 344
Mortensen, Richard 55
Moses, Edward 284
Motherwell, Robert 237, 286
Mozart, Wolfgang Amadeus 348
Mulas, Hugo 260, 319
Munch, Edvard 74
Musgrave, Victor 330
Mussolini, Benito 157, 162, 163, 194, 195
Muybridge, Eadweard 48, 116
Myers, John 238
Nagy, Tibor de 300
Napoleon Bonaparte, Emperor 238, 239
Napoleon III, Emperor 42
Nash, Paul 202
Needham, Joseph 302
Neuzil, Wally 118
Newman, Barnell 109, 223, 252, 253, 270, 300, 302, **316**
Nietzsche, Friedrich 124, 128, 129, 132, 156, 182, 183, 213, 324
Nivison, Josephine 190
Noland, Kenneth 264, 294, **334**
Nolde, Emil 100
Novalis 324, 325
O'Doherty, Brian 294
O'Hara, Frank 238
O'Keeffe, Georgia 136, **174**, 252

Olbrich, Joseph Maria 78
Oldenburg, Claes 272, 297
Olitski, Jules 150, 252, 300, 334
Orlovsky, Peter 239
Orozco, José Clemente 242
Osen, Erwin 114, 118
Oudinot, Achille-François 32
Ovid 218
Ozenfant, Amédée 72, _73_
Paladino, Nimo 350
Palermo, Blinky _320_
Paolini, Giulio 276, _277_
Paolozzi, Eduardo 248
Parmigianino 298
Parsons, Betty 212, 292, 302, 316, 322
Pascin, Jules 290
Pasmore, Victor 314
Permeke, Constant _188_
Pforr, Franz 298, 299
Phillips, Peter 249, 278, 288
Picabia, Francis 116, 127, **_142_**, 160, 186, 322, 366
Picasso, Pablo 25, **_80_**, 82, 84, **_88_**, 92, _92_,
　　　　96, **_110_**, 120, 132, 136, 144, _145_, 154,
　　　　158, 176, 186, _186_, **_198_**, 204, 212, _213_,
　　　　216, 223, 229, 266, 290
Pichot, Ramón 204
Piene, Otto 255
Pinkham Ryder, Albert 136
Piper, John 314
Pisis, Filippo de 146
Pissarro, Camille 16, 25, 33, 51
Pistoletto, Michelangelo _282_
Plato 156
Plüschow, Wilhelm von 49
Poe, Edgar Allan 76
Polke, Sigmar 304, 320, **_358_**, 362
Pollock, Charles 212
Pollock, Jackson 150, **_212_**, 215, 223, **_226_**, 237,
　　　　238, 242, 256, 290, 291, 298, 300
Polyclitus 48
Pontormo, Jacopo Carucci da 170, 298, _299_
Poons, Larry 252, 294, _295_
Poussin, Nicolas 24, 25, 314
Preece, Patricia 202
Price, Ken 284

Prinzhorn, Hans 232
Proudhon, Pierre-Joseph 9
Proust, Marcel 18, 68
Puvis de Chavannes, Pierre 50
Rabelais, François 218
Rabin, Sam 330
Ranson, Paul 56, 94
Raphael 14
Rauschenberg, Robert 234, 246, 318
Ray, Man 206
Read, Herbert 314
Redon, Odilon 18, 25, **_76_**
Reger, Max 182
Reinhardt, Ad 287, **_292_**, 294, 296, 303
Rembrandt van Rijn 36, 54, 76, 358
Renoir, Auguste 20, 25, 30, 95
Ribera, Jusepe de 16, 36, _37_
Richards, Ceri 314
Richter, Gerhard 90, **_304_**, 320, 358, **_374_**
Rigotti, Hena 170
Riley, Bridget _330_, 362
Rilke, Rainer Maria 210
Riopelle, Jean-Paul 55
Rivera, Diego 192
Rivers, Larry _238_
Roessler, Arthur 114
Rönnebeck, Arnold 136, 137
Rood, Ogden 50, 52
Rooney, Hugh 360
Roosevelt, Franklin Delano 209
Rosenberg, Harold 241
Rosenquist, James 358
Rothenberg, Susan _352_
Rothko, Mark 109, 215, 223, 240, 252,
　　　　253, **_256_**, 293, **_324_**
Rouart, Henri 28
Rouault, Georges 18
Rousseau, Henri ('Le Douanier') _72_
Rousseau, Théodore _10_, 20
Roussel, Ker-Xavier 18
Roussel, Raymond 127
Ruscha, Ed _284_
Ruskin, John 12, 38
Russell, Bertrand 120
Ruthenbeck, Rainer 320

Ryman, Robert 303
Rysselberghe, Théo van 54
Saint-Denis, Ruth 114
Sarfatti, Margherita 194
Sartre, Jean-Paul 266
Savinio, Alberto 128, 146, **182**, 194
Schad, Christian 184, 344
Schapiro, Meyer 292, 300
Schiele, Egon 79, **114**, **118**
Schlemmer, Oskar 102
Schlesinger, Peter 336, 337
Schmela, Alfred 320
Schmidt-Rottluff, Karl 100, 104, 105, **132**
Schönberg, Arnold 102
Schönebeck, Eugen 298
Schopenhauer, Arthur 124
Schwitters, Ernst 166
Schwitters, Gert 169
Schwitters, Kurt 148, **166**, 306
Scriabin, Aleksander 102
Serner, Walter 184
Sert, Josep Luis 176
Sérusier, Paul 56, 60, 94, 131
Seurat, Georges 50, 58, 59, **64**, 76, 84, 104, 111, 311, 330
Severini, Gino 124, 112, 134, 154
Seymour Haden, Francis 27
Sickert, Walter Richard 28, **90**, 218, **219**
Signac, Paul 58, 59, 86
Siqueiros, David Alfaro 212, 226, **226**, 242, 264
Sironi, Mario 112, **162**, **194**
Sisley, Alfred 16, **20**, 30
Slevogt, Max 152
Sloan, John 208
Smith, David 300
Smith, Dick 330
Solman, Joseph 256
Sordini, Ettori 255
Sorgh, Hendrick Martenz 180
Soutine, Chaïm 154, **164**
Spencer, Stanley 202
Sprovieri, Giuseppe 162
Stalin, Josef 140
Steen, Jan 178, 180, _180_
Stein, Gertrude 136, 142

Steiner, Rudolf 130
Stella, Frank 69, **260**, **294**, **312**
Stieglitz, Alfred 79, 136, 142, 174
Still, Clyfford 240, 253, 270
Storr, Robert 304
Stravinsky, Igor 122, 336
Strindberg, August 132
Stuck, Franz von 79
Sutherland, Graham 314
Sylvester, David 327
Tamayo, Rufino 300
Tanguy, Yves 237
Tanning, Dorothea 206
Tàpies, Antoni 276
Tatlin, Vladimir 140
Taylor, Brook 336, 337
Terk, Sonia _see_ Delaunay, Sonia
Thoma, Hans 79
Tilson, Joe 330, 362
Tobey, Mark 293
Tolstoy, Leo 238
Toulouse-Lautrec, Henri de 58, 154
Trotsky, Leon 148, 192
Tucker, Benjamin 316
Turnbull, William 248
Turner, Joseph Mallord William 33, _38_, 39, 42, _42_, 52, 358
Tworkov, Jack 264
Tzara, Tristan 142
Uccello, Paolo 156, _157_, 170
Uhde, Fritz von 79
Uhde, Wilhelm 110
Valadon, Suzanne 232
Vantongerloo, Georges 158, 322
Velázquez, Diego 16, 36
Villon, Jacques 116
Vilstrup, Ada 100
Vlaminck, Maurice de 84, 86
Vollard, Ambroise 84, 110, 200
Vuillard, Édouard 95, 346
Vytlacil, Vaclav 300
Wagner, Otto 79
Wagner, Richard 102
Warhol, Andy 90, 249, 297, **318**, _372_, **376**
Washington, George 238

Waters, John 348
Weber, Max 256
Wesselmann, Tom 358
Whistler, James Abbott McNeill <u>26</u>, 30, 33, **<u>38</u>**, 90
White, Patrick 315
Whitehead, Alfred North 120
Whitman, Walt 136
Wilde, Oscar 90, 218
Wildt, Adolfo 258
Wittgenstein, Ludwig 246, 247
Wolfegg, Maria 290
Wolff, Albert 31
Wood, Robert 90
Worringer, Wilhelm 130
Zadkine, Ossip 334

Acknowledgments for photographs

Amsterdam, Collection Paul Andriesse,
© Stichting René Daniëls, Eindhoven/
Henk Geraedts 336

Amsterdam, Stedelijk Museum 258, 296, 332

Baltimore, The Baltimore Museum of Art, The
Helen and Abram Eisenberg Collection 33

Barcelona, Museu d'Art Contemporani 372

Basel, Kunstmuseum Basel 92 (photo Martin
Bühler) 106, 160

Berkely, Art Museum 57

Berlin, Staatliche Museen zu Berlin, Neue
Nationalgalerie © Bildarchiv Preussischer
Kulturbesitz 46, 228, 232

Bern, Kunstmuseum 83

Bologna, Museo Morandi, Palazzo d'Accursio
274

Bonn, Kunstmuseum 298

Bonn, Städtisches Kunstmuseum 107

Bordeaux, Musée des Beaux-Arts
© RMN/A. Danvers 278

Boston, Museum of Fine Arts 16, 28, 98

Brussels, Xavier Hufkens Gallery 258

Buffalo, Albright-Knox Art Gallery 60

Cambridge, Fitzwilliam Museum 20

Canberra, National Gallery of Australia 176, 234

Cardiff, National Museum of Wales 28, 68

Chicago, Terra Foundation for the Arts 252

Chicago, The Art Institute of Chicago 10, 130,
208, 230

Cleveland, Museum of Art 12

Cologne, Galerie Gisela Capitain © Estate
Martin Kippenberger 356

Cologne, Museum Ludwig © Rheinisches
Bildarchiv 272

Cologne, Wallraf-Richartz-Museum
© Rheinisches Bildarchiv 206

Des Moines Art Center 208, 246

Detroit, The Detroit Institute of Arts 12

Düsseldorf, Kunstsammlung Nordrhein-
Westfalen 152, 178

Edinburgh, National Gallery of Scotland
60, 82, 274

Eindhoven, Van Abbemuseum 336

Essen, Folkwang Museum © Artothek 106, 130

Fort Worth, Amon Carter Museum 49

Fort Worth, The Modern Art Museum
of Fort Worth 286, 290, 368

Ghent, Museum voor Schone Kunsten 54

Greenwich, The Brant Foundation 354

Grenoble, Musée de Grenoble 150

Hagen, Karl Ernst Osthaus Museum 172

Hamburg, Hamburger Kunsthalle © Bildarchiv
Preussicher Kulturbesitz 122, 232

Hannover, Niedersächsisches
Landesmuseum 42

Hermes Trust, U.K., Courtesy of Francesco
Pellizzi 295

Historical Picture Archive/CORBIS 337

Houston, The Menil Collection 280, 318

Houston, The Museum of Fine Arts 158

Humlebæk, Louisiana Museum for
Moderne Kunst 364

Kansas City, The Nelson-Atkins Museum
of Art 35

Karlsruhe, Städtische Galerie 336

Kassel, Staatliche Museen, Neue Galerie 364

Lausanne, Josefowitz Collection 60

Leipzig, Museum der bildenden Künste 46

London, Courtauld Institute of Art Gallery
44, 70, 92

London, Tate Collection 13, 204, 210, 216, 274,
278, 288, 298, 302, 328, 360

London, The National Gallery 14, 35, 82

London, The Saatchi Gallery 328

Los Angeles, Frederick Weisman Company 230

Los Angeles, Los Angeles County Museum
of Art 178, 348

Los Angeles, The J. Paul Getty Museum 54

Los Angeles, The Museum of Contemporary
Art 322

Madrid, Museo Nacional Centro de Arte
Reina Sofía 204

Madrid, Museo Nacional del Prado 37

Madrid, Museo Thyssen-Bornemisza 66, 148,
172, 190, 280, 362

Mamiano di Traversetolo, Fondazione Magnani
Rocca 244

Manchester, Art Gallery 346

Marseille, Musée Cantini 226

Merion, The Barnes Foundation 22, 86

Mexico City, Museo de Arte Moderno 192

Mexico City, Museo Dolores Olmedo Patiño
© Art Resource/Scala 192

Mexico City, Museo Tamayo Arte
Contemporáneo 236

Milan, Civiche Raccolte d'Arte 156

Milan, Civico Museo d'Arte
Contemporanea 112

Milan, Pinacoteca di Brera © Scala,
Florence 156

Milan, Pinacoteca di Brera 274

Minneapolis, The Walker Art Center 254

Moscow, Pushkin Museum of Fine Arts 58, 66,
68, 101, 341

Moscow, State Tretyakov Gallery 102, 140

München, Bayerische Staatsgemälde-
sammlungen, Staatsgalerie moderner
Kunst © Artothek 152

New Haven, Yale University Art Gallery 58, 220

New York, André Emmerich Gallery 290

New York, Dia Art Foundation 302

New York, Matthew Marks Gallery 330

New York, Michael Werner Gallery 370

New York, The Metropolitan Museum of Art
40, 98, 136, 154, 210, 238

New York, The Museum of Modern Art
© Scala, Florence 62, 86, 108, 112, 126,
148, 152, 158, 160, 180, 214, 220, 234, 237,
242, 243, 252, 262, 286, 288, 302, 308,
336, 338

New York, Solomon R. Guggenheim Museum
102, 122, 302, 338, 340, 368

New York, Whitney Museum of American Art
190, 220

Niigata, Niigata City Art Museum 94

Osaka, Municipal Museum of Art 140

Ottawa, National Gallery of Canada 23

Otterlo, Kröller-Müller Museum 58, 62, 104, 158

Palo Alto, Stanford University Museum
of Art 218

Paris, Musée d'Orsay
© RMN/Gérard Blot 68, 216
© RMN/Hervé Lewandowski 8, 10, 16, 18,
22, 40, 42, 57, 84, 86
© RMN/René-Gabriel Ojéda 94

Paris, Musée du Louvre © RMN/Hervé
Lewandowski 32

Paris, Musée du Petit Palais © Photothèque
des Musées de la Ville de Paris 110

Paris, Musée Gustave Moreau © RMN/René-
Gabriel Ojéda 18, 206

Paris, Musée Marmottan 68, 150, © RMN 30

Paris, Musée National d'Art Moderne,
Centre Georges Pompidou
© RMN 130, 214, 262
© RMN/Adam Rzepka 186
© RMN/Philippe Migeat 144
© RMN/Jacqueline Hyde 84
© RMN/Jacques Faujour 216

Pasadena, Norton Simon Museum © Norton
Simon Art Foundation 154

Perth, The Art Gallery of Western Australia
344

Philadelphia, Jefferson Medical College,
Thomas Jefferson University 37

Philadelphia, Philadelphia Museum of Art
116, 120, 126, 234, 308, © Bridgeman
Art Library 126

Philadelphia, Pennsylvania Academy of Fine
Arts 48

Pittsburgh, Carnegie Museum of Art 136, 234,
348

Princeton, Princeton University Art Museum
230

Providence, Rhode Island School of Design,
RISD 32

Raleigh, North Carolina Museum of Art 25

Reims, Musée des Beaux-Arts © RMN 28

Rennes, Musée des Beaux-Arts
© RMN/Adélaïde Beaudouin 24

Riehen, Fondation Beyeler 232, 326

Rivoli, Castello di Rivoli, Museo d'Arte
Contemporanea 342, 370 (photo Paolo
Pellion)

Rotterdam, Museum Boijmans Van Beuningen
244, 296

Rouen, Musée des Beaux-Arts 18, 24

Saint Louis, The Saint Louis Art Museum 228

Saint-Paul, Fondation Maeght 322

Saint-Tropez, Musée de l'Annonciade 84

San Francisco, San Francisco Museum
of Modern Art 300, 340

Santa Barbara, Santa Barbara Museum
of Art 32

Saratov, A.N. Radischev State Art Museum 140

St Petersburg (Florida), Salvador Dalí
Museum 204

St Petersburg, State Hermitage Museum 34,
108

Stockholm, Moderna Museet 104, 176, 270,
311

Stuttgart, Staatsgalerie 146, 196, 250

Sydney, Art Gallery of New South Wales 354,
362

Tokyo, The Bridgestone Museum of Art 244

Tokyo, The National Museum of Modern Art
138

Tokyo, The Watari Museum of Contemporary
Art 358

Toronto, Art Gallery of Ontario 350

Troyes, Musée d'Art Moderne © RMN/Gérard
Blot 218

Tübingen, Kunsthalle 248

Turin, Galleria Civica d'Arte Moderna e
Contemporanea 170, 244

Venice, Peggy Guggenheim Collection
(Solomon R. Guggenheim Foundation,
New York) 116, 128, 134, 180, 206

Vienna, Leopold Museum 78

Vienna, Österreichische Galerie Belvedere 78,
119

Washington, Hirshhorn Museum and
Sculpture Garden, Smithsonian Institution
48, 196, 264, 266, 314

Washington, National Gallery of Art 155, 186,
228, 238, 264, 272, 298, 306

Washington, The Phillips Collection 144, 252,
300

Weimar, Kunstsammlungen 228

Wuppertal, Von der Heydt-Museum 14

Zürich, Galerie Bruno Bischofberger 372

Zürich, Kunsthaus Zürich 138